Youghiogheny

Pronounced, Yock-a-GEN-ee

Youghiogheny
APPALACHIAN RIVER

Tim Palmer

UNIVERSITY OF PITTSBURGH PRESS

Published by the University of Pittsburgh Press, Pittsburgh, Pa., 15260
Copyright © 1984, University of Pittsburgh Press
All rights reserved
Feffer and Simons, Inc., London
Manufactured in the United States of America

Second printing, 1985

Library of Congress Cataloging in Publication Data

Palmer, Tim.
 Youghiogheny, Appalachian River.

 Bibliography: p. 321
 Includes index.
 1. Youghiogheny River. 2. Youghiogheny River Valley.
3. Stream conservation—Youghiogheny River. 4. Rafting
(Sports)—Youghiogheny River. I. Title.
F157.Y72P35 1984 974.8′8 84-2301
ISBN 0-8229-3495-7
ISBN 0-8229-5361-7 (pbk.)

The maps in this book were prepared by Howard N. Ziegler.
"The Run at Ohiophyle" was adapted from the Youghiogheny River Guide, courtesy of Rich
Designs, Columbus, Ohio.

All modern photographs are by Tim Palmer.

The University of Pittsburgh Press gratefully acknowledges
the Richard King Mellon Foundation and
the Pittsburgh Foundation
for their support of this publication.

In memory of my father,
who first showed me this river.

Contents

	Map of the Youghiogheny	viii
	Down the River	ix
	Historical Events Along the Youghiogheny	xi
One	The High Ridge	3
Two	A Gathering of Waters	13
Three	Wild River	29
Four	The Dam	74
Five	The Confluence	106
Six	The Singing River	119
Seven	Ohiopyle: The Old Days	137
Eight	The Park	161
Nine	Whitewater	188

The Rapids and the Pioneers § Commercial Rafting § Managing the River

Ten	Ohiopyle and the Run	247
Eleven	The Mines and the River	268
Twelve	Beyond the Appalachians	283
Thirteen	Winter	307
	Acknowledgments	317
	Sources	321
	Index	333

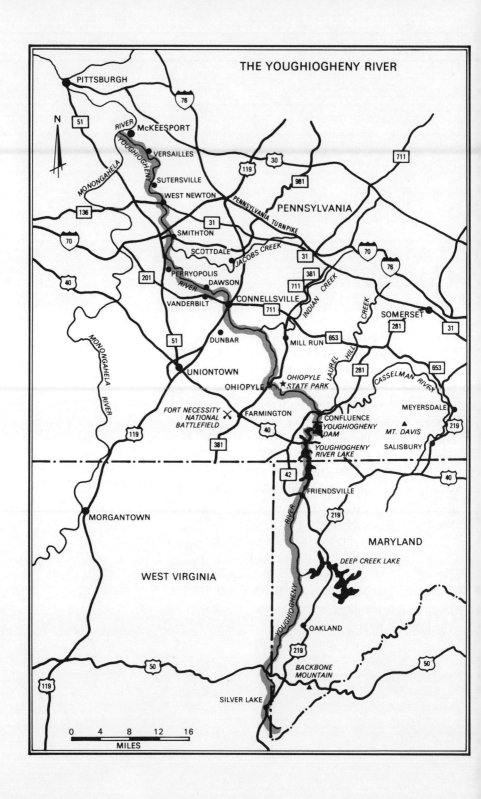

THE YOUGHIOGHENY RIVER

PITTSBURGH

McKEESPORT

VERSAILLES

SUTERSVILLE

WEST NEWTON

PENNSYLVANIA TURNPIKE

PENNSYLVANIA

SMITHTON

SCOTTDALE

JACOBS CREEK

PERRYOPOLIS

DAWSON

CONNELLSVILLE

VANDERBILT

DUNBAR

MILL RUN

INDIAN CREEK

HILL CREEK

LAUREL

SOMERSET

UNIONTOWN

OHIOPYLE

OHIOPYLE
STATE PARK

CASSELMAN RIVER

FORT NECESSITY
NATIONAL
BATTLEFIELD

FARMINGTON

CONFLUENCE

YOUGHIOGHENY
DAM

MEYERSDALE

MT. DAVIS

SALISBURY

YOUGHIOGHENY
RIVER LAKE

MONONGAHELA
RIVER

FRIENDSVILLE

MORGANTOWN

MARYLAND

DEEP CREEK LAKE

WEST VIRGINIA

YOUGHIOGHENY
RIVER

OAKLAND

BACKBONE
MOUNTAIN

SILVER LAKE

N

MONONGAHELA RIVER

YOUGHIOGHENY RIVER

RIVER

0 4 8 12 16
MILES

Down the River

Site	River Miles (from source)	Site	River Miles (from source)
Silver Lake	1.0	Big Bend	55.0
Pleasant Valley	4.0	Youghiogheny Dam	59.0
Charcoal Hill Gap	14.5	Jim Prothero's house and	
Snowy Creek confluence	15.0	River Path headquarters	59.8
Crellin	15.2	Confluence	60.0
Little Youghiogheny		Casselman River confluence	60.4
confluence	19.5	Ohiopyle State Park,	
Oakland bridge	19.8	upper boundary	61.8
Miller's Run confluence	22.8	Laurel Hill gap	61.0–71.0
Swallow Falls	27.0	Sugarloaf Mountain	65.0
Deep Creek confluence	27.8	Victoria Flats	67.0
Deep Creek Dam outlet	29.2	Elephant Rock	70.0
Sang Run Bridge	33.0	Ohiopyle	70.5
Site of Kendall	39.5	Ohiopyle Falls	70.8
Friendsville	42.0	The Loop	70.8–72.5
Youghiogheny Reservoir		Meadow Run confluence	71.2
(upper end)	43.0	Kentuck Mountain	71.5
Site of Selbysport (now flooded		Dimples Rapid	75.0
by Youghiogheny Reservoir)	45.0	Jonathan Run confluence	75.5
Site of the Great Crossings		Stewarton	77.5
(now flooded by		Bruner Run take-out	78.0
Youghiogheny Reservoir)	51.5	Ohiopyle State Park,	
Route 40 bridge	51.6	lower boundary	79.0
Site of Somerfield and National		Indian Creek confluence	81.5
Road crossing (now flooded		Exit from Chestnut Ridge gap	86.0
by Youghiogheny Reservoir)	51.7	South Connellsville	86.5
Jockey Hollow (now flooded by		Powerhouse Dam	87.2
Youghiogheny Reservoir)	52.0	Connellsville	88.0

Site	River Miles (from source)	Site	River Miles (from source)
Broadford	91.5	Buena Vista	120.0
Dawson	94.5	Boston Bridge	128.0
Linden Hall	97.0	Versailles	128.0
Layton	101.5	McKeesport	130.0
Layton Islands	102.0	Fifth Avenue Bridge	131.8
Banning	105.0	Monongahela River and the end of the Youghiogheny	132.0
Jacobs Creek confluence	105.8		
Smithton	107.5	Pittsburgh and the Ohio River	147.6
West Newton	113.0		
Sewickley Creek confluence	115.5	Mississippi River	1,113.0
Sutersville	117.0	Gulf of Mexico	2,082.0

Historical Events
Along the Youghiogheny

8000 B.C. First Indians arrived (date approximate).

1600 A.D. Monongahela Indians lived in the basin.

1737 First reference to the Youghiogheny on a map.

1751 Christopher Gist explored the Youghiogheny at the site of Confluence.

1753 First journey of George Washington across the headwaters. William Stewart lived at the site of Connellsville.

1754 Washington's second journey, including the first recorded Youghiogheny canoe trip and his surrender at Fort Necessity.

1755 English General Edward Braddock's defeat by the French and Indians at the Monongahela. David McKee settled at the site of McKeesport.

1765 John Friend settled at the site of Friendsville; William Crawford at Connellsville.

1769 Evan Shelby started Shelbysport (now flooded by Youghiogheny Reservoir).

1775 First record of the Mitchell family in the Ohiopyle area.

1784 George Washington's final Youghiogheny journey, including his search for a canal route to the Ohio Valley.

1787 John Potter settled at Jockey Hollow (now flooded by Youghiogheny Reservoir).

1789 The first iron furnace was built near Jacobs Creek (probably the first furnace west of the Alleghenies).

1794 Whiskey Rebellion.

1817 National Road completed from Cumberland, Maryland, to the Youghiogheny.

1818 Philip Smyth founded Somerfield (now flooded by Youghiogheny Reservoir).

1825 Army Corps of Engineers began their work on rivers by clearing the Ohio River channel.

1828 Samuel Potter built a gristmill near Ohiopyle.

1830s Coke production began in Connellsville.

1840 First dam built at Ohiopyle for water power.

1848 Two dams and a four-foot-deep channel completed from the Monongahela to West Newton.

1851 B & O Railroad opened from Baltimore and Cumberland to Oakland.

1853 Railroad opened from Cumberland to Wheeling.

1865 Flood waters destroyed the two dams below West Newton.

1871 Henry Clay Frick began development of coal mines and coke ovens near Connellsville.
 Railroad tracks were completed up the Youghiogheny, connecting Pittsburgh to Baltimore (this later became the B & O Railroad line).
 Ohiopyle House hotel opened.

1891 Confluence and Oakland Railroad built to Kendall.

1892 Opening of the Preston sawmill in Crellin.

1906 A hydroelectric plant at the Ohiopyle Falls brought electric lights to Ohiopyle.

1912 Flood control report prepared by the Flood Commission of Pittsburgh, recommending a dam on the Youghiogheny.

1914 Western Maryland Railroad line completed through Ohiopyle.

1915 Coal mines in the Casselman basin polluted the Youghiogheny.

1919 Holt's store constructed in Ohiopyle.

1920s Connellsville coke production ended.

1924 Deep Creek Dam built on a Youghiogheny tributary.

1925 Shelby Mitchell and Hugh Rafferty were the first known boaters to run the rapids below Ohiopyle.

1935 Tygart Dam (on a Monongahela tributary) was authorized as the first large dam to be built solely by the Army Corps of Engineers.

1936 Pittsburgh and Ohio Valley flooded.

1936 First Flood Control Act passed by Congress.

1938 Flood control act passed authorizing West Fork Dam in West Virginia (to be replaced with Youghiogheny Dam).

1939 Construction of Youghiogheny Dam began.

1943 Construction of Youghiogheny Dam finished.

1949 Mine acid spill in Snowy Creek killed fish to Friendsville.

1951 Ferncliff Peninsula at Ohiopyle was bought by Edgar J. Kaufmann and deeded to the Western Pennsylvania Conservancy.

1956 Jean and Sayre Rodman were the first rafters below Ohiopyle.

1958 Bob Harrigan and John Berry were the first known canoeists below Ohiopyle.

1959 Tom Smyth, Dave Kurtz, and Bill Bickham were the first boaters to run the upper Youghiogheny from Sang Run to Friendsville.

1961 Keister tract near Ohiopyle was deeded to the Western Pennsylvania Conservancy.

1962 Secretary Maurice Goddard of the Pennsylvania Department of Forests and Waters announced the intention of establishing a state park at Ohiopyle.

1963 Project 70 passed a statewide vote, approving money for state park acquisitions.
 The beginning of Ohiopyle State Park was announced.

1963 First commercial raft trip at Ohiopyle.

1964 Ohiopyle House hotel burned.

1968 National Wild and Scenic Rivers Act passed Congress, which included the Youghiogheny as a river to be considered.

1973 Regulations adopted to limit the numbers of guided rafters at Ohiopyle.

1975 Western Maryland Railroad discontinued.
 Maryland State Wild and Scenic Rivers Act passed, designating the upper Youghiogheny as a Scenic and Wild River.
 National Wild and Scenic River study undertaken.

1978 Chessie System Railroad officials closed the Stewarton take-out to whitewater boaters.

1979 Bruner Run take-out opened for whitewater boaters.

Youghiogheny

The High Ridge

"*It seems* that most people who came up here were trying to get away from something," Prothero said. "They were renegades or dropouts—people trying to escape. Or maybe they were the hunters, the ones who were looking for something, and they thought this would be a good place to find it." I had figured Jim Prothero came to the Youghiogheny River of southwestern Pennsylvania to guide raft trips, since that's what he did for five years after he arrived, but he corrected me. He came here after he broke up with a girl friend. He needed to get away, and there is nothing like a daily soaking in whitewater for a change of pace. River guides at Ohiopyle are responsible for eighty people on a busy day, and there is no time for a past or a future. It is day-to-day, exactly what this man needed.

That was a long time ago. Since then, Prothero has seen some of the Youghiogheny. He has guided two hundred commercial raft trips and spent five years renting canoes on the reach from Confluence to Ohiopyle. For sport he has kayaked the dangerous upper Youghiogheny. But in all this time, he had never been to the headwaters. This river that had brought escape, pleasure, and livelihood—he had never seen where it starts. Few people have. Maybe he was just avoiding the work at his riverside house in Confluence, but when I said I was going to search out the beginning of the river, in May of 1981, Jim Prothero said he would come along.

From maps, I couldn't tell if our final destination was in Maryland or West Virginia. But somewhere up there, close to the border

on Backbone Mountain, the Youghiogheny River begins and our search would end.

From its first spring at an elevation of about 2,700 feet above sea level, the Youghiogheny flows 132 miles to the north and west, draining 1,764 square miles (an area about the size of Delaware) and joining the Monongahela River at McKeesport, elevation 719 feet, 15.6 miles south of Pittsburgh. In this book, we will explore the entire river and meet the people who live along its shores.

To find the source, I drive my van to Silver Lake, West Virginia, a half-mile-long reservoir built in 1928 by damming the Youghiogheny (sometimes called the "Yock"). Below the dam, the river can be stepped across. Floyd and Edith Cowger from Fairmont, West Virginia, recently bought the lake with its seven cottages and twenty-five campsites. They installed a wood stove in a sagging but comfortable cabin and moved onto their new land.

"This used to be a popular recreation site, even into the fifties," Cowger says. While he, Prothero, and I talk, he hones an axe with a file, then thumbs the blade to test its sharpness. "We like it here," he says, "and we think other people will, too." Though the lake has been sold and resold by owners unable to earn a profit, the Cowgers are hopeful. They know what they want: a small family business on a good piece of ground. Meanwhile, Floyd finds jobs in construction and spends weekends refurbishing cabins. He plans to stock the lake with warm-water fish such as bass, and to have a small fleet of boats for tourists to row, paddle, or sail. Almost at the Youghiogheny's source, the Cowgers are the first of many who hope to gain a livelihood from this river.

Topographic maps show only an "intermittent" stream at the Silver Lake inlet. Prothero and I want to find the absolute beginning of this river, so with Cowger's permission we walk across his land and aim upstream. The inlet is choked with mud; one-third of the original reservoir is now a swampy delta from soil washed off the mountain.

Beavers inhabit the place. We cross one of their trails, worn smooth by the hauling of bigtooth aspen and black willow. Like cowboys who erase their footprints in old-time movies, the beavers obliterate their tracks with the branches they drag. Prothero watches everything and spots wild turkey scratchings where the gobblers have scattered leaves during their search for bugs to eat.

Shortly we find a dirt road and follow it for half a mile, but it is too far from the river. We walk closer to the water so that we can always spot the largest fork and follow it to the true source, but a rhododendron jungle encloses the Youghiogheny and I almost have to be in it to see it. With my hands, I part the branches as if they were curtains, but they are supple; without warning they swat me in the face. Rhododendron is the state shrub in West Virginia and the unofficial but inescapable shrub of our small Youghiogheny.

The river splits in two. Most records say that the Youghiogheny's source lies in Preston County, West Virginia. Since the river comes from the south, I can see the reason to call the southernmost branch the source, but when I was there, the Maryland branch, coming from the east, was nominally larger—maybe forty inches wide versus thirty-six. We follow the Maryland branch through a maze of fallen timber. Crisscrossed and at every angle, logs bridge the river, two or three feet above it. I step from one trunk to another, never touching ground except when a log breaks and I drop straight down into the Youghiogheny, all of three inches deep. "You know how to swim?" Prothero asks.

We are heading toward the top of the Appalachians. Backbone Mountain, on which we walk, is the divide between the Potomac, which flows into the Atlantic Ocean, and the Youghiogheny, whose waters are bound for the Gulf of Mexico. It is the continental divide of the East, and one of many northeast-southwest trending ridges that make up what geologists call the Allegheny Mountain Section of the Appalachian Plateaus Province. All of this is a part of the Appalachian Mountain chain, 300 million years old, running 1,600 miles from Alabama to Quebec's Gaspé Peninsula, spanning one-sixth the distance from the equator to the North Pole. We are 600 miles up from the Alabama end. The summit above us is Hoyes Crest, 3,360 feet high. It is the highest point in Maryland, a claim that borders on the sneaky, since you can almost spit into West Virginia.

As I fall in the water for the third time I am speared again by a dead branch, and I wonder why it is so important to see the source. Prothero doesn't wonder. He enjoys the challenge of this search. He likes to be tested, to see what he can do, to be savvy and to prove to himself that he can go anywhere. Maybe it is part of his escaping. Over the years this drive has led him to whitewater. First he guided on the lower Youghiogheny in a raft, then a kayak. He tells me

about paddling a waterfall of forty-five degrees, more or less, in Banff Park, Canada. He almost died. I say he was crazy and he agrees. Prothero now paddles open canoes which are much more difficult in rapids than kayaks.

What difference does this spring make? The Youghiogheny sips from thousands of springs. Seventy percent of the river's flow emanates from groundwater that seeps down from springs. Why is the Source so important? I think it has to do with beginnings. To me they are important times, important places. Finding the beginning of the river has something to do with grasping the whole thing, with understanding this part of the earth. After seeing the source, I will know the river better when I launch my canoe or my raft seventy miles downstream at Ohiopyle, or when I stand on a sandbar in the shadow of the U.S. Steel tube mill where the Youghiogheny dumps without grace into the Monongahela at McKeesport. Maybe it is like holding a baby. Even though there may be little similarity between infant and adult, somehow the person is known better, or known more completely, if you know him when he is young and then see him grow. A river shows all of its ages at once. Right now we see its birth. Farther downstream we can see it as a child, then as an adult, and finally in old age. A river offers a chance to see the natural process, to see the workings of life. It involves changes, growth, cycles, setbacks, and healing, and eventually includes us whether we want to be included or not.

Something here also involves gradient and elevation. There was an ancient belief that rivers flow from the center of the earth. That idea may entice those interested in myths, but to me, the reality that rivers come from the highest places on earth is more powerful. To go to the top of the river is somehow alluring. If this river began at the end of a flat plain I would not be so drawn to its source. The fact that I must climb to reach the beginning of the Youghiogheny is an extra attraction.

To some people, gradient has an appeal wherever it is found: mountains, cliffs, sand dunes, waves, skyscrapers, balcony seats, waterfalls, whitewater rapids. Some mountain people become edgy in the flatlands. They would rather look up to peaks and down to valleys, nap in the shade of a cliff, be confined between the walls of a canyon, or free as the wind in the limitless space on top. Gradient is what makes mountain people what they are. These old hills—the Appalachians—were our nation's original symbol of gradient, and

it is an essential element in the story of this river. Prothero and I climb higher.

Discovery may also be what I am after; finding something new. Maybe I am driven by what drove the old explorers, maybe by modern restlessness, or maybe they are the same. I want to go somewhere I have never been. The 1700s are considered the age of exploration for the Appalachians, but these mountains are as new to me, today, as they were to Christopher Gist and George Washington in the 1750s. Those explorers hit only the highlights. Since I plan to see every mile of the river, I may as well start at the top.

Beginnings, gradient, discovery: all could be reasons for this climb. Prothero is content to say, "I just want to see it."

We come to the mossy remains of two concrete dams. One is eight feet high, another is four feet high, but neither hold water any more. I automatically see dams as problems. They block the flow, bury the riffles, stop the migration of fish, warm the water by ponding it, collect mud and silt. They are piles of cement dumped into my river. My bias is clear. I would hope that to dam a river, there would be some very good reasons. Prothero, on the other hand, does not judge, does not get angry. He only wonders why, and how. He has a fascination for man-made stuff. He has the eye of a tinkerer. He *is* a tinkerer. While I wonder how to blow these dams up, Prothero looks at them closely and notices their shape— narrow at the top and wide at the base. He wonders how far into the hill they extend. He decides that this one is not rooted deep, because all the water seeps through underneath. He wonders how the builders carried the cement up here, and of course, he wonders what the dam was for. Later I learn that it was built in the 1920s for a trout-rearing pond.

As we gain elevation, the stream remains a junkyard of fallen logs, but thick shrubbery is left behind and I enjoy seeing the sky. We can walk up the mossy, loggy bed in a ravine about six feet deep and twelve feet wide, or we can walk above the ravine where the greenbrier—viny with sharp spines—is healthy. It's a good substitute for barbed wire. We take the ravine.

Before I started this trip, I had a vision of the Youghiogheny headwaters. They would be clean enough to drink, tucked away in a wild corner of the Appalachians, a sweet untouched spring. What I found were hundreds of acres that had been clear-cut twenty years ago. Every 200 feet an old logging road, now paved with grass and

weeds, fords the river, each time making a muddy goo even after all those years. This is where the silt that chokes Floyd Cowger's lake comes from. The river starts in a clear-cut; it ends at a steel mill. The miracle is that in between, it is one of the finest wild and scenic rivers in the eastern United States. In four different sections, the Youghiogheny offers some of the best water for expert kayakers, intermediate canoeists, commercial rafters, and gentle-water paddlers. It is one of the country's outstanding examples of reclaimed water quality and a return of trout. But not to get ahead of the story.

Where is the highest spring, that elusive Youghiogheny source? Prothero says that this hike reminds him of a training trip for Canoe Trails. Back in Beaver, Pennsylvania, in tenth grade, he signed up for a scouting program. Each year, a group went to Canada for ten days, but not before intensive preparation, including cross-country orienteering. The Canoe Trails program went co-ed while Prothero was there, and that is where he met his heart-break girl friend—the one who led to his Ohiopyle escape. Eventually, Prothero was kicked out of Canoe Trails for "insubordination." He says, "There were a lot of good things there, but also a lot of stuff that you grow out of, and the program doesn't grow with you." When Prothero started his own programs on the Youghiogheny, the emphasis was on growth.

Soon the river is but a trickle. In places it goes underground like a phantom, then pops up again. Any moment I expect the flow to give out altogether, and it does. Within a grove of tall tulip poplar skipped by the loggers and surrounded by third-growth striped maple, speckled alder, yellow birch, and red maple, a hemlock tree stands with a spring at its base. Hay-scented ferns are green and thick. At the rate of perhaps one cup a minute, the Youghiogheny flows toward the Gulf of Mexico. This seems an appropriate source, but above, the ravine continues, and where there is a hollow, there is water, at least when it rains. We keep walking.

The Youghiogheny at this altitude is a damp spot in the bottom of a Maryland ravine. As we press upward, sink-sized pools of water appear now and then with drops of current running through. Then, up ahead, I finally see the highest limit of the ravine. I see where it begins in a cavity like a tiny cirque, fifteen feet across. Above it, the mountain simply rises to its summit, uncut and uneroded by the flow of water. Below it, there is a channel for the Youghiogheny, continu-

ous for 2,082 miles. And right at the back of the cirque, tight against the mountain, is a spring measuring one foot across, two inches deep, and edged with the yellow pollen of May.

Hoyes Crest, above the Youghiogheny source, is not a peak at all. It is only a little higher than other places on Backbone Mountain, which runs fifty miles from Parsons, West Virginia, northward to Westernport, Maryland. From the crest you see only trees, with barely a glimpse of the upper Youghiogheny Valley and the North Branch Potomac Valley.

For a better view—to see the lay of the land—I travel a few days later to a different apex of the Backbone: Eagle Rocks. They rise east of Loch Lynn and Oakland, and are accessible by dirt road off Maryland Route 560. On the topographic map it is a dramatic site. First of all, the name. Maybe an aerie was here. Maybe eagles soar past in the spring or fall. The map's contour lines are congested, crowded together, indicating the concave rise of a rocky summit. On the map it says "quarry."

It is evening when I turn off the highway and test my van's springs on the washboard road to the rocks. To what is left of them. It seems the quarry has eaten the best of the eagle habitat. The remaining rocks are hard sandstone surrounded by a coarse, white, remarkable sand. An acre of the summit has been excavated and removed for use at lower elevations. On my heels, in fact, is a pickup with two men who will shovel half a cubic yard of Eagle Rock super-sand and drive away with the treasure. The mountain-top will be reincarnated as a slab on which a suburban doghouse will sit. Even so, a few rocks remain. I scramble up the slopes of the quarry and reach a path that lures me to where a ten-foot-square stone catches a gale of wind and the last glint of springtime sun. To soak up both, I climb on top.

Pittsburgh and Baltimore may as well be on another planet. To the east the mountains are graceful; they are the smooth-topped mountains of Maryland. Wide valleys with seas of grass lie between. Even during the Indians' time there were grasslands down there with buffalo grazing in them. The scene reminds me of central Pennsylvania, or of a diminished version of Virginia's Blue Ridge. In all, about ten high ridges run in a northeast-southwest slant between here and the Atlantic Ocean, the easternmost mountain rising near Frederick.

Below me is the tip of western Maryland, a part that is geographically, economically, and culturally a part of West Virginia or southern Pennsylvania. More coal mines than horse farms, more food stamps than dividend checks, more chewing tobacco than Virginia Slims. Deer rifles; not duck hunters' shotguns. This is remote Garrett County, Maryland's equivalent to Alaska. To the southwest I see the massive rounded peaks of West Virginia where there are national forests and rugged river canyons. To the north and west it looks equally wild, a jumble of topography incised by gorges—a wildness that runs into Pennsylvania, where the Youghiogheny and I will be going on a journey to last a year.

Journeys are dated things. It seems that few people take journeys anymore; instead, people simply go places. A person could travel the length of the Youghiogheny in one hour by airplane, in three hours by car. Some people could even walk from one end to another in a week, and what is seen between origin and destination may be unimportant. Not for me. For me, the going is the thing. Look around. Talk to people. Go slowly. Enjoy it. The place will never be the same, and will probably never again be this good.

With thoughts spurred by past journeys and by the pickup truck full of sand heading down the mountain, I feel an impermanence here, even on the mountain. Especially on the mountain. Everything that is up here will end up down there at the river. Water, soil, nutrients, rocks, trash: all of it will erode and roll from the top to the bottom. Instability is resolved by moving downhill. That truckload of sand was only getting a premature ride. So will we end at the bottom, giving in to gravity, yielding to its greater strength.

Water descends the east side of the Backbone, runs into the Potomac and past the nation's capital to Chesapeake Bay. Mountains to the south feed the Cheat River, which with the West Fork, forms the Monongahela at Point Marion, Pennsylvania. The north side of the mountain sheds water to the Youghiogheny. Nearby are more excellent whitewater rivers than perhaps in any other place in the country: the Savage from the eastern slope of this mountain, the North Branch of the Potomac, the Big Sandy and Blackwater which join the Cheat, the Cheat itself, and the Youghiogheny.

Down there along the Youghiogheny are people fiercely protective of their land, and others who would sell it in a minute. There are old-timers like Gwen Waters and Shelby Mitchell who have seen the changes. There are newcomers like Jim Prothero who will keep

coming back. The whitewater down there is the most popular in the United States, and for recreation it is the most efficiently managed, whatever that is worth. There are gorges and towns and cities; ospreys, rare plants, and rare people. Parts of it stubbornly show our country's past; parts may show its future.

Down there it looks rugged and green, but this is not an empty region. Far from it. In the Youghiogheny basin there is one place— only one—where you can be more than a mile from a road. All of the land, save a few acres in two state parks, has been logged. Counting small "ground hog" mines in the sides of hills, thousands of coal mines have been dug and their spoil piles remain.

From Eagle Rocks I see the tall stacks of the Mount Storm power plant to the east, burning coal and belching smoke for the megalopolis. The plant sits in a valley but its stacks rise over the mountaintop. To the northeast is the paper mill at Luke, Maryland. You have to be within a mile to spot it by sight, but on some days it can be smelled the whole way to Ohiopyle, a straight-line distance of forty miles. To the north, hidden by mountains, is Deep Creek Dam on a Youghiogheny tributary, where the Pennsylvania Electric Company generates hydroelectricity for peaking power—mainly for air conditioners. Beyond, in all directions but barely visible from here, are strip mines where coal is dug. Much of it is then exported to Japan and Europe.

Up here, it is easy to see that the Youghiogheny story is one of use and exploitation. The region was a resource colony of Pittsburgh, a city made possible through the use of water and coal from these mountains. The Youghiogheny basin was, and still is, controlled in many ways by Pittsburghers. Its history includes boom and bust, the despair of Appalachia, people fighting to take from the land, fighting for a living, fighting outsiders, and fighting among themselves. It is a place where expectations soared and fell, where desires were imported with settlers and then grew in a singular, regional way, sometimes realized, often blunted. Hopes were raised, then abandoned as old people clung fast and young people left. Chances to use the land in a sustained and durable way were not realized and were passed by.

Today, there are new chances to use the land in lasting ways, because this has been a place of recovery and healing, of forests and waters partly reclaimed from two centuries of abuse. It is a place full of contradictions, beginning with the ancient rocks and the

recent quarry as neighbors here on top. Threads of wilderness run through it all, from the highest spring to the willow-thicket shorelines where the Youghiogheny nears Pittsburgh.

So the place has been sapped of its wealth, but in other ways it has been saved. Compared with the rest of the East, parts of the basin are a storybook wilderness. Within fifty miles of the middle river are almost three million people; this wild river is so close to urban centers as to be a curiosity, a magnet, a refuge.

The Youghiogheny has been the target of more escapees than Jim Prothero. Others were Delaware Indians after being driven from eastern Pennsylvania, the man who claimed to have shot General Braddock in the French and Indian War, a Pittsburgher whose doctor told him to flee the city and seek clean air, a schoolteacher who could stand working in the Hill District of Pittsburgh no longer, an office equipment salesman who would rather run the river and drink wine, and a machinist-inventor who wanted no more of the nine-to-five routine, and a river guide who would probably have destroyed himself in any other environment.

Down below me there are homes, and hopes, and joys shared, and dreams, though the dreams are often buried among hard realities.

The horizon at Eagle Rocks is golden, then red, then navy blue as the light fades and Venus shines in the west and stars decorate the sky. In early May it is cold and windy. A deer mouse flashes past so fast I can hardly see it but I feel it touch my foot. Each ridge of the Appalachians recedes in its own shade of blue. Then they all turn to black. It is nighttime and dark, but our journey down the Youghiogheny has just begun.

A Gathering of Waters

It may be only chance that has given us the spelling of Youghio-
gheny. The earliest reference to the river is a caption on a map
drawn in 1737 by William Mayo: "Spring heads of Yok-yo-gane
river a south branch of the Monongahela." In 1751, a map of
Virginia and Maryland called the river the Yawyawganey. One year
later a trader's map listed Ohio Gani. Captain Robert Orme of the
Braddock expedition in 1755 called the river both Joxhio Geni and
Yoxhio Geni. Nicholas Cresswell, an Englishman who traveled west
to acquire land for a group of Virginians, wrote in 1775 that he
"crossed the Yaughagany River at the Steward's Crossing." Local
petitioners for a road from Uniontown to the river spelled it
Youghiogheni in 1784, and in the same year, George Washington
spelled it Yehiogany. In 1798, Robert Proud's *The History of Penn-
sylvania* referred to the "Yoxhiogany River." Early land grants
spelled it Yohogania, and other variations were Yochi Geni,
Youghanné, and Yuh-wiac-hanne. For some reason, none of these
spellings stuck.

The meaning is also obscure. Monongahelas lived in the basin (the
land that drains into the river and its tributaries) between A.D. 900
and 1600, and after their disappearance, Shawnee, Seneca, Dela-
ware, and Erie Indians all camped and hunted here from time to time.
The word *youghiogheny* originated in one of their dialects. Most
historians agree that it means "a stream flowing in a contrary di-
rection," or "in a roundabout course." The direction of the Yough-
iogheny is unusual: north for sixty miles, then north and west. The

Youghiogheny also runs in a roundabout course: north, west, then northwest, with occasional loops and bends that cover almost 360 degrees. Another interpretation is "rough or dare-devil stream. That it is. Still another definition is offered in Christopher Gist's journals: *youghanné* is said to be from the Kanhawhas Indian tribe. *Yough* meant "four," and *hanne* meant "stream" or "rapidly flowing stream." Gist's four streams were the upper Youghiogheny, the Casselman River, Laurel Hill Creek, and the main stem of the Youghiogheny below the town of Confluence.

As rivers go, the Youghiogheny is no giant. It drains 1,763 square miles, the tenth largest basin in Pennsylvania (the eleventh if you count the Mahoning, which is mostly in Ohio). The Schuylkill (1,912 square miles) and Kiskiminetas (1,887) are comparable in size. In contrast, the Ohio at Pittsburgh drains 19,132 square miles, the Susquehanna at Harrisburg drains 23,091, and the Delaware at Philadelphia, about 10,000. The Monongahela basin, which includes the Youghiogheny, is more than four times the size of the Youghiogheny alone.

Nor is the Youghiogheny a small river. Its total length is 132 miles, according to my measurements on U.S. Geological Survey topographic maps (other sources, no two of which agree, list a length of 123 to 133 miles). If the Youghiogheny were stretched into a straight line originating at Pittsburgh, it would reach either Erie, Cleveland, Zanesville, Parkersburg, Hagerstown, or State College. Eighty-five of the river's miles are in Pennsylvania, forty-two in Maryland, and five in West Virginia.

The river carries an average of 3,000 cubic feet of water per second at its end in McKeesport, totaling 2,522,880 acre-feet a year (one acre-foot covers an acre with a foot of water, which is enough to fill a municipal swimming pool, or enough to supply a family of five for a year). From the town of Confluence downstream, there is always enough water to float a canoe or raft.

No other river in Pennsylvania combines the Youghiogheny's size, water quality, wildness, and rapids. It is one of a handful of good whitewater rivers in the East that run all summer, due to an Army Corps of Engineers dam that saves Pittsburgh from floods and increases the river's flow during dry seasons.

Counting tributaries, there are over 1,700 miles of stream in the Youghiogheny basin. The largest of these is the Casselman River

(53 miles long), draining the coal country of northern Maryland and southern Pennsylvania. Laurel Hill Creek (30 miles) is a clean stream joining the Casselman just above the Youghiogheny. Other large tributaries are the Little Youghiogheny River (13 miles) from farmland and towns of western Maryland; Deep Creek (14.5 miles) which has been dammed in Maryland for hydroelectric power; and Indian Creek (27 miles), damaged by strip mines but still providing the water supply for Connellsville, Greensburg, and other towns. Jacobs Creek (29 miles) and Sewickley Creek (30 miles) are mine-polluted tributaries from foothill farms and old coal towns of the lower river.

In Pennsylvania, 505 square miles of the Youghiogheny basin lie in Somerset County, 350 in Fayette, 360 in Westmoreland, and 40 in Allegheny County. Most of the remaining 513 square miles are in Garrett County, Maryland, and a few are in Preston County, West Virginia.

At the lower end of the river, McKeesport receives thirty-eight inches of precipitation a year. Somerset County, in the highlands of the basin, receives forty-three inches and is the wettest region in Pennsylvania. Garrett County, where temperatures drop below freezing 150 days a year, sees forty-seven inches of precipitation, including seventy-seven inches of snow. Throughout the upper basin, June and July are the wettest months; November is the driest.

About 336,000 people (eight-tenths as many as in the city of Pittsburgh) live in the Youghiogheny basin: in the Appalachian towns of Oakland, Friendsville, and Confluence; in the coal mining communities of Crellin, Dunbar, and Smithdale; and in the industrial cities of Connellsville and McKeesport. Most of the basin, however, is sparsely settled. The hillsides are dotted with modest ranch houses, mobile homes, occasionally a rambling country estate, and old frame houses. Average population density is 191 people per square mile, but 244,000 residents (73 percent) live in the lower twenty-six miles of the basin in Westmoreland and Allegheny counties, leaving a density of only 52 residents per square mile throughout 80 percent of the basin. For comparison, the population density of Pennsylvania is 262 people per square mile, and Maine—the least-populated state east of the Mississippi—is 32.

At the headwaters in Maryland and West Virginia, forests blanket the ridges. Below these mountains, farms border much of the river from Silver Lake to the Little Youghiogheny confluence near Oakland,

Maryland. Then the shorelines are mostly unsettled with only three bridges in the twenty-two miles to Friendsville. Youghiogheny Dam impounds the river for seventeen miles to Confluence, Pennsylvania, where the Youghiogheny, the Casselman River, and Laurel Hill Creek join. A twelve-mile reach, mostly undeveloped, forms the river's mid-section, ending at the town of Ohiopyle, also the site of Pennsylvania's largest state park (discounting Pymatuning which is mostly reservoir and not land). Below Ohiopyle are seven miles of rapids; ten more miles to Connellsville run wild and remote. Through this section, the river cuts a gap in Chestnut Ridge and flows out of the Appalachians. If you were to keep traveling west on Route 40, the next mountains you would see would be the Front Range of the Rockies at Denver. Below Connellsville the Youghiogheny winds for forty-four miles around farmlands, small towns, and coal mines, finally penetrating the urban and industrial fringe of Greater Pittsburgh.

The total gradient of the river from Silver Lake is 1,773 feet, or 13.4 feet per mile. From top to bottom, you can see almost everything that the Appalachians and their western foothills have to offer, and you can see almost everything that people can do to the land, from preservation to utter exploitation.

As near as archaeologists can tell, people first came to the Youghiogheny about ten thousand years ago. This was about seven thousand years before the first Babylonian empire, which predated the Egyptian empires. The Monongahela Indians lived here one thousand years ago, but unaccountably vanished shortly before white people came. The Youghiogheny became a fringe territory for tribes in surrounding areas. Archaeologists have uncovered village sites near the headwaters, at Confluence, Connellsville, and other places, but little of the native heritage remains. Even Indian place names are few, but included are Youghiogheny and Ohiopyle, which meant "white frothing water."

Where Pittsburgh now stands, the broad and boatable Ohio River opened access to the entire western frontier, and for this reason, the Ohio became the target of colonial explorers, traders, armies, and settlers in the 1700s. To the English—engaged in a westward movement—the upper Youghiogheny basin was strategic; it was the height-of-land between the Potomac Valley and the Ohio Valley. Trails from Virginia were among the first routes leading to the interior, and they crossed the Youghiogheny.

This land was claimed by the Iroquois Indians after they spent twenty years fighting other Indian nations for it. The French thought the land was theirs; they dated their claim from 1682 when La Salle canoed the Mississippi and declared that the entire basin was owned by France. However, the British believed that because they intended to settle the land, it ought to belong to them. Additionally, they claimed the land through a 1744 treaty with the Iroquois at Lancaster. Perhaps more to the point, prestigious Virginians, under English rule, organized the Ohio Company in 1747 for real estate and obtained a 200,000-acre grant in the upper Ohio Valley. George Washington's half-brother, Lawrence Washington, was a partner in the company. The French, Indians, and English would fight it out.

Guided by a Delaware Indian, Nemacolin, the British built a horse path across the eastern continental divide in 1753, linking the headwaters of the Potomac with those of the Ohio. Called Nemacolin's Path, it probably followed ancient routes of the Indians, crossing the upper Youghiogheny and its tributary, the Casselman. In his first of four trips through the Youghiogheny country, twenty-one-year-old George Washington journeyed this way in November 1753, carrying a message from Governor Dinwiddie of Virginia to the French at Fort LeBoeuf (near today's town of Franklin, Pennsylvania, up the Allegheny River). The message said to stop occupation of lands claimed by the English.

In 1754, Washington returned to the Youghiogheny with 300 militiamen. Colonel Joshua Fry was in command, but died, leaving young Washington as the ranking officer. He left Cumberland in early May, advancing about three miles a day. The group forded the Casselman River at the "Little Crossings" near today's Route 40 at Grantsburg, Maryland: "we halted to dry ourselves, for we had been obliged to ford a deep river, when our shortest of men had water up to their arm-pits." They reached the Great Crossings of the Youghiogheny (above today's Route 40 bridge over Youghiogheny reservoir), where Washington waited several days for lower water while exploring the river below. Then he proceeded to the west.

In late May, the first skirmish between Washington and the French resulted in the death of nine Frenchmen and their leader, Joseph Coulon de Villiers, sieur de Jumonville, and marked the beginning of the French and Indian War. Washington retreated to

his camp at Great Meadows on the headwaters of the Youghio-
gheny's Meadow Run, where he set his men to building Fort Neces-
sity. On July 3, his supplies exhausted and his troops outnumbered,
he surrendered to the French. This was Washington's first major
military experience and his only surrender. The French let him go,
possibly hoping that the defeat would discourage British settlement.

In 1755, General Edward Braddock, commander of all British
forces in America, crossed the Nemacolin route, which was improved
and renamed the Braddock Road. He had ignored warnings about
the Indians, saying, "These savages may, indeed, be a formidable
enemy to your raw American militia, but upon the King's regular and
disciplined troops, sir, it is impossible they should make any impres-
sion." The army forded at the Great Crossings, waded the Youghio-
gheny again at the site of Connellsville, and proceeded to Turtle
Creek, eight miles from Fort Duquesne, which had been built by the
French at the point where the Allegheny and Monongahela rivers met
to form the Ohio. With 2,000 men and George Washington as aide-
de-camp, Braddock was ambushed by the French and Indians on July
9. He forced his men to fight in the open the way armies did in
Europe; as a result, 456 were killed and over 421 wounded. The
French and Indians lost only 32 men. Of eighty-nine commissioned
officers, sixty-three were killed or wounded, including every one
above the rank of captain but Washington. Braddock, who had four
horses shot from under him, was severely wounded and died on the
return trip to Cumberland. Three years later, the British retaliated.
General John Forbes, after cutting a road through the mountains of
Pennsylvania, routed the French and built Fort Pitt on the ruins of
Fort Duquesne. With another French loss at Fort Ligonier in 1759,
the French and Indian War ended. Pontiac's War, four years later,
marked the last Indian effort to retain their lands in the Youghio-
gheny basin. British control was assured.

In 1784, George Washington again traveled across the Yough-
iogheny to inspect his Ohio Valley properties and to scout the re-
gion for a road or canal that would link the Potomac and the Ohio.
When he reached the Casselman River he wrote, "This is a pretty
considerable water and, as it is said to have no fall in it, may, I
conceive, be improved into a valuable navigation." On September
25 during his return trip, Washington camped near Swallow Falls
on the upper Youghiogheny and wrote, "The little Youghiogheny
[the Casselman] from Braddocks Road to the Falls below the

Turkey Foot [Confluence], may, in the opinion of Friend [Charles Friend], who is a great Hunter . . . be made navigable—and this . . . would open a very important door to the trade of that country." About 1830 the Chesapeake and Ohio Canal survey indicated that a water route from Cumberland to Pittsburgh via the Casselman and Youghiogheny would need 246 locks and would be expensive. The canal from Washington, D.C., was extended only to Cumberland, although the Casselman-Youghiogheny route was studied by the Army Corps of Engineers and supported by congressmen as recently as 1930.

In 1759, George Washington had recommended that the Virginia House of Burgesses consider the construction of a road from the Potomac headwaters to the Ohio. Two years after receiving 20,000 acres in the Ohio Valley, he had again recommended a road, introducing legislation so that individuals could subscribe at their own expense for construction. After a decision that the taxpayers should pay for the road, and a heated debate over constitutionality, the nation's first federally funded highway was authorized by Congress in 1806. Known as the National or Cumberland Road, it was started in 1811 and followed the old Nemacolin Path and Braddock's Road across the Youghiogheny headwaters. In 1817 it reached from Cumberland to the Youghiogheny. The National Road became a main link between eastern and western America. Vestiges can yet be seen: it crossed the Casselman at Grantsburg where the original bridge—the largest single stone arch of its day— is preserved. The Casselman Hotel in Grantsburg opened in 1824 and is still used. People followed the road to the Monongahela River at Brownsville, Pennsylvania, which was expected to grow larger than Pittsburgh. When there was enough water in the river, pioneers transferred to flatboats or keelboats and floated down to Pittsburgh, Ohio, Kentucky, and finally the Mississippi River. The opening of the railroad to Pittsburgh in 1852 changed all that, causing National Road traffic to decline, stifling Brownsville's growth, and stimulating Pittsburgh to economic dominance. To-day's Route 40 follows the path of the old National Road.

Proposed in the 1970s by the National Park Service, the Potomac National Heritage Trail is planned to run 825 miles up the Potomac River to Cumberland, to use part of the old National Road, and then to skirt Youghiogheny Reservoir and connect with Ohiopyle State Park. Here it would meet a river trail to Connellsville and the

Laurel Ridge Trail to Johnstown. The Washington-to-Cumberland section is completed along the old canal.

After leaving its source on Backbone Mountain and its first dam at Silver Lake, the Youghiogheny winds as a four-foot-wide pastoral stream gathering small tributaries, dropping gently ten feet per mile to lowlands on the west side of a farming region called Pleasant Valley. This is a high basin, two miles wide, shadowed by Backbone Mountain which forms an eastern wall, seeming to hold the megalopolis at bay. All the time, the Backbone reminds me that I am on the western slope of the Appalachians. From here it is downhill to the middle of the continent.

Rich and velvety, Pleasant Valley stretches ten miles to Oakland. The ridge and the valley have edges that are sharp and clean; the mountain is covered with forest from top to bottom, and where it ends, fields begin. Farms are tilled or grazed and are outlined by fence rows, oaks, and walnut trees. In Wyoming, where so much is made of ranching, cowboys need at least forty acres to raise a steer. Here, farmers need about two. Hay is collected in huge bundles that look like Shredded Wheat. Abundant herds of dairy cattle account for 75 percent of local agriculture, and Holsteins are so black-and-white they seem to have been scrubbed. Barns are freshly painted. Pleasant Valley is unlike the rocky, steep hill-farms that are scattered through much of the Youghiogheny basin. Families have farmed here for generations, and much of the valley seems untouched by modern encroachments.

Most of the soil up here is classified by the federal Soil Conservation Service as class 2 or 3, both considered "prime." Yet census reports indicate a 47 percent decline in land used for agriculture between 1959 and 1974. The number of farms decreased by more than one-third. While this is a statewide and national trend, Garrett County's agriculture seems to be even more troubled than most. The farm population is dwindling due to consolidation, mechanization, and the loss of land in production.

West of Redstone lies one of the widest expanses of unmarred field, yellow-green with the springtime growth of grains and grass, but in it, obvious from Route 50, is a sign: "For sale, 230 acres."

Tim Dugan, Garrett County Planning Director, says, "Because it is so beautiful out there—such a pastoral setting with its mountains and farms—everybody would like to live there." Land development

elsewhere takes vast chunks of farmland, but here it follows a buckshot pattern. An acre here, an acre there. A corner lot is sold for a homesite. Five or ten acres next to an 1890 farmhouse are deeded for $1 to a son or daughter. A wedge of land that is not easy to plow is conveyed to a young couple who move from Oakland or Hagerstown.

Throughout the Northeast, many approaches have been tried to keep prime farmland for farming. These include reduced property taxes if farmers agree not to sell lots, agricultural sanctuaries that are off limits to highways and dams, government loans for improvements on farms and in agribusiness, free advice from county agricultural agents and the Soil Conservation Service, and zoning intended to discourage the big real estate developers by requiring lot sizes of five or ten acres. "But there is fierce opposition to zoning," county planner Anna McNallie says. Small farmers continue to go out of business and sell their land.

The immigration of Amish and Mennonite families represents a reversal of this trend. Horse-drawn carriages are common in Oakland, and in Salisbury and Meyersdale along the Casselman. A local farmer near Redhouse says, "The Amish aren't hit with the cost of fuel and machinery. They just keep on farming the way they always have." Here at the headwaters is an alternative culture not vulnerable to the economics of Exxon and Saudi Arabia, and one that supports the idea of farming the land forever.

After the Youghiogheny flows past the farmland of Pleasant Valley, the first town is Crellin, Maryland, fifteen miles below the source and four miles southwest of Oakland. Crellin was a company lumber and coal town—a turn-of-the-century community with frame houses, garages, sheds, and weathered privies. About the time George Washington passed through, two of the last four buffalo in Garrett County were killed near here.

Settlers named the town Sunshine, but Rolland P. Crellin, a Pennsylvania investor with the Preston Lumber Company, built a sawmill in the 1890s, the name was changed from Sunshine to Crellin, and the cutting of timber began. From 1892 to 1905, the Preston company sawed 250 million board feet of lumber into mine props, boards, and pulpwood. The Kendall Lumber Company then bought the mill and cut another 350 million board feet until 1925, employing up to 750 men. Laborers built makeshift dams on the

Youghiogheny near Silver Lake to create temporary ponds which were filled with logs. Blasting of the dams allowed the logs to ride the flood to mills in Crellin.

As the lumber business declined in the 1900s, coal mining boomed, and in 1925 Crellin consisted of seventy-five families in company-owned houses. In 1949, mine acid from Snowy Creek, which joins the Youghiogheny at Crellin, killed fish for twenty-five miles to Friendsville. Snowy Creek is the largest source of mine drainage on the upper river, though there is potential for much more.

In 1943 the Army Corps of Engineers proposed a dam at Crellin to store water for hydroelectric power. The site was later identified in a "Potential Plan of Development" by the Army Corps for the Appalachian Regional Commission in the 1960s, but nothing has happened.

Even with the added water from Snowy Creek, the Youghiogheny remains a small river, less than 100 feet wide until it receives the Little Youghiogheny—a tributary from another high valley and from the town of Oakland.

In the upper Youghiogheny basin, Oakland is the only sizeable town, with 2,000 people. It lies twenty miles from the source and is the largest riverfront community between Backbone Mountain and Connellsville, sixty-eight more river miles below. Regarding general appearance, I'd say that Oakland is the most attractive town in the entire basin. It is the commerical center for Garrett County and for a northern corner of West Virginia. Twenty percent of the county's employed work in retail trade—most of them, here. This is a service center (18 percent of the county work force), a manufacturing center (17.7 percent), and the home of county government (total government employees are 14.9 percent of the work force).

Oakland has the look of a rural county seat: the courthouse dominates, old houses are freshly painted, a few Victorian mansions show old wealth, fancy-corniced brick buildings fill the downtown, and churches are plentiful. A Queen Anne style railroad station dating to 1884 is a historic landmark. The local newspaper—the *Republican*—reflects a 59 to 39 percent ratio of Republicans to Democrats. Countywide, 11.5 percent of the people are sixty-five or older, compared with 7.6 percent statewide. Young people—especially college graduates—used to leave Oakland and many did not

return, but as employment opportunities opened up in the seventies, more young adults stayed. The decade between 1970 and 1980 showed a 23 percent increase in county population—the largest of the century, while the number of jobs grew by 51 percent, mainly due to tourism, manufacturing, and services, rather than dependence on the old extractive industries. Cycles continue: a severe recession in 1982 forced unemployment to 23 percent.

Oakland was not chosen as a home by most of its residents; their ancestors chose it years ago. This is typical throughout the Youghiogheny basin. Yet there is movement of young adults to the headwaters. Data show that 70 to 100 young families immigrated to Garrett County in a ten-year period. Gloria Salazar came from Alburquerque, New Mexico. She had traveled through visiting a cousin, then decided to stay. "I love it here," she says. "The weather's beautiful—fog and rain are fine with me. I had enough sun out there, and enough fast and easy friends. Here, people are very conservative. Friends come slowly, but they're good friends. It's a place where people stay, where they hang onto old, solid values."

Other people I talked to had moved from Pittsburgh, Tennessee, and Hagerstown. One of them said, "I don't like going fifty miles to Cumberland to hear classical music, and above all I detest the way people watch you constantly, but that is something you have to accept in a rural area. It's a hard way of life here, but people are good. Money is not so important to most of them. Their values are sound. I like a slow-paced life, and I found it here." Young professionals come, looking for a place to raise their children. There are back-to-nature types who buy an old country place, or urban refugees who refurbish a small-town home. "I had no idea what Garrett County was like," one new resident said. "I came for a job interview, took one look around at the mountains and said, 'I'm staying.' "

Oakland may be a fine place to live, but what it does to the Youghiogheny is not so good. This is the largest town in Maryland and the only county seat without any sewage treatment plant. It is the largest town without treatment on the entire river. About thirty pipes dump raw sewage straight into the Little Youghiogheny one mile above the Yough. The biggest conduit is twenty-four inches, behind the Carnation plant. Sewage is one reason why the shorelines of the Little Youghiogheny, an ideal park site through town— are relegated to brush, parking lots, and industrial backsides.

Decades ago the state ordered the town leadership to clean up. About fifteen years ago the Maryland Department of Natural Resources imposed a ban on new sewer hookups (Oakland has sewer lines but no treatment plant) until the town progressed toward treating its waste. "Gradually they got off that moratorium," says Edgar Harmon, Director of Environmental Health for the County Health Department, a joint county/state agency. "Nothing of substance was done. There were studies, but no pipe in the ground."

Engineers discovered that the people of Oakland used only 150,000 gallons of water a day, but the discharge from the sewer system totals 600,000 gallons. The pipes leak from the outside in.

The state encouraged Oakland to combine its sewage with Mountain Lake Park (population 1,680, one mile up the Little Youghiogheny) and with Loch Lynn (population 582, three miles away) in one treatment plant. "The politics of the situation made that impossible," Harmon says.

While Mountain Lake Park and Loch Lynn, which began as resort communities in the late 1800s, pooled resources with federal and state grants and built a sewage system, Oakland went to court against the state's order to clean up, and won. The judge ruled that Oakland could build its own system. But when town officials studied a separate plant, they found it would be uneconomical. For $96,000 a plan was devised to pump sewage up to the Mountain Lake Park plant, but in the early 1970s the state saw that energy was becoming an important factor. It would require a lot of fuel to pump 600,000 gallons of water upstream every day. The state did not grant approval. Without it, the 75 percent funding from the federal government and 12 percent from the state were not available.

The proposal died. In the late 1970s the state imposed a second moratorium. Oakland officials went to court again, lost, but later talked the state into allowing ten hookups a year. A 1979 proposal for line repairs, pumps, and aerated lagoons totaled almost $2 million. The local share would be about 14 percent, or $280,000, which can buy ample attorney-time to win delays against the state. Harmon says, "Some people say it's not hurting anything, that the river's always been this way."

If the strategy was to delay, it worked. In the 1980s, budget cuts of the Reagan administration mean that the federal share for construction will not be available, and there is no way the town can front the money. Meanwhile, every flush in Oakland goes straight

into the river. "We never swim there" a local teenager says of the Youghiogheny below here. "Stinks too bad."

Except for a small gap through Charcoal Hill above Crellin, the Youghiogheny has flowed between Appalachian ridges that lie in a northeast-southwest slant. Now the river will cut through the mountains for sixty-seven miles to Connellsville.

Below the Little Youghiogheny confluence, Mount Nebo and Roman Nose Mountain (both being extensions of Negro Mountain) rise from the eastern shore, and the complex of Snaggy Mountain rises from the west.

Gentle riffles flow for seven-and-a-half miles, then ledges and boulders cross the riverbed. Nine miles northwest of Oakland is Swallow Falls in a gorge 200 feet deep. By this time, some of the pollution from Oakland has been diluted, or has settled to the bottom of pools, or has been treated by nature through aeration in riffles. At Swallow Falls State Park, swimming standards are met during low flows, which allow natural treatment, but when the water is high, it is muddy and foul.

In 1784, George Washington camped near Swallow Falls. In 1921, Henry Ford, Thomas Edison, and Harvey Firestone camped here. In 1980, 230,000 people came to the state park, "mostly to hike and see the falls and river," park manager Gerry Sword says. "Up here we get a large percentage of young people. I think it's the attraction of the outdoors, more of a natural park. It's not developed. All the river area is set aside."

Swallow Falls is a twelve-foot cascading drop, featured on the cover of the 1981 Chesapeake and Potomac telephone book in suburban Washington and Baltimore.

A number of people have drowned in the falls. During high water of May 1975, ten-year-old Richard Bouchard slipped and fell into the river. His parents stared helplessly as Richard sank in the froth beneath the falls. He did not come up. A scuba-diving rescue team was summoned from Somerset, Pennsylvania (about sixty miles away), to search for the body. Twelve hours after Richard disappeared, while his parents were being treated for shock at the Oakland hospital, a determined diver ventured beneath the pounding current, surfaced behind the falls, and found not a body but Richard himself perched on a two-foot-wide ledge. He had only a slight case of exposure.

In six miles from Swallow Falls to Sang Run the river drops a precipitous 314 feet. Expert whitewater paddlers run this stretch, but only during spring runoff or after it rains. Below Swallow Falls is Lower Falls, a six-foot ledge. These are two of the three "big munchers," as kayaker Phil Coleman calls them, on the "Top Yough" run. "Suck Hole Rapid," or "Wildman's Carry" is a few miles below Lower Falls.

It was there, in the spring of 1976, that Dave "Wildman" Gunther, a notorious kayaker, was swept beneath a split and undercut rock which he described as an open drain gulping about half the river. Like Richard Bouchard, Wildman vanished. His boating partners stared at the rock and feared the worst. Then a paddle popped up. Then a kayak bobbed up on the lower side of the rock. Then, in near disbelief, they saw Wildman's hand sticking up and waving from the crack in the rock. Eventually they fished him through the crack with the use of a safety rope.

There are easier ways to enjoy the scenery. Ten miles of trails follow the river, wind through forty acres of old-growth hemlock, and reach other attractions in Swallow Falls Park: Muddy Creek Falls (fifty-one feet) is the highest waterfall in Maryland, and Toliver Falls is on a smaller tributary. Fishing is popular, and state officials say that the Youghiogheny has the highest potential for a sustained trout fishery of all Maryland streams.

Swallow Falls and 1,300 acres of land bordering the river are not owned by the state, but by the Pennsylvania Electric Company (Penelec), which planned hydroelectric dams below the falls. They abandoned their plans due to high transmission costs of delivering the power to central Pennsylvania customers.

The Army Corps of Engineers also recommended a dam at Swallow Falls as part of a network of hydroelectric projects. House Document 644 of the Seventy-eighth Congress, second session, 1944, released a study that had been prepared under the "high security classification" of the Espionage Act. The report had been classified because it "contained information affecting the national defense of the United States." It recommended dams at Crellin, Swallow Falls, Sang Run, and two at Victoria (one for power and one for reregulation or stabilization of flows), two miles above Ohiopyle. The complex would produce 138,000 kilowatts at a cost-benefit ratio of 1 to 1.36. The Corps reported that the projects, "should be undertaken . . . if new installations are required to meet

the needs of the national defense program." Colonel Vogel of the Army Corps in Pittsburgh sent the report to Washington a few days after the bombing of Pearl Harbor, but his recommendation for the five dams was vetoed by his superiors because it would have diverted too many men and too much equipment from military construction.

One mile below Swallow Falls is the mouth of Deep Creek. All but two-and-a-half miles of this tributary were dammed for hydroelectricity in 1924. The twelve-mile-long lake with sixty-two miles of shoreline and 3,673 acres of water is the largest reservoir or lake in Maryland. Built by the Youghiogheny Hydro-Electric Coorporation and now owned by the Pennsylvania Electric Company, the dam releases water to generate peaking power, usually on weekday afternoons in summer when air conditioners and home appliances run full tilt. About 31,437 megawatt hours are generated per year and transmitted to Pennsylvania customers north of Somerset County.

The lake accounts for most of Garrett County's tourism; 1.8 million visitors a year make this the largest industry, providing 20 percent of county employment. More than 77,000 people camped at Deep Creek State Park in 1981. Ninety-six percent of the shoreline is privately owned. Most of the county's 2,500 second homes are here, many being owned by people from Greater Pittsburgh and some by residents of the Baltimore and Washington areas where billboards advertise "The Brisk Alternative—Garrett County, Maryland."

With new development and with restaurants, motels, and lodges, Deep Creek landowners saw unending change. In 1975, with no opposition from affected landowners, government leaders adopted a zoning ordinance for the lakeshore. This is the only zoning in the county, and it was brought about by noncounty residents. The one other attempt at local or county land-use regulations was the adoption of a subdivision ordinance in 1971. Under local pressure, the state delegate pushed through legislation in Annapolis to require a retroactive referendum for approval of the Garrett County ordinance. Even though the governor vetoed the bill, the county commissioners repealed the ordinance.

On the other side (the eastern side) of Negro Mountain from Deep Creek, headwaters of the Casselman River flow north and

become the Youghiogheny's largest tributary. After the north and south branches join above Grantsville, this river winds nine miles through Maryland, then past the Pennsylvania towns of Salisbury and Myersdale, and around Mount Davis, which, at 3,213 feet, is the highest point in Pennsylvania. Thus, waters from both Maryland's and Pennsylvania's highest mountains drain into the Youghiogheny. The summit of Mount Davis is so gentle and rounded that you hardly know when you are on top. Mountain peaks are not the main feature in this landscape. "The mountains aren't very high, but the valleys are deep," local people say in this geography of gorges.

The Casselman flows forty-four miles through Pennsylvania with sections that are popular among canoeists. Above Rockwood, the river has carved a gorge 700 feet deep. Markelton to Fort Hill is a nine-mile section of exciting Class II and III rapids, but only in high runoff. The Casselman meets the Youghiogheny at the town of Confluence.

After World War I, deep (tunnel) mines along Coal Run and other Casselman tributaries were abandoned, draining acid into what had been the best bass fishing river of the region. Since about 1915 it has run sterile and red with iron. Reclamation programs in the fifties and sixties eliminated some of the problem, but new strip mines have spread across the Casselman basin and on hills overlooking the river. The same could have happened to the upper Youghiogheny.

At the mouth of Deep Creek, the Youghiogheny slices its second gap in the mountains. Winding Ridge lies to the east with its arms of Marsh Hill at Deep Creek and Ginseng Hill at Sang Run. The Piney Mountain complex rises to the west. Five miles below the mouth of Deep Creek, the Sang Run Bridge crosses the river. This is the only bridge between Swallow Falls and Friendsville, a distance of fifteen miles. The riverfront changes. It is no longer a mixture of farms, towns, and parks. The Youghiogheny from Sang Run down is eminently wild, dangerous, and troubled—a good place to avoid.

Wild River

O*n the* count of three, Steve Martin and I heave the twelve-foot-long rubber raft off Sang Run Bridge. The boat falls as though in slow motion, like a parachute, like a rafter's nightmare of Niagara Falls. The airborne craft drops fifteen feet and lands right side up with a rifle crack smack on the Youghiogheny River. Steve had tied one end of his seventy-foot safety rope to the raft and looped the other end around the bridge railing.

"Okay," he says, and I climb quickly down the pier. I cling to angular chunks of sandstone, placing my feet carefully, but above all, hurrying. I stop at a ledge, seven feet from the top, and Steve hands me our gear: two helmets, three paddles, a small pump, and my camera bag. I set these in the boat while Steve clears the rail and descends in a kind of controlled free-fall as a pickup truck approaches.

"Uh-oh" I say, but Steve advises, "Don't worry." He flattens himself against the pier of the oldest iron bridge in Garrett County, Maryland, here for 100 years but used as a rafter's put-in only since 1974. Steve does not move, does not speak, just looks at the muddy, greasy guts of a macho pickup idling with a rusty muffler directly above us and visible through the steel ice-cube-tray deck of the bridge. I smell cigarette smoke. Steve's frozen posture does not confirm his casual advice, which I would have dismissed in any event. I look at him and he raises his eyebrows. Steve Martin is at home with adventure.

From the cab of the pickup we are invisible, but our rope, looped

around the railing and vulnerable, shows the topside visitor our plans. It shows him that boaters are putting in. After a minute, the pickup leaves.

Steve Martin is about as good a river guide as there is, working for Wilderness Voyageurs, a rafting company in Ohiopyle. He is one of the better kayakers in the country. He has run the upper Youghiogheny, Sang Run to Friendsville, many times. Unlike some "hair" boaters who specialize in dangerous water, he is safety conscious and not likely to kill any passengers by dumping them in rapids unexpectedly. Or so I think. Since I now cling to life a bit tighter than I used to, I won't trust just anybody to guide me down the upper Youghiogheny. Fact is, I trust nobody, but Steve Martin comes the closest, and when he asked if I wanted to see this section of the river and said that we could go in his raft on his day off work, I weighed the risks and answered yes. With us is kayaker Michael Normyle, another Wilderness Voyageurs guide.

To Steve, putting in from the pier is fun. "I love throwing rafts off bridges," he says. But this is more than sport. The pier is necessary because local residents do not greet boaters with open arms but with loaded guns: deer rifles and a versatile backup arsenal. Those people want us to go away and stay away. I guess that we are all undesirable elements at some time or another, to someone or another, and this is my turn. One of my turns. Only because we are rafters are we unwelcome in these parts.

The Thomases own the left shore (facing downstream). Imre Szilagyi, a commercial rafting operator, owns the right shore, and while he is not the type to shoot us, he does not want rafters putting in there either. So to be cautious, legal, and relatively safe, we gained access from the pier and set not a foot upon private land. I have started a lot of river trips, but this one has a certain unrepeatable quality. This promises to be some adventure.

Sang Run consists of the bridge and several houses. Its name goes back to the Friend brothers who settled in Friendsville in 1765 and explored southward where they found ginseng, a small plant of the deep woods. They filled their bags with the gingerbread-man-shaped roots and named a Youghiogheny tributary "Ginseng Run." The rooty little plant was sold for export to the Far East. In traditional Chinese medicine, ginseng sounds impressive: "a tonic to the fine viscera, quieting animal spirits, establishing the soul, allaying fear, expelling evil effluvia, brightening the eye, opening up the

heart, benefiting the understanding, and if taken for some time, it will invigorate the body and prolong life." Additionally, it is considered an aphrodisiac. The alleged qualities of ginseng seem dissonant to what Sang Run has become: a hotbed of disputes between boaters and landowners with latent violence on a short and unpredictable fuse.

In his guide to Maryland canoeing, Edward Gertler calls these nine-and-a-half miles of the upper Youghiogheny "the big whitewater challenge. . . . Specifically what makes it so special are four miles of unrelenting boulder piles, ledges, blocked views, unobvious passages, menacing undercuts and technical difficulties." There are five Class V rapids. (Class I includes gentle riffles; Class VI is nearly impossible. The American Whitewater Affiliation describes Class V as "extremely difficult. . . . There is a significant hazard to life in the event of a mishap.") Long stretches are Class IV ("long, difficult rapids with constricted passages that often require precise maneuvering in very turbulent waters"). The channel is choked with boulders, many of which are undercut—concave underwater traps where the current can suck you in and hold you. At the top of many rapids, half a dozen chutes appear impossible to negotiate, and their gradient is so steep that they all disappear as they drop ahead of you. You look downstream and see nothing but treetops and distant slopes of the gorge. Some of this section drops 120 feet a mile. In comparison, the Loop on the Youghiogheny at Ohiopyle drops 32 feet a mile, and the Cheat River drops 25 feet. The upper Youghiogheny is strictly a run for the expert, and then, only with a guide. All of this has me not a little intimidated, yet the danger of the place is matched by its beauty. I have come to see the river, the wild gorge, and to learn firsthand about the whitewater challenges up here, but if I only live through the day I will declare the trip an unqualified success.

This is a top whitewater run in the East, and for that matter, in the country. "Well, it's the top run where you can depend on the water level five days a week," Steve Martin says. "A few other streams, like the Big Sandy and Blackwater in West Virginia, are about as challenging, but they need high runoff from snowmelt or rain." The Gauley River in southern West Virginia has been considered the most challenging commercially rafted river in the East, but guides agree that the upper Youghiogheny is a large step up in difficulty, with more rocks and tight dangerous places.

The reason that the upper Youghiogheny runs five days a week all summer is Deep Creek Dam, where electricity is generated by dumping water from late morning until late afternoon, Monday through Friday. When the dam's gates are open, a wave of boatable water pours downriver, burying rocks and hitting Sang Run an hour later. The level rises 1.4 feet. Then, and not a moment before, the paddlers start their trips. Otherwise it is mostly a river of rocks.

The beginning of the upper Youghiogheny run is deceptive. Gentle water—a ten-foot-per-mile gradient—is all you see from the bridge. George Washington doubted the intensity of this section. On September 26, 1784, while passing through on his canal-scouting trip, he skeptically recorded the views of local residents who discouraged him because of the "Rapidity of the Water . . . and Falls therein." Not having seen this reach, and being an undying canal enthusiast, Washington reserved judgement: "but these difficulties, in the eyes of a proper examiner, might be found altogether imaginary; and if so, the Navigation of the Yohiogany and North Branch of Potomack may be brought within ten Miles and a good Waggon Road between." To this day, the mountain Marylanders are exasperated by easterners who do not believe them. We shall see whether the difficulties are imaginary or not.

Three miles from our put-in, Gap Falls plunges over a five-foot ledge with a slope on the left like a ramp for the handicapped. We run a shade to the right. "Eee-haw," Martin yells as our raft dives over the ledge. The gorge deepens. The riverbed is now 600 feet beneath the ridgetops and ominously dropping. To travel the next three miles, we must run some of the steepest rapids of the entire Youghiogheny.

For a warm-up, we face Class III and IV rapids, sporty drops, prelude to the big ones. We negotiate Charlie's Choice, Snaggle Tooth, Triple Drop, and reach National Falls. When we get there, six other boaters are standing on a rock.

A red-headed, balding man is Roger Zabel, winner of an upper Youghiogheny race earlier this year. He took the event seriously, moving up to Friendsville from Washington, D.C., to train. His girl friend in Friendsville may have had something to do with that, too.

Another boater is Al Davis, now paddling the first R-1 down this section. R-1 means only one person paddling a raft, which is difficult to do. Davis and Martin are civil, but their conversation is strained. They had been good friends, but Steve ended up with Al's

girl friend. We don't stay long, but for safety, we travel more or less with Zabel, Davis, and the other kayakers. They are excellent boaters, even though they live in the Midwest and have no place near home to learn. Legends about the upper Youghiogheny have filtered across the flats of Ohio, Indiana, and Illinois, luring these men to Friendsville where they asked Zabel to guide them down the river.

With only Steve and me in the raft we are light and maneuverable. We dance on piles of bubbles. Martin knows the river and its monster rocks like most people know the way to the grocery store, and so we do all right. My favorite rapid is Heinzerling (named after one of the great early paddlers), where we ride onto a huge pillow of water against a rock, then slide down the mound of foam. At Meat Cleaver we turn radically left to avoid pinning against a boulder. Then by luck more than skill, we miss the cleaver-rock that splits the river dead center, almost impossible to miss. "Eee-haw," Martin yells. He says that's the cleanest he's ever run it. He adds, "One week ago there were five of us, and we smoked a joint back at National Falls. Well, nobody was together or much on top of things. I said 'left turn' and nobody did anything until we hit the rock. Too late."

At the top of a boulder sieve—almost a falls—Steve says, "We're going to take the route Phil Coleman says to stay away from." Phil Coleman began kayaking this river in 1974. In 1981 he ran it forty-eight times. He has illegally kayaked the eighteen-foot Ohiopyle Falls about sixteen times. In short, he is one of the ultimate "hair" boaters—highly competent, with maybe more guts than is good for the health.

"Steve, why does Coleman say not to run it?" I ask.

"Because you can pin and wrap and get washed down on some rocks and hit them real hard and get pinned yourself and die." Martin smiles a little through his red mustache, the way he did under Sang Run Bridge. A fifty-five-year-old friend of mine told me that until you're fifty, you don't really believe you're going to die. This flashes through my mind but I have no time to think about it, much less believe it. I have no time because we are sucked into the falls. We hit some rocks. We do not pin, wrap, or die, but if I were not with Steve Martin, I might have.

As well as I can determine, the upper Youghiogheny was first run on May 31, 1959, by Tom Smyth, Dave Kurtz, and Bill Bickham, all of State College, Pennsylvania. They had no idea what they were

getting into, but were excellent paddlers. After checking out some topographic maps at the Penn State University library and hunting for a river with steep gradient, they packed up and came to Sang Run with aluminum Grumman canoes having standard keels, handy for paddling on lakes. The water was at a non-release level that is now considered unrunnable. They carried around a few rapids and ran many others. "Zing, bam into rocks," is how Kurtz describes the day. Bickham, who was the national canoe slalom champion for four years and wildwater champion twice, pinned his canoe on a log and after hours of struggling to free the boat, left it there. The log lurks in the river to this day. Kurtz kept a journal of this and other pioneering trips in the fifties and sixties. He called the upper Youghiogheny "an expert run." The only "sour note of the day" was when Bickham pinned.

Jean and Sayre Rodman, who were the first modern-day boaters on the Youghiogheny at Ohiopyle, were probably the first rafters here, also. With four friends, all rowing solo, they ran this section in about 1961. Jean says they had to "pull up on one tube sometimes to get through."

Except for a few fishermen who wandered in to Sang Run, the upper Youghiogheny remained unknown to outsiders. Many local people saw it as a rock pile full of rattlesnakes, as a gorge too steep for the cutting of timber. But like barren high country, bird-filled swamps, and dangerous rivers elsewhere, this gorge that was regarded as worthless or forbidden would become a powerful place. It would lure the most daring whitewater paddlers.

Dave Damaree, one of the first guides for Wilderness Voyageurs in Ohiopyle, pioneered modern boating on the upper Youghiogheny, running it many times in the mid-seventies and figuring out which way to go through all those blind drops. Since then, older boaters have passed the information down to new paddlers. Guidebooks are almost useless; there is simply too much, too fast. The only reasonable craft are kayaks, whitewater (decked) canoes, and high quality twelve-foot rafts. A few open canoeists have made it, but they are exceptional.

Walking out is no easier—though marginally safer—than running the river. Boulders lie from mountain or cliffside to the river. Rhododendron, southern arrowwood, and black currant are tangled wherever there is soil. Rattlesnakes are legendary. But the principal threat comes from local people with guns.

In 1974, Peter Zurflieh, John Brown, Bill Dallam, and Mike Fentress drove to Sang Run to paddle the river. They were ready to go, then discovered that they were one helmet short, and this river of rocks is no place to be without a helmet. Dallam drove back to Friendsville to retrieve the helmet from the take-out car. The other men waited on the bridge and were soon joined by Sam Thomas.

Sam was not a boater, but rather an old-timer who lived in the house next to the bridge and owned the farm on the left side of the river. "He wasn't hostile," Zurflieh recalls, "but figured he could explain the situation: that they didn't want boaters on the river. We went over to the house and talked for quite awhile. Sam even said that we didn't seem so bad, but that if his neighbors were to hear that he let us on the river, they'd burn his barn down." The boaters did not change Sam's mind. Helmet in hand, Dallam returned to a canceled trip.

Back in Ohiopyle, Zurflieh, Brown, and others brainstormed about how to put in at Sang Run, and they came up with the bridge idea. They would climb down the pier, and that way trespass on nobody's private land. If they didn't hustle, they'd still have to deal with Sam and his shotgun, so they designed a commando-style routine. They would tie boats to the roof rack with pop knots that come undone with one tug. Two men would immediately scramble to the bottom of the pier and two others would hand down the boats. At most it would take two minutes. John Brown volunteered as shuttle driver. If his van was going to be chased out of Sang Run, it might as well be him driving it. As soon as everybody was safely in the water, he would speed off to Friendsville and prop his feet in the security of Al's Riverside Lounge while the kayakers worked their bubbly way north.

So they did it. They silently stopped the van on the bridge. Everybody wore their boating gear and had their helmets buckled. All four doors swung open on cue and the paddlers jumped out. Two scurried down the pier, two unloaded boats, and in one minute all but Brown were on the river. It went like clockwork. But the commandos had forgotten one thing: the river. They hadn't looked at the water level. "There we sat with no water," Zurflieh says. The release from Deep Creek Dam was late. "We were sitting ducks with nothing to do but wait." John Brown was leaning on the rail talking to Zurflieh, who sat in his kayak in a little pool of water surrounded by rocks.

Zurflieh recalls, "This big guy on a motorcycle blew in out of nowhere and skidded to a stop and started yelling at John, poking him in the chest with his finger, 'Who do you think you are, we don't want you around here.' " Brown used all the diplomacy he had learned in five years of guiding commercial customers for an Ohiopyle rafting company. He backpedaled toward the Thomases' end of the bridge as the hulking local kept advancing and poking with his finger.

"I decided to climb up top," Zurflieh says, "yet I didn't want to be threatening. He could have kicked both our asses." This I do not believe. Zurflieh is only five-foot-six, but he could be the real-life inspiration for Mighty Mouse (additionally, he is a lawyer). He has the compact musculature of a badger. He has a big heart (he stops his car rather than run over a turtle), but he looks like the type of guy who joins the marines. He was a Pennsylvania state finalist in high school wrestling and had an excellent athletic record at Columbia University. He is quick to the extent of being a blur. My guess is that Zurflieh could throw almost any 250-pound attacker right off Sang Run Bridge if he wanted to. He says, "I stayed back pretty far, maybe fifty feet behind them. I didn't want to upset the guy." Zurflieh just wanted to make sure that John Brown wasn't killed.

So there they were: Brown walking backward toward the Thomases' house of all places, an aggressive bully poking and yelling at him, and Zurflieh keeping his distance, following the action like a little kid watching the big kids fight. Nonetheless, when one of the Thomas women walked onto the bridge and saw Zurflieh as he followed the retreat of John Brown, she yelled, "Look out, there's another one behind you." The man said something to the effect of "I'll kick both of them" and started after Zurflieh, then turned back around to Brown. From there it got worse. A jeep rumbled onto the bridge and out jumped Rusty Thomas and a mean friend. Zurflieh remembers the woman pointing at Brown and yelling The Accusation for Rusty to hear, "That's the man who said I don't love Jesus."

"What?" Brown said as he stopped walking, stunned.

Rusty started yelling at Brown, whose game plan had worked so far. He resumed walking backward (now on his second lap across the bridge) and kept talking. "We're not hurting anybody, all we want to do is go down the river. We'll be outta here just the minute

the water comes up. 'Cept me. I'm not even going down the river. Not even steppin' off the road. I'll just be driving straight outta here. Not even past your house. Why do you think the water's late? Got any idea? You guys got a nice place here, I don't blame you a bit for wanting to keep it. I'd feel the same way," et cetera, et cetera.

Somewhere along the line the four residents realized that four boaters were patiently sitting in kayaks under the bridge and eavesdropping on the topside discussion. They leaned over the rail and heaped abuse onto the dry-docked paddlers, who sat there and took it. Eventually enough people in cities turned on their air conditioners so that the demand for electricity triggered the gates at Deep Creek Dam. By the grace of the Pennsylvania Electric Company, the upper Youghiogheny was at long last runnable. The boaters were saved. Zurflieh escaped over the stone wall of the pier as in a jail break, and the boaters took off hell bent for Gap Falls. John Brown jumped into his van and peeled out of Sang Run as fast as six old cylinders could take him.

"I'm surprised no one has been killed," a local resident said. "It came very close a number of times."

Legally, it all comes down to the tedious issues of navigability and access. Waters are either navigable or non-navigable, the former being open for public use, the latter often not. Old English law defined navigable waters as the ones that are subject to the "ebb and flow of the tides." In this country, laced with four million miles of rivers and streams, it was obvious that the English formula would be inadequate, and so an American approach was invented. "Commercial usefulness" was accepted as a definition for navigable rivers. Rafts, barges, and riverboats on the Mississippi, Ohio, and Monongahela are, of course, commercial. Also included—at least in some states such as Pennsylvania—are rivers that were used to float logs to sawmills. This would include the Youghiogheny up to Silver Lake, but Maryland has not adopted the log-floating logic. In some states there is a trend to apply the "pleasure boat" test: if the waterway can carry a pleasure boat, it is navigable and open to the public. However, neither Pennsylvania nor Maryland has, on a state-wide basis, yet bestowed on canoes the status held by barges or logs.

A 1782 Pennsylvania law says that "the said rivers [Youghiogheny and Monongahela], so far up as they or either of them have

been or can be made navigable for rafts, boats, and canoes, and within the bounds and limits of the state, shall be, and they are hereby declared to be, public highways." The state of Maryland has determined nothing about the navigability of the upper Youghiogheny. "The attorneys won't act on it," says Dave Wineland of Maryland's Department of Natural Resources. "It's too big an issue to get into. Why would attorneys tackle something like that before they have to?"

Other questions arise about the riverbed. For example, if the public has rights to the water, can people also use the rocks under the water? Dare a boater touch a rock? Can paddlers wade in the river or must they float to avoid trespass? Can they use the shoreline up to the normal low-water line? To high-water line? In Pennsylvania, many riverbeds up to their low-water marks are owned by the state. In Maryland, riparian (riverfront) owners own the riverbed, except in tidal waters. For an interpretation of the law, courts must rule on a specific case.

Tom McEwen, a well-known whitewater boater, taught whitewater paddling near Washington, D.C., and one weekend, about 1974, he brought his best students to the upper Youghiogheny. It happened that a landowners' picnic was being held that day in the pavilion east of Sang Run Bridge. To greet McEwen were all the locals the mountains could yield. For this event, coon hunters would spend a different night out, hay balers would risk rain, and firewood cutters would accept less seasoned wood. It was an all-star cast, a who's who of the mountain folk. They were congregated at Sang Run for a good time, which can include tough talk about kayakers. Right past this same pavilion drove McEwan and his unwitting students with rooftop kayaks enough to float their cars. They had driven three hours for a lark and a lesson and were worried about Meat Cleaver and Double Pencil Sharpener, but not about Rusty Thomas.

One could say that an old culture met a new one, or one could say that there was an ugly confrontation. McEwen drove out to a phone booth and called the state police, who said he was within his rights to put in from the bridge. He requested a police escort, but was told that they would not come out unless trouble was underway. McEwen returned to Sang Run where a picnicker who doubled as a sheriff's office representative warned that McEwen would be arrested. He embarked anyway and ran the river alone.

A few weeks later a warrant for criminal trespass was served to McEwan with fines up to $500. The district court found him guilty. The Canoe Cruisers Association in Washington, D.C., put up money and McEwen appealed, saying that the public right-of-way on the bridge includes the right to walk there and to launch a boat. In the appeals court it was up to the state to represent the locals' position, but Maryland dropped the case against McEwen, choosing to leave the boaters' rights ambiguous. We still do not know what the legal rights of paddlers are, and we won't until the appeals court hears a case.

Kayakers told me other tales about putting in at Sang Run. There was the time when Pete Zurflieh, Jim Prothero, Bob Seiler, Jesse Hall, and a few other boaters went to run the river. The "commando raid" had been perfected, so everyone was ready to go when a pickup truck, guns in the rack, pulled onto the bridge. A heavy man started shouting at the boaters. "You guys get outta here, this isn't your river." All of the boaters but Jesse Hall were ready to pull on out of there, to split as fast as paddlers could go, but Hall was not so committed to peace. He was different. Jesse grew up in Ohiopyle and was a wild local himself. "He wouldn't let anything pass if he could make trouble out of it," another paddler said.

Rusty Thomas and his father, Sam, were spending a quiet day fishing below the bridge. It was right after the doctor had told old Sam that he had cancer. It was a father-and-son day, a can of worms, sunshine, and old times. Maybe they would catch something, maybe they wouldn't. They had as good a reason as anybody for wanting to be left alone. They witnessed the boaters absorbing abuse up at the bridge, so there would be no point in pushing matters, no point in engaging in argument or ruining an otherwise beautiful day. The boaters would be past in a minute, it was no big deal. So as not to stir the pot too much, they would keep it simple and short: "Get outta here you no-good kayaker!" Jesse happened to be the one who was passing at that moment.

Jesse, too, only wanted to do what he was doing. And the one thing he loved about kayaking (everyone knew it was not the skills because he wasn't that good) was the freedom and independence of it, the one-on-one against danger, nobody telling him what to do. Now here were Rusty and Sam offering advice. So Jesse retaliated at Sam: "Hey you're too old to tell *anybody* what to do." Both father and son were sensitive about Sam's age. But Jesse really blew his

chance at riparian coexistence when he paddled right over Rusty's twitching fishing line.

Picture the fishing rod as an extension of the arm—an arm for casting. Then picture the fishing line as a longer extension. What you really have out there at the hook is a fisherman's hand. And never forget that running over that line is a violation of space. As personal an assault as to sit unannounced on the shiny hood of a greaser's Chevy. Not unlike preempting a jock's locker while he's in the shower.

In short, Rusty was irate. The panic buttons had been pushed. Sam yelled, "You got the whole river." Rusty said, "Now get outta here and don't come back," and he jerked his pole to pull his line in.

"Are you threatening me with that fishing pole?" Jesse screamed back, his own temper slightly out of hand.

So went the preliminaries. Now Rusty Thomas plucked a stone from the shore and heaved it at Jesse Hall. To dodge this, Jesse rolled his kayak, and while he was underwater wiggling out of that straightjacket-boat, he explored the bed of the Youghiogheny until he came up with a rock of his own. He emerged with water pouring from his helmet and his arm cocked to throw.

Annihilation seemed inevitable in the cobblestone storm that followed. Zurflieh, Prothero, and Seiler turned upriver to behold the two mountain men in what seemed a life-and-death struggle to find rocks and wing them. Rocks splashed like cannonballs in a battle at sea. Rocks skinned the bark of trees behind Rusty. Rocks peppered the kayak and dented the tackle box. Testament to bush-league aim and probably double vision from spleens about to burst, nobody— not even Sam who was a relatively innocent bystander—was hit.

Maybe Jesse ran out of rocks. In one account his kayak was floating away and he had to retrieve it. Another says that both men were so impotent with rocks that the disagreement was escalating toward hand-to-hand mayhem, and that they both knew a no-win predicament when they saw one. Too: the allegation that someone on the bridge showed up with a gun. Or maybe the pleading of Zurflieh, Prothero, and Seiler sank in through Jesse's helmet. At any rate, he quit, reboarded his kayak under an unannounced and tenuous truce, and exited downstream.

So far, the only people I had seen on the upper Youghiogheny were the paddlers who are crazy about this river. Some of them

seem to live for this river. Many of them accept the combative natives the way Daniel Boone must have accepted the Indians. It would not bother these boaters to sneak across a piece of private land if there were no other way to the river, but the last thing they would do is damage property or cause harm. Their nature is easygoing. Zurflieh says, "I've paddled up there thirty times and never seen anybody doing anything. You just get on and go." With the exception of a few like Jesse Hall, they have been peaceful and nonaggressive. Even Jesse did not throw the first rock. It sounded like the other side was outrightly belligerent, so I figured it was time to meet them.

Next to Sang Run Bridge on river left sits a two-story white farmhouse, old but well cared for, with shrubbery and a mowed lawn. One hundred yards farther is a barn showing the weather and generations of use. Between is a mobile home and a utility shed. I guess it is a garage for farm equipment. A classic Appalachian farm. Sam Thomas, the number one gun-toting chaser of boaters, raised Holsteins here for most of his life. He raised a family, too, and in the winter of 1979, he died of cancer. His widow, Bernice, remains here. Her daughter, Jean Stuben, lives in the mobile home, and Mrs. Thomas's sons, Sam and Rusty, are often here working the farm. I would guess that all three children are in their early forties. I arrived and talked to Jean, who would not discuss the river. I would have to return and see her brother.

His real name is Bryson, "but everybody calls me Rusty," he says. His rust-colored hair is fairly short but untrimmed. A few days' worth of rusty whiskers cover his long, bony face. He has a severe look, a hard look, yet maybe honest. To me, it reflects something of this place. He is about six feet tall and lean, but probably strong as a mule. His old pants and flannel shirt show that he has spent recent days at work. He smells of cigarette smoke and labor. His boots are made for farmwork and for stomping through the neighborhoods of rattlesnakes. His cap advertises "Grow Masters." All morning he has been tinkering with his corn picker, resulting in a backlog of work for the afternoon. I suspect that he has a backlog for life: with a farm up on the mountain near Route 219, several leased tracts, and this place, he and his brother tend 1,000 acres and 200 milk cows. I get the feeling that Rusty has better things to do than to shoot the bull about the river.

Mrs. Thomas, unlike Rusty, has a peaceful look—almost serene—which also seems to reflect something of their river valley site. She has a grandmotherly look, one that makes you want to sit down, visit, and eat apple pie. She opens the conversation. "Are you one of *them* or one of *us?*" I say that I am only a storyteller, and that I want to get both sides of this controversy. "What for?" Mrs. Thomas asks, and I am no longer hungry for pie. She would have to ask The Question: Why am I doing this? I forget what I told her.

This is no time to hesitate. "So what's the problem with the kayakers?" I ask. Rusty exhales and doesn't look any happier, no friendlier than when I met him. He is stony as a rock at the river's edge.

"Well, let me tell you. One day my sister saw this gang in the yard settin' up camp. Longhair trash [pronounced 'longhairtrash']. She goes out there and says, 'Like the sign says, this is private land,' and this girl throws a stone at our trespass sign and says, 'That's what I think of your signs. It's God's earth and it's here for everybody to use. It's people like you that nailed Jesus Christ to the cross.'

"Well," Rusty calmly recalls, "my sister didn't think much of that and neither did I. Got my thirty-thirty and said, 'They want to see the river, I'll blow them right into it.' Some of them left, but others were still there trying to load their raft into a van. I gave the raft a good kick and one of the guys came over, and, you see that scar?" Rusty holds a calloused finger at the bridge of his nose. "Well, that's where he clipped me with a paddle. That was it man, right there. I laid him out with the stock of my rifle. His buddy and the girl, they picked him up and shoved him like a sack o' feed into their van, Pennsylvania tags on it, and drove off saying they were getting the police." That, apparently, is the incident for which the innocent John Brown later took wrath.

"Used to be," Rusty says, "that people would ask permission if they wanted to cross our land. My dad never turned anybody down."

Mrs. Thomas chimes in, "Why, they'd ask if it'd be all right to fish, and Sam would take 'em out and show 'em where to go. Best holes."

"Then the problems started in the early seventies," Rusty continues, "when the wild river law was passed. People started coming by the carloads. They'd say, 'The state took this over. Now it's ours to use.' "

Mrs. Thomas details, "They left cans and bottles. You had to watch where you stepped if you know what I mean. They even left their underwear over there."

"They've stood right on the bridge and urinated," Rusty says. "I got my little daughter; who wants to see that?"

"There was this one guy who came to the house and asked permission to hike. Said he was on the police force someplace in Ohio. I said yes, then saw him and his friends strapping on revolvers. 'What for?' I asked, and he said, 'Rattlesnakes.' Two days later I saw a bunch of buzzards, followed 'em, and found a gut-shot deer." Now, gut-shooting and leaving a deer is something you don't do in the mountains. You can steal tires off the game warden's truck, make moonshine, dynamite fish, and shoot off a neighbor's chimney, but you don't gut-shoot a deer. "I had the tags checked," Rusty says, "and Ohio didn't even have the license number. Next day a store up the mountain was robbed, and they had the same description of the vehicle." I ask if they were boaters. "No."

I ask if there was a rock battle—the Jesse Hall incident. "Sure was," Rusty says. "I'm the one who dunked that bastard and I'd dunk him again. We were fishing right after my father found out he had cancer. Four or five kayakers came by and one ran right over our lines. My dad said, 'You got the whole river,' and the kayaker said, 'You're too old to tell anyone what to do.' So I threw a rock and dunked him. He came up and gave me some mouth and said he'd fight and I said, 'Come right on over,' and that was enough for him. He left." Rusty will have no more chances to dunk Jesse Hall. He had been drinking with friends, and their car crashed into a tree near Ohiopyle in the summer of 1981. Hall was killed.

"That 'wild river' business," Rusy says. "Rules and regulations. Say you can't fly the flag. Can't cut anything within 300 feet of the river. By the rules, I shouldn't cut my lawn."

I ask who told him that he can't fly a flag. "It's right there in the rules and regulations."

"I suppose if it was Russia's flag it'd be okay," Mrs. Thomas adds without looking at me. She pours another cup of coffee.

"Can't fix up your house without a permit," Rusty says. "Well, they better not come snoopin' aroun' here to find out." During public hearings regarding the regulations several years ago, Rusty said, for the record, that anybody trespassing on his property would be shot on sight. He will do nothing rash; like a rattlesnake, he gives warnings.

"It says you can't operate a commercial business on the river, but this guy from West Virginia's doing it. There's a nigger in the woodpile someplace.

"Why do you suppose they stopped the wild river at Miller's Run instead of running it up to Oakland?" Rusty asks. He answers: "I'll tell you why. This realtor is on some state advisory committee and has land up there." I note all of these as issues to investigate, and this realtor as a man to interview.

"You can't even pick up a stick of firewood without five permits," Rusty says. "Three of 'em if you want to cut a Christmas tree. *On your own land!*" Property rights are taken seriously here. People get worked up about them. "You own your land and pay taxes on it but there's nothin' you can do!"

"The other day I had to wait with my hay baler; sat half an hour on the bridge waitin' while some guys threw their boat over." Mrs. Thomas pours second and third cups of coffee while Rusty gets more worked up and I get the caffeine jitters.

"You wanna know why we don't like kayakers? Well, I could tell you stories till I'm blue," Rusty says, taking a gulp and lighting another cigarette. "The rescue squad was out hunting a boater one day and while they were gone a woman up the road had a heart attack and there was no ambulance to come get her." Rusty puts his coffee cup down with a conclusive collision of china. I later learned that the ambulance driver fell asleep at the wheel on the way home from the river rescue and destroyed the vehicle.

"People'd change their clothes right out there," Mrs. Thomas says, pointing through the window, where I see a part of the river and the brushy shoreline on the other side. It seems to me that it would be difficult to see a cow on that shore, let alone a person.

"Finally we had to put a stop to all of it," Rusty says. "Even though not everybody's that way. Some come to enjoy the river and others come to mess it up. Some seem like real nice people."

Mrs. Thomas says. "This young woman from New York asked if she could hike here. I said yes. She ended up sleepin' right under the willow tree out there, and I gave her breakfast. I got a Christmas card from her and everything." Mrs. Thomas goes to get the card, which she keeps handy.

"Shame," Rusty says, "a man and his kids came here to fish, and they was from Wisconsin. But if you let one in you let 'em all in. They got us earmarked as the sons o' bitches on the river,

but the landowners've all banded together. If we let people in, then the other landowners'd be on us. Burn our barn down." I think of how nice it must be to have such supportive neighbors. "Let me show you something." Rusty leads me into the living room, full of old furniture and pictures on the walls. In a corner of this period farmhouse (circa 1920) sits an incongruous pile of electronic equipment and a spaghetti tangle of wires. "That linear is 300 watts. We can call people for miles around and within minutes they'll be down here to help. And on mine, I got 2,500 watts." Rusty smiles just a hint. "That baby comes on and the lights go down and everybody's TV in the valley fades. I can reach Wheeling, West Virginia, and there'd be people from West Virginia up here if we needed 'em. These people up here stick together. You get some Johnny-come-latelys that don't, but they don't stay too long."

These people are isolated but prepared. They are what hillbillies are supposed to be. I am impressed in an unexpected way, not with the electronics, but with the entire repertoire for self-sufficiency, ranging from milk to guns; from family cohesion that brings mother and sons together for afternoon coffee, to public threats of violence in the event of territorial infringement. Yet their professed self-reliance seems to border on the fanatic.

Real independence is a myth in a world of store-bought flour, CB radios, and refined Arab oil in the pickup. Even the most independent people—the most authentic mountain farmer or the back-to-earth purist—must maintain a relationship with the rest of the culture. The question is, what will that relationship be? Will people adjust to the inevitable or fight it? Will they turn away the makers of change in hopes of saving what is best? Will they support their independence on money earned through the system? Whatever they do—whatever the contradictions and even hypocrisies that might be involved—I am all for anyone who tries an alternative to the mainstream. The mainstream is in trouble, deep trouble, and the more people who try to escape, and the more different ways they try to do it, the better. People outside the system may become the only survivors. I want to be on their side, except that this thing about the kayakers is ridiculous.

"We got other plans to stop kayakers, too," Rusty adds. We go back to the kitchen for another cup of coffee. "Some of the landowners want to string wire across the river."

Jim Prothero

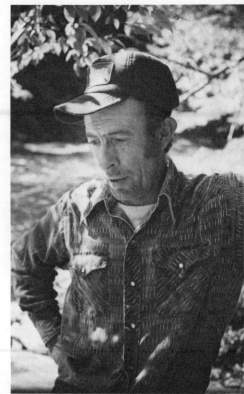

Rusty Thomas

Crellin

Oakland and the Little Youghiogheny

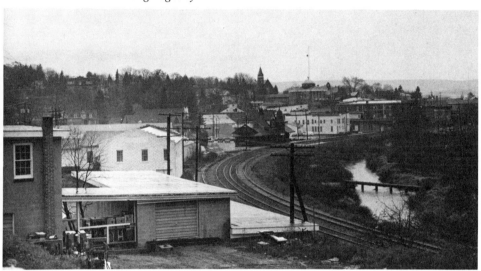

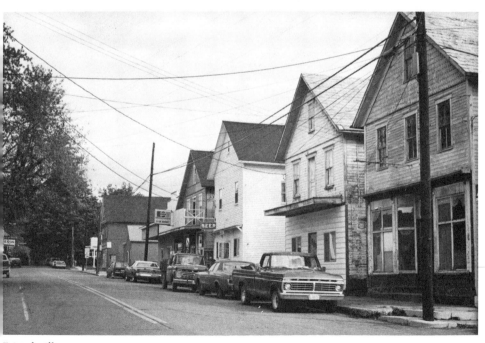

Friendsville

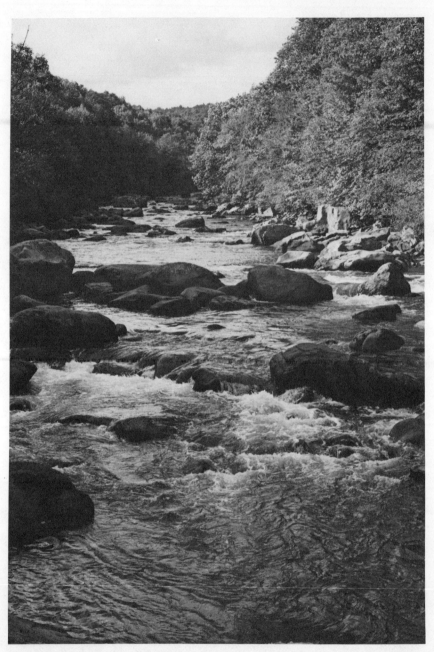

Youghiogheny above Friendsville at low water

"But I'm not going to," Mrs. Thomas says, "That'd look like a dirty job. Somebody'd run into it and cut his head off. I wouldn't do that, no."

Rusty says, "With a charge of dynamite, placed just right—and I know where—you could bring a couple million tons of rock down in the river. That'd play hell with them in there.

"There was this truck over at the picnic area and they was loading up seats from the old church," Rusty says. "Stealin' 'em. And over in the graveyard they was goin' around with metal detectors. They'd dig up the dead." I ask if boaters did this. "I don't know, but they all seem affiliated. Crime around here has gone up. More than Baltimore." In the mountains of western Maryland, there is nothing worse, nothing more decadent, nothing that epitomizes contemporary corruption more than Baltimore, unless it's a kayaker from Baltimore who gut-shoots a deer. The Sang Run landowners' petition against Senator Edward M. Mason, a cosponsor of the wild river bill, said, "He joined Baltimore City representatives who are trying to get the right to use our privately owned land, up here, for their sport and entertainment."

"It's all because of recreation," Rusty says. "We didn't used to have this problem."

"And you think it's the boaters?" I ask.

"That, and motorcycle gangs now too," he says. "That is *bad* news. If you're gonna get one of those guys, you have to get 'em all. The state police were out here three weeks ago. Got the bikers to leave, but they was goin' to camp right out there. When I wasn't around, another gang of 'em cut my fences to ride back that road out there."

"We get the trash in here," Mrs. Thomas says. "People are different from what they used to be."

"I saw about six of 'em stealin' my field corn up above," Rusty says. "One of 'em was a colored man with a white girl, which sets me to fire to begin with, but that's their own business I guess. But when they're stealin' my corn, that's my business. I stopped 'em at this intersection and I went out to their van and said that wasn't their corn, and they said, "You aren't going to miss twelve ears of corn," and I said, 'Yeah, but if everybody from Baltimore took twelve ears where would I be?' So next thing one of 'em takes a handful and throws it out the window right at my feet, and so I grab the guy next to the door and give him a shakin', and then the

others empty out of their van. Well, just then this semi comes barrelin' up and stops and that truck driver comes out of there with an ax handle and let me tell you he cleaned those hippies up."

"Long hair hippies," Mrs. Thomas says.

By now I am feeling comfortable with the Thomases, so I ask, "Is my hair long enough for me to be a hippy?"

Mrs. Thomas smiles a little and says in a bit of a sing-song, " 'Bout half."

Rusty adds, "Lots of people have long hair now, but the way I see it, the hippies started it, and that's what I think of when I see it."

It seems we have diverged from the topic of the river, though perhaps not much.

Now that old Sam is dead, most boaters think the access problem is past. They've been putting in on the other side of the bridge on Imre Szilagyi's land and from the bridge pier. "The boaters tell me that things have quieted down," I say.

"Oh so you *are* one of them," Mrs. Thomas accuses. For some reason, Rusty saves me trouble by interrupting, "Yeah, well I just got tired battling them." He lights his fourth cigarette.

"I got hypertension and everything," Mrs. Thomas says. "I don't want nothin' to do with it. Nothin'!"

Rusty says, "I have an attorney workin' on it. We own this side and the other side below the bridge, up to the high-water mark. I'm just waitin' till I'm sure I'm within the law, and then I'll be stoppin' all trespassers. I'm not dumb like some other landowners. I'll stay within the law. But I'll make it stick if I have to sit on that ridge with my thirty-aught-six."

"Doesn't Szilagyi own all that land on the other side?" I ask.

"*He* thinks he does," Mrs. Thomas answers.

"But we have a lease from Penelec," Rusty adds. "The power company bought up a lot of this land through here, years ago. Still own it, but lease it to us for one dollar a year. They planned a dam. Be this side of the falls."

He means Gap Falls, three miles down river. The dam would rise ninety feet. A second dam was planned above Sang Run.

"What would you do if they built the dam?" I ask.

Mrs. Thomas says, "I wish they would. I'd move out and be done with this."

Rusty says, "There's nothin' we could do. They own it."

I ask, "Doesn't the state wild river designation stop dams?"

"I don't know. But if it's necessary—if Pennsylvania needs it—they'll take it, like for a road. By law they can do that for a road or a dam."

The wild river regulations prohibit dams, and a separate law in 1977 fortified this protection: "A dam or other structure impeding the natural flow of a scenic river may not be constructed."

At risk of stressing the obvious, I say, "This place would be under water if they'd build the dam."

"Yeah. I'd hate to see it," Rusty says.

"Oh you don't even live here," his mother rebuts.

"Heck I don't. I grew up here. I work here every day, and I'm stayin' till I'm ninety." Then Rusty grins at me and says, "Unless some kayaker gets me."

I am surprised that the Thomases are complacent about a dam that would flood the entire farm and river, while being so opposed to kayakers simply floating on the water. But the Thomases don't believe the hydroelectric dam will be built. I'm not so sure. In 1979, about eighty applications for hydroelectric dams were filed with the Federal Energy Regulatory Commission. In 1981, 1,800 were filed. The hydropower rush is on, and developers are scouring the countryside, finding new sites wherever there is water and gradient. A site such as Gap Falls, where the land had been acquired, would be a prime target, and a few landowners—even armed ones—wouldn't slow anybody down much.

In later research, I learned that three dams, including Gap Falls, had been proposed in the 1920s by the utility preceding Penelec; that one dam above Friendsville was recommended by the Army Corps of Engineers in 1938; that four were recommended for construction by the Corps in 1942; that a Crellin dam was recommended by the Appalachian Regional Commission in the 1960s; and that Sang Run and four sites on Pennsylvania's Youghiogheny were listed by the Federal Power Commission as potential hydropower projects in 1966. The wild and scenic river program, and especially designation of the Youghiogheny as a national river (which has not occurred), would outlaw all these projects.

It seems that the value we attach to the land does not run deep enough to overcome the other pulls. Roads, dams, or whatever is needed for progress come first. We can accommodate these changes, but people—that is different. To be confronted with people we cannot understand—the kayakers—seems to be more threatening than a

dam that would drown the entire spread. A few visitors have grated on local people in the worst ways: the Jesus incident and changing clothes, and a little bit of those things goes far toward hatred. The Thomases don't accept the dam as an issue, so I return to the topic of access. "Do you mind if people use the bridge pier?" I ask.

"There's nothing I can legally do about that," Rusty says, "and I'm not doing anything that isn't legal. So long as they don't touch so much as one rock in the river. When they do, they're trespassing on my land.

"This outfitter from West Virginia, they ought to use his place so it won't bother anybody. He owns land above the bridge that they could use. Get them damn vehicles and stuff out of the way. Or if the state'd put in an entrance and exit place, that would solve a lot of problems. 'Cept nobody here would sell. Nobody'll even talk to 'em. Look, I'm reasonable. You go up to some of these other guys and they'll choke the shit out of you. This guy from up at Deep Creek, he tried to mediate this problem. I was willing to listen, but next guy he went to, they threw him right off.

"Another thing the state ought to do: they ought to have a limit on the number of people. The river can only stand so many. There's not too many now 'cause we hold 'em down. One thing, I mean *one* thing we don't want is another Albright." Rusty is talking about the crowds of commercial boaters that converge in Albright, West Virginia, to run the Cheat River every spring. "Local people down there can't even get to work on time, the roads are so tied up. We don't want that happenin' up here.

"The state should have patrols on the river. People go out cuttin' firewood, buildin' fires. Some day that whole thing is gonna go up in smoke. But the state doesn't want any part of it. This is a bigger mess than they thought. They started it and now they want nothin' to do with it."

I ask, "How much of your complaint is because of the kayakers, and how much of it is because of the wild river system and the land use controls?"

" 'Bout six o' one half dozen the other," Rusty says. "The wild river is the main thing and the kayakers are taking the brunt of it. They're the only ones who are around."

Another resident later told me, "There was no problem before the wild river. Then local people figured, 'Okay, the state wants to save the river for other people, well, no other people are going to *see* the river.' It's retaliation against the land use controls."

It is two o'clock. "Guess I'll get going and let you do your work," I say, but Rusty offers, "Look, you're writin' 'bout the river; you ought to see it. You want to go for a ride in the pickup?"

Rusty fires up the truck and it roars. The muffler is either riddled with holes or absent. "This truck will do okay, but the last one I had—that one was outfitted to chase kayakers. A 440 with two four-barrels. Pick the front wheels right off the ground." The pickup sounds like a B-25 as we climb the hill.

We pass through a field of pine seedlings planted by the landowner. "I don't want you getting the idea that we don't want this river preserved. We want it preserved, but havin' these people come in is not the way that'll happen. The landowners aren't gonna abuse this river. They've loved the river. That's why they've been here for a hundred years, livin' out of the rocks, livin' through winters. Developin' this land is the last thing we want. It's not for sale, but we're not givin' it away for any wild river either. They try takin' it, may as well bring in the National Guard."

Maybe the local people will never sell for development, but previous owners, through Garrettland Realty, recently sold 100 acres, including prime river frontage, to the West Virginia outfitter. And along the dirt road to Oakland, there are tracts that have been subdivided into miniature lots for trailers.

We drive a few miles to the end of the road. Time to walk. "Keep your eyes on the trail," Rusty warns. "Rattlesnakes." We cross a field and enter a deep woods. It will be a big year for acorns, and thus, squirrels. Hunters will start tramping the woods in October when small game season begins. Rusty warns me that kayakers could be mistaken for squirrels: "I'll tell you honest to Christ if I was a boater I wouldn't be on that river from October fifth on. Some of these guys are a lot crazier than me, and if they have a gun in their hands and they're ready to shoot somethin' anyway." I ask if anybody's ever been shot at. "I wouldn't say shot *at*, but close enough. They *thought* they were shot at.

"Ha," Rusty says and grins. "We were down the river one day. We saw this gang sittin' 'round a fire and smoking dope or whatever makes 'em so crazy. What happens but one of 'em gets up and strips himself naked and jumps in the river, hoopin' and hollerin'. Well, this guy I was with took his rifle and peppered the water all around that guy and he came outta there *fast*."

We eventually reach the Youghiogheny. I spot an empty pop

bottle with its lid on. It is the only trash I've seen along the water, and it probably floated from Oakland. I stash it in my camera pack. Then we hike downriver for ten minutes. We talk about elk hunting in Colorado where Rusty goes every fall. Upriver a lone paddler materializes. He is short, muscular, and advances cautiously our way. He is Pete Zurflieh. He knows me from Ohiopyle; Rusty from the Sang Run Bridge. "Hey, how are you doing?" he asks. He is friendly, easy going. He smiles and stops in an eddy twenty feet in front of us. "Not bad," I say. "Rusty's showing me some of the river."

"Sure is a nice day to see it," Pete comments. I say that I wouldn't paddle it alone. "But today is too good to stay inside," he answers. "Maybe see you in Friendsville. I'll be there in few hours."

It is difficult to see Zurflieh as an abusive hippie. Rusty and I look at the river awhile. I ask, "Let's just say it's wild river or dam. Which would you have?"

Rusty looks at me. "Then I'd say wild river."

We retrace our steps. When we are in the brushy section, Rusty stops and picks up a large plastic container. He shakes it and hears maybe one pint of liquid. "This is a bad one," he says. He reads the label, which consists of six-syllable names of chemicals and a lot of numbers. "This stuff here'll kill ya," Rusty says. It is a discarded pesticide jug, probably used by a farmer upstream. Rusty will carry the container one mile to the truck. "There was another plan the landowners had," he says, "to dump toxic stuff in the river." That is where Rusty drew the line. He says, "I couldn't see it myself, but they were sayin', 'if we can't have it, nobody can.'

"These herbicides, now there's something. There's no way you can poison weeds year after year and not be killing birds and poisoning the ground. We've got to make some changes. But the big problem is acid rain."

"So you keep up on that stuff?" I ask.

"I've been readin' 'bout acid rain for years," the mountain farmer answers.

Here is a man who would shoot at a kayaker but who is also a student of acid rain. Rusty shows a mix of redneck and radical, old and new, local limits and world view that will be repeated at other places along the Youghiogheny. In Rusty Thomas's view, the kayaker and the acid rain have something in common: they are both threats to his way of life.

We arrive at the truck. I say, "The boaters are going to come no matter what. You want a limit on their numbers. You want to ban commercial outfitters. You don't want to develop the land anyway, and let's forget the bullshit, there's no way the state is going to stop you from mowing your lawn. With setbacks from the river, you can log in there. And the dam: the first thing wild river programs do is stop dams. So what's *wrong* with the program?"

"You gotta get permits to do anything."

"When's the last you got a permit?" I ask.

"I have a two-forty-three and that's the best permit in the world," Rusty says.

"That's your gun?"

"Gun. Hell. I got more guns you can haul in the back of this truck."

The pickup roars and we bounce and rattle over ruts, rocks, and a fallen branch. "What'll finally happen?" I ask.

"I figure somebody's gonna get hurt. Then maybe the state'll put in an access area or somethin' like that."

We ride awhile and Rusty says, "I have a three-year-old kid, and I just want him to have what I had, growin' up here."

The Maryland State Scenic Rivers system began in 1975 with legislation that designated several "scenic" rivers, including a three-mile stretch of the Youghiogheny from Oakland to Miller's Run, and one "wild" river which is this section of the Youghiogheny from Miller's Run to Friendsville. State policy is to "protect the wild quality of these rivers and fulfill vital conservation purposes by wise use of resources within this Scenic and Wild river system." "Wild" rivers are more carefully protected than "scenic" ones.

The law required the Maryland Department of Natural Resources to write regulations for the use of land inside a corridor (land that can be seen from the river). These were adopted in 1976 and amended in 1979. Since all of the 10,600 acres along the river belong to eighty private landowners (one of them owns 7,000 acres), land use regulation, rather than public acquisition, was considered the only feasible protection.

Steney Hoyer, president of the Maryland Senate in 1976, sponsored the act, and Edward M. Mason of Cumberland, representing Garrett County, signed as a cosponsor. In 1981, Senator Mason is the minority (Republican) leader. At his office above Mason's 1892

Restaurant, east of Cumberland, he recalls how his river support nearly cost him an election. "I was about defeated in the primary, 1978. Won by 119 votes. They ran ads against me. Absolutely false accusations. They only called me Communist and pinko. Now that's hard to take." The senator was threatened that he'd better not go to Friendsville. Yet there was also support in Friendsville. "Some farmers backed it. People who didn't own land down there supported it, but quietly. Then there were down-state conservation groups behind it, but what good do they do me?"

"Why designate the river in the first place?" I ask.

The senator answers, "To stop strip mining in the gorge. That was the reason. During the coal boom there were requests for permits to mine in there, and if we didn't have the wild river legislation, the upper Youghiogheny might have become another Casselman. When we have this river, and it's the only really wild river in Maryland, we should try to protect it."

The law says, "Mining of any minerals by the strip or open pit method is prohibited." Mason says, "The only people aggrieved are the miners. That is the only thing that we stopped."

Ed Mason is no friend of the coal industry. In the seventies he cosponsored legislation to prohibit mining on slopes of 20 percent or greater. He helped pass a bill to deny mining permits on state-owned land. He tried to get a coal excise tax to pay for county road damage caused by coal trucks. "The coal industry used to run this district," Mason says, but it seems they are still only 119 votes away from it. Some coal company operators, including Bridgeview in Friendsville, contributed the maximum funds allowable to Mason's opponent. It was not coal companies, but landowners who circulated a petition calling for Mason's removal from office, yet coal interests are major donors to a landowners' fund for fighting the state in court.

About the wild river, George Edwards of Delta Coal in Grantsville said, "I think the state usurped our authority. Instead of buying the ground they came in and zoned it. That's a job that's usually left to counties." Indeed, Governor Harry Hughes, at Deep Creek in October 1981, bragged that the state had protected one of the outstanding wild rivers of eastern America without buying private land. From a conservative point of view, you can applaud this savings of tax dollars and this respect for private land ownership, or you can criticize the state for using its authority in the name of the "common good."

"In the long run," the senator says, "everybody will be well served by the protection."

In the state house of representatives, Garrett County delegate Decorsey Bolden disagrees. I met with Bolden at his car wash outside Oakland. "It's confiscation of private land without compensation. Adolf Hitler did that in 1949 in Poland. My position was—still is—that if the state of Maryland wants a wild river they should buy it. We can't afford to put our natural resources to rest for the next 100 years. Rather than preserving all the natural resources for posterity, we should use them now to improve the quality of life. I have no problem with people building on the edge of the water if they want to risk a flood. Look at the house that famous architect built near Ohiopyle." He refers to Fallingwater, a house built along a Youghiogheny tributary and renown for its integration with the natural site. It is elevated above flood levels.

The concept of land-use regulation is that reasonable restrictions, for the public good, can be placed on land. The validity of flood plain and steep-slope zoning is established: courts have agreed that public hazards and costs can result if these areas are developed in the wrong way. Zoning for aesthetics—to keep a river wild, for example—is not so well established.

"What about landowners' rights?" I ask Senator Mason.

"People can continue to live there, farm, and sell building lots of five or ten acres. They can do anything they've been doing. I'll bet property values have doubled *because* of the protection."

Tom Thayer, owner of Garrettland Realty, confirmed this view, saying, "I feel strongly that the scenic river designation adds to property values. There will be a market for the larger lots, and people who buy these won't have to worry about twenty half-acre trailer lots beside them."

Senator Mason adds, "Who wants a bunch of shanties next door? You don't have to worry about that on the upper Youghiogheny. I wish they'd put *my* place in a wild river corridor." The senator owns the farm where he grew up along the Potomac River. "It would be nice if we didn't need zoning. Or taxes. Or jails. But we do, and nobody in local politics had the backbone to do it.

"Part of the problem is this: The Department of Natural Resources was not in favor of establishing regulations, but we—the legislature—pushed it. When the draft rules came out they were ridiculous." It was from the draft rules that local people inferred

that they could not paint their houses, fly the flag, and mow their lawns. "It drove them up the wall, and I don't blame them, but we got those things changed."

The fourteen pages of wild and scenic river regulations are administered by David Wineland of the Maryland Department of Natural Resources from his office near Cumberland. He is thirty-one, trim, and clean-cut. He wears a crew neck sweater and engineer's boots.

Wineland has had some difficult times along the Youghiogheny. The landowners' association chairman, Colonel Browning (an ex-marine fighter pilot), once invited Wineland to one of their meetings. "I said a few things," Wineland recalls, "and let them know that I would answer questions and take any of their concerns to the people in Annapolis. Well, the lid blew off. They attacked me for forty-five minutes. They threatened to haul me to court for fraud because I had not taken a loyalty oath to the state when I was hired. That was an old practice back around World War II but isn't followed any more. Eventually, I said, 'If you'll excuse me, I'll leave.'

"The door locked as I closed it behind me," Wineland recalls, "and then I found out my car was surrounded by pickups. There was no way I could get out. I went back and knocked on the door. No one answered. I knocked on a window and heard them laughing inside. I sat in my car for an hour and a half." It was a cold rainy night.

So what about the restrictions on painting the house, mowing the lawn, and flying the flag? "That's nonsense," Wineland says. "The regulations were never intended to prevent those things. But the earlier version could be interpreted that way. We changed the earlier version." Property owners are, in fact, supposed to get a permit to paint their houses. "The idea is that day-glo orange wouldn't look good from the river." I suggest that nobody is going to paint their house that color anyway, unless maybe to spite the state for requiring a permit. "The original regulations were fashioned after the wetland regulations for the Eastern Shore," Wineland explains. "I don't think they [the government people] understood the situation up here." That has been true since George Washington doubted local accounts warning of whitewater too rough for canal boats.

For most of the designated area, the regulations require at least ten acres per·lot for subdivisions, and that any new buildings be set

back 300 feet from the river. To cut timber, five permits are not needed, but a plan must be sent to the Garrett County Forest Conservancy District, which makes a recommendation to the state Department of Natural Resources, which then approves or denies the request. By regulation, the department "shall ensure that natural vegetation on or near the shoreline remains undisturbed so as to screen the logged area from the river." Commercial development, dams, and strip mining, except on unreclaimed sites that were never backfilled, are prohibited.

Some landowners favor the regulations. Whether or not they owned barns that could be burned, they spoke only with assurances that they would remain annonymous. "We don't want neighbors close by," one said. Ten acres per lot is fine with me." Another said, "no commercialization. No building near the river. I like that. I don't want anybody to detract from the beauty of the river. Five- and ten-acre minimums—I think that's great. No outlandish buildings over thirty feet high. No shanty towns. I don't think that's too bad."

What about problems with kayakers? "There are always a few troublemakers in any group, but really, what harm can a kayaker cause? They don't even leave a path in the river. I think all this will die as the younger generation moves in and the river will open up again, the way it used to be."

The state has conceded on some troublesome points. Wineland explains, "The law says we are to regulate the corridor, and we will, but we want to be as reasonable as we can." The corridor was drawn from topographic maps with a computer, apparently one with X-ray vision, because property was included that cannot be seen from the river. Landowners, including the Interstate Lumber Company, asked the state to revise the boundary. Meanwhile, Interstate requested a strip-mine permit, which Wineland rejected. Interstate appealed, hiring a Baltimore law firm which argued that the mining site should be exempt: you can't see it until you are far downstream. The miners also argued that the state should compensate the mineral owners if the mine were prohibited. State planners reviewed the computer-drawn boundary and reduced the corridor 31 percent, eliminating the strip-mine site from the protected area.

Regarding land development, Wineland says, "The first plan we processed was for the Big Eddy subdivision by Tom Thayer. He's a friend of Department of Natural Resources Secretary Coulter but

got no special treatment from us. We set up a 600-foot buffer along the river and he was able to go ahead selling his lots. Thayer was very cooperative, making every effort to comply."

Wineland says that the state has done nothing to promote recreational use of the river. "Far from it. The state's position is to do nothing but administer the regulations; certainly not to encourage people to go up there." The state plans no access area. "To buy land would incite violence."

Yet Garrett County Planning Director Tim Dugan says, "State zoning on behalf of the public, but without any provision for public access, is an abuse of state power. The river is saved, but for whom? The only beneficiaries are the landowners." A County Planning Commission proposal calls for the state, with local participation, to prepare a plan for the river that would manage land development and allow minimum, controlled public access. But Wineland says, "So long as local people regard anything we do as a problem, we're not going to be moving at all toward public access."

One issue that the local people *do* want the state to address is commercial rafting. One resident says, "Albright [where Cheat River trips begin] has a reputation as a town that's hard to live in on weekends. Rafting interferes with church services. It's hard to keep the town clean. We don't want that to happen here." To this day, some Albright residents loathe Ralph McCarty, owner of Mountain Streams and Trails rafting company, because two of his customers urinated against the church some unremembered number of years ago.

Landowners say that commercial operations are outlawed because a section of the regulations entitled, "Commercial" says "prohibited." The question is whether commercial *use* is prohibited or only commercial *development*. Wineland believes that only development is banned. "The outfitters can't build a motel, or a building. Access to launch rafts does not constitute a commercial development." But the regulations are vague. In reading them, I, for one, cannot determine their meaning.

The outfitter is Imre Szilagyi (Za-LODGE-ee) who began rafting when he was a graduate student studying mathematics in Ohio. He guided one season for White Water Adventurers of Ohiopyle, then opened his own company called Appalachian Wildwater. He offers trips on the Cheat, New, and Gauley rivers of West Virginia, and

now the upper Youghiogheny. He says, "In 1980 we ran about twenty trips with our guides. Then in 1981 we probably took fifty or 100 people. Just old and trusted customers.

"The river presents a lot of economic problems. So far, we've run two guides and two customers per raft. Commercial success will depend on having one guide per raft. I think we know this river well enough now that we can do that. Then there is the problem of access. I spent $100,000 for 100 acres so I would have fifty feet of shoreline. That's an expensive put-in." Paul Hoye bought 100 acres at Sang Run from John Friend, Sr., in 1799. He paid $2.67.

Ironically, Szilagyi, like the Thomases, denies rafters access. "Hardboats, okay. But if a rafter steps off the pavement, he's trespassing and I'll have the sheriff waiting at Friendsville." His reasons are to avoid commercial competition and to keep duffers off the water. "Anybody who wants to raft can go with my company or else throw their boat off the bridge."

Because this river runs dangerous and wild, and because landowners are incensed about commercialization, and because commercial rafters are ubiquitous on good whitewater, many people think that commercial operators should stay away from the upper Youghiogheny.

Pete Skinner, a frequent visitor here and a leader in canoeing and kayaking organizations, says, "There shouldn't be commercial trips. Passengers don't have the foggiest notion of what they're getting into."

Al Davis, whom I met on my trip with Steve Martin, has worked in commercial rafting for twelve years but says, "I'd like to see it with no commercial trips. Maybe no rafts. Leave it to the private boaters. Ohiopyle is full of people. The Cheat's mobbed. Enough. Leave this alone. Maybe I'm selfish, but I like to come up here just alone. There ought to be someplace where you can go and not have commercial trips. Even if the first operators are reasonable, it's only a matter of time until it gets to be a zoo." Davis wants no government controls either. In this respect he thinks like Rusty Thomas, but unlike the heavily armed landowners, Davis has no alternative to government action for the management of commercial use.

So there is sentiment against commercial trips. I ask Szilagyi, "Is commercial rafting a responsible thing to do at Sang Run?"

"It's safe or I wouldn't be doing it," he answers. "We keep a real low profile at Sang Run. We're in and out fast and make sure each

vehicle has a shuttle driver. If it turns out a zoo, it won't be because of what we do."

The upper Youghiogheny is probably the highest priced one-day raft trip in the world: $84 to $140 in 1981. "That river doesn't lend itself to mass exploitation," Szilagyi says. "With our equipment we have the capability of handling 600 people a day, and up there we handle five or six. There are only a few guides who can do it, and the demand is low—people know it's dangerous. It can't be run on weekends because they don't release water from Deep Creek Dam." I remind this former Ohiopyle guide that there used to be only a few guides available for the lower Youghiogheny (there are many dozens now), and weekday trips at Ohiopyle are filling to nearly one thousand customers on busy days. "Okay," Szilagyi says. "Potentially you could put on a three or four-boat trip every fifteen minutes if you had the guides and you had the customers." That comes to about a hundred passengers a day, because you can only put in between noon and 3 P.M. due to dam releases.

"A wild river is a natural resource that belongs to everyone," Szilagyi adds. "If you can show a lot of people the river and do it well, fine. I'm for excellence and against elitism." Szilagyi smiles coyly at what seems to be a contradiction. Rusty Thomas's limit for commercial boaters would be zero. Szilagyi's may be 100, and other commerical companies could raise the total to a zoo.

The questions are, how much will commercial rafting on the upper Youghiogheny grow if unregulated, and should it be regulated by the state? "Who knows," Szilagyi says of the first question. "I think the second question is some ways down the pike. There is such a thing as free enterprise, and such a thing as common sense. When the two clash, I usually side with common sense." He means government regulations. "The situation on the Cheat is obscene. The government should step in and control the number of boaters on that river."

Will other commercial outfitters start running the upper Youghiogheny? "Of course. What we've done, besides acquiring a put-in, is we've financed twenty or so trips to establish feasibility. Every one of my guides will know the river well enough to run his own trips. But this is not a business decision. Anybody who thinks that running the upper Youghiogheny can be a viable business is a fool."

"So why do it?"

"Ha, because it's there," Szilagyi answers. "Actually, Jimmy

Snyder [one of Szilagyi's guides, and one of the best kayakers, any-where] and I are fond of the old lady, and this is a good excuse to spend two days a week up there." Szilagyi reflects more seriously. "The Youghiogheny was the first great love of my life for paddling rivers. I've always remembered my first run. We made it through Double Pencil Sharpener, and there was a thunder storm that re-leased all the scents of the forest, and I felt really alive. That's an experience that needs to be shared.

"We're proud of having done it," he says of his commercial trips. "We've broadened the options available to society. This is a quan-tum rise in what can be rafted commercially. I hope that whoever else comes along will contain the risks as we have." Already in 1982, five commercial companies were running trips on the upper Youghiogheny.

If landowners are right in saying that commercial trips are out-lawed, the outfitters are in trouble. Otherwise, commercial use will be growing. Will outfitters act responsibly? Will government regula-tions be necessary? As Szilagyi says, who knows? The state will be reluctant to reopen any consideration of the Youghiogheny Wild River for fear of jeopardizing the entire program.

Dave Wineland says that regulations limiting the numbers of commercial boaters are "not out of the realm of possibility, not by a long shot. We have no data. We're going to keep count of the numbers of boaters. But so far, we don't have enough information or enough complaints."

The threat of violence remains. In 1982, rifle shots were fired near a commercial raft. Apparently the intent was to scare the people: bullets ricocheted from rocks. State police and investigators from the state attorney general's office found no suspects.

There is an unfinished item in this whole upper Youghiogheny political quagmire. It is the story of the upstream boundary—the one that Rusty Thomas and other people between Oakland and Ohiopyle say was manipulated. There were rumors that accused people of pulling strings, and since 1976, the rumors have bred cynicism and undermined state efforts. Delegate Decorsey Bolden said, "Thayer and Manning—only people in the nation who get to build down by the water. Not me, not you, not John Wayne."

Since the two individuals mentioned in the boundary question were Joe Manning—assistant secretary of natural resources in the

early seventies—and realtor Tom Thayer, and since Manning had died, I went to Tom Thayer for his side of the story.

Along Route 219 where Oakland suburbanizes with roadside businesses and with a few $200,000 homes springing from hillsides, I find the Thayer office complex. Five buildings sit back from the highway. They are built of wood, stained attractively dark, and landscaped. Though I am a stranger in these parts, the name Thayer is familiar.

The first of this family journeyed here in 1819, according to *Garrett County: A History of Maryland's Tableland.* The book's index lists ten different Thayers, and these are only the headliners. There is a Judge Thayer, a Thayerville, a Thayer Tavern, a Thayer fire tower, a Thayer wildlife refuge. Tom Thayer does not appear in the index, though perhaps he should. "The Thayers run this county," a resident along the river said. Tom Thayer is the owner of Garrettland Realty and a member and past chairman of the Department of Natural Resources' Citizens Advisory Committee.

I show up at eleven o'clock. Even with real estate in its deepest slump since the Depression, Thayer has meetings, so I return at one thirty. He is in his fifties, tall and tan with a short gray beard, sporty clothes, a gold chain around his neck. As I enter his office at the end of the hall, he lights a cigarette. He will burn to the butts half a pack before we are done.

Tom Thayer graduated in forestry from West Virginia University in 1950. "I was a conservationist before people knew what the word meant. A conservationist, not preservationist. As you know conservation is wise use; preservation is no use." He got a state job in Carroll County near Baltimore, "where I raised hell until they sent me back to the mountains."

In 1959 Thayer was promoted to district forester in Cumberland. "Two years later they were going to make me assistant state forester in Annapolis, but I said, 'No way, baby. Sit down there in a suit and tie?' I quit and came back home to Oakland and worked for a bank. Pretty soon I was appraising property, and in 1965 I went into real estate."

Thayer intended to build a campground in 1961. "I found forty acres along the river at Miller's Run—close to Swallow Falls and Herrington Manor State Parks, and bought it for $6,000. The health department required a sewage system that would have cost five or six thousand dollars, and I couldn't do it. I never built the

campground. I ended up getting divorced, later remarried, and we wanted a new home. Deep Creek Lake was the last place I wanted to be; I was selling lots there every day. That would have been like living in my office. So in 1974 I built our home on the river, 1,500 feet from the road. I didn't go back there to sell lots; I went there to hide from people, to look up and down the river and see mink and beaver." The Youghiogheny attracts escapees from many income brackets and from many professions.

In 1970 Thayer was appointed to a Department of Natural Resources advisory committee and became friends with Assistant Secretary Joseph Manning. "Joe had a beautiful home on the Eastern Shore along the Wye River, and we'd go down there and he'd come up here. He looked all over the country for a place to retire, even bought a lot in the Ozarks, but he loved it up here. He started begging me for a lot on the river. I didn't want to sell, but didn't want to hurt his feelings either. We were friends. I said, $10,000 an acre, figuring he'd say no. He jumped on it. Bought one-and-three-quarter acres. In the real estate business Joe was what we call a 'mooch.' That means a guy who, from the moment he walks in this office, he's going to buy a lot, no matter what. I thought it was the hosing of the century but Joe thought I had done him a favor. He was the most naive, simple, honest guy; he told a reporter from the *Baltimore Sun* that I'd done him a favor. Then came the story: 'Wealthy land developer does favor for Deputy Secretary of Resources.' The rumors that followed were a great sorrow to me, because people downriver—old friends I had hunted with—believed them."

The selection of Miller's Run as the upper limit to the wild river left Thayer's and Manning's land unregulated by the new state zoning. "Fact of the matter," Thayer says, "is that Oakland is the only county seat in Maryland without sewage treatment and it isn't until Miller's Run that the water quality is anything like a wild river. And there are two power lines between Oakland and Miller's Run. These were the reasons that the state made the section from the Oakland bridge to Miller's Run 'scenic' instead of 'wild.' I had nothing to do with the decision. Nobody called me. I called nobody. I didn't care one way or the other. Ten acres per lot would have suited me just fine. That way I wouldn't have to worry about people building across the river and moving in with eighteen kids."

About the boundary, Senator Mason had said, "I would have

supported the entire river as scenic or wild, from the headwaters on down. But that wasn't in the cards, so the senate passed the bill to make it a 'wild' river from the Oakland bridge to Friendsville. In the House they changed it, moving the 'wild' boundary down to Miller's Run."

The amendment to do this was added in a meeting of the House Subcommittee of the Committee on Environmental Matters, and Joe Manning was there. The *Baltimore Sun* quoted Manning as saying that he lobbied "as a private citizen," during the wild river debate.

Tax records in the courthouse show that Manning made a down payment on the land in 1974. He said he began construction on July 10, 1975, which happens to be the effective date of the act. He paid for the land and made the deed on July 10, 1975, but it was not transferred and recorded until January 5, 1976. The regulations that would have prohibited a one-and-three-quarter-acre lot and the building of a home so close to the river (ten feet) were not effective until May 26, 1976. Because Joe Manning was in before the regulations, the selection of the boundary did not affect him, one way or the other.

Enough politics. It is time to return to the river.

"Man, this is beautiful," Steve Martin says. When we started the trip from Sang Run to Friendsville, the sky wore a quilt of clouds. It rained a little. "That's okay," Steve said. "I love paddling in the rain. Rain's what makes it." Then when the sun came out at National Falls he said, "Sure is great paddling in the sunshine." Now as we cruise the lower three miles of gentle water, it rains in earnest. "This is pretty neat, the rain and the mist," Steve says. Mist flattens the textures of the hills, paints craggy silhouettes of dead pine snags. Fog and rain always add a wilder, prehistoric overlay to the wilderness. Steve sits back and relaxes in the downpour while it drips from his helmet, onto his face.

At a big pool we pass the site of Kendall. The old town has yielded to trees and rhododendron with a few piles of coal and some obscured ruins. The Confluence and Oakland Railroad was built from Friendsville to Kendall in 1891. The town had a boardinghouse, grocery, clubhouse, and homes. Today you can walk the old railroad grade three miles from Friendsville to Kendall, then another few miles to a bridge site where tram lines crossed and

climbed farther upriver. Kevin Steinhilber, a surveyor and consultant for Garrett County coal companies, says that rich coal remains at Kendall. "If there will be proposals to mine anywhere in the wild river corridor, it will probably be at Kendall."

Michael Normyle has kayaked ahead of us to catch a return ride to Sang Run where he will retrieve his Volkswagen. Steve and I paddle under the high bridge of Interstate 48, then under new Route 42, and finally under the old Route 42 bridge which is part of the town's main street.

The upper Youghiogheny take-out is as special as the put-in, as friendly as the put-in is hostile. There at Al's Riverside Lounge, boaters do not worry about locals with shotguns. Al's is not much to look at, worn by the weather and by floods. On the outside it barely survives, but on the inside it is throbbing with life: backslapping, tall tales, thirty-year-old feuds, Friendsville lore, country music, pool games, hot rum, hot chili, and cold beer. Al's Lounge houses a can't-be-duplicated blend of hair-boater and Appalachian-local.

As Steve and I approach via raft, six boaters who are propped on the porch drink beer, watch the rain, and applaud us. We beach below the bar where a golden retriever welcomes us. Then a black Labrador licks our hands if we let them hang in range. Like the loveable Lab, we are soaked to the skin, but unlike him, we care. My camera bag has kept a wool shirt dry, but all other dry clothes are in the car. I pull the shirt on; someone offers his extra to Steve.

Here are the whitewater hard-core. Keith Bachlin from Albright sits at the end of the porch. He is a paddle maker; many boaters think he is the best. His kayak paddles run $150 to $290, but are works of art. Phil Coleman is here. Two guys are named Jimo and Jesse. Roger Zabel refreshes with a Stroh's and talks to Karen, Big Al's red-headed daughter, now weaving something beautiful on a portable loom. Her eyes are bright and impish. Roger is her boy friend.

Al Davis comes floating by on his raft. He is applauded for completing the first upper Youghiogheny R-1. Many people would have thought it impossible for a lone paddler to raft this river. To understate his accomplishment, he sits on a side tube, crosses his legs, and daintily strokes the water.

Big Al Fauber emerges for a breather from duty behind the bar. He mops his brow and gazes at the rain. He really is big, partly

bald, with a drooping red moustache. He looks full of gusto, could be a jolly bartender in a beer commercial. He grew up near Oakland, then spent twenty years in the army, mostly as a master sergeant, surviving four stints in Vietnam. From Panama, he moved his family to Friendsville in 1971 because "that's where I found a home for sale." He learned new skills; tomorrow he will depart as a truck driver towing a yacht from Havre de Grace, Maryland, to Florida. Fauber bought the lounge in 1972. "Well, how're we doing?" he asks, and everybody says something like, "Okay Al." Thus revived by the fresh air and the porch crew, he returns inside.

Phil Coleman once took Al down the river. At Double Pencil Sharpener he was knocked off the tube and splashed into the drink, but not entirely. Coleman snatched one log of an ankle, leaving the rest of Al sprawling overboard. Eventually, with teamwork, they lugged the master sergeant–truck driver–bartender back aboard. Karen, in Roger Zabel's raft, asked, "Hey Dad, what were you doing down there?"

"Checking out the fish."

"Yeah? What kind of fish did you see?"

"Suckers."

The boaters on the porch talk about how much the water will rise due to rain. One foot is the consensus. They talk about an unusual, not quite suicidal way of running Charlie's Choice. Some recollect their last trip on the Blackwater River, and anticipate the Gauley (the Gauley River is run mostly in the fall). They debate the idea of drilling holes in paddle blades to let a small amount of water through as you stroke, and what angle the holes should be. They talk about a whitewater movie being produced by Russ Nichols and featuring Steve Martin, Jimmy Snyder of West Virginia, and John Kennedy of North Carolina. Also: a *Life* magazine story is to feature Phil Coleman and others.

These guys (and Karen) are comfortable on the porch, but I am the proverbial drowned rat: soaked, cold, and hungry. The beer is sucking my limited potential for warmth. I retire to the bar, and after my eyes adjust, I read a sign over the empty mugs: "It's exciting to be Polish." A Pittsburgh Steelers schedule is taped on the wall. A Schlitz poster features a boatload of rafters in whitewater. "Go for it," the poster says. I have arrived in time to catch an altercation between one local man and two others:

". . . the hell you are."

"You didn't do a day's work, how'd you know?"

"Whatta you mean you took the . . . in the . . . when . . ."

Between the dialect, the slur, and Waylon Jennings performing on the jukebox, I can't understand half of it, but sense an escalation. Sure enough: "Whatta you know. Goddamn liar."

"Hey, the sign," a fourth man challenges. The Sign, on the wall behind the bar, says "Profanity prohibited. Otherwise hit the bricks."

"Yeh, look at the sign," a fifth man says. They police themselves in this way, and Al's Lounge remains a place of decency.

Big Al is somewhat massive behind the bar. He looks at me and says, "Harmless."

I order chili from Betty, a friendly, white-haired waitress, also a bartender.

About the time Crystal Gayle comes on, Karen abandons the weather-beaten porch.

"See the cartoon?" she asks. Karen is an artist as well as a spinner and weaver. She draws cartoons of her own. This one makes sense only to boaters. The first panel is a caricature of Charlie Walbridge standing on shore. Walbridge is the American Canoe Association's safety chairman. Despite his penchant for hair water, he is a safety nut. He is continually writing articles on safety. At least a handful of boaters probably owe their lives to Charlie Walbridge's nuttiness. In the cartoon, a kayaker flounders in a huge whirlpool and yells, "Throw me a safety rope, Charlie." In the next panel Walbridge throws the entire safety rope—intact in its throw bag—to the swamped boater. If things are quiet in Al's Lounge and Karen doesn't think people will notice too much, she grabs her guitar and sings behind the bar.

Karen had gone away to Washington, D.C., but decided she would rather live here in the mountains. Under CETA (a Carter administration jobs program) she found work as a carpenter fixing homes of the elderly. Two months after pounding her first nail, she was promoted to foreman. She does not excell in carpentry. "They just needed somebody with common sense," she explains. On Saturdays she taught in a free art school for children. "Some of these mountain kids are beaten before they start," Karen says. "If they're from certain families, they know they aren't supposed to amount to much, but they start art projects and blossom out. It's a good feeling." The art work continues but CETA is dead. Now Karen

mops the floor and does odd jobs at Al's. She will not tend bar. "I don't like the whole alcohol scene," she says.

Betty serves my hot chili. Then she quits for the day, but before she leaves, we celebrate her birthday. Which one, she is not saying. Al pops the cork from one bottle, then another, and pours for everyone. I sip champagne with my chili, crackers, and beer. Meanwhile, with uncanny timing, Eddie wanders in for the free drinks.

Ed Sliger is about five-foot-two, over eighty years old. How much over? Who knows. He wears mile-weary boots and a suit coat possibly retrieved at Goodwill before my birth; a coat for a collector in New York City but only for Ed Sliger in Friendsville. He is topped with a hat, though his hair has survived the years. It has outlasted his teeth. Most of them have been dropped along the way, which makes Ed difficult to understand. I don't know, maybe he would be hard to understand anyway. When smiling, the handicap of his gums is more than compensated by his grinning squint, which appears immediately upon seeing Karen.

Eddie has a treasure for her. Karen holds out her freckled hand, closes her eyes, and receives a rusty nail. Eddie says, "Pretty soon we'll celebrate *my* birthday." Karen responds, "I thought we just did that last week," and Eddie explains, "Celebrate it twice. Pretty soon's the real one."

After Eddie climbs onto a stool at the bar and the champagne party has cooled, he exhumes a larger treasure from his suit-coat pocket. "What you got there, Ed?" Al asks. Eddie looks at Al and says something like, "Weeana."

"What?" Al asks.

"Weeana."

"Sweet anise," an adjacent old-timer interprets.

"Wannaseeit?" Ed shows the sweet anise—a green herb with finely textured leaves—to cronies at the bar. The smell of licorice blends into the Al's Lounge atmosphere and improves it.

"What do you do with it?" Al asks.

Ed says, "You chew 'i up, spit 'i on fishin' worms, then go fishin'." That is what Ed does with it.

Ed lived in Kendall clear up until 1934. He worked in the mines, riding the train down to Friendsville now and then, later walking it. I think that Ed exaggerates. He says it took three hours to walk out, and that he once did it in a storm of hailstones *this* size, and he indicates a basketball. They were somewhat smaller than the trout

that he caught after spitting sweet anise on his worms. He talks about the size of trees he cut, about the height of floods Friendsville has survived. This past-century-recap could go on indefinitely, which would be okay with me, but after awhile another old man, perhaps Eddie's son's age if he had a son, says, "Ed, you better get up there so you don't miss your supper again." A woman in Friendsville cooks for Eddie but does not tolerate his tardiness, especially when Al's Lounge is the source.

Today, Ed has money. He holds up several dollars and asks Al's wife for a flask of Seagrams VO. She peers under the bar for a moment and emerges, hopefully saying, "Don't have any Ed." He says, "Corby's then." Al's wife glares at Ed, who sits poker-faced and with resolution that outdoes his height, age, and absent choppers. Al's wife reluctantly surrenders the booze. Ed pockets it, vacates the bar, and walks across the Youghiogheny River bridge as he has done thousands of times, back into town, the rain beating on his shoulders.

Friendsville started out as an Indian Village and remains a quiet, pleasant place, with 604 people. The town was not named for the disposition of its residents, though it could have been. Most of the buildings are white and well kept. There are many older people, but children, too. Even though the town lies in the heart of the mountains with a heritage of timber and coal, it doesn't show much of the grime, the ramshackle facades, the broken windows, the dark red brick and rusty railroad tracks indigenous to most Appalachian burgs. It is without the company-town look of Crellin, the only other Youghiogheny riverfront town in Maryland. It could be a small farming community in New England.

When I visit Friendsville, I meet Carl Helmick on the main street. He is an old-time resident who says that the "ones that want to work get out, the ones that don't, stay." I meet tall Bud Fisher who came up here twenty miles from Confluence because in 1932 the Friendsville high school had basketball and Confluence didn't. One thing led to another: he met a girl and stayed fifty years.

Emery Friend, seventy-three, didn't come to play ball. His family has been here since 1765 when Swedish John Friend established this as the first white settlement of Garrett County. He squatted in defiance of King George III's proclamation that prohibited occupation of Indian lands west of the Alleghenies. In 1766 there were

additional edicts by the Pennsylvania and Virginia governors to remove people from this frontier. Pennsylvania passed a law in 1768 stating that anyone living on Indian lands would be punished by death. Friend and other settlers were outlaws clearing forests and building towns on land they didn't own. They were trespassers causing far more trouble to the local population than kayakers do today. When George Washington visited the Ohio River headwaters in 1784, he called the squatters "fit subjects for Indian vengeance."

Emery Friend grew up on a farm in the early 1900s. For work, he delivered posts to the mines around Uniontown. He was thirty-two when he was drafted into World War II. Why did he return after the war? "I don't know why. If I had it to do over, I'd go someplace else. To be different I guess. For better opportunities. Maybe stay in the army."

I asked what changes he has seen. "Well, yesterday the bank was robbed." The thief appeared with a briefcase and claimed there was a bomb inside. It was the first bank robbery in Friend's memory.

He thinks beyond yesterday. "The railroad used to go right through here, two coal trains a day from Kendall. The streets were all mud. Used to drive down along the river in a car, right along the river to Somerfield. Then they built the dam down below. They covered it up. Dam took it all. Ran them all out. There were farms and houses the whole way down there."

I drive my van to the lower end of Friendsville where the road that Emery Friend talked about still follows the river. It is rough because no one maintains it any more. I park and walk. The forest grows lush. The river winds around bends and sings over rocks and gravel. The Youghiogheny reflects green in dark pools, but mostly it is riffles shining in the afternoon sun of early summer. Sycamores lean over the bank. They are friends of the trout since they shade the water and keep it cool. Rhododendron and seeding grasses crowd the shore.

Then an outline of rocks-without-plants appears along the water's edge, as if it were scraped. The outline swells by inches, growing to feet as I walk downstream. It is a tidal zone without the life of tidal pools. Eddies of current creep upward along the shore. I walk another quarter mile. Slack water expands toward the middle of the river. Riffles are gone. The only current runs down the center, squeezed thinner by flat-water at the sides. Shoreline plant

life is banned for three feet above the water. I can see that the only current there is created by the momentum of the river from above. The Youghiogheny is like a hose in a big watering trough, and its pressure is spent and dissipated as it dumps into the still-water. In another quarter mile there is only a slight agitation in the center; tiny whirlpools and waves come to the surface and vanish.

Then the river dies. It has run unblocked and with speed since Silver Lake, but now it stops, because down below is the dam.

The Dam

It is made of dirt and rocks, 184 feet high, as tall as a fifteen-story building. With a length of 1,610 feet, the dam fills a tight spot in the Youghiogheny valley 59 miles down from the river's source and 1.2 miles above the town of Confluence. Only two dams in Pennsylvania rise higher: Raystown, 225 feet high on the Juniata River, and Francis Walter, 234 feet high on the Lehigh. Like any rock pile, Youghiogheny Dam tapers from bottom (1,000 feet wide) to top (25 feet). It was built and is operated by the U.S. Army Corps of Engineers, the largest engineering organization in the world.

The dam is a plug, a tub, and a spigot, all with certain potential, certain limits. When runoff is high, the dam holds back water. Then when the river is low, extra water is released for industries and towns, incidentally aiding barges on the Monongahela River. Thus, for the river downstream, the dam makes high flows lower, and low flows higher. Below Confluence, the higher summer flows also benefit whitewater paddlers at Ohiopyle, though this was not foreseen when the dam was built.

The full reservoir covers seventeen miles of what was river, 3,566 acres of what was land. Thirteen streams, including Mill, Braddock's, Buffalo, and Tub runs, drain into the reservoir, and the lower ends of these are also submerged. The shoreline—the perimeter of the reservoir—totals thirty-eight miles, only four miles more than the old river, which means that in most places the reservoir is skinny—a narrow flooded valley without the bays and inlets of

74

nearby Deep Creek Reservoir (on a Youghiogheny tributary) which has a twelve-mile length but a sixty-nine-mile shoreline.

Many other differences between the Youghiogheny and Deep Creek reservoirs stem from this topographic fact. Most of the Youghiogheny frontage drops sharply from mountaintops to reservoir depths. This means high mud lines when the water is drawn down, and it means poor access. The lake frontage is not conducive to cabin sites, tennis courts, or even a three-by-three spot to stand and fish. The steep waterfront is owned by the Army Corps of Engineers, which has reserved a belt of open space. Deep Creek has a gentle shoreline. It more resembles a natural lake in New York or Minnesota than a flooded Appalachian valley, and the development follows suit. Expensive homes with shaded lawns adjoin Deep Creek Lake, while on the Youghiogheny there are cottages, cabins, and trailers, clinging to notches cut into the rocky slopes.

As to the type of dam, the Corps calls this "rolled earthfill and impervious core," meaning it is dirt, rolled to squeeze out the air, with a clay curtain in the center extending from top to bottom. Unlike piles of rocks or sandy soil, clay is fine grained and nearly waterproof. Large stones armor the outside of the dam. Considerable soil and rock was dug up and dumped to make the dam—over 3 million cubic yards or 375,000 dump-truck loads. The dirt and rock would be 1,600 feet deep if piled onto a football field with walls around it.

The reservoir holds 82,766,154,000 gallons of water, or 254,000 acre-feet. The greatest depth is 126 feet. At the dam, an eighteen-foot diameter tunnel releases water from the cold depths of the lake where sunlight does not reach. Army dam tenders adjust and tune the volume of the release by opening or closing three gates in the tunnel.

Gene Amocida has worked for the Corps since 1955, and now heads its hydrology branch in downtown Pittsburgh. His Reservoir Regulation Section includes five full-time employees who decide when to hold water back and when to release it at fifteen reservoirs in the upper Ohio basin. The water level you see at Pittsburgh is partly a result of their decisions.

At 8:15 every morning, field men call Amocida's office by radio and announce their reservoirs' levels. The information is punched into a computer for storage and for calculations if operations become complex. For Youghiogheny Reservoir, Amocida's men add a

point to a graph with one axis showing water levels and the other showing dates. The point will fall within one of six zones indicated by lines revealing cubic feet per second to be released. During floods, Amocida's men are on duty around the clock. With help from a computer, they adjust the discharges of all eleven Army Corps dams above Pittsburgh and four others in the Beaver River Basin in order to get the best mix of storage. During these times the job is not so cut-and-dried. Amocida will compare the route and speed of storms, the expected crests of dozens of streams, and the flood hazards of scores of communities. He will strategically jettison or hold water by use of his fifteen spigots and plugs. But except in emergencies and unusual weather, it is simply a matter of plotting information and releasing the amount of water that a graph says to release. Most of the planning and figuring was done when the graph was created and was based on the purposes of the dam.

The main purpose is flood control. Engineers studied 200 years of information, older data being inferential, and calculated the volume of the 100-year flood—the size of the largest flood expected once each 100 years. They computed the amount of rainfall and runoff that would cause this flood, and the dam is operated to hold it all. Empty space is reserved for 4.3 inches of runoff from summer rainfall and 6.5 inches of runoff in winter. This means a maximum pool level of 1,439 feet above sea level in summer and 1,419 in winter.

The secondary purpose of the dam is low-flow augmentation. The goal is to keep an optimum amount of water in the river below the dam. Somebody established this optimum back in the forties when the operations plan was devised, but the records are buried as archives, and at the Corps office there are no survivors of that era. Amocida says they have all died or moved to Florida. But we know that a gauge thirty miles downriver in Connellsville is used to determine the releases. The lower the gauge reading, the more water is dumped from the dam, although this is rationed so that even during the worst known drought (the "drought of record" in 1930–1931) the reservoir would not quite go dry. Even then, a pool level of 1,344 feet above sea level (95 feet below the highest summer pool) would be kept while maintaining a minimum of 200 cubic feet per second at Connellsville (including the flow of tributaries below the dam). This is almost enough water to float a canoe, but would raise the Monongahela at Braddock only one-tenth of one foot.

During most years, the reservoir reaches summer pool elevation

about April 1. It is kept at that high level, convenient to motor-boaters, until August. Then the Corps lowers it until mid November when rains raise the inflow.

In summary, operation of the dam is thus: Empty space is reserved to hold the 100-year flood, and water is released to provide a minimum of 200 cubic feet per second at Connellsville during the drought of record.

There are other variables. The Army Corps always releases at least 100 cubic feet per second so that the river doesn't drop bone dry, killing fish. Extra water is released to dilute the Casselman River when it is delivering caustic acid from coal mines. Once, the Corps shut the water down so rescuers could recover a drowned body below Ohiopyle.

Youghiogheny Dam's three flood gates can release at most 10,000 cubic feet per second, which fills the river to the top of its banks. If more than this amount flows into the reservoir, the water rises until it reaches the emergency spillway at elevation 1,490. This is a notch, 400 feet wide in the top of the dam, where the skin is reinforced with 17,00 cubic yards of concrete. If it weren't for the spillway, water could rise higher until it would flow over the breast of the dam which could then burst, wreaking havoc on the communities it was designed to save.

Through the years ten dams have been built on the Youghiogheny: two trout ponds in the headwaters, the ten-foot-high dam at Silver Lake, a dam of spruce branches built by Elijah Friend at Sang Run in 1854, Youghiogheny Dam by the Army Corps, three diversion dams (built one after another) at Ohiopyle in the mid-1800s, a hydroelectric dam at Connellsville, and two navigation dams below West Newton in about 1850. Today only three impoundments remain: low dams at Silver Lake and Connellsville, and the big Army Corps dam.

To float boats was the first reason to build dams in the Ohio basin. Pioneers moving westward took the National Road over the Appalachians to Brownsville along the Monongahela, or to Pittsburgh. By flatboat or keelboat, they floated down the rivers to the frontier of Ohio, Kentucky, Indiana, Illinois, and the Mississippi River. In 1788, 323 boats embarked on the Ohio River. After Lewis and Clark's journey in 1803, settlers continued overland to the West. Some rode steamboats up the Missouri River to the Rockies. The rivers were vital links in the westward movement.

One problem was that the first leg by river—on the Mononga-hela—dried up in the summer, sometimes for months. The Ohio was not much deeper. Meriwether Lewis wrote, "At this stage of water, oxen make the best sailors on the Ohio River." In 1814, the Pennsylvania General Assembly passed an act authorizing a survey of the Monongahela River that would recommend dams and levees from Pittsburgh upstream to the state boundary. In 1844, eight-foot dams were completed, opening flat-water travel between Pittsburgh and Brownsville.

The Pennsylvania legislature also licensed the Youghiogheny Navigation Company, which built two dams and fourteen-foot-high locks on the lower Youghiogheny and which in 1848 opened a four-foot-deep channel to West Newton. In 1865, a flood destroyed these dams.

By 1929 the Army Corps of Engineers had built fifty dams on the Ohio River and several on the Monongahela. Tygart Dam on West Virginia's Tygart River, a Monongahela tributary, was authorized in 1935 and was the first large dam in the nation built solely by the Army Corps of Engineers. Because Congress authorized Tygart Dam for navigation, most of its water is unavailable for towns and industries, though droughts pose problems. Water supply agencies are required by the state to prepare emergency plans that could involve rationing of water or importing it from other basins. State officials also supported the building of Rowlesburg Dam on the Cheat River, but environmentalists and West Virginia blocked this because of the Cheat's unspoiled character and the farms and homes that would be flooded.

Youghiogheny Dam helps slightly to alleviate low water problems on the Monongahela, but this was not the main reason for the dam. The main reason was not to cope with low water, but with high water. Youghiogheny Dam was built to save Pittsburgh from floods.

Pittsburgh had its start the year after twenty-one-year-old George Washington had identified the confluence of the Allegheny and Monongahela as a strategic military site. Fort Prince George, Fort Duquesne, and Fort Pitt followed, and a town grew. In 1760, 146 houses had been built. Because of river transportation during the westward movement, Pittsburgh thrived as the frontier gateway.

The town was near coal, essential for the melting of iron ore. Too, Pittsburgh sat central to the developing nation: accessible from

the east by road and rail and opening routes to the heartland via the Ohio River, road, and rail. The Allegheny and Monongahela provided plentiful water and natural sewers. Labor was cheap, and this was the home of Andrew Carnegie, Henry Clay Frick, and other pioneering industrialists. Pittsburgh became the largest city at the edge of the Appalachians. Next to Atlanta, Georgia, it still is. In the late 1800s the place hummed as the nation's largest steel producer. River wharves grew warehouses, and the homes and shops that were confined to the triangle of land between the Allegheny and Monongahela gave way to factories and many-storied buildings. Industries with forests of smokestacks sprawled up and down both sides of three rivers. Pittsburgh, first a fort, then a frontier gateway, became the nation's industrial giant, and much of it was built where the rivers would flood.

South of the city, the Monongahela reaches into the heart of West Virginia. To the north, the hundred tentacles of the Allegheny penetrate into New York and east to the Susquehanna divide. About 11,254 square miles drain into the Allegheny; 7,384 into the Monongahela, and these two megarivers merge at Pittsburgh. The Pittsburgh Point was *made* by the rivers, colliding during floods. It is formed of alluvial soil eroded from places such as Backbone Mountain, Eagle Rocks, and the Casselman.

When the Ohio River reaches twenty-five feet on a gauge at the Point, the Army Corps calls it a flood, the first known one occurring in 1762. From then until 1936, the Corps listed 115 floods, the largest in 1762, 1763, 1784, and 1832. From March 1907 to March 1908, three floods, the highest being 38.5 feet, caused $6.5 million in losses (1908 dollars).

Enough was enough, and the industrial establishment formed the Flood Commission of Pittsburgh with H. J. Heinz as president. On April 16, 1912, it presented a fat volume of research and recommendations to the chamber of commerce. This report was the first thorough plan for flood control in the United States. It recognized the importance of damming the Youghiogheny (the second largest tributary of the Monongahela, the Cheat being the largest), and the Kiskiminetas, a major Allegheny tributary: "one or both of these streams have been important factors in every great flood that has visited Pittsburgh." The commission recommended seventeen reservoirs above the city, incorporating sites on the Youghiogheny. Alternatives included the gorge above Confluence, though their dam

would have been lower than the Army Corps', flooding only eight houses. The report said, "By careful adjustment of flow line it was found possible, in the aggregate to obtain considerable storage without overflowing important settlements." Other damsites were plotted at the Maryland state line, 1.5 miles above Friendsville, 2.5 miles below Sang Run ("consists of several small stores and a few unimportant dwellings"), and at Swallow Falls. The commission identified five Casselman sites.

In 1913, E. A. Schooley of the Connellsville Chamber of Commerce echoed the Pittsburghers' recommendation when he wrote to the Army Corps of Engineers: "As a preventive measure we suggest immediate construction of the proposed reservoir south of Confluence and impounding of waters of the Youghiogheny River." Schooley was asking for no less than a new role for the Army Corps. Thus far, it opposed flood-control dams, arguing that they would be too expensive and of dubious value.

Then came the big flood in 1936. To many people, it is as memorable as Pearl Harbor. Snowpacks and thick river ice had already been swept away, but on March 17 the Ohio basin was engulfed by wet snow and heavy rains in Old Testament proportions. The Ohio River rose from 21.7 to 30 feet that day. It crested on March 18 at 46 feet. Water from the Monongahela and Allegheny rivers made Pittsburgh boatable up to the door top of the Jenkins arcade and the Joseph Horne department store. Chocolate water submerged the downtown almost to Smithfield Street and cut all access and communication: railroads, bridges, and telephones. The power died with the flooding of the James Reed generating plant. One hundred thousand people were driven from their homes. Firemen waded waist-deep in floodwater while directing hoses at blazes that roared out of control. The National Guard occupied the city and the Red Cross fed 50,000 people. After five soaking days, the waters finally dipped below flood stage, leaving 36 dead, 500 injured, and $150 million to $200 million in damages (1936 figures). Thirty thousand Work Progress Administration laborers helped to mop up Pittsburgh. Scores of Eastern cities flooded in 1936. That year was to floods what 1968 was to race riots, 1973 to gasoline shortages, and 1977 to Western drought.

Congress took action, passing the Flood Control Act of June 22, 1936. The act says that "destructive floods upon the rivers of the United States, upsetting orderly processes and causing loss of life

and property, including the erosion of lands, and impairing and obstructing navigation, highways, railroads, and other channels of commerce between the states, constitute a menace to national welfare." For the federal government, Congress accepted that flood control was a "proper activity," to be under "jurisdiction" of the War Department and "prosecuted" by the Army Corps of Engineers. The Corps would study the Youghiogheny, together with over two hundred twenty other rivers, plus many tributaries, for flood control. Congress authorized nine reservoirs, not including the Youghiogheny, for construction in the upper Ohio basin.

The Flood Control Act initiated one of the most massive manipulations of nature and landscape in history. Hundreds of dams would be built nationwide. In the flood year, 1936, the Army Corps was to be a savior, and it was given license to study and build almost anything it saw fit. Perhaps no domestic agency, save the Bureau of Reclamation, which dams rivers in the West, has been embraced so unquestioningly, and Youghiogheny Dam illustrates this point perhaps as well as any example.

To reinforce public support, the Ohio River at Pittsburgh exceeded flood stage a confounding six times in 1937. The highest of these was about eleven feet lower than the 1936 crest, but downstream from Wheeling, the 1937 flood was the worst. Half a million people vacated their homes in the lower Ohio Valley. While the brown waters still roiled toward the Gulf of Mexico, the House Committee on Flood Control passed a resolution calling for even more Corps recommendations.

In Document Number 1 of the House Committee on Flood Control, first session of the 75th Congress, 1937, the Army Corps recommended forty-five reservoirs. Only two fell within the Monongahela basin: West Virginia's Tygart and West Fork, but officials and residents of West Virginia opposed the West Fork project since their land and homes would have been permanently flooded to prevent occasional flooding of Pennsylvanians downstream. Document Number 1 included no reference to the Youghiogheny.

The Flood Control Act of 1938 authorized $75 million for reservoirs and $50.3 million for levees and local protection. Section 4 of the act states: "The general comprehensive plan for flood control and other purposes in the Ohio River Basin, as set forth in the Flood Control Committee document Number 1, Seventy-fifth Congress, first session, with such modifications thereof as in the discre-

tion of the Secretary of War and the Chief of Engineers may be advisable, is approved." The Youghiogheny was not mentioned, but "modifications" and "discretion" would be consequential words.

A December 15, 1939, Army Corps memo recognizes authorization of the West Fork site but says, "Considerable local opposition in West Virginia has arisen against the provision of the proposed West Fork reservoir. The Youghiogheny River reservoir could serve as a substitute for the West Fork reservoir, under the project modification authorized by the Flood Control Act of June 28, 1938, and, if selected and approved by the Chief of Engineers, the reservoir would become an authorized unit of the reservoir system project for the protection of Pittsburgh and the upper Ohio River Valley with incidental protection for the Youghiogheny River Valley."

The Youghiogheny project, which would impound seventeen miles of the river and flood 1,430 acres of farmland and 262 buildings, was considered a "project modification," pursued because of local opposition to the preferred West Fork site. Youghiogheny Dam was not specifically authorized by Congress, though the Corps probably discussed the switch with J. Buell Snyder of Perryopolis (along the lower Youghiogheny), who was chairman of the War Department Subcommittee of the House Appropriations Committee. The Corps "modified" the West Fork dam by moving it 100 miles to another river and another state. This may indicate the solidarity of support for flood control, the confidence of the Army Corps, and the freedom that it enjoyed. A dam would not be built today without specific Congressional approval.

Army Corps planners had considered a dam below the town of Confluence. This would have impounded the Youghiogheny, the Casselman, and Laurel Hill Creek. The site was dropped, not due to Confluence, but to the cost of railroad relocation. They considered other sites at 3.8 and 3.9 miles above Confluence—at the lower end of Big Bend.

The site 1.2 miles above Confluence was selected because it offered better flood control. Page one of the Army Corps Definite Project Report of 1939 (the fundamental document about the dam) lists purposes of flood control, navigation, and pollution abatement. But page fourteen omits navigation: "The dam would create a reservoir primarily for the purpose of flood control, but with integrated use for low water regulation for the benefit of irrigation, pollution abatement, and water supply." It was also noted that releases could

be used to dilute acid mine drainage from the Casselman and to provide water for the Youghiogheny River Canalization Project—a lower river channelization including two dams below West Newton authorized in 1930 but never built, perhaps due to the Corps' preoccupation with flood control after 1936.

Later brochures by the Army Corps list only purposes of "flood control and discharge regulation for industrial and domestic water supply and for pollution abatement." Gene Amocida says that the dam is operated for flood control and low flow augmentation, not for navigation.

No hydroelectricity is generated here, though it was considered. In 1939, G. Albert Stewart of the Pennsylvania Department of Forests and Waters (now the Department of Environmental Resources) wrote to the Army Corps: "The Board does not favor hydro-electric design of, or hydro-electric use of the proposed dam, said development being inimical to the interests of one of Pennsylvania's basic industries—coal—and an unwarranted expenditure of public funds not contributing in any way to the solution of the main problem of flood control."

In the 1970s, the rising cost of oil, air pollution from burning coal, and concern about the safety of nuclear power stirred interest in hydroelectricity. In 1979 the Army Corps began a study of retrofitting the dam with turbines, but the investigation was halted in 1982 due to lack of funds. Three other sponsors applied for a Federal Energy Regulatory Commission permit to study the addition of turbines, and in May 1981, the commission issued a permit to the borough of Seven Springs, home of western Pennsylvania's largest ski resort. After their study is completed in 1983, town officials may request permission to tap power here.

Most hydroelectric dams are operated for peaking power. This results in minimal water being released most of the time, then great surges being flushed when electricity is needed. To minimize these all-or-nothing hydraulics, a reregulating dam is often built below the main dam to catch the crest of water during releases and hold it back for steadier flow.

While planning their dam in the 1930s, the Army Corps listed a cost/benefit ratio of 1 to 1.54 and later 1 to 3.16. It is unclear which of these is the final figure, but for every dollar spent, $1.54 or $3.16 would allegedly be returned to somebody in benefits. The Definite Project Report lists 89 percent of the benefits for flood control, 3 percent for navigation, and 8 percent for pollution abatement.

According to the Corps' estimates, the dam would have reduced the 1936 flood in Pittsburgh from 46 feet to 45.2 feet. In 1972, during the Hurricane Agnes flood, it cut the crest by half a foot. Combined, ten reservoirs in the Pittsburgh flood-control system reduced the 1972 flood by 12.1 feet. Army Corps figures indicate that Youghiogheny Dam prevented more than $93 million in damages as of 1979.

Benefits have accrued from Youghiogheny Dam, but benefits to whom? Direct beneficiaries of river navigation—a small part of the dam's justification—are the barge companies. Between 1957 and 1976, federal aid to navigation totaled $9 billion—more than aid to all other transportation modes combined, according to the Congressional Research Service. Federal subsidies provide 43 percent of the barge industry's revenues, compared with 3 percent for railroads. In its National Waterways Study, the Army Corps recommends that $22 billion more be spent on navigation during the next thirty years. Additional billions will be needed for maintenance.

Navigation improvements by the Army Corps have been built entirely at taxpayer expense. User fees, until 1981, were nonexistent. In that year, a four-cent tax on barge towboat fuel was levied, to rise to ten cents in 1985, which will recover less than 25 percent of ongoing outlays for the dams, locks, and canals. Two-thirds of all tonnage on the Ohio River consists of coal, oil, and petroleum products, and the Federal Trade Commission reported in 1978 that four of the nation's top ten coal producers were subsidiaries of oil companies.

Dilution of pollution accounts for 8 percent of Youghiogheny Dam benefits. This is also called "water quality control." When runoff is low, increased flows from the dam dilute acid mine drainage, sewage and industrial waste. Dam planners considered this a valid purpose in the thirties, but in 1972, stopping pollution at its source became federal policy. Dilution benefits can no longer be cited to justify dams. Source clean-up can work for sewage and industry, but to counteract the Casselman mine acid, emergency releases from Youghiogheny Reservoir remain essential. Reclamation work may someday eliminate the Casselman threat, but that is years—maybe generations—ahead.

Flood control from Youghiogheny Dam helps anyone who has flood plain investments below. Owners of the undeveloped flood plain also benefited, since the dam reduced flood risks and yielded profits when previously worthless land was developed.

Youghiogheny Dam was built when the best reservoir sites were available. Most of these have now been developed, and new flood control dams are criticized as uneconomic. Since 1936 the federal government has spent more than $10 billion for flood control, but a 1966 study by the Federal Flood Control Task Force directed by the prestigious water policy analyst, Gilbert White, reported that in spite of federal spending to halt floods, damages continued to rise. The reason was that development on the flood plain went unabated: every home kept dry by the Army Corps was offset by a new house in an area still subject to flooding. Behind dikes or levees, people were lulled into a sense of security that was false and they built more homes. But in June 1972, floods overtopped a Susquehanna levee around Wilkes-Barre, Pennsylvania. Eighty thousand people were displaced and the homes of 20,000 destroyed. North of the Youghiogheny, the Army Corps channelized Stony Creek and the Little Conemaugh River in Johnstown after the 1936 flood, but in 1977, high water killed another eighty-seven people. Even below dams, residents are not as safe as they sometimes think. Pactola Reservoir was built only fifteen miles above Rapid City, South Dakota, but below the dam a deluge hit in 1972, causing one of the deadliest flash floods in the nation's history.

In the 1970s, federal policy began to favor nonstructural flood control, for example, flood plain zoning, where new construction is directed away from hazardous areas. Recognizing that the best damsites have already been developed and that new dams are too costly, President Carter in 1978 adopted water policies calling for such nonstructural measures as zoning, relocation, flood proofing, and improved flood warning.

The building of Youghiogheny Dam started in 1939 with the excavation of sandstone, shale, and siltstone in the narrow gap above Confluence. Contractors completed the emergency spillway and began the dam itself, but because materials, labor, and money were needed for the war, the Army Corps halted work one year later. Until the dam was built as high as the spillway, a major flood could have filled the reservoir and poured over the breast of the dam, destroying it. At a meeting in 1942, Army Corps officials argued that failure of the dam could cause damage as great as an enemy bombing raid. They decided to finish the job.

Confluence boomed with 500 men working around the clock,

packing 18,000 cubic yards of shale a day to finish the dam before the spring floods of 1943. They completed most of the project early that year, except for the half-mile-long Route 40 bridge that was delayed because priority on steel was given to ships and tanks.

With full operation in 1948, the dam became part of the plumbing system that keeps Pittsburgh dry during floods and water flowing during drought. It is, in essence, Pittsburgh's dam, built for the urban good, and it reinforces a fact of life along the Youghiogheny and throughout the Appalachians: to be in the mountains means to be out of the mainstream, but it also means to have resources taken away. Loggers cut trees, mainly for use elsewhere. Coal was hauled away, leaving only yellow streams of acid mine drainage. Railroads shuttled local people, but mainly they hauled out raw materials. The coke industry that thrived on the lower Youghiogheny at Connellsville was a cornerstone to the steel empire of Pittsburgh. The mountains were a colonized territory, nourishing Pittsburgh's industrial growth.

The dam is just one more chapter: through a political process and the Army Corps of Engineers, the river, the land, and two towns were permanently flooded to avoid temporary but costlier flooding of Pittsburgh and other towns. For the city's good, the government bought the land, even though there were mountain people who did not want to give it up.

If you want to see the Youghiogheny River, you can go look at it: the source at the high ridge, Swallow Falls, Sang Run and the wild river, Friendsville, Confluence, Ohiopyle, Connellsville, and on to McKeesport. For 110 of 132 miles, seeing the river is no problem so long as you can drive, walk, paddle, swim, and maybe trespass and be shot, or bit by a rattlesnake. But twenty-two of the miles are different because they are buried and there is no way to see them. It won't be long—twenty or thirty years at most—until all the people who remember the dammed part of the river are dead. What is down there under today's reservoir? What went on when that was a river and a valley?

Elsie Spurgeon, a retired schoolteacher in Confluence, used to live at Jockey Hollow, across the river from Somerfield, now under thirty feet of water. "Nobody wanted to move," she says. "Not one person. We were very happy there. It was an old town. It meant a lot to us; a lot had gone on there."

Elsie has her mind on more recent history, but the things that people did along that stretch of the Youghiogheny began about ten thousand years ago. Underneath's today's reservoir lie twenty known archaeological sites, and this may be a small fraction of them all. Indians probably forded the river near Somerfield when they first entered the area.

In 1753, George Washington passed the site of Somerfield, which explorers called the Great Crossings, just upstream (south) of today's Route 40 bridge. In 1754 he again camped at the Crossings. Because it blocked the path and forced travelers to wade, the Youghiogheny became a landmark and a challenge on the trail west. On May 18 Washington wrote, "The waters being yet very high, hindered me from sending forward my men and my baggage wherefore I determined to set myself in a position of defense against any immediate attack from the Enemy, and went down to observe the river."

Washington was one of the earliest (perhaps the first) white men to canoe down the Youghiogheny. He explored the river because he thought it might offer the easiest route to Pittsburgh. On May 20 he wrote: "Embarked in a canoe with Lieut. West, three soliders, and one Indian; and having followed the river along about a half a mile, were obliged to come ashore, where I met Peter Suver, a trader, who seemed to discourage me from seeking a passage by water; that made me change my purpose of causing canoes to be made; I ordered my men to wade as the water was shallow enough, and continued myself going down the river. Now finding our canoes were too small for six men, we stopped and built a Boat; with which, together with our canoe, we reached Turkey-Foot." The account is confusing. Parts of Washington's journal may have been omitted or incorrectly translated after the book was later left at Fort Necessity and confiscated by the French. But it appears certain that Washington canoed from Great Crossings to Turkey-Foot—the site of Confluence. Then beyond.

The Somerfield-to-Confluence section, now dammed, was probably similar to the Youghiogheny below Friendsville, where the river runs in quick riffles, tightly shaded by beech, hemlock, and sycamore. Washington would have seen rocky mountainsides alternating with broad flood plains that were later farmed.

He paddled around Big Bend—halfway between Somerfield and the dam. Here is the largest, widest expanse of water in the reser-

voir, but until 1943 it was a gravel-bottomed stream making two bends through meadows encircled by mountains. On topographic maps, it appears that the Youghiogheny's Victoria loop, downstream between Confluence and Ohiopyle, is almost a carbon copy of the submerged Big Bend.

In June 1755, Washington again forded at the Great Crossings with General Braddock and his army. Captain Robert Orme wrote, "The 24th of June we marched at five in the morning, and passed the second branch of the Yoxhio Geni, which is about one hundred yards wide, about three feet deep, with a very strong current." After their defeat on the Monongahela, Braddock's survivors retreated, and on the day the general died, his men crossed to the eastern bank of the Youghiogheny where they cached supplies, probably near today's Somerfield marina, so that the wounded and stragglers would not starve and die on their return to Cumberland.

In 1912 the Flood Commission of Pittsburgh described the area: "From Friendsville to a point several miles beyond Confluence, the valley widens considerably, and the stream, for the greater part of the distance, flows in level flood plains, which are in pasture or cultivation and alternate from side to side." The 1931 topographic map shows the river winding more than it does below Friendsville or Confluence. Farmers worked many stretches, especially the flats at Horseshoe Bend one mile above today's dam, and at Big Bend. Army Corps records list 1,000 acres cultivated, 430 pastured, and 1,300 wooded. Dirt roads and the Confluence and Oakland Railroad followed the shore to Friendsville.

Some of the region's pioneers settled along this stretch. Captain Evan Shelby, in 1769, started Shelbysport, Garrett County's largest town until after the Civil War when the railroad spurred Oakland to prominence.

Another early settler was John Potter, who left New Jersey in 1787 and settled on the west side of the Great Crossings at Jockey Hollow. Potter family lore says that he was a captain in the revolutionary war and rode in Washington's boat during the crossing of the Delaware on Christmas Eve, 1776. How Potter discovered the Youghiogheny site is unknown. Maybe he was traveling west, stopped to dry his clothes after fording the Youghiogheny, and stayed. Or maybe soliders who had been across Braddock's Road twenty years before during the French and Indian War told him about the beautiful, isolated valley.

Potter operated a distillery near the Youghiogheny, served as justice of the peace, and in his log cabin he housed travelers, including soldiers dispatched to quell the Whiskey Rebellion in Uniontown. He wrote a 251-page book published in 1820, titled *An inquiry concerning the most important truths, namely: what God is—where he dwells—what that knowledge of God and Christ is, which is life eternal: what the atonement is, and for whom made: how an interest therein is obtained, and respecting predestination and the Methodist doctrine concerning it.* Potter had four wives (three died before he did in 1826) and nineteen children, eight dying as infants.

Potter built a Youghiogheny bridge which was burned after someone dumped a barrel of tar on the wooden deck and struck a match. No one knows the motive. A three-arch stone bridge was built in 1818, north of today's Route 40 crossing. Under the reservoir's surface, the stone bridge still stands, and when the Army Corps drops the water to a very low level, the old relic appears like a muddy spook from John Potter's days.

In the late 1700s Jockey Hollow had nine houses, a store, a blacksmith shop, and Flanigan's Tavern on Braddock's Road. Nearby, John Piper laid out a racetrack, which may be where the name Jockey Valley came from. A flour mill stood there, though the first in Henry Clay Township was near the mouth of Tub Run, now underwater near the Army Corps's Tub Run recreation area. In the 1930s, a dozen or more families lived here. Today, the Jockey Hollow picnic area sits at the reservoir's edge.

Somerfield, on the east side of the river, was founded by Philip Smyth in 1818 and was first called Smythfield. Being on the National Road (which became Route 40 in the 1920s) the community prospered. "It was a great little town," Elsie Spurgeon says. Her father ran a store in Jockey Hollow, and Elsie began teaching school in the 1920s. "There was the McCullough store and Jim Hook's store," she says of old-time Somerfield, "and a Methodist church, drugstore, and garage. The Great Crossings Inn was there, and so was the Cornish Arms, which was a noted hotel." President William McKinley vacationed there during several summers. "In the twenties there was a new school where I taught, and a bank that closed in 1929 with the crash. Dr. Jacobs's old flour mill was there. There must have been a hundred houses, and they were nice. It was nicer than Friendsville and the houses were bigger. No shacky places like you can find in Confluence. Senator Endsley's house was

there, and Bob Augustine's house was a mansion. The Confluence and Oakland trains stopped, and when I was real young I remember people would come to town with wagons and teams of horses, and they'd load lumber onto the trains. It was quite a busy place.

"We had a rope swing below the bridge, and there was a deep hole where a few people drowned over the years. There were some shelters on an island where we'd have picnics, and on up river there were Presbyterian and other church camps. Then farms like the Colyer's and Glover's and others went clear up to Friendsville, and we figured it would be that way forever."

While Elsie Spurgeon knew the Somerfield area of the old Youghiogheny, George Groff, another retired schoolteacher in Confluence, knew the lower end. "Kids from town would walk up there all the time—up the dirt road, then duck down over the bank to the river. There were swimming holes and deep fishing holes: the Hanna hole, Flannigan, and Flat Rock hole. It was quite a bass fishing stream. I remember a twenty-two-inch smallmouth I caught. Later on I took gangs of kids up there and we'd camp a few weeks every summer and live on fish. We'd pole a flat bottomed boat—it was shallow with gravel, but had deep holes. There were no steep rapids anywhere up there, not even at the dam site. We'd stay at the old Hannah place, a big Victorian farmhouse that the Clouses owned. There was a Tiffany lamp in there four feet around and I often wondered what happened to it. There had been log booms at different places—chains of logs in the water where they'd catch timber as it came floating down the stream. Then they'd pull it out and cut it in the sawmills.

"Back before my time, excursion trains from Pittsburgh would come, and guys from the livery stable in Confluence would meet people and take them to the river up above the dam. There were farms along some sections. The river bottoms are the good farming areas around here with soil that washed off the hillsides, six feet, ten feet, even deeper.

"The first I heard talk of the dam was in the thirties. Men would sit in my Uncle Dokie's store and talk about it. Eventually someone would say, 'Ah hell, they'll never build it.' J. Buell Snyder was the congressman in Washington, and he's the one who pushed it. He was a Democrat, and up here it's three to one Republican. People up here didn't want it. They didn't like being run out or told what to do. You know how people hate changes anyway. I never heard of

anybody opposing it though." These people were unlike the West Virginians whose objection to the West Fork dam caused the Army Corps to look elsewhere.

"People just resigned themselves to it," George continues. "The last time I was up there with a bunch of kids, we weren't really thinking much about the dam. We were thinking about the war. We were concerned about the draft."

Elsie Spurgeon's family thought about the dam because they had to move. She recalls, "Neighbors would come over and gather in my dad's store and some would say, 'There's going to be a dam and they're going to take our houses,' but most people thought that was the weirdest thing and that it would never happen in our times."

Country store skeptics in Confluence, Somerfield, and Selbysport declared, "They'll never build that thing," and they would have been right, but then the flood of 1936 made this project a pushover. Because of the Depression, and the floods, and the war, decisions came rapidly. Action was the priority, and in two years the Army Corps designed the dam and began construction—a process that now takes at least a decade.

Elsie continues, "Next thing we knew, the government came in making arrangements to buy all the property. Some of the business people downtown held out for more money, but most took what they offered. No one tried to fight it. In these little towns there isn't enough push to retain anything."

"The old country boys, they didn't organize like they do today," George Groff reflects. "If that was today, someone would get ahold of it. Times have changed."

Elsie says, "The worst of it was that it came during the Depression. The bank closed and Dad lost his money. The Army Corps of Engineers bought our house. It was close to Christmas time and my brother came in and said they declared war and it about killed us because I had three brothers. Those things all happened about at once."

The Army Corps listed acquisitions of 115 buildings in Somerfield (population 142) and Selbysport (population 150), 8 mills, 20 stores, 77 farm buildings, 25 cottages, 3 schools, 4 churches, 7 "oil" stations, a camp, hotel, theater, and 185 graves. For farmland they paid $55 to $100 an acre, for woodland $35, and for town lots, $600 an acre. This was before government relocation assistance: the Army Corps bought the homes and the locals were left scurrying for cover.

In Pittsburgh—below the dam instead of above it—the outlook could not have been more different. Enthusiasm ran high. A headline in the *Pittsburgh Press* on December 29, 1943, said: "Gigantic Youghiogheny Dam at Confluence Completed, 9-Million-Dollar Flood Control Project Cuts 17-Mile Swath Through Somerset County." The reporter wrote, "Today the great dam stands as a monument to the ingenuity of Army engineers."

"We didn't visualize the water at all," Elsie recalls. "It was the breaking up of the town that we thought about. We were very close, and then people scattered like the wind. Eight or ten families came here to Confluence, but it was hard to find housing. Some went to Addison. Some to Uniontown. Jim Hooks is in Connellsville. The people who owned the Great Crossings Inn are in Florida. You hardly ever see any of them now, except when there's a funeral of someone from Somerfield. Then it's a homecoming."

I ask what she thinks of the dam today.

"It's sort of a blessing. It could have been selfish to try to save our homes. The dam slows down the floods now, and people from all around come here for recreation."

The Army Corps of Engineers reports that 1,122,589 people visited Youghiogheny River Lake in 1980. Three hundred motorboats are moored at the marina which floats above old Somerfield foundations, 500 motorboats are tied at 101 private docks around the lake, and many more boats are shuttled up for weekend use only. The Army Corps says that "boaters consider the Youghiogheny the best power boating and waterskiing lake in western Pennsylvania." Corps data show that of fifteen dams in the Pittsburgh District, Youghiogheny ranked first in numbers of water-skiers, second in boaters, third in fishermen, and fifth in total use.

Youghiogheny Reservoir is so busy that on weekends there are only 6.5 acres of water to a boat (there are 2,840 acres total in the summertime pool). "Optimum" density is considered 8.5 acres, which means that the lake is crowded. The Army Corps does not encourage more motorboaters, and will not expand the three public launch areas.

Fisherman also flock to Yough Lake, known for its walleye and smallmouth bass. Other species are the northern pike, tiger muskellunge, largemouth bass, and fish that anglers brag less about: the northern hogsucker, black crappie, channel catfish, golden shiner,

white sucker, carp, and minnows. Yet the Army Corps reports that the reservoir is not highly productive. Corps ecologists use the term *oliogotrophic,* which means low in nutrients, or infertile. They say that the fluctuation in pool levels is an "adverse influence" during fish spawning periods and prevents the growth of weed beds. With few plants, insect life is sparse, and without insects to eat, fish are few and stunted. Most fishing is done from boats on weekdays, since the banks of the reservoir are muddy, steep, and without access, and on weekends the lake is busy with water skiers. Swimming is popular at the Somerfield and spillway beaches. Three campgrounds fill up during weekends, June through August.

In its 1979 Master Plan Update, the Army Corps says that recreation demands exceed capability. "The Youghiogheny River Lake project has extremely limited potential for accommodating additional recreational facilities because of site constraints including steep topography, poor soils, limited land between the lake and the government property line, limited access opportunities and other factors." In other words, the lake is about as popular right now as it ought to get.

Many landowners around the reservoir cut their timber, then sold lots to visitors who had discovered the lake and wanted a piece for themselves. Along with motorboats, cabins proliferated. Hundreds, owned mostly by Pittsburgh area residents, dot the mountainsides. People come for vacations, summer weekends, and for hunting in the fall.

Red Jordan was one of the first people to come here for fun. "Thirty years ago a friend and I had a motorboat that we'd put in at Somerfield," Red recalls. "We had one of those surfboard saucers that you pull behind, and we'd go out in that thing all summer long. We put a chair on it and stood up. We took it out one day when it was snowing. Big army coat overtop a life jacket that'd float you from here up," and Red draws a line beneath his bushy mustache. "We were crazy."

Red is now gray but still crazy. He is a retired plumber with arthritis, but he lives at his Big Bend cabin until the snow flies. He likes it better than his Monongahela valley home at Elizabeth. He doesn't do much; doesn't need to. Red has mastered the art of relaxing and takes it easy, either alone or with his wife, Aggie.

His cabin—small and warm, white frame with red trim—arrived in large pieces. It had been built up near Sugarloaf, above Ohiopyle.

"But the kids liked it here. They liked the lake," Red explains. In the family, the kids enjoyed a lot of jurisdiction; there are five of them. The Sugarloaf house cost fifty dollars. "I had thirty-five and told the owner, 'I'll pay you the rest next week.' " Red cut the dwelling in two and hauled it on a flatbed truck to this mountainside. For two years he improved it. "Those windows—they're from a church. But those ones—they're from a bar. You can see through 'em all. That redwood—I took that off a house back home, and that pipe—that was left over from a job. Didn't spend five hundred dollars on the whole thing." For twenty-seven years the cabin has been the site of good times at Youghiogheny Reservoir.

When Red, Aggie, and their children first came here, they didn't have a boat club membership, and at Big Bend, you are nobody if you are not a boat club member. You may not moor a boat, nor may you set foot on the dock, and the only alternative is a quagmire-shoreline. You must be *on* the water to enjoy it. "We went down swimming," Red says. "The kids wanted to jump off the dock and I couldn't blame 'em. A sign said Members Only, but the kids begged, 'Just one, Dad.' I finally agreed. 'Okay, just once.'

"Right after they jumped off, somebody on the hill yelled, 'Get to hell outta there.' I looked up but couldn't see anybody. I said, 'Hey kids, take another jump,' and the guy somewhere up the hill yelled, 'Get to hell off the dock or I'll come knock ya' off.' So I said, 'Hey kids, you wanna jump again? Well jump again.' Then I yelled back up the hill, 'You come on down and *try* to knock me off this dock!' " That's the way it was in the early days at Big Bend. Red joined the boat club as soon as he got a boat.

For twenty years, Red never knew who had threatened him for his trespass. Then in 1974, only one day after he retired as a plumber, he walked down to the dock. "All the sudden I was hit with this attack of pain so sharp I couldn't stand it. I passed out. Hell of a way to start retirement, isn't it? It was the arthritis but everyone thought I had a heart attack. As I came to, I could hear voices, like they were real far away. A woman was crying. Couldn't see anybody. Just a fog. Then there was this voice that finally came clear. It was Loftus saying, 'Hey Red, ya think ya can still punch me out?' "

Red has proved that even with stiffening arthritis, he can have fun. It only requires special planning. For example, several of the Jordan children—now adults—arrived with a motorboat in tow for a weekend of water-skiing. Rather than have Red walk to the dock,

the team of sons reasoned it would be easier for him to board the boat at the cabin, ride in it on its trailer down the rocky hill, and sit there while his capable red-headed children backed the trailer into the lake and launched. Red agreed, "I guess so." All went smoothly until the critical moment when the trailer entered the reservoir and the boys lifted the front end. The boat—with Red on board—would not slide backward into the lake. It was stuck. Only by rocking the trailer up and down and giving their father a disrespectful mechanical-bull-ride did they finally wrench the craft free. The kids have inherited Red's sense of humor: "Isn't it awful how old people are treated these days," one son commented while his brothers huffed and puffed with the trailer and Red clutched his plumber's hat and fumbled for a handhold.

People like the Jordans visit the reservoir all summer to ride motorboats, water-ski, swim, fish, and escape from the day-to-day of wherever they are from. Many are escaping from the heat and the crowded mill towns along the Monongahela and Ohio. It is easy to see why they enjoy the place, and it is easy to see why they leave in the fall. The road into Big Bend is steep, narrow, and rough in one of the most snowed-upon regions of Pennsylvania. The power fails. Nobody is around. The lake is drawn down for spring floods when Pittsburgh's dryness depends on empty space in the reservoir to catch runoff. Like residual soap in a half-drained bathtub, a wide mud ring encircles what remains of the lake, and by nearly anyone's standards, it is ugly. The festive, vacation atmosphere of summer is replaced by an icy silence. People staying for the winter must be ready for the hardships and isolation.

The Hutchinsons are the only people who live year-round near the lake at Big Bend. Bob is in his seventies; Evelyn, her sixties. Bob has had a heart attack; Evelyn has a bad hip, but she is recovering. She began swimming in the lake only a month after her operation. They own a four-wheel-drive vehicle with a snowplow; Bob is the Big Bend road crew. Their water supply comes from a spring; their heat from a wood-burning stove with electric backup. They keep a CB radio but can reach almost nobody from their sheltered mountainside.

Bob is a Youghiogheny native. His relatives were among the first settlers along the lower river near Dawson, below Connellsville. The sixth generation still farms there. Bob first discovered this part of the river as a child. "The bass fishing right down there was the

best," he says, pointing to the lake, to what used to be the river. Spiker's Hole was his favorite.

Evelyn also traveled to the Youghiogheny in the early days. "When we were in high school down at Brownsville we'd come up to Somerfield and go out on an island for picnics and to swim," she recalls. "It was nice, but now more people enjoy it with the lake."

When the dam was being built, before the United States entered World War II, Bob piloted B-25's across the ocean to Britain. He worked on development of the atomic bomb in Los Alamos, New Mexico. He also worked as a highway engineer and a commercial airplane pilot.

In 1948, while living at Brownsville on the Monongahela, the Hutchinsons bought their cabin at the reservoir so they could get away, so their children would have a place to play. Bob and Evelyn moved here full-time in 1975, but they have yet to retire. Bob sells heavy hardware, driving to businesses, mining companies, and construction outfits throughout southwestern Pennsylvania. This couple doesn't stay at Big Bend because of convenience, but because they like it. Evelyn says, "I'd go crazy in town, nothing there to look at. Here I have the woods and the birds and raccoons and deer that come up in the yard. The kids love to come back in the summer and water-ski. This is a place where we can all get together."

The reservoir divides the Youghiogheny. Above, it is Maryland's river; below, Pennsylvania's. The Mason Dixon line, surveyed in the 1760s and later the demarcation between North and South, crosses the reservoir above Somerfield, and it divides more than the jurisdictions of states. People of the upper river travel to Oakland, Cumberland, and Baltimore; lower residents to Uniontown, Connellsville, and Pittsburgh. The river is mostly uncontrolled above, but below the dam, the Youghiogheny is governed by the gates in an eighteen-foot tunnel that enables men to turn the water on and off like a spigot.

The dam divides the river, and it also divides people. There are those one know the Youghiogheny only as a reservoir—as a place to motorboat and water-ski. Others know the Youghiogheny only as a river—a place to canoe, kayak, or raft, a flowing waterway. A few people know it as both. My brother, for example, water-skis at Big Bend, and he canoes and kayaks in the whitewater. But he is rare. Most people prefer either the lake or the river.

On a quiet weekday in the summer, I paddle my canoe out onto the reservoir. I practice bracing and cross-stroking. It is mainly exercise that I am after. Along the shore, mud clouds the water, but ten feet out it is clear, metallic green where the hillside falls deep. Rain is coming. The wind picks up and dark triangles of waves reflect the sky's silver. I get the urge to paddle, so I stroke far from shore. In a canoe, you sit low on the water; you can feel as much in it as on it. The expanse of Big Bend suddenly seems huge; it engulfs me. I look around and enjoy the sensation of a vast circle of water. I accept the reservoir for what it is, for the good that it does, but my mind drifts back in curiosity about what was here; about how we have changed this piece of land, about the river and the life than ran 100 feet below where I float.

What is down there today is a lot of mud—four feet deep in much of the reservoir. Each year, 197.8 acre-feet of mud settles to the bottom. In thirty years mud has totaled 5,935 acre-feet, taking up 2.34 percent of the reservoir's space. At the end of 100 years (the projected life of the dam for interest-payment purposes) there will be 19,780 acre-feet of mud, thirteen feet deep, according to an Army Corps study in 1975. If the dam lasts long enough, the lake will eventually fill with mud.

As reservoirs go, this one is okay. It lessens floods by half a foot in Pittsburgh, dilutes acid mine drainage, and raises the flow for rafters. But I feel no magic in the place. People have fun here—so do I—but I feel no power or fascination for this big valley gorged with water that is stored and released according to those graphs in Gene Amocida's downtown Pittsburgh office.

Anybody who worships nature would pay homage someplace else, and people who worship material things would go someplace else, too. Maybe to the upper Ohio Valley, which is what this dam is for. By building the dam, we were able to improve upon Pittsburgh, since it was built on the flood plain, but this place did not need improving. This part of the Youghiogheny would have suited me fine when George Washington canoed it. It seems that the place has vanished forever.

This dam is the closest thing to permanent that has been built along the Youghiogheny River. The dam will last hundreds or thousands of times longer than houses, bridges, or roads. Sections of the Pennsylvania Turnpike, abandoned in the 1960s, are already yielding to poison ivy, blackberries, and sumac. It will take longer for

the dam to disintegrate, but it is not really permanent. It requires upkeep all the time. In 1981 the Army Corps fixed the eighteen-foot-diameter tunnel. The original concrete walls were wearing out, so they were replaced with stainless steel.

It strains our imagination to think of things collapsing, but looking into the deep waters of the reservoir, my mind wanders off in that direction. Scientists say that the earth is 4.75 billion years old, and that many mountain ranges have come and gone. The rocks around me are 500 million years old. If this were represented by a string 500 feet long, written history would occupy only one-tenth of an inch. People have lived along the Youghiogheny for only 10,000 years.

Modern technological society is just over 100 years old, already showing the ability to self-destruct, showing a death-wish to outdo an Ohiopyle Falls kayaker. What we regard as permanent may be only a blink of time in the larger scheme of things. All things considered, we may not survive as long as the dinosaurs, which we hold up as one of nature's inventions that did not work. They roamed for 135 million years, compared to our two or three million so far. Society as we know it will probably fall into ruins, and when it does, nobody will take care of nuclear waste dumps, and nobody will take care of Youghiogheny Dam and Youghiogheny River Lake.

Even though the outlet tunnel is shiny stainless steel today, it will eventually collapse or will fill with rocks and waterlogged timber. But the river will keep running, and with no outlet, the reservoir will fill to the brim in a rainy year or two and all the water will exit over the emergency spillway. Then in a few years, maybe less, the 17,000 cubic yards of cement that protects the dam and makes the spillway smooth will crack, and chunks of it will break out like the potholes that infest the roads of western Pennsylvania. Picture, for a minute, the full flow of a flood-stage Youghiogheny screaming over that spillway and plucking slabs of concrete from the water's spectacular path. Ten-foot chunks will be tossed like toys. In no time, the river will begin to slice into the heart of the dam itself, and from that moment on, the dam's days will be few.

Maybe a few years from then—maybe 1,000—the river will wear its channel deep, rolling the Army Corps rocks like dice downriver and digging a slot in the 184-foot pile built during a forgotten World War II. Like the river's cutting of the mountains, it will cut

the dam, only this dam will be cake. It is, after all, nothing but loose rock and dirt, compacted only by a contractor's earth roller; not by the eons. The dam will not go one grain at a time the way the Pottsville sandstone goes from Backbone Mountain. The dam will go in hulking chunks. Someday there will be nothing but an exciting rapid 1.2 miles above Confluence, and above there, the bass will be superb and the riverbottom soil rich, and if any natives are around, there may even be a ford across the Youghiogheny at the Great Crossings, the way there was for almost 10,000 years.

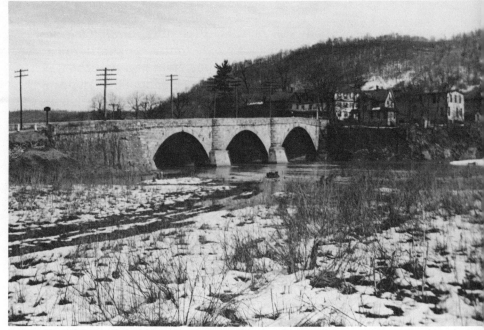

Route 10 and Somerfield before flooding by Youghiogheny Reservoir

Ceremony celebrating a survey for a flood control dam, Somerfield, 1938

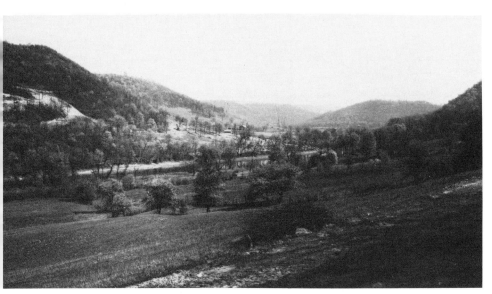

Youghiogheny above Confluence, before dam construction, 1941

Old foundation at Mill Run, Youghiogheny Reservoir

George Groff

Water skiing, Youghiogheny Reservoir

Eleanor Augustine at Viola's Restaurant

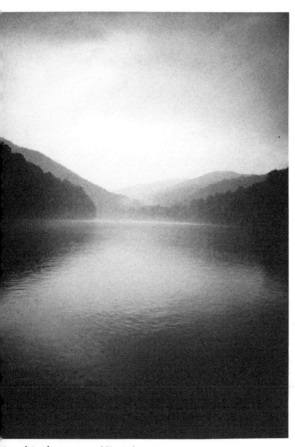

Fisherman at Confluence

Youghiogheny near Victoria

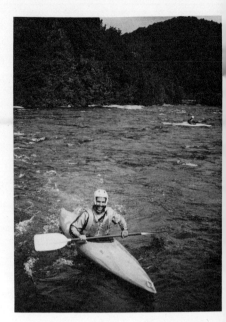

Kayaker John Lichter at Drake Rapid

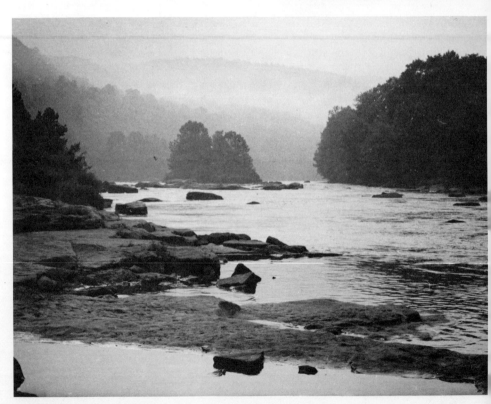

Youghiogheny above Ohiopyle

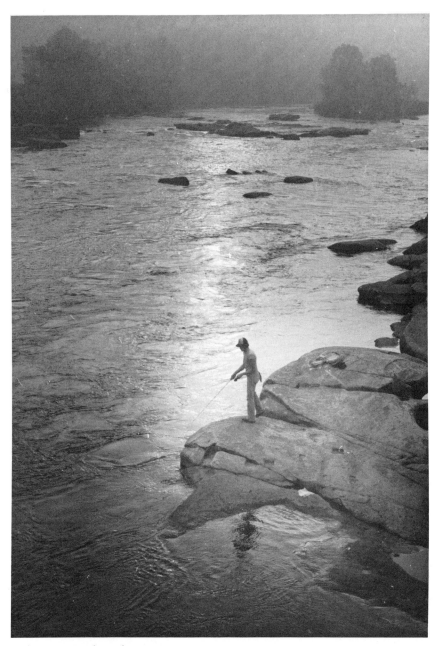

Fisherman at Ohiopyle

The Confluence

A *long the* river, below the dam, the first house belongs to Jim
Prothero, who bought it in 1977, soon after he was married.
For all he knew, the town of Confluence was going to be home
forever.

There is a certain animation about Prothero: he will point,
scratch his head, tilt back his cap, cross his arms, clap his hands,
shrug his shoulders, and laugh loudly. People enjoy his company.
His smile covers his face and pinches his eyes almost shut. During
his guiding days, some people called him "Smiley." He is quick to
laugh, and, without trying, good at getting others to join him. He
can lighten friends' loads and make strangers comfortable.

Prothero is as blonde as a Swede, his hair—just noticably thin in
front—is two inches long and always rustled by the wind or dishev-
eled for some other reason. A few of his grin-wrinkles at the eyes
are permanent, and his forehead easily furrows. He is thirty-one.
Unlike a typical river guide, he works indoors too much for a tan in
1981. About five-foot-ten, he stands solid and muscular, heavily
built but not fat. He always wears glasses, and usually a cap. He
carries coffee around in a thermos, smokes cigarettes but tries to
hide them, and to his oatmeal he adds sugar but calls it "white
death."

In 1977, Prothero came as a newcomer to Confluence, but he was
no stranger to the Youghiogheny. Since 1973 he had been working
for a rafting company called Mountain Streams and Trails in Ohio-
pyle, twelve miles downriver. He guided raft trips, but more impor-

tant to Ralph McCarty—the company owner—he maintained the equipment and buildings. For this he was qualified, having grown up in the Prothero Electric Company of Beaver, thirty miles northwest of Pittsburgh, and graduated from Pennsylvania State University in architectural engineering. He could wire, plumb, build, and in general take care of things. He put these skills to work while still paddling on the river a few days a week when he could splash around, be a showoff in his kayak, meet girls, and watch the scenery.

Several things led him out of Ohiopyle. There was the ordinary burn-out; guides seldom last longer than three or four years. There was a disenchantment with Ohiopyle itself and with the crowds of people that came to run the rapids. "It was a rat-race down there," Prothero says. "Millions of people, the money makers living off the thrill seekers, eighty customers a trip and you had to keep them moving. Few people had much in the way of roots or ties to the place.

"I liked working on the river, but Ohiopyle got to be a dead end. At Mountain Streams and Trails we had a lot of bosses, a lot of experienced guys. Ralph McCarty owned the company and his son, Mark, managed it when he came back from Vietnam. Fish [Bob Seiler] took care of scheduling the guides, and Al Davis had been around a long time too. Too many chiefs, and you knew you'd never move up, because Mark was there, and Mike—his younger brother—was coming right behind him."

Then came his marriage. Cindy had worked in the gift shop at the Falls during her last summer in high school. A few years later she returned for a river trip, met Jim Prothero, and eventually stayed. They lived in a cabin outside Ohiopyle: wood stove, snowdrifts, water from a spring, an outhouse, and a frigid winter. Cindy had always been a city girl, a Pittsburgh girl, and the changes didn't come easily. Later she became accustomed to country living, but the cabin was a bit much. They looked around for something else.

Prothero wanted a river business of his own, and in those days he did not have to look far. The Youghiogheny above Ohiopyle is one of the better beginner and intermediate canoeing rivers in the East, especially during summer when other streams dry up. The twelve miles from Confluence down is the right length for a one-day trip, but also long enough for two days if you go slowly, hike, and look around. No road follows the river. After the first three miles, no houses remain because both sides are Ohiopyle State Park. Class II

rapids are excellent for the intermediate paddler and, except in high
water, are not too hazardous for a beginner with some experience.

In 1977, few people had discovered this reach, now called the
"middle" Yough, but Prothero could imagine more coming; in ad-
dition to the river being so suitable, Confluence is near Ohiopyle,
which had become the most popular whitewater boating site in the
nation with park visitation of more than one million in 1977 (2.3
million in 1980). Yet few canoeists were experienced enough to run
the difficult rapids below Ohiopyle. A canoeing business on the
gentler middle Youghiogheny seemed to be a sure thing.

Jim had only been to Confluence once or twice, but Cindy
worked near Ohiopyle at a rehabilitation center, and while taking
boys to the doctor's office in Confluence she noticed that the two-
story house across the bridge from town was for sale. Lance Martin
and Wendell Holt, who own rafting companies in Ohiopyle, had
looked at the property but decided against buying it.

The Protheros bought the house and nine acres for $40,000 and
moved in. Cindy filled the place with antiques that they bought at
auctions all over the mountains. She intended to open an antique
and crafts shop. They worked out plans to remodel the house.

The typical river-thrills trip was not Prothero's idea. He wanted
to get people down the river, but also to create new opportunities,
to offer a program that would lead to something more for the
customers. He saw his section of the Youghiogheny as a place for
discovery, a place for people to begin doing their own river trips,
and he named his business River Path.

The beginnings were modest: Prothero bought twenty-five canoes
and rented them for $20 a day. He planned to develop facilities and
skills for additional programs, but the status of these remained
somewhere between a dream and a plan. As a profit-making river,
the middle Youghiogheny had potential, nothing more. Remember-
ing his first summer, Prothero says, "There was some money com-
ing in, but a lot of money going out. Those canoes didn't come
cheap, and one drive over the mountain to Ohiopyle to shuttle the
customers back cost ten dollars." In 1978 he made $3,000 and
spent $15,000. Only a family-backed loan sustained cash-flow.
With enough business, plus an instruction program and an equip-
ment store, River Path might pay its way, but that would be some-
time later.

To make ends meet, Prothero started a contracting business, "Do-

ing what I knew how to do," he says. He bought more tools and equipment, hired some help, and went to work building and remodeling houses near Confluence. He always had jobs, but between the two businesses he labored sixteen hours a day, always pushing. "That's what I thought you were supposed to do," he says. "My dad had always worked that way; when you have your own business, you work until things are done. If somebody called during the middle of dinner and said their furnace broke down, I went to fix it. Looking back, that's not the way I'd do it again. Now I'd wait until we'd finish dinner."

He was doing hundreds of things for the first time: hiring men, framing a split-level house, doubling insulation, mulling over tax forms. Sometimes he would lose money on a job and see all that time spent for nothing. He would fall asleep at his desk when he tried to work up estimates at one o'clock in the morning. It was a lot of labor and pressure. Partly because of this and maybe due to other things, the Protheros split up.

Jim sat in the old house with twenty canoes chained to the fence and orders for two houses to build. "It throws you for a good one," he says. "Everything I had planned on was gone." The first week after the breakup, Prothero assigned his crew to gut the house. They tore out the interior walls and ceilings as preparation for remodeling, though Prothero knew that the future floor plan would be different from what had been considered. He landed more contracting jobs and rebuilt houses in Uniontown.

"I wanted to see if I could make it in the real world," Prothero says, the "real world" being something other than the river. He had grown up building things; doing that was the reality of life. He was also living in a community where the basics are the important things; in Confluence, the essential things count, almost to the exclusion of everything else. Does that mean that river trips are too frivolous to be a part of the "real" world? Is the real world made of nuts and bolts, of keeping the truck running and the roof watertight, or doing work that people have to have done—work that they are more willing to pay for than canoe trips? Prothero was not the only river guide to ask these questions, nor the only one to resolve them—for the time being—on the side of tradition, work ethic, money, and security.

Staying in Confluence didn't feel right anymore. The place was too rural, too remote to make it on his own. To go so far out, it

seems that most people need a partner. There is too much work for one person and not enough play. There are no support groups, and few young adults. In Confluence, family life is the big thing. This town could be a good place for a couple or a family, but for a single person it is lonely.

In the summer of 1980, Jim's father talked to him about the electrical business. The Prothero brothers, sisters, and cousins had no interest in inheriting the company, successful though it was. Would Jim come back to help run the business? A career and a steady income waited for him, and it looked better than living alone, scrambling for building contracts in a depressed housing industry in the most depressed counties of an economically declining state. It was hard to leave the river, but harder to stay, so Prothero returned to Beaver. He did not give up the river business; he still did what he could to keep that dream alive.

Every Friday night from May to September he drove up to Confluence, two-and-a-half hours. He rented canoes, repaired gear, ran shuttle, then returned home at midnight on Sunday. Even with marginal attention, the business began to flourish. It paid the bills but no salary.

While all this was happening to Prothero, Jim Wilson taught high school shop in Washington, Pennsylvania. Like Prothero, he traveled to the Youghiogheny on weekends, but his reason was to catch trout. After fishing at Yough Dam four or five times, Wilson began to wonder what was down below. While driving over Sugarloaf Mountain from Confluence to Ohiopyle, he pictured the river in that lonely gorge, parallel to the road but two miles away, inaccessible. He imagined twelve miles of trout pools, and curiosity got the best of him. The next time he went to Confluence, Jim Wilson rented a canoe from Jim Prothero.

The fishing wasn't bad but the paddling was excellent. Wilson rented again, stopping to talk with Prothero for half an hour, and at the end of the day, helping him load boats at the take-out. Wilson, whose marriage had also recently dissolved, returned to do odd jobs at the River Path house.

Early in 1981, Prothero suggested that Wilson become manager of River Path. He had the seasonal freedom of a school teacher and could stay in Confluence from June through August. So it was agreed that Wilson would take care of the place and rent canoes seven days a week instead of Prothero's two. Prothero provided the

land, house, and equipment; Wilson invested his time as manager. They agreed to split any profits. With Stoney's Beer bottles in hand, a leaky raft exhausted on the lawn, and a pile of house-remodeling rubble out back, they laughed loudly at the prospect of money.

Prothero was already an accomplished open canoeist, and Wilson became one. There were days when they finished the last shuttle from Ohiopyle to Confluence, then tied Blue Hole canoes on top of their cars and drove to Ohiopyle to run the Loop (a 1.7 mile section of the river with good rapids) at nine o'clock. "You like to paddle in the dark?" I ask, and Prothero says, "With five shuttles on Sunday, that's the only time we *can* do it. You get good night-vision and good ears." For a stunt, they both Eskimo-roll their canoes— they roll the boat upside down, stay in it underwater, then roll it back upright with the use of their paddle.

Prothero and Wilson have combinations of talents. Wilson is a craftsman on a small scale. He rebuilds the wooden gunnels of the River Path fleet and repairs paddles. Prothero is a builder. He will reconstruct the house into a shop, office, and living quarters. Eventually.

Prothero has a way of talking that makes people feel at home. He answers the telephone, listens for awhile, then asks, "How much experience do you have?" He listens, then says, "Sounds like what you need is a pound of confidence. We can fix you up with that. . . . Yeah, we'll give it to you when you pick up the canoe." You can get more free information and advice from Jim Prothero than from a preacher, although the advice is vastly different. He will stand in the lawn talking to somebody for twenty minutes about canoe design.

Wilson is a teacher, and it shows. When he starts a group of beginning canoeists, he talks for fifteen minutes on technique and safety, covering everything important. Most rental dealers just take your money, require you to sign a waiver in case you die, then point to the river. When Wilson rents to a group of beginners during high water, he paddles along as a guide, for no extra charge.

Prothero's and Wilson's dream is for River Path to become an outdoor center. They have started a school for canoeing and kayaking. They would like to guide paddlers on other, little-known rivers, and in 1982, they offered Casselman trips for rafters. Someday they hope to begin overnight expeditions where people can get more of a feel for river traveling. "Let's see what else is there besides thrills," Prothero suggests.

"We want to be more than a rental shop," Wilson says. "We want to help people and to have fun doing it. Over on the Delaware there are outfitters who rent twelve hundred canoes a day, but they forget how to hold a paddle. It's nothing but a business. We don't want that to happen here." Yet they know that if one of the big outfitters in Ohiopyle wanted to try, it could start a giant-rental program at Confluence. "With their mailing lists and promotion and bucks, they could blow us right out of the water," Prothero admits.

Prothero came up here to escape the commercialism of Ohiopyle, but it could catch up to him. What would he do then? "The minute it becomes crowded like the lower Yough or the Cheat, my reason for coming here is gone. Maybe we'd have to go find a new river." He requires elbow room; he needs to get away. But Jim Prothero is an enigma. He wants to leave the crowd, yet his business depends on a certain amount of crowd. It is a contradiction, but then, this river and its people are full of contradictions. Prothero says, "Some of us have tried the idea of living in a cabin where you don't see anybody. That doesn't work. Crowds of people don't work either. There's something in between those two."

One of Prothero's goals permeates the modern recreational Youghiogheny: the re-creation of discovery and adventure, over and over again in the same place. He says, "We can't go off and run the Amazon. Close to home, we have to learn how to enjoy and experience places, and to somehow do that without ruining them."

Like Prothero's house, the rest of Confluence is old, and it, too, is somewhat gutted. One generation ago there were five hotels. Only the Dodds Hotel remains, housing older men as long-term renters. Elsie Spurgeon says that two of the best general stores of the region were here. "Confluence had shops of all kinds," George Groff recalls. There was a small hospital and a bakery where they sold fresh bread Monday through Saturday. People worked in a sewing factory, a chair factory, a printing shop, a bottling plant, and a cold storage plant. A tannery did enough business to pollute the river for many miles. All this happened when the railroad was the way to travel. Both the Baltimore and Ohio and the Western Maryland stopped here, making Confluence, deep in the Appalachians, the equivalent of a modern interstate highway intersection, although much more liveable.

Some turn-of-the-century railroad towns are bordered by today's main highways, letting old burgs thrive in spite of changing transit. Not Confluence. Here, the more the railroads declined, the more the town declined, because by road it is out of the way. Route 40 is seven uphill miles south, and from there it is still a long way to anyplace of economic note. Somerset, along the Pennsylvania Turnpike, lies twenty-five mountainous miles north, and of all turnpike towns, Somerset is one of the most remote.

Confluence became a backwater within Appalachia, a place by-passed, nestled down along the river in a mostly forgotten valley. Call that good—out of the mainstream—or call it bad. "It's a shut-in place," Elsie Spurgeon says. "We used to have the trains, but now there is no way out but by car. No bus service. To go to Monroeville yesterday, I had to hire somebody to take me."

Confluence was out-of-the-way when Christopher Gist came through as one of the first explorers. He was a friend of George Washington's and in 1750 worked as an agent for the Ohio Company of Virginia, a frontier real estate firm. Gist was one of the first settlers west of the Alleghenies, clearing a plantation beyond Chestnut Ridge, south of today's Connellsville. On November 24, 1751, he crossed the Youghiogheny, calling it the "south fork," and calling the site of Confluence "Three Forks" and "Turkey-foot." Laurel Hill Creek joins the Casselman River only a quarter mile above its meeting place with the Youghiogheny. These three streams were known as the South, Middle, and North Forks of the Youghiogheny. Even without aerial views, imaginative explorers saw that the pattern where the three streams met resembled the toes of a turkey, and the name Turkeyfoot stuck. Today, local governments include an Upper Turkeyfoot Township and a Lower Turkeyfoot Township. A Turkeyfoot Area Medical Association is trying to recruit a doctor and pharmacist to an abandoned storefront in downtown Confluence, so far without success. Students from Confluence attend Turkeyfoot Area High School, but would like to change the name.

George Washington visited the site in 1754 during his canoe voyage from the Great Crossings. At the confluence on May 21, he wrote: "Tarried there some time to examine the place, which we found very suitable for the erection of a fort, not only because it was gravelly, but also because it was at the mouth of the three branches; and in some places there was a good tough bottom on

which to build it." Like Pittsburgh, Confluence would arise at the meeting place of rivers, but unlike Pittsburgh, there was to be no fort. The site never became significant or strategic enough for anybody to care.

Among the first settlers were the brother and father of John Friend—the first white settler in Garrett County, Maryland. Only a few people followed. They all evacuated in 1763 for fear of Indian raids during Pontiac's war, but about ten families returned in 1765 and 1766 in spite of government warnings that Indian land was off-limits. Population reached 1,031 in 1920 and has been stable since. In 1980, 968 people lived here.

Despite its steady population, Confluence has enjoyed cycles of boom during the lumber, mining, and railroad eras, but now it is bust, a typical Appalachian town. No trains stop here. There is a Ford garage, a bank, a post office, a laundromat, two grocery stores, two gas stations, and a restaurant named Viola's. That is about how things stack up. Alice's Bar serves as the local beer joint, recently fined by the Liquor Control Board for serving to underage customers.

Dr. Edwin Price, semiretired, keeps an office in the forty-year-old hospital building. Dark wainscoting climbs five feet up the walls. Brown bottles populate shelves and cabinets. In its wire cage an electric fan sits ready. Tiny flourescent lights are circle-shaped like halos without angels. On a squeaky glider in a sun porch, I peruse a two-year-old *U.S. News and World Report* while I wait to interview the doctor, who soon appears with his dog. We talk mainly about a National Wild and Scenic River proposal for the Youghiogheny, a designation that the doctor and many Confluence residents fought.

The two Confluence grocery stores are adequate for meat and potatoes. Frozen and canned vegetables they have. I hunt for fresh vegetables and find wrinkled green peppers and yellow-tipped broccoli. The celery and carrots are okay. When I check out I ask the woman at the cash register, "When's the fresh produce come?" She smiles and says, "Just about every day." I ask if they have tortillas. She smiles more and says, "Noooo."

The hardware store is something else again. Maybe it reflects priorities in Confluence. First things first. You can find almost anything in the hardware store.

On the nearest radio station, American Top 40 is sponsored by the Somerset Milling Company, "For all your animal-feed needs."

Country and western normally dominates air time. Uniontown's WASP is the next-closest station.

Twenty-three percent of the people in town are sixty-five or older, one of the highest such percentages outside nursing homes, Florida, and Phoenix. Statewide, 12.7 percent of the people are 65 or older. Median income in 1970 remained less than $6,000. In Somerset County, unemployment averaged 10.3 percent in 1980 (statewide it was 7.6 percent). Figures are unavailable for Confluence, but it is worse. Twenty of the 253 families collect welfare checks.

While many of the young people emigrate, some are unable to move, and other are stubbornly or lovingly determined to stay. They like the quiet, the fishing, the hunting, and the friendly neighbors. But jobs are scarce. George and Jane Groff's son worked construction and commuted to Johnstown, to Pittsburgh, and for one summer to Du Bois, two-and-a-half hours one way. Other men drove daily to the coke plant (it is now closed) in Clairton, one-and-a-half hours, or to U.S. Steel's tube plant in McKeesport.

George Groff stayed as a Confluence high school teacher for thirty years even though he was offered better jobs in the city. "Here it's too nice. It's easy to teach. No city or ethnic problems out here."

The largest source of jobs is the Faymore Manufacturing Company, a sewing factory hiring 120 people. More than 18 percent of the labor force is employed in manufacturing. Only 2.9 percent work in mining, in spite of there being 330 strip mine permits in Somerset County. Eighteen percent are employed in trade, 12 percent work in transportation, 11 percent are "professionals," and 9 percent are in public service.

If you are looking for a quiet place and you can do without a movie theater, a clothing store, a book store, a hospital, a bakery, a bus station, and a job, this may be the place. If you are looking for a good buy in real estate, do like Jim Prothero did and go to Confluence. Properties will be turning over. There are many fine homes. They are plain, simple, and 100 years old, but they may outlast the new stripped-down ranch houses that sell for $60,000. New houses built in Confluence between 1970 and 1980 totaled two, but eight mobile homes lighted here.

People are friendly, but in a mixed way. At the hardware store, they are happy to help you with anything, and they know all the ins

and outs to guide you to what you need. At the Ashland Station, through a haze of smoke, they would hardly talk to me at all, but Jim Prothero went in, lit a cigarette, and talked for twenty minutes about the mechanic's plans to rent a motor-home for a Colorado elk hunting trip. When I went to the district magistrate for a vehicle registration renewal form and told the woman it was for a van, it was as if I said something wrong. She asked where I was staying. I said my brother's cabin at the lake. "Who's that?" she wanted to know.

I knocked on Elsie Spurgeon's door because I wanted to interview her about old Somerfield. She cracked the door, then reluctantly let me in. After she learned that I am related to a friend of hers from Ohiopyle, everything was okay.

Prothero says, "Once these people know you, they are the friendliest in the world. They'll do anything for you." At Viola's they love Prothero. A wiry old man was cleaning up around us because it was closing time. Jim said, "Bet you'd like us outta here," but the man said, "No, take your time. Tastes better that way, ha ha." After Jim and his wife had separated, he ate at Viola's twice a day. By habit he appeared at closing time, but they forgave him because he bused tables and washed dishes.

Over the months, I did some time at Viola's myself, although I avoided late hours, and the dish-washing staff always seemed adequate. In the morning, local men (only a few women) crowd the place for breakfast or coffee.

"Know of any old Fords around, '68 or '69? Need a manifold."

"Try that place up in Fairchance . . ."

"How many'd he git?"

"Four."

"Jus' four?"

"The limit's four, Harry."

"When we'd get four, we'd make another trip. Used to make three, four trips . . ."

"Flurries up your way?"

"Flurries hell. An inch or more! October fifteenth goddamn I don't like it."

When Viola returned from Texas, what she had seen was the topic of the week. "Flat!" she said. "People fall asleep at the wheel all the time. They drive thirty miles to go to the store. And expensive! Coffee, sixty cents. A hamburger for $2.95. Meat—can't buy

it! Guess they can afford it. They make money on those oil rigs, but you can have it. I couldn't wait to get back home." Back to mountains and gradient: even if it is literally an uphill struggle, it is home.

The first morning I went to Viola's, I forgot my wallet and had no $2.02 for my egg, homes fries, toast, and coffee. "Don't worry about it. You can pay us any time," said Eleanor Augustine, the waitress, who had never seen me before.

One other day I met Reverend Arthur Gotjen—the Methodist minister who also preaches in Ohiopyle. He is probably forty-five but looks younger and wears a beard. Gotjen started out studying biology at West Virginia Wesleyan and worked on a government-funded project identifying coastline habitat world-wide. Then he learned that the Department of Defense was the sponsor and that it wanted the inventory so it could determine which herbicides to use where. "The whole world!" reverend-to-be Gotjen said. "Something basic is wrong here." He decided to deal with the basics, he abandoned the biology program, and he entered theological school. Life sciences remain an interest; a few years ago he taught biology part time at Garret Community College near Deep Creek Lake. He recently opposed a toxic waste dump along the Casselman.

Reverend Gotjen was asked to deliver an invocation at a 1977 meeting of government officials and 600 angry residents over the possible designation of the Youghiogheny as a National Wild and Scenic River. Instead of the usual, he read the 1854 letter of Chief Seattle: "The rivers are our brothers. They quench our thirst. The rivers carry our canoes and feed our children. If we sell you our land, you must remember and teach your children that the rivers are our brothers and yours; and you must henceforth give the rivers the kindness you would give any brother. This we know, the earth does not belong to man; man belongs to the earth."

The Original Confluence was rich in the life of the river. Girthy silver maples and sycamores shaded these lowlands which were blanketed with sandy soil delivered by the floods. Willows were tangled near the water in thickets, excellent habitat for the beaver, mink, muskrat, and maybe otter. Songbirds, ducks, geese, and shorebirds were plentiful. In a land of mountains and gorges, the river at Confluence created a great oval basin. Indians camped and built villages—one of them along the Casselman upstream from today's senior citizen housing project.

The meeting of the Youghiogheny and Casselman is now bordered by the B & O railroad on the north and the abandoned Western Maryland right-of-way on the south. Willows still grow redolent on the southern shore of the Youghiogheny. The point of land between it and the Casselman floods often, so it remains with trees and grass, but houses sit close behind. Laurel Hill Creek enters the Casselman amid the peeling-paint homes and sagging two-story buildings of the downtown fringe.

We have reached mile 60—almost halfway through our 132-mile journey from the beginning to the end of the Youghiogheny. Since its Backbone Mountain source, the river has flowed north from West Virginia and Maryland. Here at Confluence it takes a bend to the west and then northwest. We have left the southern, upper river. Now we face Pittsburgh. The river will cut through the final mountains and then will wind out through the foothills.

Along the entire Youghiogheny there is no other place where waters meet as they do here from the north, the south, and the east. At this one spot, the branches collect and become a mature river, 200 feet wide. The point of land between the Casselman and Youghiogheny—a mile below Jim Prothero's house and at the edge of Confluence—is a quiet place of change, of meetings, of flowing-together.

We can stand on the Route 281 bridge and look downstream to where the river bends and disappears behind steep slopes, beneath high ridges.

Below here the Youghiogheny is hundreds of time larger than its headwaters. It does not have the pollution from Oakland, nor the dangerous rapids of the upper river. It is not dammed by the Army Corps of Engineers. It does not run in big whitewater as it will below Ohiopyle, nor as the lazy water that will drift on down to McKeesport. Instead, this is the undeveloped middle Youghiogheny of riffles and rapids, rocks and sand, all surrounded by green. It does not warn of danger, but drops easily, invitingly through the mountain. It is a place for people to come along and relax, to enjoy, and to learn about river life. It is the singing river.

The Singing River

N*o longer* can I stand on the bridge in Confluence and be content watching the Youghiogheny flow west. It is time to see where the green current goes, to drift along, to explore the shores from here to Ohiopyle, to run the rapids. It is time to join the river.

After packing my canoe I am off on a lonely trip, 227 years after George Washington canoed here and wrote, "We also found other places where the water was rapid but not so deep, and the current smoother, we easily passed over them, but afterwards we found little or scarce any bottom. There were mountains on both sides of the river. We went down the river about ten miles." Washington would have walked almost twenty miles back to the Great Crossings on May 22 and 23, but the record of that is lost. After the French made off with Washington's journal at Fort Necessity, their translator, apparently having no interest in New World lay-of-the-land, omitted notes about the return trek, writing, "From the 22nd to the 24th the Journal contains nothing but a description of the country." A description of the country is what I am after, but unfortunately, Washington's manuscript has never been found.

Today, June 21, is the longest day and the midpoint of the year, and it is the day when my Youghiogheny journey will take me past the exact center of the river, halfway from source to end. In some ways, today will show me more of the river than any other day. This is partly because the middle Youghiogheny is natural and unpopulated, partly because it is gentle and invites me to look around, and partly because I am alone and have little else to do but to notice what is here.

Eight or maybe ten times I have canoed this part of the river with friends in groups of two to thirty. Today, I wouldn't go alone if there was anybody here. I would rather celebrate this place and the solstice with friends, but as it goes, none of those types are around. Going alone is okay too, just me floating with the ducks.

From the dam down to the Casselman, the river gently riffles. Shorelines on the left grow willows; on the right, lawns are mowed by people who live there and feed the ducks with the pleasure of old men and young children who scatter bread to pigeons in Philadelphia. Most of the birds are mallards, but they cohabit with snow-white ducks and mottled mongrels in pairs and half-dozens and flocks of twenty. Canada geese waddle here and there. To waterfowl, the Youghiogheny promises refuge as it slips past town. Beyond the homes I will see the merganser—a duck that does not mooch off riverside residents. Fisherman wade the shallows and cast flies, lures, or bait. Rainbow trout have been stocked by the Pennsylvania Fish Commission and they thrive in the clean, cool water from the dam.

The Casselman River joins a mile below Jim Prothero's house, where I began. It is a scenic river with Class I, II, and III whitewater for canoeing during high runoff, but the rapids are the only life. The Casselman is without river creatures; it is polluted by mine acid that for fifty years killed the Youghiogheny, too.

Since the Devonian era when Somerset County was tropical, the coal and over-lying shale had been buried and inert. The water that ran off the mountains was pure, and the Casselman was the best bass stream to be found. During World War I, mines were opened, exposing sulfur- and iron-filled strata to air and water, and the result was like a chemistry experiment gone berserk. Sulfuric acid, iron oxides, and other poisons belched from the mouths of mines and nearby springs. Coal Run below the Shaw mines, Buffalo Run, and the Casselman were bathed in acid, potent enough to kill fish all the way down the Youghiogheny. In 1947, the state began sealing some of the worst mines. Old reports claim that acid discharges fell from 870 tons in 1937 to 185 tons in 1950, but the abandoned mines still discharged at a pH of 2.5 to 3.0 (A pH of 7 is neutral, while lower figures indicate acid; 7.8 is about optimum for most fish, though few streams are that high.) Dilution with fresh reservoir water helped, but the polluted Casselman still banned fish from the Youghiogheny.

In 1965 a Fayette County citizens groups organized to lobby for more state reclamation. The leader of the group, Samuel Magie of Uniontown, prophetically announced that with state help, the Youghiogheny and southwestern Pennsylvania could become one of the best recreation areas of the East. The Shaw mines were nominated as a priority when reclamation money became available under Project 500 (a $500 million bond program) in the 1970s, and the state Department of Environmental Resources adopted a goal of returning trout to the Youghiogheny.

By 1976, $3,778,000 had been spent sealing and daylighting. To seal a mine, state contractors cemented shut the openings and pumped cement into seams in the rock. An underground reservoir of acid water resulted but was contained inside the mine. Surface water ran off without entering the mine. To daylight the mines, areas were dug up and regraded, filling the tunnels that had held air and water.

The program was successful: half of the acid from the Shaw complex was eliminated. This was not enough to restore the Casselman, but it was adequate to transform the Youghiogheny. The state stocked fingerling trout in 1973, and two years later anglers from all over western Pennsylvania spent 12,000 fishing-days below Confluence.

Even nationwide, this is an outstanding success story in river reclamation, but it may not last. Tests for pH in 1981 indicated climbing acid levels, probably from leaking seals and maybe aggravated by new strip mines. "With the right combination of rain and runoff, we could lose the Youghiogheny in a matter of days," said Andrew "Bud" Friedrich, chief of the Division of Abandoned Mine Reclamation in the state Department of Environmental Resources.

Jim Ansel, the Waterways Patrolman in Fayette County for the state Fish Commission, said that the Shaw mines are the most serious pollution threat on the Youghiogheny, and that the seals could disintegrate any day, wiping out the river. "More work needs to be done up there," he said.

Because of limestone in the basin, Laurel Hill Creek is alkaline—the opposite of acid—and helps buffer or neutralize mine drainage, but it is less than half the Casselman's size. The creek drains state forest, game, and park lands (Kooser, Laurel Ridge, and Laurel Hill state parks cover 20,000 acres and draw half a million visitors a year), but new mining also threatens this basin. Other than Laurel Hill Creek, the Youghiogheny has almost no buffering capacity.

Even a slight rise in acid could poison the river for miles. The trout that dart under my canoe live by a slim margin.

Friedrich said that the department is considering more work at the Shaw complex, but that there may not be enough money to save the Youghiogheny. All the advances of the last twenty years could disappear in one big rainstorm if the seals fail or if new mines are not adequately inspected and controlled by the state.

At Confluence, the Youghiogheny has flowed sixty-one miles, the Casselman, fifty-three. The addition of it and of the thirty-mile-long Laurel Hill Creek increases the basin acreage by more than 100 percent. The volume of water more or less doubles: more with runoff from storms, less during dry spells because the Casselman shrinks to ankle depth while the Army Corps keeps the Youghiogheny higher by releasing reservoir water.

After rains, the Casselman surges mud-pie brown, and its silt clouds the Youghiogheny like cream in coffee. Even down below Ohiopyle, if you step out of a raft and sprawl as it tackled around the ankles, thank the Casselman's mud for the greasy footing and the splash you make. All the way to Connellsville, twenty-six miles below Confluence, Casselman mud is slippery like banana peels carpeting rocks, and is easily seen during low water. Today, the Youghiogheny turns slightly tan with the Casselman mix.

Riffles increase. Waves slap the canoe and threaten to splash in as I drift sideways, soaking up the morning sun. There will be nine good rapids (Class II) and many small ones as I travel through Laurel Hill gap to Ohiopyle.

The rapids occur where bedrock is the hardest, and they go back to the mountain's birth, 300 million years ago. These are old mountains. In comparison, the St. Elias Range of Alaska is only 20 million years old. Geologists say that this land was south of the equator. As the continent drifted north, mountains buckled up for 50 million years while the river—already flowing north and west—continued to cut its path; it is an antecendent river, meaning it predated the mountains. While the rising of Laurel Hill was unpredictable and chaotic, resulting from unrest deep in the earth, the wearing-down of the land is as steady as gravity. Geologists estimate that 200 million years ago the Appalachians reared as tall as today's Alps, but three-quarters of the original rock has worn away, most of it going down the river like the Casselman silt.

For every inch that Laurel Hill grew, the Youghiogheny stubbornly wore one inch away, slowly and elegantly creating a gap in the mountain crest that continues from here northward for forty miles (the Conemaugh River sliced an even steeper gorge through Laurel Hill near Johnstown). Where the river crosses outcrops of sandstone—the hardest rock in the mountain—water erodes slower, more rocks remain, and whitewater is the result. In this way, the Youghiogheny decorated the mountain with rapids. Whitewater can also result from tributary streams that wash rocks into the river, congesting it and forcing the current to flow faster against the opposite shore.

So I am paddling through a water-sculptured gap in Laurel Hill. One mile below the Casselman, the mountainsides rise 960 feet at 45 degree slopes. Beyond my line of sight, they climb another 740 feet. I pass Ramcat Run where George Groff's father caught forty trout in a day. At the first sharp right bend, the mountain crowds the shores. The valley has narrowed from a one-mile width at Confluence to 150 yards. Here is Ramcat, the first rapid. I dodge some rocks, rise with the waves, and splash into the troughs around the bend. I am eaten up by Appalachians, by this high ridge and its rutted slopes.

In its full length, the Youghiogheny cuts through four major mountains in the Allegheny Mountain Section of the Appalachians: through the Negro Mountain and Winding Ridge complexes between Crellin and Friendsville, next through Laurel Hill, and finally through Chestnut Ridge below Ohiopyle. Except for the lower half of Chestnut gap, this section through Laurel Hill is the widest and most open of the four, offering more views of the mountain, a wider river, and gentle rapids that average ten feet of drop each mile. This is about the average gradient for the entire Youghiogheny. Width varies from 80 to 300 feet.

Here below Confluence is the first section of river where I am able to paddle a boat and look around. The upper Youghiogheny raft trip was a white-knuckled struggle for survival; up there you are busy all the time saving your neck. Down here you have time to do anything, and the choice of doing nothing, which raises a question: what do you *do* with a river?

Swim here in summertime, fish like those men below Confluence, hike along the shore, ski on the old railroad bed, picnic at a riverside park, camp in a shaded woods that opens like a frame to the water, predict the weather and plot the stars, cook breakfast over a

wood fire, bake dessert in a dutch oven, take pictures to capture the scene and carry it home, check out birds through binoculars, scrounge to see rare plants or to eat tasty ones, lie in the sun on a sandy beach, make love, talk with friends, explore tributaries, sift through the ruins of earlier homes, turn over stones and hunt for fresh-water creatures, admire unusual rocks, snowshoe on snow covered ice, bicycle along a civilized river, paddle a raft through dangerous rapids, daydream through easy rapids, row a raft, load a canoe and travel for a week, see, smell, listen, touch, feel, and maybe even taste is what you might do. Just get out of the car no matter what. Just get close to the real thing.

There are a lot of ways to go, and one way for the most contact without quite joining the fish, is to travel in a canoe. The boat lets you drop the role of spectator. You are swept along in the river, subject to its whims, to its sights. You become a part of the river, but it is a part that you want to control, at least enough to stay dry. This means that skills are needed, and the middle Youghiogheny is the place to learn.

Jim Prothero and Jim Wilson give canoeing lessons to small groups and single people on the Confluence-to-Ohiopyle section of river. In a joint project with the state park, River Path has offered canoeing clinics. They start with the basics of safety: Wear a life-jacket. If you tip over, don't float downstream of the canoe because when it is full of water it weighs 2,000 pounds and can pin you against a rock. If you swim through a rapid, keep your feet downstream and float in a lounging position so that your head doesn't bump into rocks, and so that your feet are high and don't get snagged between rocks in the riverbed. They tell you to kneel, not sit, when you paddle through rapids. This lowers your center of gravity and allows better balance.

They teach the basic strokes: forward paddling and back paddling, then the draw stroke when you reach out from the side and pull the paddle in to the gunnel (the top of the side of the canoe). The draw stroke pulls the canoe sideways. The J stroke is used by the person in the back (stern) of the canoe who turns the paddle blade outward in the design of a J at the end of the stroke. When done on the left side, this pushes the front of the canoe to the left. The J stroke is essential in solo paddling because it keeps the canoe going straight. In an hour, people have learned new skills that are effective, useful, and fun.

Once these strokes are mastered, Prothero teaches the physics of whitewater and how to survive in it. All instability is resolved by moving downstream, a principle that applies to the soil and rocks up where this river begins, and a rule of immediate clarity in rapids.

Leaning correctly can make the difference between floating and swimming. You don't lean your upper body, but instead, you put weight on one knee or the other to tilt the hull (bottom of the canoe). When you are angled sideways to the flow, you lean downstream, exposing the bottom of the canoe to the current, which "lifts" the boat and carries you away. If you hit a large rock sideways, you must lean toward the rock. This keeps the canoe from "climbing" the rock and tilts the hull to the current which then lifts the boat rather than pushing it farther onto the rock. Once you begin to lean confidently and aggressively, you get the feeling that you are not only kneeling in the canoe, but wearing it, though this takes time.

Next, Prothero and Wilson teach the brace. If the canoe is tipping to, say, the left, you place your paddle on the left side, turn the blade flat to the surface of the water, and slap or push down on the river. This raises the left gunnel and stops you from tipping.

One more move for the advanced paddler is the cross stroke. For this, you switch sides to paddle or brace, but you do not change the position of your hands. This is awkward, but shortens the time that the paddle is in the air and unavailable for bracing.

When rocks are few, you can point the canoe the way you want to go and then paddle forward to move left or right. But when boulders come like buckshot, pointing and running often does not work. Instead of going faster than the current, you need to go slower, allowing more time to maneuver. This is done by back paddling and "ferrying" from one side to the other. If you want to go left, you point the canoe to the right, then back paddle. As I paddle down the Youghiogheny, this is how I navigate Drake, the second rapid.

Take a closer look at the river. At first it seems that the water is running downstream, all together. But it's not. The speed of the current changes all through it. If there were no bends or rocks, the fastest water would be near the middle and near the surface where shoreline and riverbed friction is least. On a bend, the faster and deeper currents are usually on the outside of the turn. Rocks change the speed of the flow. If you crouch down near the surface and look

straight across the river where there are rocks sticking up in the water, you can see the different speeds of current.

A rock splits the flow and creates a "vacuum" immediately below the rock where water swirls upstream. This is an eddy—a patch of slower current or upriver current. The faster the flow and the larger the rock, the stronger the eddy. In big water they can bulge higher than the rest of the river, an unpredictably boiling soup. Where the eddy starts is called the eddy line or fence. At the line, the current shifts aburptly from downstream to upstream. Eddies can be miniature refuges inside a rapid; a canoeist can suddenly stop by turning into the eddy. Then he can rest, or plan his route, or move, say, to the right by exiting on the right. Then he has used the slackwater of the eddy to move across the river—something that a strong current prevents. Understanding intricacies such as eddies allows a canoeist to flow with the river instead of fighting it.

Eddy turns are basic in running "technical" water—rapids with complicated currents, mazes of rocks, and the need to jog left and right. This is unlike "big" water or "heavy" water—powerful rapids with whitecap rollers and deep troughs. There are exceptions, but western rivers typically offer big water, while Appalachian runs are technical—sometimes more rocks than water. The Grand Canyon of the Colorado is the epitome of big water, and the Youghiogheny above Friendsville is the epitome of technical water.

It is time to do an eddy turn. In Drake Rapid, there is a rock sticking two feet out of the water. At a 45 degree angle to the current, I paddle toward the eddy below the rock. When the front of the canoe crosses the eddy line, I lean upstream, because the current in the eddy is running that way. I brace on the upstream side. The eddy current throws the bow upriver toward the rock while the stern is still shoved downstream by the main current. The canoe spins 180 degrees and I sit facing upstream in the eddy with the bow nestled against the rock. Without doing anything I sit while the river rushes past on both sides.

The ultimate in canoe-play is surfing. It is similar to ocean surfing, except there, the wave moves and the water stays still; in a river the water moves and the wave stays still. To surf in the Youghiogheny, I find a good symmetrical wave, maybe one-foot high. I face upriver and paddle onto the wave so that the bow is upstream of it. This causes the front of the canoe to be lower than the back, even though I am facing upriver. While gravity pulls the canoe down the

wave, the current races underneath. The river becomes a treadmill and I sit surfing upriver at the same speed that the current flows downriver and there is something illusionary in it, something that defies the world as we know it.

The rapids are fun, and challenging, but the river is more than this. Boat handling is a way of getting here; it is the ride in. The canoe is a tool. To me, being here is the main thing, and I just sit around a lot, enjoying the place. Here at the Rock Garden, the river cuts through the gorge with a special power; the Youghiogheny has carved the land and is still changing it today. The river makes the place come alive. It is the circulatory system. It generates mist in the morning and is golden at sunset. It shines, cools, hisses, and allows us to travel without effort.

You can have a good time on a one-day whitewater cruise, but that is too fast to get a feel for the place. There is a sense of surroundings, a contact with the land and water than doesn't happen during a quick trip downriver. One day is recreation, but two days is living there. There is a lot of river life that you don't see until you spend the night. You pick a campsite. You unload, sit in the warm sand or on a rock that catches the afternoon sun. You cook, wash dishes, watch the stars, grab a sweater, and wait for the moon to rise. The river takes over. You fall asleep listening to water. A beaver might swim in front of the campsite at dawn. Then you build a fire and drink tea or coffee with friends while you cook breakfast. Instead of only passing through on a sunny afternoon, you have come to stay awhile, to know the place, to allow it to affect you.

Some people don't want changes in their lives. They stick to the things they know. Opening the door to new experiences can loosen the grip on old habits, even old prejudices. New experiences can be threatening. But traveling rivers is a way to see something new and to change the pace. There is something about staying along a river—new water flowing past every second—that makes life seem youthful and renewable. "There is a whole world that I never knew existed," one river traveler said. Others say, "It's the peace." "It's the excitement." "It's living on your own." "It's making friends and learning to live with other people."

Except for the excitement part, people almost never say those things about one-day trips. Yet camping along the middle Youghiogheny violates state regulations. From Ramcat Hollow to Bruner

Run (seven miles below Ohiopyle), the Youghiogheny shorelines are part of Ohiopyle State Park where you legally camp only at a site on Kentuck Mountain equipped with flush toilets. "We have problems with people leaving trash," the park superintendent, Larry Adams, says. "Did you see those trees cut down near Elephant Rock? We figure that was done by campers. There are no sanitary facilities out there and if camping is allowed, problems would get worse." But most of the trash sites are where people drive in to the river. This is illegal on the south bank's abandoned railroad grade, but some people do it anyway.

Other rivers heavily used by campers show little abuse. For ten years, canoeists have been staying overnight along Pine Creek in north-central Pennsylvania, and most visitors carry their trash home. The Stanislaus River in California was, after the Youghiogheny below Ohiopyle, the most traveled whitewater river in the nation. About half of its boaters stayed overnight, yet because commercial outfitters kept clean campsites, the canyon was spotless. Above the Youghiogheny, the Laurel Ridge Trail winds seventy miles from Ohiopyle to Johnstown with backcountry campsites every eight miles or so, located so rangers can drive in for maintenance. There are many ways to deal with the problem. Larry Adams sees the value in overnight river trips, and wants to develop a canoe camping site on the middle Youghiogheny that would be accessible for maintenance by driving up the Western Maryland railroad grade.

At the Rock Garden, Laurel Hill rises up on both sides and insulates me from the rest of the world; civilization seems far away. Except for the railroad. Along most Appalachian rivers, trains are inescapable. Except for the 1.7-mile Loop below Ohiopyle, Chessie System tracks run along the river's north side throughout the state park. Six or more trains travel past on weekdays, fewer on weekends. The Western Maryland Railroad was built on the south side, but the Chessie System bought it and stopped service in 1975.

Through the Public Utility Commission, the Western Pennsylvania Conservancy learned that the twenty-six-mile right-of-way from Dunbar (near Connellsville) to Confluence was for sale, and after negotiating for three years, they bought it for $150,000 (appraisals listed market value at $1.6 million). The stretch through the park was resold to the state, which intends to improve twelve miles from Confluence to Ohiopyle as a bicycle trail. Larry Adams

hopes that money will be approved to do this in the early eighties. State park planners expect 40,000 bicyclists a year. The state could later extend the trail downriver to the park boundary or to Connellsville, only a one-hour drive from Pittsburgh. George Groff, in the 1920s, walked the railroad from Confluence to Connellsville in one day, but not many hikers do. "The bike trail would open the area to many people while not taking away from the wilderness of the gorge," Conservancy President John Oliver says.

There are other opinions. "It will draw more people to an area that is already heavily used," warns Ralph McCarty, owner of an Ohiopyle rafting company that serves 13,000 people a year. In 1981, state park rangers estimated that 44,000 canoeists, rafters, and kayakers paddled this middle section of the river. With the Delaware and Clarion, it is among the most-floated streams in the state.

Some canoeists argue that the Confluence-to-Ohiopyle reach offers Pennsylvania's finest intermediate canoeing, and has enough use. They say that the river is essential for their sport, but is not needed for a bicycle trail; further, that a bike trail closer to an urban area could take cars off the road by serving "commuter" needs. Some fishermen forsee an influx of picnickers at the best trout pools and argue, "You don't need a good trout river for bicycling."

Larry Adams answers, "The qualities of the river that appeal to paddlers are the same things that attract nonpaddlers, and they have just as much right to see and use the river corridor."

If the goal is to keep this section of river wild, or to reserve it for uses dependent on the natural qualities of the place, then the bike trail may be a bad idea. If the goal is to offer recreation to the most people, then it seems to be a good idea. "The goal is to provide for as much recreation as we can without hurting the resource, and without interfering with other uses of the river." says Larry Adams. "To allow cars or four-wheel-drive vehicles or motorcycles up the trail would interfere and would be incompatible with the wildness of that river. But to allow bicycles will not be a problem. I would see it as drawing some additional use to the park, but spreading use out, too. It would put less emphasis on the Falls area. Since everybody wants to see the river, this would give the more ambitious something to do."

After eating lunch at the Rock Garden, I climb back in my canoe and drift down to the islands. Youghiogheny islands are scarce. Up above Friendsville is one. Above Ohiopyle lies a rocky one fifty yards long. Below Dawson on the lower river, four islands are low and skinny. At Broad Ford there is one, a quarter-mile long. The two largest islands, each about half a mile long, are below Layton. There are small ones at Banning and below Buena Vista. Right here—halfway between Confluence and Ohiopyle—is the second largest pair of islands in the river.

Whether they are in the Caribbean, Lake Superior, or in an Appalachian river, there is something special about islands. They float without going anywhere; they tread water. Being here is like being on a boat that doesn't rock. Island are getaways, but more than that. Maybe the heritage of Huck Finn and Treasure Island counts for something. Maybe islands make good refuges since outsiders arrive only by boat. Except in cartoons about the shipwrecked, no one arrives by accident. The continent is so vast, so settled, so complicated, that when you step onto an island, you feel you've escaped and at the same time arrived. The frontier was lost 150 years ago and now there are no places for fresh discovery, yet islands give the illusion of it. I beach my canoe and explore.

An island is small enough to call one place. You can see the whole thing; walk around it. Stopping at an island is like singling a person out of a crowd. You can know a person and you can know an island.

This one happens to be carpeted with poison ivy. Silver maples crown the place and bury it in shade. They thrive on wet, sandy, flood plain soil. They grow fast, but are weak, and so the wind, snow, and ice break limbs, to be scattered on the ground. The island and shoreline plants are "riparian," meaning they are specialized to grow along rivers. For example, royal ferns are leafless for one foot above the ground to allow for high water. Sycamores—largest of the riverfront trees—can be flooded for weeks and will not die if two feet of sand is deposited around their trunks.

From the island, you can look up at the mountains, and even from a distance you can tell that the plants up there are different: red oak, red maple, and sugar maple dominating; also shagbark hickory, beech, tulip tree, black cherry, white oak, northern red oak, basswood, dogwood, and black locust. Hemlock darken a few north-facing slopes. Botanists call this the "mixed mesophytic"

forest (diverse plants with ample water). There is variety because here the beech/maple of the North meet the oak/hickory of the South.

People are drawn to edges, and islands are mostly edge; from everyplace on the island I can see and hear the river. In a small clearing that campers have made I lie down and fall asleep for awhile.

Below the islands the Youghiogheny runs calm for three miles. Slow rivers have a good monotony, moving but undemanding. There is nothing that I have to do, nothing that I have to think about. I can just sit in the sun.

Afternoon headwinds sometimes make you work to travel this part of the Youghiogheny. Not today. Today is aimless cruising, a lazy afternoon break, but any sense of monotony is an illusion. I see a lone osprey up there, circling on thermals 200 feet up. He eyeballs the water and will dive with wings half-closed, plunging into the river with feet extended, then flying away with a small fish clutched in inch-long talons. Since the state improved the Casselman, the entire food chain has benefited: more caddisflies, mayflies, and stoneflies feed more fish, which bring fishermen and osprey. Yet the fishhawk remains uncommon here. The one I see is probably a roaming juvenile—they travel for a few years before settling down. None nest along the Youghiogheny, but if the water stays free of mine acid, they may return to live at the top of dead pine or maple snags.

The fur bearers are also a comeback species. Beaver and mink thrived, then faded almost to extinction here. Youghiogheny habitat is not the best: in many areas the water is swift and the edges too rocky for plants and animals. Willow—a favorite food of the beaver—grows along the shore but not in wide thickets. Other beaver meals are aspen, birch, hazelnut, and water lily, and most do not grow here. With few animals to begin with, uncontrolled trapping and shooting easily killed the rest. State regulations now limit the killing of fur bearers, and few mountain residents are bothering to run winter trap lines, so some of the beaver and mink have returned.

Rattlesnakes we still have. They are one of three species of poisonous snakes in Pennsylvania, grow three to four feet long, and eat mostly rodents—63 percent of their diet. Rattlesnakes along the Youghiogheny were legendary. From the Sang Run area, Meshach

Browning wrote *Forty-four Years of the Life of a Hunter* in 1859, and said of rattlesnakes, "I was at all times prepared to receive their attacks; for before leaving home I always took hay, or long grass, and twisted it into a large rope, with which I wrapped my legs up to the knee; and this they would never bite through. When thus provided, I would go where I pleased in daytime; but being afraid they would creep to me in the night, if I was where I thought they were numerous, I would stuff leaves around my legs, inside of my pants, and sleep with my moccasins on; and making my dog lay down, I would lay my head on him; knowing that then no snake or animal could take me by surprise. Both ends being thus fortified, I could sleep as comfortable as if I had been in the most secure house and on the best bed in a city."

The upper river, from Sang Run to Friendsville, remains a rattlesnake haven: rocks everywhere, wet and cool in midsummer, few people. Rusty Thomas admits, "Those rattlesnakes are the one thing I'm scared of." Yet along most of the Youghiogheny, they are never seen. Only a generation ago, boys from Ohiopyle swam around the Loop and saw many rattlesnakes on the rocks. No one sees them there now. In 1978, the Western Pennsylvania Conservancy released a study that said the evidence "strongly suggests that the animal is declining, perhaps irreversibly, wherever hunted."

Besides the osprey, a few other birds keep me company on this trip: crows hunting carrion, barn swallows darting after bugs, and kingfishers, blue and white, on waterfront limbs and looking into the water. They fly out and plunge straight down, catching minnows in their beaks. They also eat crayfish, mussels, frogs, and lizards.

The merganser is a duck often seen here. Females have a red head, males, lustrous green. When flying, their heads are not up looking around like the mallard's, but low to the wind, the crown swept back, the body arrow-shaped in the line of flight. They zoom past, forty miles an hour. Mergansers taste fishier than probably any other duck, so hunters have ignored them. It shows: this may be the most visible wild duck coast to coast. Unlike the mallard, mergansers will not crowd the lawn in Confluence for bread crumbs, but hunt in the wild for crayfish, mollusks, frogs, insects, and fish. A study along trout streams shows that low-grade and rough fish made up 40 percent of the merganser's diet. They dive deep, swimming fast and long underwater. Along the shore I once

found a merganser stranded in a ball of fishing line, tangled like a backlash from a casting reel. The duck flopped in an effort to escape, but it went limp as soon as I held it. I unwrapped the line. The feathers on the right wing were broken and tattered and I thought that the duck would be helpless, that it could not dive, but when I set it in the water it disappeared like a torpedo for the other shore.

Two miles below the islands, the Youghiogheny begins a great horseshoe loop. This is the midpoint of the river, halfway from the source to the Monongahela. I'm not even aware of the loop until I notice the sun, ahead of me, then on my left, finally behind. To the southwest, the steepest slope slants at an almost unclimbable angle for 800 feet, tapers off, then tilts out of sight for another thousand feet to Sugarloaf—2,960 feet above sea level—the second-highest mountain in Pennsylvania. Unlike the flat summit of Mount Davis (the state's highest mountain), Sugarloaf's top is the apex of a ridge, 1,600 feet above the river. The gorge yawns to a half-mile width and the river describes a peninsula holding 200 acres of bottomland called Victoria Flats.

Early settlers discovered a salt spring here that attracted deer. In the late 1700s, people collected the water and boiled it down for table salt. In 1912, Thomas Meason began commercial production, gleaning ten pounds of salt from every barrel of water. Three thousand bushels were made over the next seven years by pumping from a well near the spring.

In one of five farms that dotted the flats, Harry Shipley lived through most of this century. He would grab his rumpled hat and worn-out coat and amble down the tracks two-and-a-half miles to Ohiopyle, where he would drink at the Ohiopyle House and spin tales of exaggeration. Truth is in some ways dispensable in the mountain taverns, and as another old-timer says, "Harry Shipley is the greatest teller of lies that ever was."

Loud and boisterous, Shipley would say, "One morning it was so cold that when I opened the doors in the hayloft the pigeons flew out and froze right there in the air. Two o'clock in the afternoon 'till they thawed and flew away.... We were loggin' across the river from the farm where the mountain is so steep that we sharpened the end of the logs and gave them a push down the mountain and into the river. 'Cept one got goin' so fast that it went clean

through a chestnut tree and the heat of it started a fire and burned the rest of the woods down." Ask Shipley what happened to his father and he answers, "We had our cows on the other side and we'd go over there to milk 'em. One day it was so hot that the milk spoiled before we could get it into the rowboat, so while we were crossin', all these flies followed us, and the trout in the river came jumpin' in after the flies and piled up in the boat so heavy that we sank and pappy drowned."

Early in this century, Victoria residents rode the train to Ohiopyle and Confluence, or they drove a rutted wagon road beside the tracks. When the train no longer stopped, most people abandoned their homes. Only Shipley stayed, thinking up tall tales inspired by solitude. Then in the late sixties, the state bought his farm for the state park, and he moved into an old hotel in Confluence.

Six buildings still appear as tiny squares on the topographic map of Victoria, though they have been torn down. You can leave your canoe and search for the farmhouse foundations of the Harbaughs, Holmans, Burnworths, and Shipleys.

During the early 1970s state park planners considered Victoria Flats for a recreation area with a campground, picnic area, and a beach. They even investigated the possibility of a monorail for access, but dropped the idea because of its multi-million-dollar price tag.

Two-thirds of the way around the Victoria loop, Long Run enters on the left with cool spring water from Sugarloaf. It's a good place to hike. In the middle of a trip down the river, exploring a side stream is like suddenly going back to the headwaters.

Near the end of Victoria, the Youghiogheny drops over two small ledges and forms a rapid called Victoria Falls. "Jim's Pool" is below, where Jim Wilson caught a twenty-two-inch trout on one of his first canoe trips. The river jogs to the right in a Class II rapid with waves that can swamp a canoe. Another good rapid and several small drops follow. Then, on the horizon half a mile away looms a giant rock. Its back is humped and one end bulges like a petrified elephant fording the river. The Youghiogheny beats against the thirty-foot-long pachyderm before boiling left or right. Like most rapids on this stretch, the easiest route is to the right through fifty yards of symmetrical waves. To the left, the gradient is delayed by a natural dam of boulders piled from the shore to the elephant's butt. The river plunges through a five-foot-wide chute that angles with a jolt to the left.

Earlier in the summer, when the river ran a foot higher, Jim Wilson guided a group of canoe renters. Most of the customers did well, so Wilson set them up for a thrill by coaching them for the run to the left of the elephant.

Four boats negotiated the drop. Then a pair of paddlers drifted toward the belly, which, like the real thing, is undercut, tapering in as its rib cage dips underwater. Wilson knelt in his canoe below the chute and pointed left, but the paddlers just stared at the Elephant, then slammed into it, failed to lean, and flipped to the upstream side, clinging to their boat as the current pushed it against the rock. They bounced around like sneakers in a washing machine and then the boat broke loose, smacked into smaller rocks, and washed into the eddy. The next pair of canoeists also overturned. The paddlers swam the rapid without trouble, but the boat cross-body-blocked the elephant. Half of the canoe filled with current pushing right, the other half with current pushing left, cramming the boat against the flat stomach. The hull buckled and creased in a stiff backbend. With help from four athletic canoeists, Wilson grunted and heaved on the underwater boat, but it didn't budge. He left it there and planned to return the next afternoon with air bags to be shoved into the bow and inflated, forcing water out and making that end lighter so he could heave it off the rock. This he did not have to do. The next day, a group of guys salvaged the canoe and were loading it—conspicuous by the River Path emblem—into the back of their pickup when Park Superintendent Larry Adams happened by on patrol. He told the guys that the canoe belonged to River Path, and that if they were hauling it out of there, they should drop it at the Ohiopyle take-out. Then he followed their truck down the river in time to catch them turning to high-tail across the bridge and disappear. The driver spotted Adams, turned around, and dumped the boat at the take-out.

By the time I pass the Elephant, the sun is dropping behind Kentuck Mountain. It has been the longest day of the year and I have been on the river for most of it. The largest rapid is ahead. To the right, the current makes a letter Z. Evening light is soft and blue as I drop into the foam and shy from a deep trough where the Youghiogheny turns in a dogleg. I catch an eddy, listen to the river bubbling, then reenter the mainstream. I draw to the left and nose-dive a ledge which marks the rapid's end. I drift under the new cement

bridge built in 1973, replacing an old steel truss bridge, which had replaced a covered bridge from the 1800s.

Finally I have reached Ohiopyle. Seventy-one miles of river above, sixty-one below. This is the center in more ways than miles. Here is where most people meet the Youghiogheny. Here is the state park, the Falls, and the start of the popular whitewater rafting run. There is no place like Ohiopyle, no place that even comes close. Most river recreation sites are simply remote access areas, but here is a community, an old Appalachian settlement, a river town since the first settlers arrived.

Ohiopyle: The Old Days

*T*he *last* president to visit Ohiopyle was George Washington, and that doesn't even count because it was in 1754, long before he took office. Having embarked in a canoe at the Great Crossings and camped at the site of Confluence, he paddled downstream and wrote, "at last it became so rapid as to oblige us to come ashore." When the man who would win the Revolution and lead the new nation got to the bend in the river that would become Ohiopyle, he gave up and quit. It was that kind of place.

In the mid 1700s, southwestern Pennsylvania was scarcely explored or settled. The Appalachians insulated the land from encroachment by the English to the east, and the French, barred by the Iroquois Indians, did not venture so far up the Monongahela and Youghiogheny from their western outposts. Indians were scarce, due to wars between the Iroquois and other nations in the 1600s. Trying to escape from white civilization, Shawnee and Delaware people fled to this region in the 1700s, but they were too scattered to attract missionaries or traders. So it was a blank spot on the map, and within this wild region, Ohiopyle was one of the last communities to be founded, around 1770. Philadephia and Baltimore, less than 250 miles away, were settled more than 100 years before.

Ohiopyle is like Confluence and like an island—to get there, you have to want to get there. Through the years, it remained at the edge of society. In this sense, it was a Shangri La, insulated by topography. The mountains surround everything. They make the

place what it is; they create a world apart with the river in the center. All roads out of Ohiopyle are climbed in second gear. All roads into Ohiopyle burn the brakes. Why would anyone want to go there? But as Jim Prothero said, this place was a magnet for escapees; still is. Ohiopyle is out of the mainstream, an alternative to the larger group. It is a place that is different, and it attracts its own breed of people who are also different.

Nobody knows for sure when or why the first Mitchells came to Ohiopyle, but historians agree that they were among the earliest white settlers. Family lore says that James Mitchell led a rebellion against the British in northern Ireland and was caught. Before he was banished to an island, his two sons, James and Thomas, sailed to America and pursued some unknown path that ended at Ohiopyle. A second story, perhaps a continuation of the first, says that James Mitchell fought for the British in America in the French and Indian War and was rewarded with a land grant. Still another tale has James Mitchell a colonial officer in the Revolution, but seventeen James Mitchells served, and which of these came to Ohiopyle, if any, is unclear.

What we know is that James Mitchell appears in records of the Turkeyfoot Baptist Church, September 14, 1775. Tax books show John Mitchell owning land near Ohiopyle that year, and James owning fifty acres four years later. So whatever story you believe, the Mitchells have tenure; for over two hundred years they have lived on the mountain west of the Youghiogheny. A friend of the family named the mountain Kentuck (Cain-TUCK), since it reminded him of his native Kentucky.

Simpson Mitchell owned a farm on Kentuck where the boaters' parking lot is now located above Bruner Run. Thomas Mitchell's place was nearby, where Tom Faucett lived in a cabin.

Faucett fought under General Braddock in 1755. When Braddock was ambushed, he ordered his men to stand in the open and fight like English soliders—like sitting ducks. Braddock struck his own men with the flat of his sword for hiding behind trees. One of these men was Tom Faucett's brother. Tom Faucett said that he then shot Braddock, though nobody admitted to seeing this. Faucett selected Kentuck as a place to keep a low profile until his death, sixty-seven years later at age 109.

Tilgham ("Tim") Mitchell was born in 1854. He married Cora

Jackson, and their first son, Shelby, was born in 1908 in the Ohiopyle house that is now the office for Ralph and Mike McCarty's Mountain Streams and Trails rafting company. Tim Mitchell amassed a small fortune by logging and operating sawmills around Ohiopyle and along West Virginia's Cheat River, so in 1916 his family moved into a rambling Victorian house in Ferncliff Park, on the peninsula of land formed where the river makes a two-mile loop at Ohiopyle. This is where Shelby and his brother Emlyn ("Oudie") grew up.

Today, Shelby is white-haired and hale. He is as sharp as an old fox, though he claims he can't remember things the way he used to. He will name dozens of people who have done all manner of right and wrong in Ohiopyle, and when there is a name he cannot remember, he says that his memory is failing him.

"Old Ohiopyle was a very different place," Shelby recounts. "There was none of this rafting business. But we sure had a good time. Right there at the Falls, on the Ohiopyle side, sat the old power plant—a big three-story building that was first used as a mill, later changed by the Kendall Lumber Company to make electricity for their sawmill and for lights in the town."

The Falls that Shelby speaks of are Ohiopyle's unchallenged centerpiece: eighteen feet high with more water than any other falls in Pennsylvania. Few falls in the East are as large. At the Kendall power plant, turbines were turned by the force of water as it came down a race, or wooden sluice four feet high and eight feet wide that ran 400 feet along the shoreline from a spot near the bridge.

Shelby continues, "Bunch of us boys'd jump in the race and swim the whole way through it, then reach up and grab the sides to get out just before we got to the power plant." One day Bill Joseph's son drowned in the race.

Shelby and other kids swam in the Falls. Without Youghiogheny Dam, the summertime water level was lower than it is today, and they dove in from rocks on either side. "There were a lot of people who drowned in that river," Shelby recalls, adding that he has recovered a few bodies. "With old man Tharp and my brother Oudie and other guys, we'd go out in a rowboat below the Falls and drag the bottom with a big hook. If we couldn't find 'em, sometimes we'd set off a charge of dynamite. That'd bust their gall bladder or something, supposed to make 'em float up, but it never worked much for us." People from town gathered at the Falls want-

ing to see the body when the Mitchells or other men recovered it, and there were some grisly rewards. "My brother saw a head come up and sink again, so he dove down and hooked the body under the arm and we pulled it in. One time there was two fellas drowned. Found one at the Western Maryland Bridge but didn't find the other for days. He washed up below the High Bridge, two miles on down, and the crows had picked his eyes out."

There was one known suicide in the river: Dolly Marietta jumped in at the old Route 381 bridge on a snowy day and drowned. Some would say that a second suicide involved Shelby's and Oudie's pony. "We had him tied up near the house and he broke loose. Tracked him across Ferncliff and the tracks disappeared into the river at the Briner fishing hole near Cucumber. Never found 'im." Maybe the fact that the rambunctions Mitchell hellions had painted the pony like a zebra had something to do with its plunge to death.

"That river's a whole lot better now than it was," Shelby says. "There were no fish—the tannery in Confluence and the mine'd killed 'em all. We'd cut ice in the winter and pack it in sawdust. People'd come'n get it, and the hotel and different places had it, but then we got a typhoid epidemic. A lot of people died, maybe from that ice, some thought. That was back around World War I. They buried Sam Shipley's wife and daughter in the same casket."

The Mitchell house at Ferncliff was a local mansion, testament to the wealth that could be taken from the old Appalachian forest. Shelby counts the rooms: "Three in the attic, then seven upstairs, then downstairs there was one, two, three, and the kitchen, breakfast nook, the big billiard room, and downstairs, and the wine cellar. Altogether I guess there were about twenty-two. A stuffed deer head hung over one of the three fireplaces, and young Ed Jackson was afraid to go in that room."

The house no longer stands. The Mitchells were troubled with electric line overloads, and somebody told them to put pennies in for fuses. One day when Shelby returned from Connellsville where he had been fixing up houses that his father rented, he rounded the sharp bend above Ohiopyle and discovered nothing but smoking ashes and three fireplaces where the house had stood. He had planned to get married the next day, and an inconvenience like this was not going to interfere. As scheduled, he and his girl friend, Kitty, traveled to Oakland, Maryland, where they didn't have to get a license or suffer a three-day waiting period as they would have to do in Pennsylvania.

On the foundation of the burnt house, Shelby had a twelve-room house built during the Depression for $6,000. He sold this to the Western Pennsylvania Conservancy in 1961; eventually the house became part of Ohiopyle State Park and was remodeled by the Pittsburgh Council of American Youth Hostels to sleep twenty-two guests. Shelby and his wife, Lois (his first wife died), moved to a new house along Chalk Hill Road on Kentuck Mountain where they now live.

Over the years, young Shelby earned a reputation. "An ornery hellion, that's what he was," says Dr. George Dull, an old acquaintance from Connellsville. "Those kids up there at Ohiopyle'd do anything. They were wild." Sometimes it got rough. My father, Jim Palmer, spent summers at Ohiopyle, and remembered going into a bar with Shelby, who was twelve years older. They snuck out when bystanders started getting hit with bottles. Shelby was unbridled: a cat-teasing, rattlesnake-taunting, rope-swinging mountain boy. But he was a child saint alongside his kid brother, Oudie. Oudie was always getting into fights. When I mentioned the Mitchells to George Groff, upriver in Confluence, he thought and said, "Mitchell? I knew a Mitchell." Oudie?, I asked. "That's it, and he was an ornery one." And downriver in Connellsville, an old-timer says. "Orneriest in the world."

Oudie tended toward the footloose. One day he planned to cross the bridge to Holt's store, so he asked his mother if there was anything she wanted. Cora gave him two dollars for groceries. Shelby recalls, "The last I saw him he was up between the tender and the baggage car on the B & O headed toward Pittsburgh." Nobody saw him for two years. After a couple of days Cora asked, "Anybody seen Oudie?" After a week or two nobody gave it any thought. "He left so damned often," Shelby says. Oudie homesteaded in Alaska. Later he enlisted in the navy and deserted. "They just figured he got drunk and fell overboard," Shelby says. "One day he showed up in the barn. My dad got Sam Kendall, the congressman, to get him officially out of the navy." Later, Oudie enlisted in the army air force, became a B-26 tail-gunner, flew in battles over Germany and Africa, and was decorated with a flying cross for "extraordinary achievement while participating in aerial flight." Ohiopyle claims no residents who became senators, millionaires, authors, movie stars, or professional athletes, but it has a rambling scrapper who excelled as a tail-gunner.

One of Oudie's schemes was to drive a truck, so he bought his own rig from Seamons, the Mack dealer in Uniontown. An initial venture was to carry vegetables across the country, but Oudie was delayed—he has not confessed to the details—and the load spoiled. He was $6,000 in the hole, so he returned the truck to Seamons, gave them the keys, and walked away. He tended bar in Connellsville. Eight times he was married. Shelby once received a call from a girl in Wyoming who said, "Oudie was going to marry me but he never came back." Shelby advised, "Well let me tell you something, you just forget about it." In 1981 Oudie manages an apartment building in Mount Lebanon, a wealthy suburb of Pittsburgh.

"What made him so crazy?" I ask his older brother.

Shelby answers seriously and without pause, "Heredity." I am not altogether comfortable with this since Shelby's and Oudie's mother and my great-grandmother were sisters.

Oudie traveled, never resettling in Ohiopyle. Shelby traveled too, but always returned. First, his parents shipped him by train to Gettysburg Academy for high school. "I got so damn homesick; everytime I'd hear that railroad whistle I'd 'bout cry." When he returned for Thanksgiving, a crowd of people met him with hugs and old-aunt kisses at the Ohiopyle B & O station. "After school, three or four of us went to Toledo to work in the Willys plant. It was assembly-line work—all the same. Most of us came back home."

Why do some people leave and some stay? People go for the obvious reasons: in Ohiopyle there are no jobs for electrical engineers or assembly-line workers. There are hardly any jobs at all. Some people want to make money, not only a living. Maybe they marry somebody from the outside. Some people leave to get more action than these usually quiet mountains offer.

Some people stay because they never get to see—or to be comfortable—anywhere else. Some stay because the mountains simply feel right. The up and down is a unnamed ingredient for mental health. They would go nuts in the drained swamps of Florida five feet above sea level, or in the Central Valley of California where the horizon disappears as it does on a calm day in the mid-Atlantic, or in Texas where humdrum landscape is interrupted only by roadside sprawl. Shelby says, "You know, you can take the boy out of the mountains, but you can't take the mountains out of the boy." Here in southern Pennsylvania people develop personalities to match the landscape. The result, for some, is a powerful sense of belonging.

Somehow roots grow deep on these rocky mountainsides. Shelby says, "I had a good home here. I liked Ohiopyle, knew everybody."

In 1929, Shelby and his mother moved to Hollywood, California. He worked in a hardware store until they returned a year or so later. In 1960 he and Lois traveled to California and thought about staying. "I looked at a hardware business in Oroville where they have that big dam, but they already had five other stores."

Maybe competition was only an excuse. Lois says, "Shelby didn't like anything that wasn't Ohiopyle." Speaking for herself she says, "We came back over the mountain and nothing ever looked so good as those elderberries and blackberries. Nothing ever looked so green as the way it does here." Take Interstate 80 from San Francisco to New York, and the greenest things you see are the mountains of Pennsylvania. So Shelby and Lois came home to stay.

Over the years Shelby has accumulated experience worth many nights of yarns. He worked in his father's sawmills, then ran the logging and milling business himself. While in California the first time, he was offered a job playing minor league baseball in Montana (a girl he was dating had arranged for the tryout), but he declined. He enforced the law as the Ohiopyle policeman in the thirties. "One night we had to haul this drunk away from a dance at Ferncliff; put him in jail and he set fire to his cell." For years, Shelby sat on the borough council. He worked as a brakeman and fireman for the B & O from 1940 to 1943, then operated coal mines, finally finishing his diversified careers by owning and managing an asphalt paving business.

"In those days," Shelby says, "I could pretty much decide what kind of business I wanted. Then I did it. Young people don't have those opportunities today. The timber up here is gone. The economy is poor. The mafia runs this county. The choices aren't here the way they used to be." This is a turnaround of the post-Depression notion that young people have it so good. The economy of the eighties has changed a few things.

One of Shelby's most profitable and interesting careers was that of a coal miner. One mile south of Ohiopyle, to the right of Route 381 near the Dinner Bell Road, the Potter family owned mines first opened in 1877. In 1943 the Potters decided to reopen the coal diggings and hired Shelby to manage the venture. "Goldie Potter said if she got five dollars a day she'd be satisfied," Shelby remembers. "I ended up earning her $1,000 in royalties a month." It had been a

custom mine—small, with a coal vein three feet thick. The coal had been marketed locally, but when Shelby took over, he sold it to the New York Transit System, shipping the black cargo out on the B & O. Business flourished and forty men were soon at work. Other people found jobs serving the mines: local men cut locust trees for posts and beams to support the roofs of the tunnels. Loggers drove truckloads of posts into town and bartered against their grocery bill at Holt's store. Then Charlie or Bob Holt sold the posts to miners.

With augers five inches in diameter and powered by diesel-generated electricity, Shelby's men bored into the bottom of the coal seam. Then with a six-foot cutting bar, something like a chain saw, they sliced from one hole to the next, making a horizontal slit beneath the seam so that the coal was hanging from the ceiling. Into the slit went a stick of dynamite. The miners retreated as the blast would "shoot down" the coal—the seam would crumble and fall. Shelby then climbed into the blasted area with a safety lamp to check for gas. He sometimes found "black damp," air that was very low in oxygen and high in carbon dioxide, snuffing his lamp. With added ventilation, the miners resumed work, scooping the fallen coal into a cart pulled by a pony, a horse being too tall, on railroad tracks to the outside. When the seam became uneconomically thin, the miners did a "retreat," mining out the pillars and ribs of coal that had been left intact to support the roof. As they pulled this coal out, the roof caved in.

Water from the mines flowed into a pond, then into Cucumber Run and the river. "It ran red with iron and acid," Shelby recalls, "but no one ever thought about it." I ask if the miners were fishermen, and if they saw that the acid was killing fish. "There weren't any fish in the river back then anyway," Shelby answers.

"Today, it's all strip mining. We'll be losing our well out here one of these days. Lots of people out here on Chalk Hill Road'll be losing their water. When the miners blast, it cracks the rock and the water runs on down someplace below. They might start deep [tunnel] mining out here again. I don't own the minerals here, but I want to buy the coal under this house so they don't go mining there and having the foundation crack and be full of holes."

Shelby's mother, Cora Jackson Mitchell, was one of six brothers and sisters. Stonewall Jackson, the Civil War general, is said to be further back in the line, and Cora's mother, Isabel Armstrong, is

said to be related to Indian fighter John Armstrong and to the early settlers of Armstrong County, Pennsylvania. In 1897 Goldie Jackson, one of Cora's sisters, married Dalton J. Potter, whose family was another that came early to Ohiopyle.

John Potter settled in 1787 in Jockey Hollow at the Great Crossings, now flooded by Youghiogheny Reservoir. Nine of his children moved to California and the West, but Amos and Samuel stayed. Amos became one of the first schoolteachers in the area. In 1828 Samuel married Sarah Leonard, moved to Meadow Run near Ohiopyle, and built a gristmill. In 1832 he built a sawmill and buckwheat/corn flour mill powered by water from Meadow Run. His son, John B. Potter, expanded the mill in 1852. George Potter—John B.'s brother—lived next door and operated a split chair factory in 1860, building several hundred chairs a year. His son, Charles, became an architect and designed the Mitchell house that is now the American Youth Hostel.

Early in the 1890s, John B.'s son, Dalton J. Potter (who was to marry Goldie Jackson in 1897), built a three-story mill in Ohiopyle. Dalton operated the mill into the 1930s, grinding buckwheat, bagging it, and shipping it out. The mill remains as a historic landmark, with three sets of grinding stones and with the steam engine that powered them. Flour bags say "Youghiogheny Mill—Warranted Pure—Buckwheat Flour—D.J. Potter—Ohiopyle, Pa." When Dalton worked the mill he became covered with dust from the grinding, and the kids in town called him "the ghost."

Although their mill was in Ohiopyle, Goldie Jackson Potter and Dalton continued to live at the Meadow Run farm above today's parking lot for commerical rafting customers. From 1900 to 1914, they sold goods in a store adjoining their kitchen; their place served as a gathering spot for a dispersed community of farmers and loggers. It was an idyllic valley site: open fields along the ancient flood plain, green mountains encircling, and Meadow Run, clear and cool, fifty yards from the door.

Only the foundation of the house remains at the junction of Meadow Run and Potter's Mill roads. A ramshackle wagon shed survives across the dirt road from the mill site. To refrigerate milk, John B. Potter built a stone springhouse, still in excellent condition, though flooded with water and populated by frogs. The Methodist church, founded by John B. Potter and still in use, is a two-minute walk away.

The Potters led dual lives. They lived in the country and caught fish, cut wood, and rode horses. They dug coal from "ground hog" mines in the mountain behind the mill, and children dug clay that they fired into marbles. But on Sunday afternoons, Dalton played his violin following a dinner of frog's legs and fresh trout. The family and guests played croquet on warm August evenings when the smell of corn tassels in the field was strong.

The Potter's income was based on the grain mills, and therefore on farming; it relied on a continuing harvest rather than on extraction, like logging or mining. Yet in stubborn consistency with the Youghiogheny theme of resource use, abuse, and failure in long-term productivity, the farms would become worn out and superseded by technology rendering local agriculture unnecessary, uncompetitive, and almost extinct.

At the Meadow Run farm, Goldie and Dalton had two daughters, Mildred and Adalene. When Mildred was sixteen and Adalene five, the family moved to Ohiopyle. Under huge maples, their white house featured a front porch with a two-person wicker swing that faced the Falls. Mildred boarded five days a week with family friends in Uniontown while she went to high school. There she met James Palmer, whom she later married. He became a banker and they moved to Belle Vernon, Los Angeles, and finally Rochester, thirty miles from Pittsburgh. After her husband died in 1952, Mildred returned to Ohiopyle for the summers: back home again living at the old Potter house where she watched and listened to the Falls from the spacious front porch. She was my grandmother, and her house is where I stayed, as a kid, when I escaped to Ohiopyle to run loose in the summer. The site of the old Potter house is now marked by the clothes-changing building and parking lot for private boaters.

Adalene Potter met Bill Holt even before the first grade. Through elementary school he saved her a seat, then copied her math answers when the teacher wasn't looking. The partnership, beginning during World War I, would continue for some time. Bill and Adalene began to go together. In 1933 they drove to Philadelphia to see two friends, Eunis and Pone Moore. "They talked us into getting married, so we did, right then," Bill explains. The newlyweds returned to Ohiopyle. "Adalene's mother just about to killed me," Bill jokes, or maybe doesn't joke.

Bill and Adalene bought the Jackson's house in Ohiopyle and

lived in it for thirty-three years until it was torn down by the state for the realignment of Route 381. Today, the new brick Baptist church stands near their old homesite. In 1968 they moved into Bill's father's house—a stately, fifteen-room building of white frame and green shutters that overlooks the Youghiogheny.

Bill and Adalene ran the general store in Ohiopyle for most of their lives. They were the last of eighty years of Holts as Ohiopyle merchants.

During the Civil War, Thomas Holt cut marble in Pittsburgh. After many years of this, he suffered a disease similar to the coal miner's black lung. His doctor advised him to abandon the city and to go where the air was clean. So this family of Holts came up to the mountains. John W. Holt—a brother—who lived with his wife Kiziah in a house on the site of Kaufmann's department store, also moved to the Ohiopyle area, settling on a Beaver Creek farm.

Setting a pattern to last three generations, John Holt opened a store in Ohiopyle. In 1895 he built a new store along Front Street near the bridge, and the Holts prospered. In 1918 and 1919 they built a large brick building across the street and sold Dodges and Chevys where Falls Market is today. When the old general store closed, Bob and Charlie Holt—two of five children—each went into business, Charlie converting the car showroom into Holt's Department Store and Bob remodeling an adjoining building. The two operated side by side as cut-throat competitors for the rest of their lives. They didn't speak to each other. For twenty years they didn't set foot in each other's store. Bill Holt—Charlie's son—did not enter his uncle's store.

"Why not?" I ask.

"I don't know," Bill says. "Just the way it was."

The Western Union Office was in Charlie Holt's store, and during the early years of World War II, Bill delivered telegrams that said mountain people's sons had died in France, Italy, and Africa. Then Bill himself was drafted while managing his father's store, even though he was thirty-six, had two children, and was legally blind in one eye. The explanation may be that Uncle Bob sat on the draft board. Bill did basic training with spry eighteen-year-olds, then was appropriately appointed supply officer on Angel Island in San Francisco Bay.

Both of the stores did well, though old-timers recall Charlie being better liked. Eventually Bob grew old and his eyes went bad. He

sold the store to a man from Mill Run, but only on the condition that he would not resell to Bill Holt. The Western Pennsylvania Conservancy bought the store, razed it, and sold the empty lot to Bill, who moved his gas pumps from the front of his store to the side where they stand today. "They had been on the state's right-of-way," Bill explains. "We always had pretty good pull with those guys, especially my dad did, but as your old friends die, it gets tough. You have to find new friends or else move the pumps."

Through the fifties and sixties, Bill and Adalene Holt's department store was the mainstay of Ohiopyle. They stocked almost everything: a complete line of groceries, quality hardware, clothing, even appliances. The store shone spotless. "When customers weren't here we'd clean shelves from one end to another," Adalene says, "and as soon as we were done we'd start over again." Every day Bill was there in a white shirt and necktie at the cash register, butcher counter, or wherever, but now and then he had to do field work.

An old man from the mountains near Dunbar bought a TV and never made payments, so Bill ventured out to reclaim the set. Those people were what one could call hillbillies. Bill politely explained it all and finally said, "I hate to do this, but since I didn't get any money, I'll have to take the TV back." The grizzled man stood up and walked slowly to the mantle above the fireplace, picked up an eight-inch hunting knife, touched the razor edge with his thumb and said, "I don't reckon ya' will." The TV suddenly faded to the inconsequential. Bill agreed, "I don't reckon I will either," and he got out of there lickety-split.

The Holts' store was more than a place to buy everything you needed. "Part of what we did was just listen," Adalene recalls. "Everybody would come in and you'd hear all about their lives. They'd pour out their troubles and we'd listen." That was part of the general service of a general store.

They worked long hours, 7 A.M. to 9 P.M., six days a week. Either Adalene or Bill was always there. "We really couldn't turn it over to anybody," Adalene says. For recreation and to get away, the Holts bought a lot at Big Bend on Youghiogheny Reservoir where they parked a trailer and built a cabin next to Red Jordan.

After a lifetime of running the store, Bill and Adalene reached retirement age, and in 1975 they sold the business to Leo Smith from the Washington, D.C., area. Bill had been elected mayor of

Ohiopyle for three terms, but retired halfway through his third term. "Mainly Adalene and I wanted to travel after we sold the store," Bill explains. They wanted to visit their daughter in South Carolina and their son in Cincinnati. Both had moved from Ohiopyle because of careers. "There was nothing here for them," Adalene explains.

Today, Bill is seventy-four, Adalene seventy-three, many years from their acquaintance in the first grade. Bill says, "Adalene and I, we've had some scraps, but we always managed and did all right. I wouldn't be alive today if it weren't for her. She's taken good care of me, all through the years, today especially. I can't get around, my eyes are so bad. I can't drive. Adalene keeps me going. We've had a very good life together."

The Holts' fifteen-room house is next to the store and overlooks the river. Adalene manages her second and third stories as a guest house, renting rooms to people who raft on the river or who come to see Fallingwater, the house designed by Frank Lloyd Wright, four miles north.

"This summer," Adalene says, "we had a lot of embassy people from Washington. We don't advertise at all, word just gets around. Last year we must have had a dozen or more people from the state department."

That is about all Adalene has time to say, because she is en route to the clothesline with laundered sheets and is supervising a cleaning lady in the kitchen, and most importantly, is readying the minute book for the Daughters of the American Revolution which will meet in Confluence tomorrow. "She needs to slow down," Bill says. Bill follows this advice himself. "Adalene has arthritis, and the place is a lot of work. She checks the cleaning and the beds and goes around redoing half the stuff. She has to have it just so. Adalene, she always wants everything in the house to be perfect.

"We're looking for another house. This one is too big. We need a smaller place. We don't want to leave, but might have to go to Uniontown." Adalene catches wind of our talk and says, "I just don't know how I'd leave. This is our home."

In the late 1800s and early in this century, Ohiopyle was an industrial town, its economy based on coal and timber. The place was called "Falls City" until 1881 when it was incorporated as a borough and named Ohiopyle. The name had been spelled Ohio-

pehhele, meaning "beautiful falls," "beautiful flowing water," or "white frothing water" in one of the Indian languages.

Along with raw materials of wood and coal, a cornerstone of Ohiopyle industry was water power from the river. Henry Fry first attempted this in about 1842. Above the Falls, he built a log dam to divert water for a sawmill, but like Elijah Friend's enterprise at Sang Run, a flood obliterated the dam before the first log was cut. Andrew Stewart then constructed a dam 400 feet above the Falls and built a wooden raceway to channel water to a mill. This mill burned before one dollar was made. A sawmill actually opened at the Falls in about 1850, making Stewart one of the first local industrialists. Later a gristmill was built, and in 1865, a planing mill. Stewart built a sawmill near the river at Stewarton in the 1870s. He had served eighteen years as a congressman and received the 1848 Whig nomination for vice-president.

In 1879, the Falls City Pulp-Mill began operating, powered by water. A new 400-foot-wide dam was built across the river to trap and divert the flow.

In the early 1900s, the Kendall Lumber Company converted the pulp mill into a hydroelectric plant to power its sawmill on Sugarloaf Road, and in 1906 it added a network that brought electric lights to Ohiopyle. Shelby Mitchell recalls that "in the winter you could tell whenever the ice would build up in the raceway, because the light would go dim. Not enough water was getting through to make power. Finally somebody'd have to go down and knock the ice off." This was done by the person who first became fed up with darkness.

The Falls City Shook Factory, for production of barrel parts, stood at the mouth of Meadow Run where the state park superintendent's house is today. Other industries of the late 1800s included the Falls City Spoke and Hub-Works where wooden wheels were made, and the Fayette Tannery built by Amos Potter. Grain milling at Potter's mill and elsewhere also spurred the local economy. Before 1900, much of the town was centered at the lower end toward Meadow Run. Five or six hundred people lived in and near Ohiopyle.

The railroad was critical to economic health. The Baltimore and Ohio (the first commercial railroad in the country) was incorporated in 1826. Its planners proposed a Youghiogheny line which, like the Nemacolin Path and the National Road, would connect the east coast with the Ohio Valley. The route was from Cumberland,

Maryland, to Wheeling, West Virginia, with only a spur to Pittsburgh. The Baltimore-to-Cumberland section was finished in 1844, but public opinion and politics stymied the Youghiogheny route. Pittsburghers preferred the Pennsylvania Railroad line being built from Philadelphia directly to their city; southwestern Pennsylvanians opposed the B & O because it would reduce National Road traffic and deplete roadside business.

B & O officials failed to secure an extension of their construction deadline as required by Pennsylvania law and were forced to scrap the Youghiogheny plan. They continued laying tracks to Wheeling. Meanwhile, the Pittsburgh and Connellsville Railroad Company incorporated in 1837 to connect those cities via the lower Youghiogheny. This route opened in 1855, and in 1871 the line was extended up the Youghiogheny to the Maryland boundary and Cumberland. When the B & O leased the line four years later, it began operating the route it had originally planned to build. In the 1970s the B & O became part of the Chessie System.

The Western Maryland Railroad Company began building a competing line from Connellsville to Baltimore in 1911. This followed the south and west side of the Youghiogheny from Connellsville to Confluence. The last train passed on May 21, 1975: the Chessie System had bought the Western Maryland and discontinued service. The old Western Maryland Bridge still spans the river at Ohiopyle, and the abandoned High Bridge towers at the lower end of the Loop, one-quarter of a mile away.

Trains hauled coal from Ohiopyle to Pittsburgh and Baltimore. The railroads were the steadiest local employer, and they became an inescapable part of everyday life. Bill Holt says, "We used to go down and watch the B & O's Capitol Limited go through. It was nonstop from Pittsburgh to Washington, and it was fast." Ohiopyle students rode the train to high school in Connellsville. The B & O stopped at Ursina (near Confluence), Confluence, Victoria, and Ohiopyle; then at Bear Run, Stewarton, and Indian Creek, all between Ohiopyle and Connellsville.

Because the town's economy hinged on extraction, its future was doomed. This cornucopia of riches could last only so long: the coal was nonrenewable, and the forest, too, was managed like a mine; they sawed everything as fast as they could sell it. It was cut-and-run without regeneration and without sustained yield that would

allow smaller yields of lumber forever. "You just didn't think about those things, understand?" Shelby Mitchell says. About the time its economic base faded, Ohiopyle emerged as a tourist town. To hear about those days, I visited Gwen Waters.

Born in 1897, Gwen Holt Waters is a first cousin of Bill Holt's. She lived along Beaver Creek where the original Holt emigrants had settled, but her family moved into town when Gwen was five. She is now eighty-five, standing straight with bright blue eyes, her white hair pulled back in a bun. Listening to her, I don't get the history of big names or big money, but the story of what life was like along the Youghioheny. There was an early wave of tourism, quite different from today's, and dependent, like the town's economy, on the railroad.

"We used to go down and meet the excursion trains from Pittsburgh," Gwen says. "A bunch of us girls would go, may eighteen of us. We'd go over right after Sunday school at eleven o'clock. There must have been a thousand people on one train with lots of cars. It was something for us to *see* all of those people. I was sixteen, maybe seventeen." I ask if the girls were looking for boyfriends. "No. No No."

I ask, "So it was a bunch of country girls going to see the city people?" and Gwen answers, "Yeah, that's what it was, that's what it was."

The tourists—mostly Pittsburghers but some from Cumberland, both cities being about seventy-five miles away—came for one dollar, round trip. Some stayed the day, others overnight. Local farmers, including the Shaffers, Morrises, and Grindells rode down in horse-drawn surreys to the B & O station to meet city guests who boarded at the farms for a few days, or sometimes a week or two. "People would get home-cooked meals and relax and loaf around the farms," Gwen says. The Rainer Hotel stood at the upper end of town, above today's post office on land now owned by the Pittsburgh Diocese of the Catholic church (a site where housing for the elderly has been proposed). Next to the hotel was a small amusement park where local kids rode a five-cent merry-go-round. Donner's Excursion House, known for good food and the piano playing of its owner, did business nearby. Brady's Boarding House kept urban visitors on the north side of the river where Wilderness Voyageurs rafting company owns land today.

The Ohiopyle House—the oldest hotel—stood along the B & O

tracks near the Mitchell house at the edge of Ferncliff Park. It began as a large farm building and was converted into a tavern and hotel by Andrew Stewart in 1871. Horses were boarded underneath. Owners enlarged and remodeled again and again, and through 100 years the landmark evolved from the primitive barnlike establishment to an elegant hotel. In the early 1960s the Western Pennsylvania Conservancy owned it, contracting management to the Mariettas and later the Whipkeys.

Choices were many for lodging, but the Ferncliff Hotel was the queen for overnight accommodations. It rose four stories and rambled for 101 feet before angling into two wings, 75 feet each. "It was a really beautiful place," Gwen says. "There was a big archway going down a long walkway." Fountains decorated the grounds. They boasted of 800 electric lights, a dining room seating 150 people, and an indoor bowling alley. Outside, guests played on a baseball field and tennis courts. According to travel columns in newspapers, "Every want of the visitor, tourist, and summer guest would be fully met, and the romantic spot cannot fail to become one of the most enchanting resorts in the country." Out back, a hot spring attracted those who sought restoration of health, but when the hotel was demolished, workmen disclosed an underground pipe connecting the spring to the hotel's basement boiler.

"The orchestra from Connellsville would come up and play," Gwen says. "People would dance in the evening at a pavilion right along the river below the Western Maryland Bridge. We'd go over and watch the people dance. That was something. They were dressed up fancy. We didn't dance, except now and then we'd get in on a cakewalk or square dance. Then Reverend Porter would come over and chase us. Oh, he didn't want us dancing. He thought it was terrible. Ask Bill Holt about Reverend Charles Porter. We ran down by the river and he never found us down there."

This was long before rafters or kayakers discovered the Youghiogheny; long before the invention of such equipment. I ask Gwen what people did. "All through the park they'd picnic, you know. Some would walk out to Cucumber Falls. They just liked to get out for a good time, and they had it too. They'd run all through the woods; get out of the city and relax." People escaped. The hotel proclaimed that "those who would like to flee to the mountains need not go far."

Gwen continues, "Harry Marietta from Connellsville ran the

Ferncliff for awhile and he was a great one for entertainment. That's when they had the most dances. It was nice here in the summer. A lot of people coming and going."

"Did you ever want to get out?" I ask. "To move away and be one of *them?*"

"No. We were satisfied to live here. Those were good days, yes. You weren't afraid. Everybody was jolly. People sat on their porches and talked. We really enjoyed life. My dad played the violin, and he'd yell out the upstairs window to Jenny Eney across the street: 'Hey Jenny, strike up a chord,' and Jenny would play the piano over there and dad would play his violin over here. They'd have a tune going back and forth across the street and you could hear it all up and down. Each evening a lamplighter'd come down the street, starting up the gas streetlights. It seems like a dream now, when you think back." For people to know their home so well, to accept it so fully, and to love it through the years and through the changes is rare among the mobile generations that follow Gwen Waters.

Everything was not idyllic. Most people had outhouses which worked fine, but in 1910 or so, residents converted to flush toilets and the water-borne sewage streamed in open ditches through town. "Yes," Gwen says, "it'd run down the alley and into drains, down into the river. There wasn't much trash or garbage. Chickens'ed clean most of it up."

Gwen's house, next to the Holt's, is large and full of heavy oak antiques, Victorian furnishings, and a half-dozen cats. The rugs and wallpaper are flowered in a faded design. Pictures of descendents stare from fancy gold-colored frames. "I have a picture of Front Street here somewhere," Gwen says, and she thumbs through a box of assorted postcards, black-and-white photos that have ripened to yellow, greeting cards, and Kodak Brownie snapshots. Many are portraits of young people: probably grandchildren, nieces, and nephews, some wearing wedding gowns, some in military uniforms. A photograph of the Baptist church is framed and propped on an end table. Gwen's brother, Denzel, also lives here. "Denzel, where's that old picture of Front Street?" Gwen asks. Denzel is sitting in a rocker in the other room. "I don't know," he answers in a singsong voice that is Denzel's, only.

Gwen finds the Front Street photo—a scene that has disappeared. Today's main street is farther from the river than the old Front

Street (or Commercial Street, as it was officially called). Homes and stores lined both sides. "Matthew Williams had a dry-goods store on the corner," Gwen says. "Then came the C. W. Sailor store, a house, and the J. W. Holt store on the river side. Charlie Holt later started his store on this side, where Falls Market is today. Daniels', Livingston's, and Chuck's stores were down there too. Toward the river there was a blacksmith and wagon shop, and Cyrus Shuw had a store. There was another blacksmith shop up where Bob Marietta's house now sits." This is above today's White Water Adventurers rafting office. More buildings stood on the north side of the river across the bridge. "William Glotfelty had a store there between the tracks and the river. Across the road, Tommy Glotfelty had a barber shop and ran a taxi service with a Model T Ford. The Kendall Lumber Company also had a store on that side, then Burdett & Saylor." Later, Whipkey's Restaurant was on that side.

"Down at the river, in the summertime, it was like Atlantic City," Gwen says, not referring to gamblers. "All the visitors would go swimming, and everybody in town, too. Visitors went on the other side, town people on this side." Tradition still has the local "beach" on the town side of the river, above the bridge. "Lots of people would go in the big hole under the old bridge, and boys'd do flip-flops from a rope swing there. Especialy in the evening, people in town would go down and swim after supper. The water was warm, and such a nice rocky bottom. The people from Pittsburgh had bloomers down to their knees, but us Ohiopyle girls'd just go in with our clothes on. We'd take off what we could, then jump in the river with our long dresses on. We eventually got bloomers too, but that came later. Took awhile to catch on, and for us to afford them. The boys, they'd go skinny dippin' up at the island [at Z rapid]. The girls never went. They did the peepin'. We could stand on the bridge and look up. They were so far up, you couldn't tell who they were, but you could tell they didn't have clothes on."

Gwen says, "We'd take the four o'clock or six o'clock train to Connellsville and see a movie: Charlie Chaplin or W. C. Fields. We'd take the 8:17 morning train to Connellsville, then an electric streetcar to Uniontown, and make it back to Ohiopyle at either 8:30 or midnight. That was fun. It was the only way in or out of town."

There was more interaction with Connellsville then because Ohiopyle students took the train to high school. Dr. George Dull of Connellsville says, "We knew each other more in those days." After

the roads were improved and more people owned cars, Ohiopyle's orientation switched to Uniontown, which is about the same distance, but a larger city where economic decline did not come so soon as in Connellsville.

I ask Gwen what she did after she got out of school.

"We didn't do anything," she says. "I stayed home and worked around the house, eventually got married. Some of the young people went over to the hotel and worked, but I never did. I always had enough to do helping around home. It's different now. People and the town and everything." Gwen laughs, "Make you feel like you're getting old! We used to spend evenings roasting apples, poppin' corn. We'd get together and pull taffy, boys and girls both, just for fun. Now people say, 'What for?' but that's all we had to do. We'd have a good time. Today, it's different. It's a different class of people."

The resort-hotel era endured only as long as the railroads brought customers. "Everybody started buying automobiles," Gwen explains. "To buy a Ford didn't cost an enormous price. Then people quit coming on the excursion trains. When the Western Maryland was built in 1914, the tracks cut right through the Ferncliff grounds and kind of ruined them, so each year the hotel went downhill." The Ranier Hotel was torn down, and the Ferncliff followed in the thirties. Soon the Ohiopyle House was the only hotel left, and most of its business transpired in the bar. It had started out as a tavern, and it ended up as a tavern.

From the 1930s on, it was hard times for Ohiopyle. The trees had been cut and it would be seventy years before good saw-timber would be marketable again. The thickest, richest, most accessible seams of coal had been dug and burned. A few mines reopened, such as the Potter mines that Shelby Mitchell operated, but most of the new mining would come after World War II by stripping companies hiring perhaps one-tenth the number of men as the old shovel-and-auger operators. Even coal that had been dug and loaded could not be sold during the Depression. Railroad cars, full of coal, sat on the B & O siding at Ohiopyle until the cars rusted. Moonshining, especially in the Greenbrier area beyond today's rafting take-out road, was one of the few profitable businesses. Federal officials raided the stills now and then.

The government hired some men to build the Pennsylvania Turn-

pike in 1936 and Youghiogheny Dam in 1938. A few men worked on the railroad, but for jobs, that was about it. The trains quit stopping in Ohiopyle, and it became as inaccessible as Confluence. Day by day, year by year, the old luster faded and Ohiopyle assumed the poverty of Appalachia.

During the make-work efforts of the Depression, Congressman J. Buell Snyder proposed construction of four Youghiogheny dams: two between Connellsville and Confluence, one near Smithfield on the lower river, and one on the Casselman. Based on a preliminary survey indicating that a "great power project can be developed," Snyder introduced a bill appropriating $15 million for the dams, which would provide "cheap electric power in Pittsburgh and all other communities within a 100-mile radius." He compared the potential to that of the Tennessee River, where the Tennessee Valley Authority had begun a flurry of dam-building that would not stop for forty years. The bill did not pass. The West Penn Power Company also considered a dam at Ohiopyle, and later a plan to divert water at the Route 381 bridge through Ferncliff Park, gaining an eighty-foot drop for hydropower while cutting off the river's flow from the Falls and the Loop.

The Depression deepened, and even afterward poverty clung to the region, since its resources were depleted and no stable economy had ever taken hold. In Ohiopyle and around the mountains, frame buildings built in the boom era of lumber and coal sagged and their paint peeled. Woodpiles, coalpiles, and old cars concealed the yards. Spoil piles of coal and shale from the mines dotted the woods where oaks were struggling to survive on rocky ground that had been lumbered and slash burned, its topsoil washed down to Louisiana. When some money was made, aluminum siding was nailed to houses here and there through the 1960s, the shiny veneer incongruous amid organic and decaying surroundings.

Young people who were skilled or talented or ambitious emigrated to cities of the east coast, California, and in later years the South. Some stayed because the Appalachians were home and because they were willing to do without jobs, money, and the excitement of the American mainstream, but most who could get out, left. People grew older and the median age soared. Some people collected welfare. Stonerville, once a well-kept community of twenty houses built by the East Fayette Coal Company along Cucumber Run, could have been in a classic 1960 photograph of Appalachia:

two-story unpainted buildings all alike, torn screens or no screens in the windows, mangy dogs lounging on dirt streets, chickens in the yards, children looking like rural waifs.

I first came to know Ohiopyle during the late fifties. Front Street was still there, but many of the houses were decaying. Most of the stores and blacksmith shops that Gwen Waters remembers were long gone. Gladys's Snack Bar survived, and Holstetter's gas station stood prominently near the Falls. Holt's Department Store was the center of activity. Whipkey's Restaurant was on the other side of the iron truss bridge that spanned lower and slightly downstream from today's crossing.

Raw sewage flowed down from town in ditches and seeped across the flat rocks and into the Youghiogheny, which carried the odor of rotting organics. Because of mine acid from the Casselman, no fish could live.

Bobby Marietta and a few local kids swam in the Falls. About 1959 I remember the exotic sight to two men launching a raft. To float down the river seemed to be an adventure worthy of Lewis and Clark. Except for the pioneers of whitewater paddling, boaters had not arrived and nobody imagined the river-running enterprise to come. Not one person imagined that the tool to be fondled in the hand of Ohiopyle workingmen would not be the sharpened crosscut or the weighty pick and shovel, but a canoe paddle shaped for play.

Ohiopyle was a sleepy mountain town where a few Sunday tourists from Pittsburgh wandered in to see the Falls by walking across a lawn and climbing down onto the rocks. Ohiopyle was so out of the way that fourteen-year-old kids didn't worry about a driver's license.

I rode my bicycle up Kentuck Mountain to see old Ed Jackson, my great-great-uncle, and his wife, Mary. Mary cooked on a wood-burning stove that sat next to a seldom used gas range. The Jackson's house, which had been part of an old Mitchell farm, had an unmistakable scent that has not permeated kitchens since then. It was a country-kitchen odor, a cross between stale cookies, home-made bread, woodsmoke, and who knows what else, but the blend was wonderful. Two hundred feet from the porch was the old barn: hemlock bleached golden by 100 years of sun. The place had not been a working farm for two generations, but when my father was twelve, spending summers at Ohiopyle, he and young Ed Jackson milked one or two family cows in that barn and stored the milk in the nearby springhouse.

Ed, Mary, and I sat on porch swings as grasshoppers buzzed in the field and afternoon storm clouds gathered in our view of Sugarloaf Mountain. Whenever a car rumbled past, yellow dust-cloud streaming behind, Ed got up to see who it was. It was not that often that he had to get up. He maintained complete knowledge of travelers on that road—the same that now leads to the state park campground.

So it was that the old days of Ohiopyle, and many of the old people, were coming to an end. "The town had pretty much seen its life," Shelby Mitchell says. "We had timber, and coal, and recreation, but then there just wasn't much of anything until the rafting and the state park. Today the park's okay. Lot of people enjoy it, but I don't care to go down there anymore. I like to remember Ohiopyle the way it was."

Shelby and I page through the Mitchell picture album, a treasure of extinct Ohiopyle scenes: the covered bridge, the elaborate gate that welcomed Pittsburgers to the Ferncliff Hotel, the Falls in 1890 with the pulp mill, and again in 1915 with the power plant. Front Street included the old Holt store and a dozen houses. All of these things are gone except for the river.

We come to a sepia-toned photo of eight men posing in front of a small sawmill. The person in the center is handsome, with a striking eye on the camera. It is Shelby in his twenties. Now he is seventy-three, but the eyes are the same. Shelby looks at the photo and says, "All but three of us in that picture are dead, and I'm 'bout half."

I am suddenly aware of a peaceful sadness in Shelby's old age. A friend of his said, "Shelby's had a hard time retiring. He's used to getting up at five o'clock and working all the time." Now there is not much to do. After a little while Shelby adds, "There's one thing I don't like. Every time I get up in the morning, I'm one day older.

"Used to be, you go into most any house and there was an old person there. Maybe two. Not now. Now they go to nursing homes. I sure don't want to go there, all those old people. I like it out here, feedin' my squirrels. There were eight of 'em this morning. I love to watch those squirrels. You look at animals like that. They have the same things people have. They're no different when you get right down to it.

"I used to go hunting, but the last time I killed a deer, I stood there while it was dying. He was looking up at me with those big

eyes and I said, 'Now what's the fun of killing? Isn't it better to live?' These animals want to live just as much as I do. Just as much as you do.

"They breathe, they eat, sleep. Look at them. It's life and that's the thing. We're all together, everything that's living. Just life is the main thing. If that isn't it, then what is?" Shelby also talks about nuclear war. "You watch the news and you can see that every day we're getting a little closer, a little closer." We fall silent for awhile.

"I feel myself getting pretty creaky but she just keeps going," Shelby says, glancing towards Lois, who is scurrying around in the kitchen. "Lois takes real good care of me." Shelby is looking at the mountainside of his life, and it is steep. There is a old-age sadness from this man who was a wild mountain boy and a reckless fun-lover, who once painted a horse like a zebra, who swam the Loop, and taunted rattlesnakes. Shelby, who had two marriages, who moved to California and back again twice because Ohiopyle and the mountains were in his blood, and who cut thousands of trees and supervised scores of loggers and miners, has grown old.

Something sparks on and off in my mind like a dream that I try to remember when I wake up in the night. Something about Shelby and Ohiopyle growing old together. In ten years many of its people—Gwen Holt Waters, Bill Holt, Adalene Potter Holt, Shelby Mitchell—might be gone. I think of changes coming to Ohiopyle and to everyplace, and it seems that there should be some connection between the old and the new.

Shelby is chasing his thought and I am chasing mine, each, I suspect, without success. Then Shelby says, "Let me tell you something, Tim. I've been a lucky man. I've had two good women." He smiles just slightly with the old incorrigible Shelby Mitchell twinkle in his eyes, and he adds, "Maybe I'll have three."

The Park

From a mountain town, old and gripped by poverty, Ohiopyle would be transformed in the late 1960s to a booming center of recreation. Pittsburgh had been the reason for much of the use of timber, coal, and land of the Youghiogheny basin, and that city was also the source of efforts and money to protect what remained of the wildness.

The Greater Pittsburgh Parks Association was formed in the early 1930s by business leaders and citizens whose goal was to improve the city. Their modest beginning was to plant trees and shrubbery along Bigelow Boulevard, but bigger things were in store. In a few years the group of volunteers reorganized as the Western Pennsylvania Conservancy to offer conservation education programs and to save open space by acquiring land. Dr. Frank Preston, an amateur geologist, spurred interest in McConnell's Mill and the Slippery Rock Creek Gorge thirty-five miles northwest of Pittsburgh, and acquisition of the site in 1944 resulted in McConnell's Mill State Park. With a $130,000 grant from the A. W. Mellon Education and Charitable Trust in 1958, the Conservancy directors would hire a staff to buy open space holding scientific, natural, or recreational value, and by 1982 the Conservancy would acquire 80,000 acres for protection and public use. This would include much of Moraine, Laurel Ridge, Oil Creek, and Ohiopyle state parks.

According to M. Graham Netting, Conservancy historian and early board member, the Ohiopyle park idea began in the late forties with Lillian McCahan, the Western Maryland station agent

in Ohiopyle. She wanted to save the Ferncliff peninsula as a natural area.

At Ohiopyle, the northwestern flowing Youghiogheny bends to the south, west, then north, dropping ninety feet in two miles and returning within one-quarter mile of meeting itself. This is the Youghiogheny's unique and famous Loop, and like a cupped hand, it almost encloses the 100-acre peninsula called Ferncliff. Other than the wild Youghiogheny between Oakland and Friendsville, the Loop is the only section of river where no road or railroad clings to the waterfront. Boulders ranging in size from basketballs to houses monopolize the shorelines. Lepidodendron fossils from 365-million-year-old club mosses are plentiful. Virgin hemlock, fat-trunked and twisted, grow from the steep slopes above the boulders. Ferncliff combines green and white water, tan and gray rock, and hemlock in one of the most scenic of all Eastern riverfronts.

Outcroppings of sandstone create the Falls and the rapids below Ohiopyle. Like the Pottsville formation in the Laurel Hill Gap above, rocks at the Loop resist erosion and remain jumbled barriers in the river. Below the Falls, seven rapids rush for 1.7 miles around the peninsula and come as close as physics allow to a paddler's impossible fantasy: whitewater that circles and meets itself, a continuous river.

Ferncliff is also known for its plant life. Beginning in 1916, Dr. O. E. Jennings, an internationally known Pittsburgh botanist, explored Ferncliff, calling it a "botanist's paradise." Other scientists joined him hunting unusual plants and comparing notes in the evening at the Ferncliff Hotel. They found eighty-seven species and varieties of woody plants. Logged in 1911 and selectively cut in 1947, the peninsula is shaded by oaks, hickories, tulip trees, and beech, but the rare plants are what has drawn attention: Barbar's Buttons (*Marshallia grandiflora*) and Carolina tassel-rue (*Trautvetteria caroliniensis*), grow no place else in Pennsylvania. Slender blue iris (*Iris prismatica*), autumn willow (*Salix serissima*), and buffalo-nut (*Pyrularia pubera*) normally grow to the south and are scarce in this region. Paul Wiegman, director of the Western Pennsylvania Conservancy's natural areas programs in 1982, says that the north-flowing river is unique in its transit of southern seeds to a northern gorge, protected by its deepness from the coldest weather. Frost damage is minimized and humid-

ity maximized by inversions that breed fog. "It's a northern extension of southern climate," Wiegman says. The Monongahela also flows north, but its valley is too wide to offer a protective microclimate.

In 1948, Lillian McCahan wrote to Charles F. Chubb at the Conservancy, asking if it could acquire Ferncliff. Chubb replied that it could not, funds being depleted by the McConnell's Mill project. She also wrote to the Pennsylvania Department of Forests and Waters. An official responded that Ferncliff was too small to be a state park.

McCahan became even more concerned in 1951 when the Ferncliff owner, Alex Mead, prepared to sell the peninsula for $35,000. A prospective owner planned to cut the timber and build an amusement park (a 337-lot subdivision had been plotted there earlier). The West Penn Power Company's Industrial Development Department also advertised the site as a good location with ample water for small industry. In 1951 McCahan wrote to Dr. William Mayer-Oakes, a Carnegie Museum anthropologist from Pittsburgh whom she had met in Ohiopyle. Mayer-Oakes discussed the proposal with M. Graham Netting, then serving on the Recreation, Conservation, and Park Council of the Allegheny Conference on Community Development. With Charles Chubb of the Conservancy, Netting approached Edgar J. Kaufmann, owner of Kaufmann's Department Store in Pittsburgh, about acquiring Ferncliff. Kaufmann had spent weekends at nearby Fallingwater—his vacation home—and knew the area. He agreed about the importance of Ferncliff, and he bought it from the Mead heirs (Mead had died suddenly) for $40,000. In 1951 the peninsula and the Ohiopyle House Hotel were turned over to Conservancy ownership, beginning a Youghiogheny involvement of unrealized consequence.

The Conservancy coupled a commitment to saving outdoor "museum pieces" of natural history with a growing interest in riverfronts. John Oliver, president of the group in 1982, says, "We set out in the sixties to determine which rivers had the greatest recreation and natural area potential. The Youghiogheny was high, especially after the cleanup of the Casselman. The gorge is unique and close to Pittsburgh." With the nucleus of Ferncliff, the Conservancy, in 1958, announced its dedication to preserving more of the area, the first objective being to save the Youghiogheny gorge from further mining, logging, and land development.

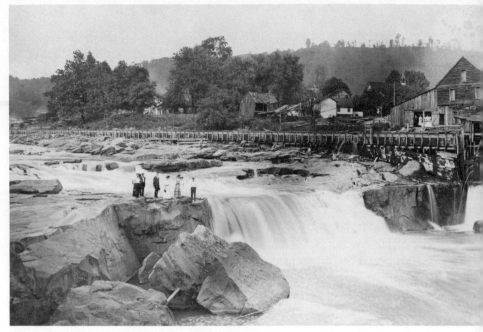

Ohiopyle Falls, mill, and raceway, about 1895

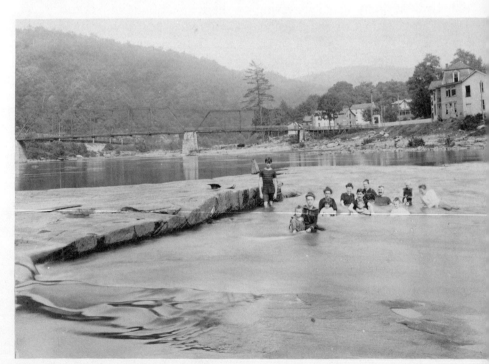

Ohiopyle and Route 381 bridge, 1908

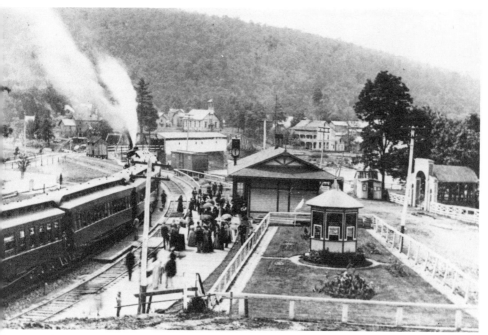

B&O Railroad, Ferncliff Park, and Ohiopyle, about 1890

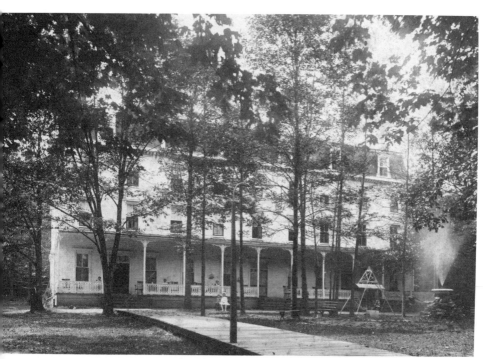

Ferncliff Hotel, about 1920

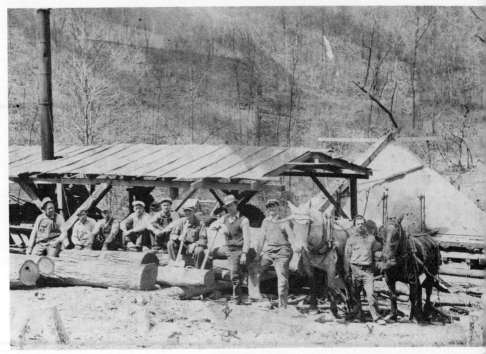

Logging crew on Kentuck Mountain, Shelby Mitchell in center (wearing vest), Oudie Mitchell on right, 1933

Shelby Mitchell

Bill and Adalene Holt

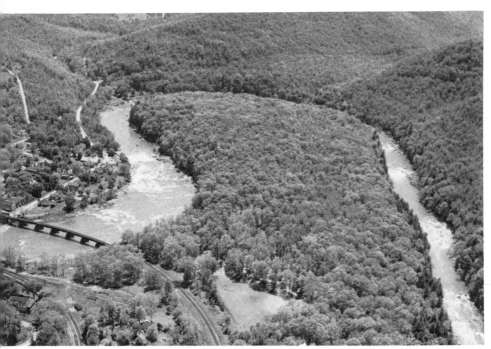

Ohiopyle and the Loop, about 1960 (photo from Uniontow Herald Standard)

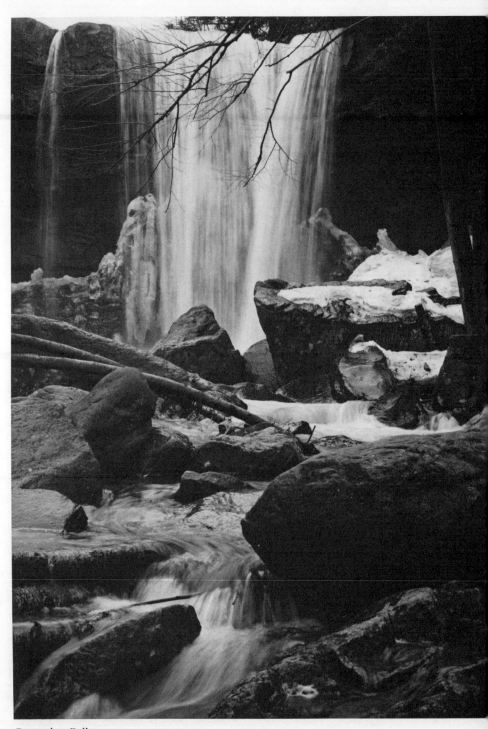

Cucumber Falls

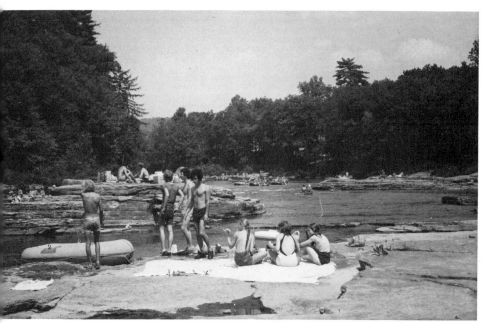

Picnickers and rafters at Entrance Rapid

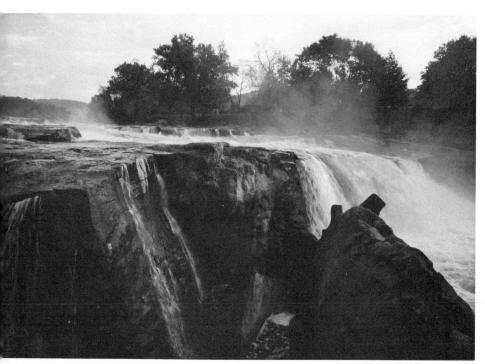

Ohiopyle Falls from Ferncliff side

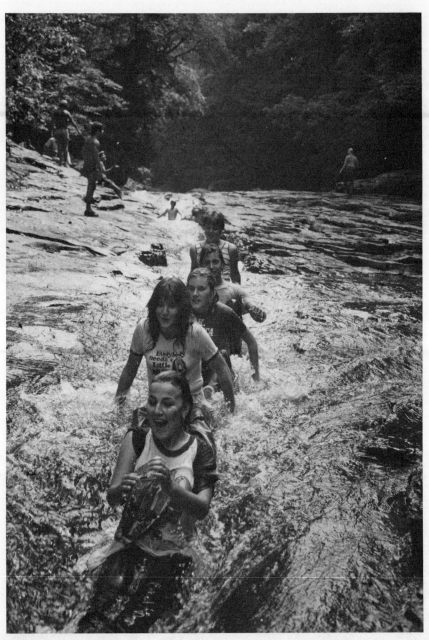

Meadow Run waterslide

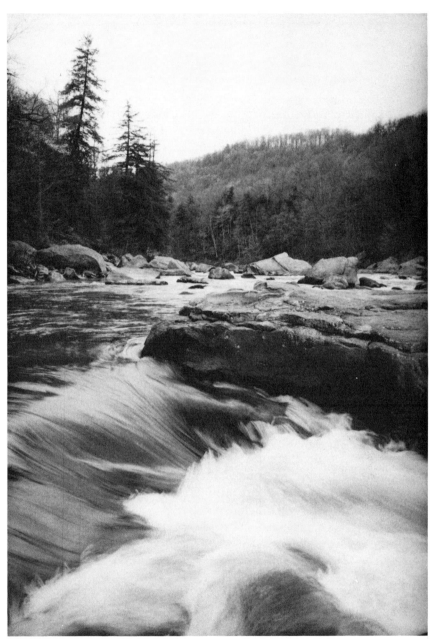

Railroad Rapid

Conservancy leaders soon realized that the potential of the Ohio-pyle effort demanded a long-range view, and that with a plan, they might persuade state officials to create a park. How much land should be bought, and where, and what should it be used for? What kind of park could Ohiopyle be? What kinds of activities would be possible? How could the key assets—Ferncliff, the Loop, the gorge—be protected from encroachments? For planning, land acquisition, and park development at Ohiopyle, the Conservancy received a $100,000 grant from a Mellon trust fund, and in 1959 they hired a firm called Community Planning Services. For one year, the planners, including David Fahringer (now a partner in the landscape architecture firm called Farhinger, McCarty, and Grey), analyzed the land, then recommended park boundaries. The Conservancy president, Charles F. Lewis, was involved in all decisions.

Because the gorge was a priority for protection, the acquisition border was extended upriver to Ramcat Run where the gap in Laurel Hill begins, and downriver past Bruner Run on the south side of the Youghiogheny. Increasing riverfront open space in Ohiopyle was also a goal, so more house acquisition was added to the plan. "The north slope of Sugarloaf had excellent slopes for skiing," David Fahringer says, "so we included part of it. Baughman Rocks, east of Ohiopyle, was an excellent overlook, so the boundaries were enlarged to protect scenic areas there. Tharp Knob ridge [Kentuck Mountain] was a good useable area for camping and a golf course. The high overlooks there are very good. Jonathan Run is a beautiful stream, and Meadow Run had potential for some small lakes. We tried to avoid good farmland. I think only one active farm—one of the Mitchell farms—was included."

The Conservancy also consulted Fahringer about the relocation of Route 381 (Front Street). The state Department of Transportation planned to relocate the road against the mountain with a 100-foot-high bridge spanning the Youghiogheny at Z Rapid. "It would have changed the scale of development," Fahringer says. "With big arches and cuts in the mountain, it wouldn't have fit with the setting." The new bridge was finally built directly upriver from the old one.

The planning study recommended that a state park be established, confirming what Dr. Jennings had said the decade before: "For a combination of rushing rapids, water falls, picturesque rocks, wooded valleys and gorges and rhododendron thickets, no park in the state is the equal of this region." From 1951 to 1959,

the Ohiopyle idea had grown from one of preserving Ferncliff as a natural area, to protecting the Youghiogheny gorges above and below Ohiopyle, to providing a large recreational park.

In 1959, the West Penn Power Company gave to the Conservancy river frontage from the Route 381 bridge to Meadow Run, including the old raceway site that led to the Kendall power plant. Conservancy officials called the gift the "most significant" they had ever received.

The Conservancy announced in the spring of 1960 that the borough of Ohiopyle would vacate an unused right-of-way along the river and that plans were being drawn for a parking lot, picnic grounds, and a trail. The Conservancy bought and razed six buildings to expand riverfront open space, and the dealings soon snowballed.

In 1961, Mrs. Albert Fraser Keister sold to the Conservancy 589 acres containing two miles along the river and one mile of Cucumber Run. This included the outside shoreline of the Loop, today's Great Gorge Trail, and forty-foot Cucumber Falls. Protection was underway, but destruction continued nearby: in 1961 a strip miner excavated an abandoned deep mine, releasing acid and iron, painting Cucumber Run orange and killing fish for sixteen miles to Connellsville. A few years later, an abandoned Cucumber strip mine was replanted by Boy Scouts supervised by Ralph Abele, who later became executive director of the Pennsylvania Fish Commission where he worked for water quality protection along the Youghiogheny. In 1962, "Keister Park" was increased by 987 acres, extending it to the mouth of Jonathan Run and to Tharp Knob on Kentuck Mountain.

Conservancy and state officials agreed that land would be resold to the Commonwealth in a pattern to become routine: The Conservancy would resell it at cost plus carrying expenses (including taxes and lost-interest payments) to the state when the slower wheels of bureaucracy would catch up. What the state would do with the land was undecided.

With Fahringer's plan, the Conservancy approached the Commonwealth of Pennsylvania about making a state park, and between the years of 1955 and 1979, this meant approaching Dr. Maurice Goddard.

The son of a lawyer-turned-minister, Maurice Goddard was born in 1912 in Lowell, Massachusetts, grew up in Kansas, attended high school in Toronto, Canada, then moved to Portland, Maine. He studied forestry at the University of Maine in the 1930s, when

resource managers faced constraints of the Depression but also a growing concept of public responsibility. From Aldo Leopold and others of that era, a philosophy of conservation gained a foothold in the schools. In the forties and fifties, emphasis would turn toward resource marketing and production, but in the thirties a crop of young foresters emerged ready to do public good, some of them with almost missionary dedication. Goddard graduated in 1935.

In his first year out of college, he taught at Mont Alto, where Penn State University sent its forestry freshmen. After several years in military service as a lieutenant colonel, Goddard returned to Penn State and served as chairman of the Department of Forestry from 1952 to 1955, when Governor George Leader appointed him secretary of the Department of Forests and Waters. In 1971 Governor Milton Shapp appointed him secretary of the newly formed Department of Environmental Resources (DER), incorporating responsibilities for public lands, water, air, mining, and recreation. For twenty-four years, Goddard was the state resource manager. Across the country, probably no other chief resource official—federal or state—has held office longer.

Many of Pennsylvania's laws and policies for conservation and environmental protection were enacted while Goddard was in office. Not much happened before, and not much since. He saw a host of new controls for clean water, clean air, and strip mining. Many accomplishments in conservation would not have happened without Goddard. Back in 1962, eight years before a wave of environmentalism swept the country, Goddard said: "We must recognize first of all, that we cannot go on desecrating this globe and expect it to be a very livable place by the year 2000."

In a few cases, environmentalists fought Goddard. For example, he staunchly supported Tocks Island Dam on the Delaware River, but in 1978 this section was added to the National Wild and Scenic Rivers System, to remain free-flowing. Together, Goddard and the conservationists were sometimes defeated. They opposed the construction of a huge tower at the Gettysburg Battlefield, but the state lost in court. Although strip-mine laws were adequate on paper, enforcement was sometimes a sham because of ineffective or corrupt bureaucrats who were entrenched beneath Goddard. But overall, he accomplished much for conservation, especially considering that Pennsylvania was an industrial state, old in every way, politically conservative, and economically declining.

Goddard combined technical expertise, a grasp of seemingly infinite detail, and the political savvy to survive under Republicans and Democrats alike (he has always been registered Independent). Down to technicians in the field, employees called Goddard "the boss," and in later years, they respectfully called him the "old man." He spoke in a deep voice and called everybody by his last name. Most people were not impressed with him as a warm and compassionate leader; he was almost feared, and seldom seen by many employees. His direct manner threatened some security-conscious bureaucrats who shunned confrontation or accountability. "So what are you going to do about *that?*" Goddard would demand of his deputies and bureau chiefs. Yet he would back them to the hilt when the politics got hot. The legislature was ready to vote to fire Bill Eichbaum, the department's chief attorney who sued the big polluters: U.S. Steel, Bethlehem Steel, and other industrial giants. Goddard called off the legislature by offering his own job in place of Eichbaum's. In these big poker games everybody knew that Goddard did not bluff. He is universally remembered for candor and honesty. His positions were clear, he played no guessing games, employed no devious plots, and for this he was respected. Today, Goddard is a living encyclopedia of Pennsylvania's environment and its protection, and for that matter, of state government since 1955.

When asked about his greatest accomplishment, he does not name a park or a dam or a cleaned-up river. He says, "Civil Service." He explains, "There were about twenty different states where the chief forester came from Penn State University, but none of the best people would work here. It was too political. Every four years employees were replaced by appointment. First thing I did was to change that. You can't build a park without competent people." Now, out of 3,200 employees, only eight are not civil service. The secretary was one of the eight, and was replaced with the former state chamber of commerce director when Republican Governor Richard Thornburgh of Pittsburgh took office in 1979.

The state park system in Pennsylvania is regarded as one of the nation's larger and better ones, and to consider it is to consider Maurice Goddard. He set a goal of one park within twenty-five miles of every citizen, and he met it, opening forty-one new parks, Ohiopyle being one.

The same year that Lillian McCahan asked the Conservancy and the Department of Forests and Waters to buy Ferncliff, Frederick

Law Olmstead, Jr. (son of the landscape architect who designed Central Park in New York and Fairmont Park in Philadelphia) surveyed the state's recreation needs. He recommend a park in the Ohiopyle region. Goddard was thus ready to listen when Conservancy President Charles F. Lewis arrived, enthusiastically promoting the Ohiopyle idea.

In 1962, at the Conservancy's dedication of the Keister additions, Goddard declared his hope "to create a full-scale state park here at Ohiopyle—one which will be almost unmatched in natural scenic beauty anywhere in Pennsylvania." In 1963 he said: "Through the efforts of the Conservancy, we have been able to acquire an important nucleus which will be expanded as rapidly as possible. I hope that all citzens of Fayette County will realize that this marks a new day for economic revival and better living." About the acquisition of the old coal-mined lands, he said, "It marks the end of waste and destruction and the beginning of real conservation and profitable recreation." No one had any idea just how profitable recreation would become. One year later, with maps signed by Governor Scranton, Goddard announced the beginning of an 18,500 acre park at Ohiopyle.

In 1981, Goddard reflects, "Until the mid-fifties, parks were much easier to establish because the state already owned the land. They simply changed state forests into state parks." Since Goddard's belief was that parks should be accessible to people, the remote state forests did not always provide adequate sites. Private land, closer to towns and cities, had to be bought. "We hated to condemn land," Goddard says. But sometimes he approved condemnation anyway, striving for the principle of the greatest good for the greatest number of people.

The problem with the state park proposal at Ohiopyle, and with the other forty-one new parks Goddard wanted to start, was lack of money. So to buy the land, Goddard initiated Project 70. "It was obvious to me in the sixties that if we didn't acquire those areas soon, we never would. The value of land was escalating rapidly." Goddard wrote in *Water, Land, and Life* (the Conservancy's magazine), "If remaining areas of scenic beauty and recreational potential are to be saved, they must be saved now. Tomorrow will be too late." He says that large-scale acquisition couldn't happen today. "You couldn't raise the money and people wouldn't support buying the land." And it couldn't have happened earlier, either. In the

1930s Governor Gifford Pinchot tried to pass a $25 million bond issue for parks, but the legislature rejected it. Goddard's presence in the department and his timing on the bond proposal were perfect.

The program was called Project 70 because 1970 was the target date for the park acquisitions. By coincidence, $70 million was the amount approved, but not until two consecutive legislatures, and voters in a 1963 general ballot, approved a constitutional amendment which was needed because of the amount of state indebtedness that would result.

It was Goddard's idea, and Goddard who sold it. He delivered 500 speeches on the topic in 1961 and 1962, working harder on this than on anything in his career, visiting each of the sixty-two counties at least three times. "It was a lot of hard work," he recalls. Goddard doubts that Ohiopyle would have become a state park without Project 70; there wouldn't have been enough money. On the 1963 general ballot, Project 70 won by 140,000 votes. "It was close," Goddard says.

Ohiopyle was the first public hearing under Project 70, and this was the first park to receive the money. "We didn't have any real serious problems," Goddard recalls. "There was a lot of support." In *Water, Land, and Life*, Goddard said that it was the "easiest series of meetings he had ever attended with property owners who would lose their land."

Conservancy officials touted Ohiopyle's potential as a natural area and also as a resort. With boosterism typical of the early sixties, the group announced that "a site will permit the building of one of the most beautiful golf courses in western Pennsylvania," and it wrote that plans were being drawn for "a modern hotel and restaurant, the largest and most modern in the region."

A 1964 issue of *Water, Land, and Life* carried a story titled "From Blight to Beauty at Ohiopyle." It said, "This total undertaking is being achieved at a minimum of disruption of the way of life in the area." Regarding a 4,758-acre acquisition in 1965, the publication said that only four dwellings were involved. "This illustrates the care which the Conservancy has exercised in attempting to build parks to as great an extent as possible out of economically unproductive and unused land."

So far, the Conservancy's approach had been to receive donations and to purchase land from people who were anxious to sell. But with Goddard's commitment to a park and the passage of Project

70, the acquisition program tracked a new course. David Fahringer's plan was pursued vigorously. Mountain land and most of Ohiopyle's Front Street were bought. The Conservancy's agent dealt with almost the force of government. A local resident complains, "The Conservancy was okay until they got the power to condemn." In fact, the Conservancy never had condemnation or eminent domain powers, but to some people, only hairs were split between the Pittsburgh group and the state.

On Kentuck Mountain, Ed Jackson's wife, Mary, had died, and in 1968 the Conservancy bought his place. Old Ed moved in with his son, Ed, down the road. So it was that young Ed, his wife, six kids, and Old Ed lived in a six-fireplace house built in 1871 by Martin Mitchell—Shelby Mitchell's grandfather.

"Through the grapevine, we heard the state was going to buy our place," Ed says. "You could see that the Conservancy started in Ohiopyle and kept moving out. I don't think anyone really knew what was going on. Then we got a letter from the state saying something like 'your place will be bought.' They offered twelve thousand some dollars." The same thing had occurred in Somerfield for Youghiogheny Reservoir in the 1930s, and was repeated in several dozen homes around Ohiopyle. Ed Jackson says, "Most people just took what they were offered. They'd say, 'You can't fight the state.' But I decided to appeal. We hired an attorney in Uniontown and he said the place [130 acres with a house and barn] was worth $130,000 because we could sell it off in lots. Turned out we got sixteen thousand something." The additional money was little more than fees for attorneys. Many people agreed that Uniontown lawyers were the only ones to profit.

"We didn't exactly want to leave," Ed remembers. "It was kind of hard. You had your whole life back there. I didn't think too well of the park, but didn't get too angry because there wasn't anything you could do when all was said and done." The Jacksons bought a few acres near Chalk Hill Road and built a house for $21,000. To do this, they borrowed $5,000 at 6 percent interest in 1968. "Most people were that way," Ed says. "To get resettled, they had to spend more than they got for their old places."

Ed's father and wife have since died. He is sixty-five and retired after having a heart attack. His kids are grown but live nearby; one is next door. "I'm getting to like it out here," he says of his new

house. "There are good neighbors. But I miss the old farm. There's lots better hunting there. I go out hunting here, but I'm not satisfied until I go back to the farm." At the entrance to the state park campground you are standing on the land that was Ed Jackson's.

Maurice Goddard was right: state representatives heard few complaints, but Ohiopyle people complained plenty among themselves. They agreed that farmers could starve while trying to coax a living from the rocky, worn-out soil and no-account cornfields of this up and down land, but they still didn't understand why the state was elbowing in on them. Ed Jackson says, "There was only one full-time farmer then, but we still figured the state had enough without taking the old places."

People complained about losing Front Street and with it, the town's basic identity, run down though it was. "They didn't have to take so much of the town," Adalene Holt says. "Front Street could have been fixed up and made into shops. Look at places like Williamsburg. They could have kept what was here."

It was difficult for people to move. A few years later, the state began relocation payments: if the state bought your house, it would pay your cost of resettling. But in the sixties there was no such help. You got market value and fended for yourself. "A lot of those old houses were falling down," Bill Holt says. "They weren't worth more than $3,000, so that's what people got. But they needed more than that to buy a new place. Most of those people were up in years and they died soon. The move was real hard on some of them."

Bill Forrey, director of state parks, says that the old farms were needed. "Not everybody wants the high density recreation areas around town," he says of the park users. In a few cases, the state bought the land and leased the homes back to elderly owners so they wouldn't be uprooted. "But not too many people asked for that," Forrey says. If people didn't ask, the state didn't offer.

"And in town, it made a lot of sense to get the buildings away from the river," Forrey explains. "The river is such a strong asset, we wanted to open it up and relocate the road away from it." Goddard says, "We had to get access to the river."

Ed Deaton, the Bureau of Parks' landscape architect for Ohiopyle, says, "I think the town adds a lot of character to the park; it tells you that this place has had a history. We saved what we could, but if we hadn't bought Front Street, it might have forced us to develop Ferncliff, and traffic would have been congested all the

time. I think we did the right thing, but obviously I'm not a resident who was displaced."

"We wanted to keep what we could of the town," Forrey adds. "We had a water and sewer system built at no local expense, even though it would probably have been cheaper to buy everybody out." More than $700,000 of federal and state funds were spent on the sewage treatment plant and its lines which serve the park and the town.

Maurice Goddard says, "The private property owner didn't suffer financially. Emotionally maybe, but not financially. If anything, we erred on the high side."

Fern Colborn, who grew up and lives near Mill Run (eight miles from Ohiopyle) can see the local view. She has been president of a local water company since 1955, dealing with land owners and their problems. She was also on the Conservancy board of directors. She says, "There isn't an honest person who was moved who won't tell you they got full value for their land. Many got more than they would get on the open market. It just comes down to the fact that the community didn't want to be moved."

Mark McCarty, owner of Laurel Highlands rafting company, saw the transformation of Ohiopyle as he began guiding raft trips in the late sixties. "In the short-term it hurts because it's your land. But it's also kind of nice of have an eighteen-thousand-acre playground."

Bob Marietta, an Ohiopyle native and co-owner of White Water Adventurers rafting company, says, "The houses on Front Street were falling down anyway and sewage was running all over the riverbank. Nobody can look down there today and say that the park isn't beautiful."

Yet discontent ran deep among many local people. The Ohiopyle House—the oldest and only remaining resort hotel—was owned by the Conservancy and had been improved in 1963 with renovated floors, ceilings, bedrooms, furnishings, and a new kitchen. On November 13, 1964, the thirty-seven-room showcase of restoration burned to the ground in a fire of "undetermined origin." The day before the blaze, a Conservancy employee had been threatened at the hotel. No guests were inside. Many local people think that the fire was lit by somebody trying to "get even." In later years, the ill feelings would be aimed at other programs of the government, whether or not they involved land acquisition; a proposed national wild and scenic river designation would go nowhere.

In the seventies, park and open space programs at both state and federal levels all over the country would encounter growing resistance from residents, while budget cutbacks would reduce the government's buying power. New approaches would gain favor, such as acquisition of easements where new development is stopped but people remain on their land. Because of lessons learned in Ohiopyle and similar places, many of the problems of displacement of people are now avoided in new park areas.

In 1982, Conservancy President Oliver says, "Today we would never imply that people should sell to us or wait for their land to be condemned by the state." He cites the Conservancy's recent program—land purchases along the Clarion River of northwestern Pennsylvania—as an example of a "modern" approach. "In some cases, we bought easements so that people can stay and do what they've always been doing. The only thing we buy is the development rights; they can't develop their land or sell off lots." The Clarion riverfront will stay the way it is and nobody had to leave.

With most of the land acquired, the Conservancy's role along the Youghiogheny faded in about 1970 and the state forged ahead. Since the beginning of the open space project, twenty-nine houses had been torn down in Ohiopyle. The Department of Transportation moved Route 381 farther from the river and then constructed a new bridge. A sharp bend on the northern approach to town was eliminated by slicing off the side of the mountain. "It's the worst thing visually that was done in the whole park," says landscape architect Ed Deaton.

Deaton and Jim Tabor—another state landscape architect—refined plans, recommending that some earlier ideas be dropped. "The golf course on Kentuck, the ski resort from Sugarloaf down to the river near Victoria, dams on Meadow Run, and the new hotel at the Potter House—we dropped all of them," Deaton says. "People hadn't considered a lot of things, like all the traffic those facilities would generate."

Goddard agrees. "The so-called artificial facilities are not what I believe should be in a state park. There's a lot of value in keeping Ohiopyle as natural as we can."

"If there are to be hotels or developments, private enterprise should do it," says Bill Forrey. "We tried to get somebody to develop a hotel, but high interest rates and the seasonal nature of Ohiopyle have discouraged that sort of thing."

The Conservancy's Oliver says, "My personal opinion is that it's good that the state did not pursue the developments. Where we have sites like the Youghiogheny, I like to see them stay in a natural condition and undeveloped." Almost everybody agreed that Ohiopyle should escape the mass-market commercialization that saturates tourist towns from Gatlinburg, Tennessee, to Jackson Hole, Wyoming. There was a minor outrage when Stu Van Nosdeln opened a Dairy Queen franchise near the Falls.

The statewide parks plan, prepared in 1970 for the DER by David Fahringer, calls Ohiopyle an "outer urban" and "resource oriented" park. The idea is to accommodate many city people, but to avoid a Disneyland. To enjoy the natural surroundings is the main objective. "The river's the heart of the park," Ed Deaton says. "The river is why people come.

"Traffic was still a big problem," Deaton adds. "People parked all over the place and carried their rafts down the middle of the road. We saw that we had to get the commercial boater's parking lot out of town. We did a transportation study and came up with a bus system." All guided rafting customers park their cars one mile south of Ohiopyle along Meadow Run, and outfitters' buses shuttle people to the put-in.

"The biggest piece was the boating system," Deaton recalls, "and the biggest design problem was the put-in. We have a lot of people in a very small space. Everybody was walking across a major highway."

The staging area—where people meet and organize—was moved from the town park on the upper side of Route 381 to the river side where Deaton reluctantly agreed to some additional clearing of land. The state was criticized for cutting down trees, but the landscape architect says, "Honest to God, we looked at every tree and they came out like wisdom teeth." They paved an asphalt trail to the river, and a small office was built where rangers can check boaters for permits.

The rafters' take-out was the other big problem. Maurice Goddard calls it the most controversial aspect of the park. Most boaters had been taking out at Stewarton—six miles below Ohiopyle at the site of an old logging settlement where a gravel road reached within 100 yards and a steep climb from the river. There was one major problem: everybody had to scramble across the railroad tracks. Fearing that they would kill somebody, Chessie System officials, reinforced by a U.S. District Court order, announced in 1978 that

nobody would be allowed to carry boats across the tracks. "We searched every possibility for a new take-out," Deaton says. "We considered using the abandoned Western Maryland line and running our own trains on it, but we needed two tracks. We considered a pipe under the railroad at Stewarton, but we needed more land. We looked at Indian Creek, Camp Carmel, and Crooked Run. Finally we settled on Bruner Run. It had a good area on top—the old Mitchell place—for private boater's parking. The road system up there wasn't heavily traveled."

Not everyone agreed that Bruner was the best site. Along the Youghiogheny in Pennsylvania, mountain tributaries more than three miles long are the Casselman River, Ramcat Run, Meadow Run, Cucumber Run, Bear Run, Jonathan Run, Laurel Run, Bruner Run, Morgan Run, Indian Creek, and another Laurel Run upstream from Connellsville. Of these, Bruner was the least affected by roads, which parallel or cross all others. Below South Connellsville, roads are even more abundant. Bruner Run offers cascade waterfalls and excellent water quality. The state owns most of the basin, which includes old timber. A railroad, wagon road, and a few houses were there seventy years ago, but these have rotted and been grown over. To reach the rafters' take-out, the state would pave a new road for 1.6 miles along Bruner Run.

Richard Pratt of the Sierra Club in Pittsburgh, Bruce Sundquist of the American Youth Hostels, and others argued that one roadless stream was not too many. "The Bruner Run area was our best for wild-area hiking," Pratt says. Paul Wiegman of the Conservancy considered Bruner among the best natural areas of its type in the region. Environmental organizations led by the Sierra Club opposed the state's plan to build the road.

Although not in opposition, the Conservancy offered the use of its land along Laurel Run as an alternative. Paul Wiegman says, "At Laurel Run, effects on residents would have been very slight." But Ed Deaton says that the state would have needed to tunnel under the railroad.

While debate ensued and plans proceeded, the rafting outfitters needed a place to take out. Stuart Van Nosdeln, owner of a raft-rental company, bulldozed a new road across State Game Commission land and to the river below Bruner Run. He was accused of doing this without right-of-way agreements and without state permits. When the four guide companies went to court in their efforts

to continue using Stewarton, the *Pittsburgh Press* reported that Van Nosdeln sent his business consultant to speak against them. Then, for $10,000 each, Van Nosdeln offered the guide companies use of his new road. They reluctantly agreed, but the deal was canceled in a huff when Van Nosdeln charged an added fee for each customer that the outfitters brought. The road was almost unusable anyway due to its slope, mud, and shabby construction.

For two years, the guide companies took out at Indian Creek (three-and-a-half miles below Stewarton), but they didn't like it because the extra distance was gentler current, and tired customers had to paddle their rafts to get home.

The final decision on the new take-out hinged on local residents, who opposed access from the northeast side of the river because it would mean traffic and acquisition. Bruner was the only alternative on the other side. Cliff McConnell, deputy secretary of Environmental Resources, said at a 1977 public meeting in Confluence: "We got petitions from . . . people in the township, so we changed and we are now working on the other side, which would be Bruner Run." It appeared that state officials would rather take heat from the Sierra Club than from local residents.

Park Superintendent Larry Adams maintains, "Bruner Run was the best all-around site, operationally and otherwise."

State contractors built the Bruner Run access in 1978. To avoid cuts in the mountain, the road is one-lane wide. It was designed to blend into the surroundings, except for one bridge where the contractor concocted a cement pigment that turned out pink instead of tan. Boaters began taking out at Bruner Run in 1979.

The state built other facilities: a 225-site campground on Kentuck Mountain, picnic areas at Tharp Knob and at the old company coal town of Stonerville where about twenty houses were torn down, and a headquarters near Meadow Run. The Bureau of Parks closed the road, ballfield, and picnic area at Ferncliff when it was designated a National Natural Landmark. The peninsula was to be a nature preserve, though some local people wanted it to stay open to cars and ballgames. The state barred four-wheel-drive vehicles in the backcountry, closing a trail from the Sugarloaf fire tower to the river. Not wanting to walk, some local fishermen and hunters grumbled.

The Laurel Ridge Trail was cleared and a snowmobile area designated on Sugarloaf. Shelby Mitchell's house, bought by the Conservancy in 1964, was converted into a twenty-two-bed youth hostel.

Policymakers and administrators like Goddard and Forrey, and designers like Deaton, were not the men facing Ohiopyle's day-to-day complications. Making the place function is the job of the superintendent and his staff.

Chuck Rea worked as superintendent from 1967 to 1975. When a opening appeared at Black Moshannon Park in remote central Pennsylvania, Rea moved. Jay Steck, who had worked with Pittsburgh city parks, served for a short time, then transferred back to Point State Park in downtown Pittsburgh. Ohiopyle already had the reputation of a headache park. A wasps' nest of problems included poor relations with local people, congested traffic, unfinished construction, and inadequate patrol and law enforcement.

Local people suffered culture shock in the park's early years as waves of visitors descended. Gwen Waters says, "In the old days, people came to the hotels or to boardinghouses and they stayed awhile. Now, people just come in and they go. They don't mix with the local people at all." It may have been for the best: in 1970 some of the visitors seemed like they were from outer space. Whitewater boaters and river guides were a new breed. There were hippies, city slickers, and teenage kids who just got their driver's licenses. There were bikers and drugs.

Shelby Mitchell says, "There was a hell of a lot of riffraff and dope."

Bill Holt served as mayor during those troubled years, doing what he could to help his town through the inevitable transition. One day while sitting on his porch overlooking the new park, he was faced with an X-rated scene—a young couple on the grass. "I yelled at them to cut it out," Bill says. "We have kids around here, and who needs that? It got worse, so I started down the steps. I didn't have to do a thing; Bobby Marietta and two other Ohiopyle boys saw my problem and they took over." All it required was a swift boot in the rear, which was an easy target. Bill says, "Our boys sent that couple running. I remember Bobby saying, 'If you ever have any problems, just let me know.'" Bobby, a teenager, was a hell raiser, and if he happened to have a good cause, that was fine. Bill laughs and says, "I never called him. Honest to God I was afraid he'd kill somebody."

Park managers dealt with the take-out controversy. Most troublesome of all, they faced an explosion of popularity in whitewater rafting. Mobs of people were trying to put in and take out at once.

When groups of eighty or more customers would congest a rapid, guides from different companies shouted at each other. Safety standards were unresolved and the way rafts were piling up at the tight rapids, someone was going to get hurt. The Youghiogheny became the most popular whitewater in the United States, and with this came the problems of Coney Island or a ski resort on Washington's birthday. Larry Adams would be the new superintendent to face these problems and to do something about them.

Fourteen miles of the Youghiogheny flow through Ohiopyle State Park—Pennsylvania's largest in land area, including 18,712 acres in 1982.

In 1968, 160,000 people came here. By 1975, this grew to 646,000 and by 1978, 1.8 million. After a decline in 1979, visitation soared to 2.4 million in 1980, fell to 1.6 million in 1981, then climbed to about 1.7 million in 1982.

A survey by Penn State University and the state park in the late seventies found that 14.5 percent of the visitors came from Allegheny County (including Pittsburgh). Fayette County (including Connellsville, Uniontown, and the park itself) ranked second with 5.5 percent. Over 55 percent of the people traveled from other states: 26.8 percent from Ohio, 8.9 from Maryland, and 6.7 from Virginia. Over half of a percent traveled from foreign countries. Larry Adams estimates that 60 to 70 percent of the summertime boaters live in other states. "No other Pennsylvania state park has a river that is such a focal point," he says. In fact, there are few other parks in the United States that are so dominated and dependent on a river.

Visitors' travel time from home to the park averaged 3.4 hours— the longest of all Pennsylvania state parks surveyed.

Average years of school completed by Ohiopyle visitors was 14.75. Four years of college were finished by 42 percent, compared with 16 percent for all state parks surveyed. Twenty-four percent of the people—more than in any other park surveyed—had incomes in 1981 of $10,000 to $15,000. Forty-five percent of the visitors hold professional or technical jobs, compared with an average of 17.5 percent for all parks surveyed. The average age of visitors was 31.7—the lowest on record.

Boating was the main activity for 33 percent of the people, compared with 1.8 percent for all state parks surveyed. Thirty-four percent of the visitors came to camp and 10 percent to hike.

On summer weekends, boating and camping space fills to capacity. Reservations are required weeks—sometimes months—in advance. Superintendent Adams says, "I expect the popularity of boating and camping will keep growing. Weekdays may be filled up in three or four years."

People who go to Ohiopyle enjoy the park. They say, "It's a beautiful place." "I didn't know anyplace this nice was so close." "We like to swim and lay on the rocks." "I came to hike the trail." "I like to paddle that river." "It's a place to get away." Surveys show that over 70 percent—higher than the state average—were "very satisfied" with the park's appearance and with its employees.

After fifteen years of change, and with improvements in state management, most of the surviving local people have grown to accept the park. Bill Holt says, "Before, there was nothing to do. The town was dying, almost dead. There was nothing left. You had to go out of town for work. Maybe guys could get a mining job near Uniontown, but even that was tough, and there were no finances to go to college. People were really against the park, but the town is better off now."

Bill Forrey says, "The park provides jobs. I don't think there are as many people on welfare as there used to be." The park, rafting, and related businesses generated $6 million a year in the Fayette County economy, according to a county tourism agency. Over 130 jobs (most are seasonal) are directly attributable to river recreation and the state park.

John Oliver of the Conservancy says, "There's a tremendous satisfaction in knowing we had a hand in creating a magnificent state park, something with national appeal."

Ohiopyle State Park is the Appalachians, the town, and the history of logging, mining, and old-time recreation. It means looking at the Falls, lying in the sun, hiking, camping, and swimming. It means these things, but above all else, it means whitewater.

Whitewater

The Rapids and the Pioneers

Do you remember the first time you saw the Youghiogheny? Steve Martin of Ohiopyle laughs. He squints his eyes a bit, remembering how his life with whitewater began. "I was about twelve. It wasn't all that much fun. My dad got me a kayak and made me come. What I really wanted to do was stay home and play with my friends." He was growing up near Altoona, Pennsylvania, where his father owned a machine shop. At an early age Steve acquired a reputation for adventurous, fun-loving antics. He rode the cows at the farm. He jumped off roofs for the merriment. He began skiing, and was soon sailing off bumps and doing flips. His father was a weekend canoeist, and in an act of genius, maybe aimed at keeping his kid off the streets, he decided to divert some of Steve's rambunctious energy into paddling.

"Summer of '69 we walked down the tracks and put in at Railroad, then ran to Stewarton," Steve recalls, "That way we missed the Loop. I wouldn't run Dimples or River's End. I walked around them. Then we came back to do the Loop and I flipped in Eddy Turn and went tumbling over the rocks. I just walked out right there. That was enough, but in two weeks I was doing all right."

When I started to write about the Youghiogheny, in the summer of '81, people in Ohiopyle advised that I talk to Steve. Jim Prothero said, "He's been there about the longest. He's the best boater." I found him on the Wilderness Voyageurs property, at the end of a

188

skinny path that winds storybook fashion up a steep hill from Garrett Street, in a little red house, upstairs on his bed, staring at the ceiling after a day of work.

Pure Prairie League was loud on the record player. "Hey, why don't we go out on the porch?" Steve asked. We went out and sat. "You want that light on so you can see your paper?" he asked and paused. "Where you from?"

I said, "I'm a nomad now."

"Yeah? Me too," and his eyes lit up and squinted as he smiled. Steve Martin stands about five-foot-nine and is trim but muscular with arms and shoulders that bulge when he is pushing his kayak to the limit. Sandy hair, several inches long, parts in the middle and drops down over his head. He has a moustache and rounded facial features. Blue eyes shine friendly.

Steve is relaxed. He is quiet. No need to fill up all the silence. He does not have a speedy impatience for the talk, is not uptight. Yet there are other times—times for which he is notorious—when he is so packed with energy that he is about to blow up. He carries on and jokes and it is like electricity crackling to an opposite pole.

Steve recalls his early days of paddling. "It was an easy way for Dad and me to go out. I never did well in school, but Dad forgave me because I paddled okay." Steve began racing at thirteen, and in two years he impressed the paddling afficionados as a budding superstar. "They sent us to Europe, but I had a big head and didn't train and got wiped out. My dad didn't push me, so I quit. There I was, fifteen and burnt out on racing."

"When I graduated from high school there was really nothing else I was trained for," Steve recounts. "I could have worked for my dad in the machine shop, but it sounded like a better idea to come here and work outside. We knew Lance [Lance Martin—an Ohiopyle outfitter and no relation] and he hired me as a Wilderness Voyageurs guide."

Jef Huey, Steve's guiding partner for seven years, said, "The first year, he made the typical rookie mistakes. It was entertaining, but his personality got him in trouble. He had too much fun. But soon he developed a real professional attitude."

Martin became one of the best paddlers anywhere. He flips his kayak end over end, shoots waterfalls, takes the most serious rapid and plays like a kid in the tub. In Sweet Falls (a Class V drop on the Gauley River of West Virginia) he throws his paddle into the air.

He misses catching it, tips over, and rolls to an upright position by use of his bare hands at the bottom of the falls.

He lives with—is drawn to—an element of danger, seeming to need it to balance or satiate something inside him. He has been reckless and prone to excesses. There is very little to neutralize his drives for adventure. Whatever the possibilities may be, he chases them and takes the consequences. "Go all the way; do it all the way," he says of most anything that he is committed to, even if he has not thought it through.

The danger catches up to Steve and he does not always escape unharmed. One year he broke his ankle, but in two weeks he was paddling again. The first day that he returned as a guide, he fell while carrying a raft and broke off a tooth.

This may convey the image of machismo, of an unapproachable crazy man, of someone nearing nuthood. That is the wrong image. Martin has a personality—I would say charisma—that reaches out and welcomes people.

"There is something about him," said Jef Huey. "He can mix so well; he's so alkaline he can get along with anybody."

Jim Prothero said, "In his earlier days, Steve talked to people on the river and it was like magic to them. He was right there. He knew what they were thinking, or feeling, or wondering."

Steve is an uncommonly human whitewater fanatic. Neither his strengths nor his weaknesses are buried very deeply. While others tend to dwell on his strengths, he dwells more on his weaknesses, especially during this summer.

Like Prothero, Martin was fleeing something else—life in the machine shop—when he arrived here seven years ago, but he was also attracted to this place: to whitewater and a job. Now, summer of '81, Steve senses that it is time to search for something new. His tolerance for the job has ebbed, though his passion for whitewater has not.

We are on the river. Steve powers his kayak up the guts of Cucumber rapid and drops the nose into a gaping hole that sucks him in where he sits surfing, foam engulfing him up to his armpits as he occasionally strokes or rudders to keep equilibrium between him and the Youghiogheny. I look at him from my canoe. He and the Youghiogheny are the same, together. He is a part of it as much as a rock on the bottom, a fish in a pool, or any bucketful of water

speeding past. To explain the joy of this harmony is to push words further than they can go. Steve Martin is not the most articulate man in the world, but on this subject, he says it best as a wave bursts over the deck of his boat, foam drenches his helmet, and he shrieks above the roar of the river, "Eee-haaaa."

Whitewater. There is something about it. I suspect that the looks of it are part of the appeal. The sound, the coolness, the movement, the reflections of sunlight; all of these things enter, but there is more to it than that.

Recent studies of ions—positive and negative charges of electricity in the air—have found that negative ions make people feel good. The unusual bombardment of negative ions at high elevations is thought to cause "Rocky Mountain high"—the good feeling that many people enjoy above timberline. Maybe this is the source of the idea that going to the mountains is good for your health. The invigorating feeling that some people have following thunderstorms may be due to negative ions, plentiful after lightning.

The air around waterfalls teems with minus ions, which may account for some of the fascination felt near falling water, whether it be along Meadow Run in Ohiopyle State Park or next to the fountain in Mellon Square, Pittsburgh. Go sit on a rock at the Ohiopyle Falls and see how you feel. Why has Niagara Falls been a honeymooner's hotspot all these years? Maybe it's all the negative ions that can boost lovers off to a good start. Negative ion machines are widely used in Europe by victims of depression. What does all this have to do with the Youghiogheny? The rapids of the river seethe with negative ions.

Canoeists, kayakers, rafters, and swimmers who enjoy a rapid-fixation might be enchanted by the rushing sound, the thrill of smashing down then surging up, the color of green depths beneath white foam, the shower of cold water on hot days, the ability to survive by wits and skill, and the freedom of letting life go. Yet there is something in whitewater that defies explanation, something that simply crazes people with pleasure. If you haven't been in whitewater, there are probably no words that will bring the feeling home or make sense. If you have been there, and especially if you had first developed some skills, and then went slowly, you may have felt the special appeal. Whitewater becomes more than fun. It becomes a passion in the body as well as the mind. This verges on

the spiritual and verges on the scientific; river magic and negative ions.

In his kayak, Steve Martin pops out of the hole at Cucumber and he is awash and aglow with the Youghiogheny. In his element. We paddle a short distance to Eddy Turn, where Steve-the-kid crashed twelve years ago. Now that he has guided for seven years, the rapid is familiar: "I kind of know this stretch now," he says in reference to hundreds of trips. This is the fifth rapid of "the stretch": seven miles from Ohiopyle to Bruner Run that are paddled by more boaters than any whitewater in America.

From the bottom of the Falls to Bruner Run, the Youghiogheny drops twenty-seven feet per mile. Entrance is the first of fifteen rapids. Ledges cross at the top; three-foot waves follow. In the lower half of Entrance, rocks are scattered like stars, whole constellations of them. Some rocks lie as smooth as a baby, others point at the sky and are jagged enough to rip a boat. It is not healthy to fall out of a raft in Entrance because you will personally meet too many rocks during a bruising swim. At low water, paddlers rate Entrance as Class III rapid ("high, irregular waves often capable of swamping an open canoe. Narrow passages that often require complex maneuvering"). At high levels it rates a more difficult Class IV.

Next comes Cucumber Rapid, entirely different. It is not shaped like a Cucumber, nor hard to find like a cucumber in the garden. It is simply located below Cucumber Run. The run may have been named for the Cucumber tree (cucumber magnolia) that grows there. Or it may have been named because of copperheads, the snakes that sometimes smell like a cucumber. Below the run, the river is crammed into a tight space between a rock and other rocks. Submerged boulders create holes and waves, and it is the kind of rapid that flushes you down with little choice and no waiting whatever. The river goes and you go with it, hopefully favoring a route that lies left of center.

Piddly, Camel and Walrus, Eddy Turn, and Dartmouth are smaller drops inviting the canoeist or kayaker to play, to eddy-turn, to thread narrow spaces between Pottsville sandstones, and to surf on waves. Camel and Walrus is named after two rocks said to resemble those animals, but you will need more than good vision to see them. Dartmouth is named after the Dartmouth Outing Club which raced here every spring before the New Hampshire rivers

THE RUN AT OHIOPYLE

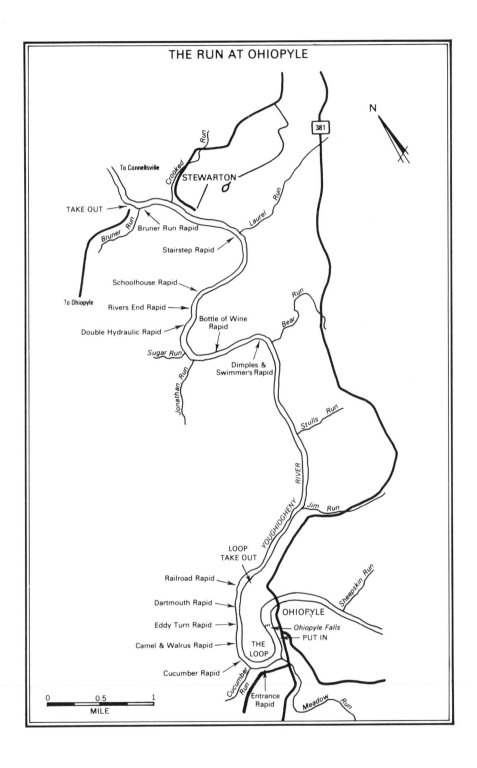

thawed. Annual whitewater slaloms including national championships are still held here.

Then comes Railroad Rapid. The High Bridge on the abandoned Western Maryland line juts through the background, but most people never see beyond the rocks at their nose. Boulders split the current into many Youghioghenys, each foaming over sandstones. Charlie's Washing Machine is a hole to the right of center that can recycle boater and gear until clean and then some. The Frog's Head is a skinny route on the far right, popular with kayakers and canoeists during high water. Railroad hosts plenty of spots where only 20 percent or 60 percent or worse yet, where only 90 percent of a raft fits. The other 10 percent gets stuck tight.

That completes the famous Loop, 1.7 miles dropping sixty feet in Class III rapids (at high water, Entrance, Cucumber, and Railroad are Class IV) that take you within a short walk of your starting point, only lower. During the afternoon, many people get out at Railroad and carry their boats to their cars, parked one-quarter of a mile up the hill (Loop trips are not allowed before two o'clock in order to avoid crowds of boaters who are going on to Bruner Run). The Loop is unique. There is probably no other place with such good rapids and so short a shuttle to the starting point. This makes Ohiopyle an excellent place to learn whitewater paddling. Many paddlers think it is the best place, anywhere, and I agree. The people giving lessons here—John Lichter, Jim Prothero, and Jim Wilson—should have a bright future.

The Youghiogheny runs quieter with small rapids for three miles. Then comes Dimples. Thirty percent of the river slams into a rock on the left shore, then splays 90 degrees to the right to pillow over another rock. Whitecaps and more rocks follow. This rapid was named by some of the first canoeists who scouted the drop and discovered a sunken canoe called "Dimples." Swimmer's Hole and a train of haystacks (large symmetrical waves) follow. This is the place where people take a break from paddling and leap from a rock to swim through the big waves. Bottle of Wine comes next—a rapid named by canoeist John Sweet who found a half-full bottle on a rock.

At Double Hydraulic, two giant holes lurk in the center, capable of trapping boats. A hydraulic is where water washes over a rock and billows into a wave. The wave breaks surflike to the upstream side, creating a hole in front of it. The current pushes a boat into

the hole, but its steep slope deflects the boat back upriver, and the boat sits there, bouncing around. Eventually, a raft will fill with water, causing it to sink lower in the current and wash through.

River's End may be the most memorable rapid, the most dangerous, and sometimes the most difficult. It does not signify the end of the trip (the take-out is still a mile away), but it does *look* like the end of the river. From the upstream view, the whole thing seems to be sucked into the horizon. The current at once plunges over a ledge and around a blind corner, threading a narrow route between van- and truck-sized boulders. Then come the rapids of Schoolhouse Rock, Stairstep, Stewarton, and Bruner Run which is exciting on the left, leading to the take-out.

This litany of rapids paints the Youghiogheny as only whitewater. In fact it is more. It is creatures: crayfish, trout, and beaver. It is raccoons dipping supper at night, mergansers chasing chubs, bufflehead ducks napping on a break during migration. It is rocks: the most boulder-riddled river in Pennsylvania. The rocks are 500 million-year-old sandstone, the hard backbone of a 300 million-year-old mountain that arose in the river's path—a mountain that yielded to the gentle but greater power of water, with this gorge being the result. The river includes the boulders that line the shores and describe a hard outline of tan and gray instead of the fuzzy edge of willow, grass, and mud that compose most river banks. The rocks are like dozens of grade AA extra-large eggs, like armor between land and water, like the earth turned inside-out. Beyond the boulders to the 700-foot mountaintop, the gorge rises in green. It is as green a landscape as one can find, accented with pines long ago stunted by lightning bolts. This place could pass for the wild eastern landscapes painted by Thomas Moran—the type of paintings that first coaxed people to love wilderness instead of hating and trying to subdue it.

The Youghiogheny is water from West Virginia and Maryland, from springs and fields, from woods and towns, from sewers, culverts, and the back end of coal mines; water on the way to Pittsburgh, Memphis, and the Gulf of Mexico. To say it all, the Youghiogheny is a river, although the full meaning is seldom felt. The way it is today, rapids are the main thing. They are the maker of thrills and of dollars in Ohiopyle.

The Youghiogheny is Pennsylvania's best whitewater that has enough flow to be paddled all summer. The Lehigh River in the

northeast holds good rapids, but is easier than the Youghiogheny. Compared to rivers throughout the East, the Youghiogheny is one of the few whitewater streams that can be run all summer, but it is not the most demanding. In West Virginia the Cheat River is more difficult (but after May it is too low), the New is several times larger and more rigorous, and the Gauley—runnable only in the fall when water is released from a dam—approaches the limit in commercial rafting with Class V drops. In high runoff the Big Sandy and Blackwater are extremely formidable, perhaps outdone only by Maryland's upper Youghiogheny. Western Maryland's North Branch of the Potomac and Savage rivers are more demanding than the Ohiopyle run, but not regularly boatable. Tennessee's Ocoee River is comparable to Ohiopyle's Youghiogheny and is the next-most-floated whitewater in the East with 60,000 boaters in 1981 on a four-and-a-half mile section. The Chattooga River of Georgia has several sections, some gentler and some rougher. The upper Hudson in New York, runnable only in the spring, is comparable to the Youghiogheny. In Maine, the West Branch Penobscot and Kennebec have short reaches with larger waves and steeper drops. In the West, rivers that are boated are typically larger and less technical: higher waves and fewer rocks. California's South Fork of the American, less technical than the Youghiogheny, may be the country's second-most-floated whitewater. The Stanislaus of California was probably second only to the Youghiogheny in popularity until 1980, but was flooded by New Melones Dam in 1982.

George Washington looked at the rapids of the Youghiogheny and decided not to go boating below Ohiopyle. Then some time elapsed. Over the next 169 years somebody probably tried to float the river, but I have found no record or memory of it. Then came Bill Holt in 1923. He and two other Ohiopyle kids, age fourteen or so, cut the finest Ferncliff peninsula saplings and nailed the green wood together, lashing with bailing twine for extra strength. They spent a week working on their raft. They covered the deck with canvas that Bill found in the upstairs of his father's store, and they fastened on a box full of food and bedrolls. They were runaways, prepared to go wherever the river would take them; to the unknown reaches of the Youghiogheny, maybe beyond. They put in at the cobblestone beach below Entrance. In less than a minute, Cucumber Rapid was upon them. They hit the first big hole and in a

matter of seconds, the raft disintegrated, dumping boys and gear to the waves. The runaway was cancelled and the kids raggled on home unsatisfied, resigned that the B & O was the only way to get out of Ohiopyle.

As near as I can discover, Shelby Mitchell and Hugh Rafferty, age sixteen or so, were the first to run the rapids below Ohiopyle. In the mid 1920s they built a boat out of tongue-and-groove flooring that they tarred to block leaks. They launched it below the Falls and paddled away. Shelby recalls low water requiring them to drag over rocks somewhere near Bear Run. By Indian Creek they had enough, so they abandoned the boat, pushed it with a kick into the river, and jumped the train home. Aside from these, and maybe other Huck Finn adventures, boating on the Youghiogheny did not begin until the mid 1950s.

In his younger days, Sayre Rodman, a Pittsburgher, dated a girl in Baltimore, and to get there he took the train. The B & O climbed up the Monogahela and then turned eastward through the distended mountain gap that for over a century had funneled travelers between the east coast and the Ohio. The B & O climbed through the Youghiogheny gorge, and from the right side of a car Rodman eyed the river and the rapids between Connellsville and Ohiopyle. He remembers that it looked "interesting," but it held no special allure to him. Young Rodman in the forties was addicted to gradient, but not the whitewater kind. He was a mountaineer, seeking high peaks since he had enrolled in summer camp at Estes Park, Colorado, at age sixteen. He learned surefootedness on rocks and frequently climbed with Barry Bishop, a noted mountaineer whom he met at summer camp.

Jean Winne, another Pittsburgh area native, attended college at Slippery Rock in 1949. Jean says, "I had a roommate who would come in late Sunday afternoon, suntanned or muddy but always smiling. She was a rock climber and a caver, and she looked like she had so much fun that I decided to go too."

Sayre had learned the rudiments of rock climbing at Estes Park, Jean had learned them at McConnell's Mill (bought by the Western Pennsylvania Conservancy only five years before) near her college, and a few years later the two adventurers met at a Pittsburgh Explorers Club meeting. They married in 1955.

"We climbed with a bunch of batty dynamite-slingers from

Washington, D.C.," Sayre recalls. Dynamite? "These people were crazy. Good climbers, but they did stuff that we gasp about today: things that are very poor practices, things that are intolerable today. If a cave entrance wasn't big enough, they'd blast it open. This sort of led them to recreational dynamiting."

Sayre and Jean are both telling me this story, competing somewhat, and when Jean gets going on an episode, Sayre interrupts over some possibly faulty detail. I listen while they resolve matters of accuracy, then I get Jean to finish. I am only a writer but after awhile I feel like a referee.

One of them says, "Rock climbing would get pretty cold in November, and one weekend those D.C. guys said, 'Come on back here later in the winter and we'll show you how we have fun then.'" So it was that Jean and Sayre Rodman began whitewater rafting.

In February 1956, twenty-four-year-old Jean and thirty-two-year-old Sayre ran the North Branch of the Potomac, Gormania to Kitzmiller, on the other side of Backbone Mountain from the Youghiogheny source. Sayre says, "Those dynamite-chucking freaks didn't even wear life jackets, let alone wet suits. Water was high and they'd pump up their boats and say, 'Go,' so we went."

"We got hooked," Jean says. "We bought a six-by-twelve-foot army surplus raft for fifty dollars, and up east of Pittsburgh we ran Crooked Creek with loud shouts of glee." Another rafter of note— Edward Abbey—attempted Crooked Creek as his first downriver experience.

"That was fun but we obviously had only two choices," Sayre adds. "Get another raft or get divorced." For fifty dollars they could afford another cotton raft, and from then on, the Rodmans each rowed separate boats.

"Sitting in the back is no fun," Jean explains. "Rowing is the fun: deciding where you want to go, then doing it, just right."

Sayre adds, "Back then everybody rowed in solo rafts." By "everybody," he means perhaps a dozen people who were the pioneers of rafting in the eastern United States. "Nobody paddled in teams like they do today." Unbeknown to Sayre, a revival of rowing rigs is beginning in the early 1980s.

"We were up for something challenging," Sayre continues, "and then I remembered the view out the train window."

In early summer 1956, Jean and Sayre drove up to Ohiopyle,

parked their car beside Castle Rock near the Meadow Run Bridge, and lugged their two rafts to the riverbank. "We didn't know what was down there," Jean says. "We had no idea, except for looking at topo maps." I ask if they scouted the rapids. "Oh, no," Jean answers. "Except for a few, like Left Angle Corner." After some descriptions and counterdescriptions, we determine that this is to-day's River's End.

"We named only a few rapids." Sayre says.

"The names didn't stick, did they?" I ask.

"Of course not," he answers. "We never told them to anybody."

After Entrance came Cucumber, which the Rodmans called Naked Lady. Sayre says, "We ran through the rapid and came into that big pool below, and there was this couple skinny dipping. Back in those days you'd never expect to see anybody on that river, but those two got a surprise. They went running into the woods."

At Railroad Rapid the Rodmans stuck their boat in the same chute where commercial passengers hang up today; they failed to turn left after the first big drop. They rowed sixteen miles to Connellsville, not knowing of any other take-out. Jean says, "It was a great river, sheer fun and not hard work. It was delightful, an incredible, joyful resource."

"It didn't seem risky," Sayre adds. "It was a real scenic river."

Why raft the Youghiogheny? Jean reflects, "It was a fondness for exploration. I loved going back in remote areas, feeling that it was *your* river. It's the idea of getting away."

Sayre says, "In rafting or climbing you can create the illusion that the rest of the world doesn't exist. It's just you and the river. There's an incredible joy in getting out there and looking as far as you can see and knowing nobody else is there." The reasons for rafting the Youghiogheny would change over the coming years.

Jean says, "Part of it is knowing you are on your own."

I ask if the thrill is important.

Sayre answers, "It's not the thrill. That doesn't have much to do with it. It's a feeling of mastering something, of a complex flow and the interaction of your skill. Of coming down a river and doing it well. You get in a rapid and it's just you and a problem—how to get through it. Doing it right gives a feeling of satisfaction. It's the combination of these things: a tremendous pleasure of technique taking you to a wilderness. That's perfect."

To row a raft, the Rodmans sit in the middle, face downstream, and pull on the oars. Almost constantly, the rower is doing upstream ferries—pointing the front of the boat the way he does *not* want to go, say to the left, and rowing against the current. This pulls the boat to the right and also slows the descent, allowing more time to maneuver. Unlike an inexperienced crew with paddles, one rower can gain precise control. He can quickly pivot the raft 90 degrees by pushing on one oar and pulling on the other. He can catch eddies. He can accelerate by pushing on the oars in big holes, "punching" them so that the raft does not get recirculated and stuck in the hydraulic. The oars must be planted where there are no rocks, and in skinny chutes, oars must be "shipped," or swung in against the raft so that everything fits. Camping gear is easily carried on a rowing rig—a rigid frame of wood or metal that holds the oarlocks and a seat for the guide.

Rowing is common in the West, but most Easterners paddle their boats. This way the raft more easily threads the eye between crowded rocks. Less skill is needed, letting novices run difficult rivers. Most importantly, paddling involves all of the people in the raft; everybody does the work, and most people have more fun.

Other popular craft on the Youghiogheny are kayaks and whitewater or decked canoes. The kayaker sits in the boat with his legs stretched ahead of him and strokes with a double-bladed paddle. The C-1 or single person decked canoe looks much like a kayak, but the person kneels and uses a single-bladed canoe paddle. A C-2 is a decked canoe for two people. Kayaks and decked canoes offer advantages: they are fast, maneuverable, and watertight: waves wash over the top of the boat but not inside. If the paddler tips over, he can stay in the boat and roll himself upright by use of his paddle.

Open canoes are a different matter. In large rapids, these older, traditional craft are more difficult to paddle than kayaks or decked canoes. Open canoes are larger, slower to turn, and as the name says, they are open, allowing waves to fill the boat with water. Unlike rafts that you can stop to bail water, swamped canoes sink low and become uncontrollable. An advantage of canoes over decked boats is that they can be easily loaded with gear for camping trips. However, the hardboats—the canoe, kayak, and C-1—do not bounce off rocks, but crash with consequences sometimes serious.

Two of the earliest hardboaters to run the Youghiogheny below

Ohiopyle were Bob Harrigan and John Berry from Washington, D.C., who pioneered many of the difficult runs of the middle Appalachians. They also initiated decked boats in the country, starting out with a tarp over and open canoe and later designing a C-2 that they called the Berrigan. Berry's Eskimo-roll of a homemade C-1 was the first in America (one of the next people to roll—Dave Kurtz—consulted with Berry by telephone to learn the technique).

"We heard about the Youghiogheny through the writings of Walter Burmeister," Harrigan recalls. Based on canoe travel, or roadside scouting and topographic map research, Burmeister wrote canoeing guidebooks for most of the eastern United States, but in the fifties he was just starting and had produced only a mimeographed copy, which Harrigan and Berry read. Burmeister says that he ran the Youghiogheny below Ohiopyle alone in a foldboat—a large collapsable kayak—about 1955, but he did so many of these trips that he does not recall details.

In June 1958, Harrigan, Berry, Osgood Smith, and Jim Johnson canoed the Loop, with only Harrigan and Berry running all the rapids. A few weeks later the two men returned and paddled from Ohiopyle to Stewarton. At Dimples they found the remains of a wooden canoe with AYH on the bow, so somebody else had already attempted the run. "It was a very beautiful river," Harrigan says. "One of our favorites. You had a feeling of owning these rivers, of possessing them. Not just anybody could go down."

Knowing nothing of Harrigan and Berry's trip, a small group of paddlers from State College, Pennsylvania, also discovered the Youghiogheny in the late fifties.

Like many people on the Youghiogheny today, Dave Kurtz came from the Midwest. With his first Explorer Scout canoe trip in Michigan at age fifteen, he was hooked, summer of '47. Seven years later at Penn State University, he met Tom Smyth, an avid canoeist.

In central Pennsylvania, Kurtz and Smyth canoed the West Branch Susquehanna, Moshannon, Beech, Loyalsock, Penns Creek, and Black Moshannon in its rocky, wooded canyon of the north-central highlands. "We were paddling down through the trees in open boats and I upset and swam half a mile," Kurtz recalls. He kept journals of these trips, including a summary for the 1950s titled "Log of upsets." On this list, the Youghiogheny appears prominently.

It was an age of river exploration. "We'd check out some topo maps at the library and start looking for rivers," Kurtz recalls. "We'd mark where the contour lines crossed. We'd measure the watershed to see how large the river might be, then we'd load the car and go." They had no guidebooks, no advice, no experience on these streams. When they launched, they didn't know what they would find. It was high adventure, anachronistic to modern day Pennsylvania. There was a thrill in going somewhere no one had gone. The American frontier was explored 200 years ago, but in choosing the paths of whitewater rivers, these men were able to roll back time and explore the land in a way never done before. Today, people do this in Chile and Tibet, but just twenty-five years ago, Kurtz and his friends needed to go only to the Youghiogheny.

Kurtz, Smyth, and Bill Bickham drove to Ohiopyle on May 30, 1959, parked their car at the Falls, and put their boats in the river. They survived Entrance. After scouting Cucumber, they lined the top of the rapid from the right shore (they tied ropes to their canoes and walked them through). They attempted the lower half and Kurtz upset. He says, "Smyth ran with the philosophy that if you upset it was a bad move. I carried that for life. A lot of people now think it's fun to tip over." About the rest of the trip, Kurtz's log humbly says, "There are more nice rapids for several miles." They took out at Indian Creek.

The three adventurers had another escapade planned for that weekend. They parked a car at Friendsville, drove to Sang Run, and set their three old aluminum Grumman canoes in the river again. This was probably the first descent of the upper Youghiogheny. They lost only one of the three boats.

Why canoe the Youghiogheny? Kurtz answers, "It's exciting. Just to get through it you have to think. And it's getting out into nature, real nature. You feel the power of it. You can see nature by being really close to it. Not like a state park where somebody has made the trails. Only the river makes the trail.

"I like to think of harmony. Here is the natural world. Are we going to fight it or learn to live with it? When we run rivers we are learning to live with it, to flow with it. We were not trying to conquer the river. That was not the point at all. We were *enjoying* it. After awhile, a big part of the fun gets to be starting other people out and taking them down the rivers." Kurtz started Paul Grabow, who works at Ohiopyle. He and Jef Huey—Steve Martin's guiding

partner—won the 1980 national championship in C-2 slalom (fastest through gates) and wildwater (fastest time straight downriver). Kurtz has started dozens of paddlers from his State College explorer post, and many of them advanced to the Youghiogheny. In 1981, twenty-seven years after their first canoe trip together, Dave Kurtz and Tom Smyth share an office at Penn State University.

After Jean and Sayre Rodman pioneered the Ohiopyle rafting run, they invited their Washington friends up to row the river on the condition that they brought no dynamite. Then they recruited Pittsburghers. "Other than our party, we'd never seen anybody," Sayre says. "The Casselman acid was still strong and there weren't even any fishermen." In 1959 the Pittsburgh Explorers Club rafted, and were followed one year later by a student group from Carnegie Tech. Small groups of canoeists began to paddle the route. In 1962, an article by Pittsburgher Ivan Jirak, titled "Great Gorge Challenges Rapids Runners," appeared in the Western Pennsylvania Conservancy's magazine. The Rodmans led Pittsburgh boy scouts down the river, but they still saw no other groups. Jean says, "I don't remember seeing a soul until the commercial rafting started."

Commercial Rafting

Lance Martin was a sixteen-year-old Explorer Scout from Pittsburgh's suburban North Hills when he first saw the Youghiogheny in 1958. For fifty dollars, the Scout Council had bought an army surplus raft, and Lance and his friends shot the rapids, or bounced through the rapids, or whatever.

After five years, and with scouting days behind him, Martin was still doing this. Sitting around a campfire outside Ohiopyle one night, he and his friend, Karl Kruger, wondered, "Would anyone pay us to do this?" People pay for stranger things: to ride in glider airplanes, to ride Kennywood roller coasters, to raft the Grand Canyon, to raft Pine Creek near Wellsboro. "Let's give it a try," they agreed, and the decision began a chain of events as momentous to sleepy Ohiopyle as the Bessemer process was to Pittsburgh, as the dark coal mines to Uniontown, as the acrid coke ovens to Connellsville.

While some say the changes were like the railroad chugging through Oakland and belching a welcome prosperity as it went, others say it was significant like Youghiogheny Reservoir drowning

the old town of Sommerfield. Some say the changes were a mix of good and bad, like timber magnate Rolland P. Crellin coming to the headwaters town of Sunshine and hiring all the men but stripping the woods bare. Some say they wish commercial rafting had never happened, others say it is better than nothing. Some saw it as an end of a quiet way of life, others saw it as the beginning of an exciting life. "This is what Ohiopyle was to be," says Shelby Mitchell with an acceptance of fate. Whatever, however, the changes were inevitable, given the Youghiogheny and given the yearning in our culture for a good thrill.

Martin turned twenty-one in 1963 and had begun a career as an Olivetti office equipment salesman in Pittsburgh. Lance, his wife Lee, and Karl (who worked for the Red Cross) guided the first passengers down the river, marking the start of commercial trips on the Youghiogheny and the birth of the biggest commercial whitewater-running scene in the nation, perhaps in the world. In 1968, 5,000 people ran the river below Ohiopyle. In 1978 there were 95,000, and in 1982 over 150,000. Most of these were customers with a guided group or in a rented raft. Over $4 million is collected each year by five Ohiopyle businesses that together own more than a thousand rafts. Poor in some ways, Ohiopyle is likely the wealthiest American town in number of boats per capita. Rafting employs about one hundred people, and many more if you count "spin-off" enterprises such as the Mill Run Campground, Glisan's restaurant, and state park permit-checkers. When you talk whitewater in Ohiopyle, you're talking big business, but it started with Lance Martin, Karl Kruger, and Lee Martin in a remarkably small way.

From Bob Marietta, Lance rented a room on the third floor of the Ohiopyle House, and from Bill Holt, he rented a single-wagon garage, now demolished but then sitting next to Bill's house where the red brick Baptist church is today. Inside, Lance blew up two surplus rafts with Holt's electrolux sweeper. They took a few hundred people down the river in 1964. The Youghiogheny entrepreneurs printed a brochure and the news spread by word of mouth. "Go raft the Yough." Martin and Kruger named the company Wilderness Voyageurs.

Meanwhile Ed Coleman had been rafting the Youghiogheny. He taught high school chemistry and joined as a third partner, but spent most of the summer guiding his own canoe trips in Canada. "Ed came back and we had differences," Martin says. "He thought

we bought the wrong kind of life jackets. There were other problems, so we bought him out for a nominal fee. I think it was a few hundred dollars."

Martin and Kruger were among the first outfitters to run whitewater trips in the East. Perhaps their only predecessor was venerable Ed McCarthy who turned fifty-five when Lance was twenty-one and had been commercially guiding on Pine Creek through the Grand Canyon of Pennsylvania near Wellsboro since the year before the Rodmans first rafted the Youghiogheny. At seventy-three, McCarthy was still leading paddlers down Pine Creek, long after Lance and others delegated on-water jobs to younger hands.

With McCarthy, Martin and Kruger were probably the first outfitters anywhere to offer trips where the customers paddled their rafts. In the West, where river trips had been popular for years, boats were rowed by guides, and the customers just sat up front and watched scenery, or just fished, or just got wet and shivered. Lance says, "We quickly found that guests enjoyed paddling and getting their own rafts to the end of the river. People said that the trip was as exciting as bigger water out West because our boats were smaller and the customers got to do the work."

Today Martin sits, cigarette in hand, on the porch of the mobile home that is the Wilderness Voyageurs office. He is trim with very curly hair, eyes that still shine like a Boy Scout up to mischief. He laughs a lot, cracks jokes at anybody. I can see how Martin sold plenty of Olivetti office equipment and plenty of raft trips. He is confident, a goodtimer, and it is no wonder that people on his trips had a good time too. He is also a businessman who just happens to be working a river.

"It was literally a hobby for three or four years," Lance says. He corrects himself: "It was a wine party. We'd do trips, then come back and have hot pickles, Mogen David, and play guitars. We charged no deposits. We'd be sitting down there waiting for forty people and nobody would show up."

In 1967, 1,600 people ran the river with Wilderness Voyageurs. "Karl and I had our differences," Martin reflects. "He was more laid back, wanted to let things happen. When we had started, sitting around that campfire, we decided that when it wasn't fun, we wouldn't do it, but my definition of fun changed. I didn't want to let things happen, but to make them happen, so we split up." This all had to do with money, and regarding money, many differences of opinion would flourish in coming years. The ways that people

looked at the Youghiogheny would depend on whether they were after money or whether they were not.

Without any of his original partners (except Lee, his wife, and they would eventually split up also), Martin launched a full-time river business. "My job in Pittsburgh was easy; I'd sell for twenty hours a month. I had gotten a promotion with a car, all that crap, then bagged it." He was the first of many to drop out and come to the Youghiogheny for its whitewater. "After the split with Karl, we concentrated on making more money. All that means is we didn't drink so much wine."

Everything became more businesslike. Lance recalls, "In the early days, Karl, Jon Dragen, and I used to challenge the entire group to throw us out of the raft at once, and they never could do it. The customers might get two of us out, but then one of us would climb back in. We used to dive off rocks. We don't do any of that now— too much chance of getting sued." The business prospered.

Wilderness Voyageurs had outgrown Bill Holt's garage, so Lance bought other properties, including Whipkey's Restaurant. For one year he leased it as a restaurant, then converted it into an equipment store. Like the Conservancy, Martin bought more parcels, one by one, until he owned most of the land along Garrett Street across the river from downtown Ohiopyle. Perhaps more symbolic to the early years of commercial rafting, he was on the other side of the tracks.

Martin's holdings now include several trailers, a red house on the hill for guides, a white house along the street, and a large cement block garage and boathouse built in 1975. For the best visibility in town, Martin rented the old Potter Gristmill above the Falls from Bill and Adalene Holt. Inside the mill, he sells boating equipment and tee shirts.

In every year but 1980, Wilderness Voyageurs generated more business than any other company. "We had a head start," Martin explains, "but that doesn't count much now. We like to think we are a little more particular in the way we run a trip. If people notice, they come back. Some outfitters don't realize they're in the hospitality business. They think they're trucking turkeys down the river. We're there to make the trip enjoyable."

Wilderness Voyageurs has a reputation for being organized and efficient. The warehouse is almost spotless, in contrast with the clutter of other river houses. Steve Martin says, "Yeah, it's *too* clean. It doesn't need to be this clean. I don't like things this neat."

Guides from other companies say, "They are the clean-cut college kids." They are also good paddlers. Jon Lugbill, world champ C-1 slalom racer in 1981, went to Wilderness Voyageurs when he needed a job.

For years, Lance Martin's employees were warned not to associate with other guides. Wendell Holt, co-owner of White Water Adventurers (another rafting company), says, "Lance's guides weren't allowed to come over here, but one time they did." Proud of his piracy, Wendell smiles and blinks his eyes and says, "We hired four of them."

Turnover of Wilderness Voyageurs guides is rapid. This is partly because they are the lowest paid in Ohiopyle, and partly because the company recruits college students who are competent but who regard guiding as more a lark than a profession. Steve Martin is an exception in lasting seven years, and says, "You do a good job and you're rewarded. Last year everybody got a $300 bonus."

In 1981, Wilderness Voyageurs guided 18,000 people down the Youghiogheny—3,000 more than any other company.

Ralph McCarty grew up near the water. It was Lake Erie, with no rapids, but it would still make McCarty a water person. His brother piloted a charter boat for fishermen and Ralph labored as a pot (cabin) boy, chipping 150 pounds of ice into garbage cans to keep dead fish cold. Every Sunday, lanky young Ralph, carrying two bags stuffed full of walleye without ice, boarded the midnight Greyhound and returned to his home in Cleveland. "I'll tell you, I had not problem getting a seat to myself," he recalls.

Ralph may be one of few kids to take up sailing during the Depression. "Getting onto or into or closer to the water was the name of the game," he says. He met his wife, Martha, on a sailboat.

McCarty has an unusual way of talking: colorful, animated, witty, and corny. He calls his home in Monroeville the "head shed." World War II is "World War eye eye." He does not read the "writing on the wall," but the "scroll on the wall." For a rafting customer to be dumped overboard and caught between the boat and a rock is a "Hertz donut" (hurts, don't it?). A paragraph of his speech might incorporate the unlikely wedding of all these terms. Ralph has broad interests and they merge together like sardines in a can.

After a World War II military career when McCarty ran "rehabilitation" programs including horseback riding in the California

desert and yachting off San Diego, he opened a machine shop near Cleveland and with Martha he settled down at Mentor Headlands: "Three hundred feet of Shangri La at the edge of the lake. The kids—Maureen, Mark, Meg, Mike, and Mary—started growing skin between their toes." So how did Ralph McCarty get into the river business at Ohiopyle? "It's like the girl in the house of ill repute. She had a bachelor's diploma from Smith on the wall. She had a Ph.D. from MIT on the wall. I asked, 'How'd you ever get into a business like this?' and she said, 'Just lucky I guess.' "

I press for the real story, which Ralph seems to have forgotten or else habitually buries in bullshit. But I make headway. Through his sailing, Ralph became involved in the Red Cross and served as a volunteer small-boat instructor. People asked for canoe lessons. In response, Ralph ordered an eighteen-foot fiberglass boat with wood trim, but when it arrived, the Red Cross treasurer stubbornly refused the bill. Ralph was stuck. He bought the canoe himself, and that boat led him toward an unexpected future.

For weekend escapes, Ralph took Mike, age eight, on local river trips ("Mark was a rebel," Mike recalls, "but I was younger, submissive, and a better paddling partner"). They did the Grand River near Cleveland, the Ashtabula, Conneaut Creek, and the Cuyahoga. Eventually the McCartys tackled whitewater: the Cattaraugus in New York, French Creek, the Connoquenessing, and the Slippery Rock in western Pennsylvania. Small rivers, each, but preparatory ones. Amplified and maybe enhanced across the humdrum flats of Ohio, tales of the Youghiogheny—enticing and reckless—reached the McCartys. When they went to see it in 1966, they met Lance Martin and arranged an outfitted trip for their church group. The McCartys later returned when the state park was only starting, and the "Mad Hatters" canoe club, organized by Ralph, camped at the construction site amid stockpiled drain and sewer pipes.

Meanwhile McCarty-the-machinist made it big as an inventor of the "extruded hone process' designed to take burrs off metal. The process amounts to silly putty with an abrasive added, forced around metal to smoothen its edges. A Pittsburgh firm bought the invention, and it was arranged that the McCartys would leave "Shangri-La" and move to the Steel City so Ralph could manage the honing. Going to Pittsburgh, in the Appalachian foothills, happened to cut travel time to the Youghiogheny by 70 percent.

Inventors, as a class of people, don't enjoy working for somebody

else; they are creative types. Ralph says, "Ten years of anything is enough. I ran machine shops for fifteen." He was ready to drop out.

His son Mike says, "The schedule was getting to him, but Mom valued the nine-to-five security. She never really got into the river stuff, but resigned herself to it. It's what Dad was going to do. Mom still worked hard doing the bookwork." While Ralph's oldest son, Mark, fought in Vietnam and Mike attended high school, Ralph left the machine shop, started a business called Mountain Streams and Trails, and invested his savings in rubber ducks.

Simply called "duckies," they are inflatable rubber kayaks with a fiberglass deck that, in rapids, keeps them from folding up like a hide-a-bed gone berserk. Always thrifty, this child of the Depression, Ralph found a team's supply of hockey helmets and bought them for his kayakers. He added life jackets and paddles and that was all he needed. The McCartys began business on Connoquenessing Creek, then came down to the Youghiogheny. Ralph assured Lance Martin, "I'm not going to compete. You do rafts, I'll do kayaks."

Early on Saturday mornings, Mike and his sister Meg propped signs up at the old bridge advertising lessons and trips. "It didn't really take off though," Mike says. "To drum up business, we went to sports shows. We bought one raft—a pig boat called a Black Mariah." With this they became the first outfitter on the Cheat River.

Ralph says, "Solo kayaking was to be my great contribution: to show people how to get down the river on their own. But it was not profitable enough to stay alive. The Washington Canoe Cruisers would come up. Eighty of them would go on raft trips with Lance and six would come with me; it don't take no brick wall to fall on me. Meanwhile, Ed Coleman was running trips. Then Wendell Holt came over to me in Whipkey's Restaurant and said, 'Guess what? We're getting into the rafting business.' I went back to Lance and said, 'Since everybody's doing it, I may as well too.' " So began the McCarty rafting empire.

In 1969 Ralph hired Sue Spindt, the second woman guide on the river (only Lee Martin worked earlier). Women guides came early to the Youghiogheny, though there were never more than three or four at once, and few women work as guides today.

As the business grew, more help was needed, so Ralph arranged for members of the Cumberland (Maryland) Explorer Post to move en masse to the big gray house where Shelby Mitchell was born. It

was rented from next door neighbor Elmer Wolf. "Elmer didn't like the noise," Mike recalls. "We were in here singing while we did dishes and Elmer came over and yelled, 'Cut out that caterwalling.' Then Greg Green moved in." Green is a black man. "Neighbors didn't like the young people. This black guy. To make a long story short, Elmer didn't renew the lease." Ralph searched for new quarters for the housing of his guides and office.

The Laurel Lee had been an institution. Only four miles north of Ohiopyle toward Mill Run, this bar sat down from the road so that when you drove past you saw mainly the roof. It was a totally unimaginative, rectangular box of cement block and red brick. These things made it seem like an end-of-the-road-place, a secretive place. It didn't belong there, next to the Western Pennsylvania Conservancy's Bear Run Preserve. But it was an institution, none the less, and being the only bar short of Route 40, it attracted men from the surrounding hollows and ridges. It was rough, and they said that if you could see over the bar they'd serve you at the Laurel Lee. If guys from Ohiopyle didn't show up in the Connellsville bars and a good rumble was overdue, then Connellsville guys journeyed by pickup caravans to the Laurel Lee. They looked for trouble and they found it.

As fate would have it, fire engulfed the place in 1967. A charred shell soaked in the rain and the snow until 1971, when in a seemingly courageous move, Ralph bought the Laurel Lee ruins. The McCartys set out to rebuild the place and Mike immediately dubbed it the "Last Resort."

"It *is* the last resort," Mountain Streams and Trails guides say, though nowadays it is simply called the "Resort." Burnt timbers can be seen, but it offers free housing for the staff who have bedrooms, a kitchen, and an activities room that once featured a pool table. True to its heritage, the Last Resort became a party place, and tradition had it being a mess, somewhat worse than the usual clutter of guides' stuff and wrecked boats. Ralph never liked it that way, so now and then he prodded his employees to clean up. Once too often he arrived to a sinkful of foul plates, cups, and saucers. He grabbed an armload of the reeking plastic ware, dumped it in the parking lot and ran over it with his car.

Now and then Ralph would be that way. Impulsive. "Mac attacks," recalls Jim Prothero who worked there. He says, "Back then all the guides lived at the Resort and Ralph cooked breakfast. When

it was ready he'd hell, 'Come out or I'll kiss you,' and let me tell you, that brought everybody out. Ralph is eccentric, no doubt, but now that I'm running my own business, I find myself remembering things that he said—principals about how to do things, and I'm using them. I'm repeating some of the things Ralph used to say." For an example, Prothero says, "He was on our cases all the time about being careful with equipment, so we 'weren't making old things out of new things.' I use that line and philosophy in all my talk-ups to people renting canoes or taking lessons." Prothero adds, "Ralph's inventiveness and ability to hear the different drum always fascinated me."

Jim Prothero began his Youghiogheny career with Mountain Streams and Trails in 1974 when guides received room, board, and $300 a summer. "I hitchhiked up," he says, "and after walking half the way from Farmington, I finally arrived at the Last Resort. There was kind of a moat around it because it had rained a lot. As I walked down the driveway, Cass [Cashmere P. Chestnut, a guide] came running around the corner of the building shrieking, and right behind him was Lucky with a bucket of paint. Those guys were total space cadets." Prothero was taking a term off from school and didn't have anything to do. "When I saw the problems at the Resort, and the opportunity to use my hands working on it, and then the river, I decided to stay. They didn't ask any questions and I didn't need any. That was the year of the gas lines, and life looked pretty bad for the world, but I started feeling good. I was going to be a river guide."

Prothero, who started renting canoes at Confluence four years later, was not the only Mountain Streams and Trails guide to develop his own business. Tom Love owns a raft repair service near Donegal. John Lichter, who guided and later managed the staff, teaches kayaking in Ohiopyle. Al Davis sells equipment and tee shirts to river runners throughout the East. John Brown excells as a kayak builder.

Greg Green—the first black man to guide on the Youghiogheny— was hired by Ralph in 1969. Mike recalls, "The normal rafting crowd was a shock to many of the local residents, but a black man? What you see now in Ohiopyle as a tourist town is different from what you saw back then. I remember walking out of Whipkey's Restaurant with Greg and somebody saying, 'Hey nigger, get outta here,' and Greg grabbing a paddle out of the truck and going after

the guy." Eventually Green was accepted. Today, he contracts with two of the four Ohiopyle outfitters to take rafters' pictures which customers then buy. Green has expanded his market, hiring photographers and building a rafting-photo business that reaches to Maine.

The character of the guides has changed over the years. Tom Love says, "Ralph called the old-style guides the 'Huck Finns.' " Love was one of them. "The Huck Finns were hippy types: long hair, rope belts, and cutoffs. Ralph decided to phase out the Huck Finns and bring in the 'tennis crowd' for a preppy image. He wanted everybody in gym shorts and uniform life jackets. But you know, the early days were when the guides would fix the trucks, patch the roof, rebuild rafts, anything." The guides packed lunches for the customers and the production line wound through the Last Resort kitchen and into its bathroom, where bread was stacked on the back of the commode. "Now the guides only want to paddle," Love says.

Mark McCarty managed the Ohiopyle operation under his father's supervision, but the two argued stubbornly, so when another company—Laurel Highlands River Tours—came up for sale, Mark bought it in 1978, clearing the way for brother Mike to manage Mountain Streams and Trails.

Mike had guided since he was a high school junior in Monroeville, his first trip being a duckie expedition on Connoquenessing Creek. "I'm really glad my dad got me away from that suburban scene," Mike says. "My values switched to Cucumber Rapid. I came to value the river more than anything in the city." In 1972 Mike guided Sargent Shriver and his wife, Eunice Kennedy Shriver, down the Youghiogheny. "Dad made me and Tom [Love] get haircuts for that one," Mike recalls. He also remembers the Shrivers' raft flipping in Railroad Rapid. It was high water after the Hurricane Agnes flood.

After graduating from Grove City College in 1977, Mike moved to Ohiopyle and operated the "trails" part of Mountain Streams and Trails, starting a backpacking and cross-country skiing program that failed to prosper. He began managing the rafting company in 1979. The McCartys bought the house that Ralph had originally rented from Elmer Wolf, and Mike and his family now live there, upstairs from the rafting office.

Ralph is still around during weekends. On Sunday morning he

hustles at the put-in, pacing long-strided back and forth with the speed of a dish-stacker in a cut-rate cafeteria, occasionally hefting a raft, welcoming the world to the Youghiogheny, and tipping his three-cornered Revolutionary War hat (Ralph is a colonial history buff, specializing in the travels of George Washington in southwestern Pennsylvania).

Today, Ralph and Mike McCarty own hundreds of rafts—three complete fleets for the Youghiogheny, Cheat, and Gauley. Customers return again and again; in 1982 one man repeated for the nineteenth time. Like the other companies, Mountain Streams and Trails hires about twelve full-time Youghiogheny guides in the summer. Another one hundred are employed on the Cheat in the spring. Ralph says that his company ranks as the world's largest rafting business in numbers of customer-miles ("eight trips around the earth at the equator") and numbers of customers—20,000 a year on three rivers. In 1981 they guided 13,000 people down the Youghiogheny.

Along with teaching chemistry nine months a year, Ed Coleman had been running wilderness canoe trips in Canada when he started rafting the Youghiogheny and when he entered a brief and doomed partnership with Lance Martin and Karl Kruger. After that falling out, he started his own Ohiopyle business called Laurel Highlands River Tours.

He bought an old three-story building in Mill Run, eight miles north of Ohiopyle, where he housed equipment and staff. The guides lived downstairs; Coleman, his wife, and children slept upstairs, and he maintained order with few similarities to the Last Resort. "It was kept up real nice all the time," Kevin Grady remembers, "because they lived there."

Grady, who guided for Coleman, says, "He was different, but he had his act together as a business. He wasn't only into running trips on the Youghiogheny. He did all that Canada stuff, and last I heard he was thinking about some South American trips. He explored around. He wasn't really that bad a guy, just a little unusual." Other employees say that he preached and moralized to the guide staff. Coleman was a born-again Christian and did not run trips on Sunday. Partly because of this, Laurel Highlands did not grow into a rafting giant. "While other companies were booming in the mid-seventies, Laurel Highlands was marking time," Grady says. "It didn't seem to matter to Coleman how many people he took down

the river. Whatever he did was enough. He was having a good time, but his wife hated the lifestyle—packing up with three kids and moving at the beginning and end of every summer. And Ed was teaching college chemistry at Indiana [of Pennsylvania]. He didn't have the time that it takes to really run a river company."

Two Laurel Highlands guides and later a Wilderness Voyageurs guide approached Coleman about buying the business, but nothing happened. Among the other outfitters, Coleman seemed to get along best with Ralph McCarty, so when Ralph's son Mark asked Ed Coleman about buying the business, he talked, and in 1978 Mark bought the company.

Through high school, Mark McCarty had paddled a kayak as a volunteer safety boater for Lance Martin. After graduating in 1966, Mark attended college for one year. He intended to work in the machine shop for his father, but he went to Vietnam instead. Two years later he resumed guiding for Ralph and managed the company until he bought Laurel Highlands.

Outfitting in Ohiopyle is a family affair. Mark of Laurel Highlands is son of Ralph and brother of Mike McCarty. Mark married Linda Marietta, daughter of Bob Marietta who is co-owner of White Water Adventurers. Her brother Bobby manages that company. Ralph's daughter, Mary, married Stuart Van Nosdeln—son of Stu Van Nosdeln who owns a fifth rafting company (though he does not provide guided trips). Lance Martin is the only outfitter without family crossover. In Ohiopyle, Appalachian town that it is, half the people seem to be related, and this goes for newcomers. As Mark began to build Laurel Highlands, the family worked to his advantage: Mike sent the overflow from Mountain Streams and Trails, and the Mariettas sent overflow from White Water Adventurers.

While each of the other companies has a distinct personality, Laurel Highlands does not seem to have any apparent trademark since Ed Coleman left. Unless, superficially, it is their new Avon-brand rafts bought in 1982 and especially designed for the Youghiogheny. Some people think that Wilderness Voyageurs and Laurel Highlands run the best trips. "Laurel is more easy going than other companies," says Blake Martin, a White Water Adventurers guide.

"We're just your basic, solid river company," says Kevin Grady, manager for Mark McCarty.

From 5,000 people a year, Laurel Highlands grew to 13,000 in four years. Jim Prothero says, "If you're looking at rafting compa-

nies during the last few years, it is Mark who has made something out of nothing."

Wendell Holt and Bob Marietta grew up on Ohiopyle. The earliest Holts had arrived in 1895, and the Mariettas came from Mill Run during the first World War. Unlike Olivetti salesmen, machinist-inventors, and born-again chemistry professors, these two were about as local as two can get.

One night Holt and Marietta drank at the Ohiopyle House and talked and said, "We've been here all our lives, may as well get in on this rafting." So they got an old suicide raft—a cheap yellow one—and Wendell, Bob, Bob's eighteen-year-old son Bobby, and Bobby's friend Johnny Spittle went down the river. They survived and bought three more rafts, and White Water Adventurers, owned by the unlikely partnership of Holt and Marietta, was born in 1967.

The Holts, as a clan, are respectable, God-fearing merchants and town leaders. Wendell talks fast, slurring words, saying "huntin" and "su'cide raf'," and while talking at this rapid pace, he blinks his eyes again and again. He has one of the friendliest personalities in Ohiopyle; he is always there with something to say. I walk in the store and there he is at the counter next to Leo Smith. "Hey Tim, look at this." Wendell thumbs through a magazine and stops at a picture of a 1952 Ford truck. "I gave one of these to a guy up here. Some others wanted to buy it, but I gave it to this fella. He's rebuilding the whole thing. Gonna be like new."

Like most local men, Wendell once left Ohiopyle, hunting work in big-city industry the way Appalachian youth and laid-off miners have been hunting for three generations. He landed a job in a car assembly plant near Cleveland, but like Shelby Mitchell, he returned to Ohiopyle. "Everybody used to joke and laugh and call us hillbillies and say Ohiopyle was the boondocks," Wendel says, "but now everybody wants to come here and stay. Why's that?"

By trade, Wendell is a carpenter. He built houses, then became a cabinetmaker, working on gun closets, custom doors, and furniture. Carpentry, however, would not compete in the Ohiopyle of the future. Wendell's old woodworking shop, one block from the Falls and next to Potter's Gristmill, was converted into the Holt and Marietta rafting office. With other purchases and additions, White Water Adventurers occupies a choice location. Anybody passing through the park sees their headquarters.

White Water Adventurers is a family business. Becky Holt, Wendell's wife, comes from Farmington. She married a country carpenter and ended up with 15,000 customers a year, 200 rafts, fifteen river guides on the payroll, tee-shirt sales in the thousands, a campground off Route 40, and a very decent income. She stands tall, pretty in a simple way. She has a welcoming smile, maybe the warmest smile in Ohiopyle. Wendell says, "Any customers who are problems—people who want refunds and stuff like that—we let 'em talk to Becky." She tries to negotiate fairly and they quit being angry. Becky also keeps the books. She carries a charm of being young; a charm of being old. Other than real mothers, she is the only woman that river guides call "Mom." Not that she is old enough; not that she looks it. She doesn't even look old enough to be the mother of Gary, Wendy, Brenda, and Todd.

In the summertime the four Holt kids are always in the White Water Adventurers shop, or in the store, or on bikes around town, or jumping in the Youghiogheny at the swimming hole above the bridge. Wendy and Brenda are learning to kayak, taking lessons from John Lichter. In 1981—her first year paddling—fourteen-year-old Brenda won third place in a Pennsylvania Cup race.

The Mariettas are different. Wendell Holt is tall, Bob Marietta is short and almost old enough to be Wendell's father. They are Ohiopyle's Mutt-and-Jeff. Bob's father, Buck, was infamous for carousing and brawling. "Buck was a fighter," eighty-five-year-old Gwen Waters remembers. He was outdone only by Bob in his earlier days. Now there is Bobby, son of Bob.

Before World War II, Bob Marietta worked odd jobs around Ohiopyle and cut timber. "All you needed to be in business was a saw and a rattletrap pickup," he says. "Then I worked on the Squirrel Hill tunnel [in Pittsburgh] for a few years, but always came back here." Thirty years ago Bob's father and mother leased the Ohiopyle House—the only remaining hotel—from Alex Mead. Mead also owned the Ferncliff peninsula which the Mariettas intended to buy. "All of a sudden Mead died on a golf course," Bob says, "and the deal fell through." When the Western Pennsylvania Conservancy acquired the property, Bob Marietta worked as caretaker of Ferncliff and the Ohiopyle House for eleven years.

In the summer, Bob now ambles around town in shorts and thongs looking more Californian than Appalachian, though he sounds and acts like pure Ohiopyle. He is friendly, but is also

recognized as a local power figure. "Bob Marietta *owns* this town," a resident said. That is not true—the Marietta holdings are not so vast—but Bob has combined old-time local influence with astounding success in White Water Adventurers. He has come a long way from his hell-raising days. He gets along with almost everybody, cultivating the cooperation that he needs with the state park, the police, the borough council, or whatever.

Bob's wife, Shirley, also works full-time helping to run the company. Their son, Bobby, is the manager, scheduling guides and making sure the equipment works. He is not the PR type. Some people are scared of him because he loves to fight. In this way he is a chip off the old block, only the chip is now considerably larger. Bobby is built like a studio wrestler. One night he inflicted $10,000 damage on a bar and its occupants in Connellsville.

Bobby's style didn't change on the river. An old Mountain Streams and Trails guide remembers being delayed, allowing Bobby's group to catch up. Bobby started yelling at the other guide to get out of the way. In front of both groups of passengers, the two faced off, ready to duel with paddles on a big rock. Talking about the early days of commercial rafting, a Wilderness Voyageurs guide said, "There was never much trouble except for guys like Bobby Marietta. He's big and he gets his way."

Bobby grew up swimming in the Youghiogheny, tubing above Ohiopyle and around the Loop. At low water, Marietta, Johnny Spittle, and other boys would swim down the river from the bridge and slide straight over the Falls, kicking out at the top so they would land in the foam and not be pushed down by the undertows. "Other times we'd wade out to the middle above the Falls, holding onto each other, then dive into the center of it," Bobby says. Sometimes they'd get sucked under for a long time. "The water would push down, but up too, and you'd sort of stay there a little ways under. Then finally it'd spit you out." Marietta and the other Ohiopyle kids swam all the Loop's rapids except Railroad. "Older kids—Lynn Orendorf and Peachy Bungard and guys like that—they said stay out of Railroad, so we did."

Bobby Marietta didn't grow up rafting. No local kids did. "We'd be playing baseball over in Ferncliff and throw stones at the rafters when they'd carry their boats back from running the Loop," he says.

While we talk, Tom Finn, a White Water Adventurers guide, sits

with us on the bench outside the shop and says, "Hey, *I* was one of those boaters!"

Holt and Marietta started as a shoestring operation. "The guides did pretty much the whole thing," old Bob says. "We'd run shuttles, then come back here and lead the rafts down. We had an old trailer that we'd pile the boats onto. Every now and then it'd cut lose and roll down through the woods at Stewarton."

Young Bob says, "You know the foot pumps that we take along in case of an emergency? Well, one of those is what we blew up all the boats with."

"One of the real crazy days was when the motorcycle gang came to town," Bobby recalls. "Must have been five hundred. Leather jackets, cut off sleeves, chains, the whole works. Then the cops came. Lots of them, helicopters even. Those guys wanted to go rafting, so we hustled 'em around the Loop, carried the boats back and took more."

In 1980, Holt and Marietta's White Water Adventurers did more business than any other company. Most years they are second. In 1981 they guided 15,000 passengers.

This is without question the river company of the local people. "At first they didn't know what was going on," an old-time Youghiogheny paddler says. "They were a bunch of locals who knew nothing about rafting. The guides didn't know about paddling or rescue." But they learned. They had a reputation for drinking, for showing up late, but today they tend to be the oldest guides and include some of the most experienced and colorful. This is partly because they get paid the most and partly because some of them grew up here and want to stay. Ohiopyle is home.

To White Water Adventurers guides, the Youghiogheny is not an exotic thing. As Wendell Holt says, "It's more of a job to our boys. Growing up here, you take the river for granted." To them, the aesthetics do not overwhelm. The river does not lead to much in metaphysics. It does not offer escape. It is scarcely recreational. What it means is a job; an income without welfare, without commuting to McKeesport, without the mines. It is a well-paying, seasonal, exciting, challenging job with the elements and with people.

Bob Marietta says, "My boys have been pretty rough individuals. Not renegades, but tough individuals. That's changing now. You have to change. Today you need a little more public relations. People are looking for that."

Blake Martin, an excellent paddler and sophomore at Williams, works for White Water in 1981 though he is the typical Wilderness Voyageurs guide. On the river, he waves and calls out in French to his customers, "Venez ici, donc!" ("come on over here"), and people love it.

Still, ribald stunts continue. At Swimmer's Rapid, Rob Baron (a Mountain Streams and Trails guide who was fired for blowing up the Last Resort's pool table, and then was hired by White Water Adventurers) found a mud-dog—a ten-inch-long amphibian enveloped in slime, with a tail that is like a fin and a head squashed like an alligator. Because of these characteristics, some people consider the mud-dog the most revolting of creatures, and they coax a squeamish reaction from one and all. Baron was going to slip the innocent dog into the raft of a customer who had grated on his nerves that day. First he consulted with Needles (Bobby Daniels). Needles said no: "Might freak 'em out and the word'd get back to the comp'ny." But non-paying Ohioans are fair game; they are foreigners here. While a flatland woman was swimming in the rapid, Baron granted the mud dog amnesty in the bow of her kayak. She returned and nestled herself into her boat, fastened her spray skirt securely, paddled out into the river, and only then felt the creeping claws of the dog as it began its slow, slimy ascent on her bare legs.

Those are the four big river companies in Ohiopyle. At about the same price ($18 to $22 on weekdays; $25 to $35 on weekends) they offer about the same services: trips from Ohiopyle to Bruner Run with customers paddling their rafts, being coached by two guides in kayaks and another two in a raft loaded with lunch and rescue ropes.

A fifth company started in 1973. Stuart Van Nosdeln opened Youghiogheny Outfitters where customers rent rafts, paddles, and life jackets, but go down the river guideless. Van Nosdeln's shop sits between Route 381 and the river, below the Falls, and is unmistakably identified by a Dairy Queen sign.

When I introduce myself, Stu flashes a big smile. He is the PR type. He wears a cap, pale blue jeans, a shirt for an Ocean City tourist, and Docksiders. He is of medium build, and when he tips his cap (or cowboy hat in winter), his dark hairline shows some retreat. I guess him to be in his late forties. He takes a phone

call and I order a milkshake that fills a Dennis the Menace paper cup.

Stu Van Nosdeln came from Baltimore, though his parents grew up near Mill Run north of Ohiopyle. He returned to visit relatives, met one of Ed Jackson's granddaughters, got married, and moved to Ohiopyle in 1957. He worked on the B & O, then became a real estate salesman for an agency in Connellsville. This came naturally because Van Nosdeln can spot a deal.

Take this building for example. It occupies the only slice of river frontage that is not state-owned within miles of Ohiopyle. In the early seventies, before Van Nosdeln became mayor of Ohiopyle, he negotiated a no-strings-attached lease for this ground, which is owned by the borough. "The lease is good to the year 2000," he says. "No, 2030. I'll be ninety-five years old." He laughs. I ask if it was difficult to get the lease. "No. I just asked for it." Details of the agreement are unclear since the council minutes covering it have been lost. Bob Marietta originally held the lease, then gave it up, presumably on the condition that Van Nosdeln would rent bicycles, not rafts. But there was little demand for bicycles, and Stu was not one to bypass a good business opportunity. "I felt there was room for a novice to use this river," he says. "Heretofore, guided tours, with the help of the state park, were the only way. Why should the public be regimented into a guided tour?"

At least part of Van Nosdeln's theory embracing raft renting as a public service is sound. There are growing numbers of experienced, physically fit, and responsible paddlers who do not need a guide on the Youghiogheny. There are also growing numbers who are inexperienced, unfit, and irresponsible.

Since the days of the Rodmans, experienced boaters had seen burgeoning incompetence and growing competition for river space. The large guided trips definitely had an urbanizing impact, but when Van Nosdeln began renting rafts to almost anybody who showed up, an unimagined brand of chaos reigned on the Youghiogheny. To understate, a lot of hell broke loose. Guides from the four companies earned their money trying to protect customers from novices whose trust-to-luck technique in rented rafts led them to plow straight into other boats. In 1977 Wendell Holt said, "Our boys throw ropes to people who fall out of rafts, and only 10 percent of 'em are our own. The rest are not in a guided group."

Cass Chestnut, a White Water Adventurers guide, later said, "We

quit throwing them ropes; that's not our job." If the guide throws the rope to a rental rafter, his attention is diverted, his rope is uncoiled, and he is unprepared to save one of his own clients who might also need help.

State park officials and others believed that unguided trips were unsafe for the inexperienced, but Van Nosdeln convincingly says, "In eight years we've had 250,000 people with no drownings or serious injuries. We've proven it's safe. We give a safety talk, equipment handling instructions, and a plastic map so people don't walk out of here cold turkey not knowing what to do." Though it is unclear where the 250,000 figure came from (this averages 31,250 a year, yet Van Nosdeln later says that in 1981 he rented to only 12,000 to 15,000 people), the record is impressive.

The *Pittsburgh Press,* August 13, 1978, carried a story about Reverend Fred Cooley who had rented a raft from Stu Van Nosdeln. At River's End, Cooley's raft hit a rock and he was dumped into the river. Colliding with another rock, he became pinned by the current with water washing over his head at times. "I'm afraid I gave up at one point," Cooley said. "If it wasn't for the young guide from Wilderness Voyageurs, I would have drowned." Jay Douglas happened to be there with a safety rope for his customers. When he saw Cooley's predicament, he waded a risky route to the overweight preacher, and with the help of two other men, saved him in a rescue that required forty-five minutes. Meanwhile the Wilderness Voyageurs trip was short one guide, creating additional risks for which Douglas and Wilderness Voyageurs owner Lance Martin were responsible. Cooley condemned Youghiogheny Outfitters for "gross negligence." He said, "I think, they were irresponsible for failing to provide guides and a safety program in terms of instruction. He didn't tell us what the risks were."

Van Nosdeln answered, "We are safety conscious. We have the best equipment on the market. We feel we do the best for John Q. Public. We try to cater to the sense of adventure of the individual." About guides rescuing private boaters, Van Nosdeln replied, "They're just crying because I'm taking away their customers. We don't provide guides because they are an unnecessary expense in a cost-conscious economy. We don't want to get into that part of the business at all. I'm sorry about Reverend Cooley, but accidents will happen."

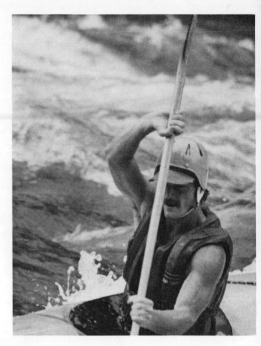

Steve Martin

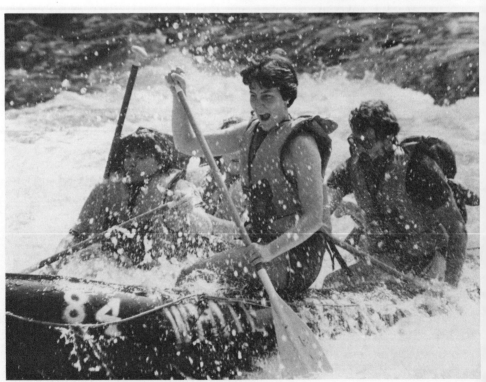

Rafters, Cucumber Rapid

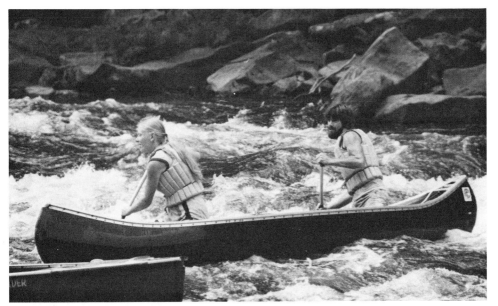

Canoeists in Entrance Rapid

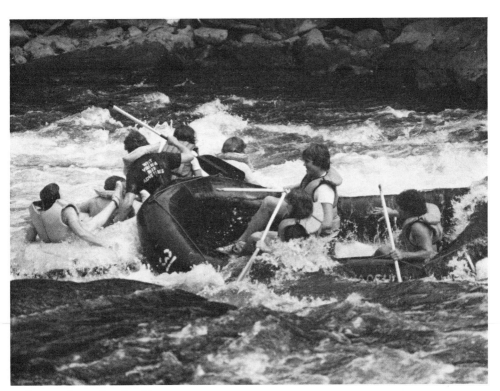

Rafters at Cucumber Rapid

Stuart Van Nosdeln

Bob Marietta

Dave Kurtz

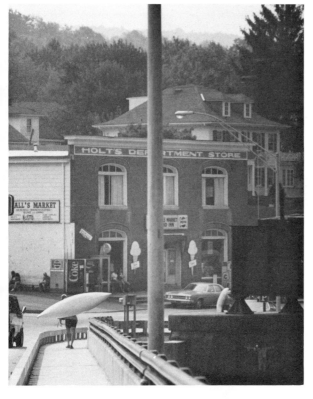
Falls Market

Larry Adams

Winnie Glotfelty

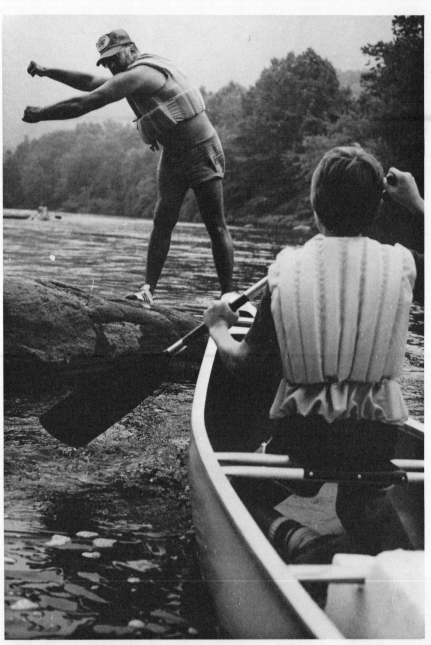
Bill Calantoni giving a canoeing lesson

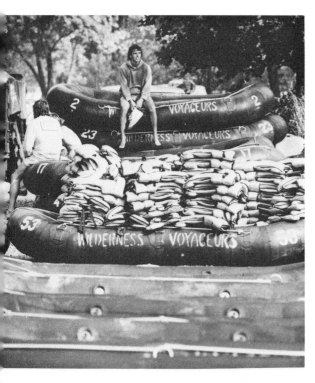

*Equipment ready for
a commercial trip*

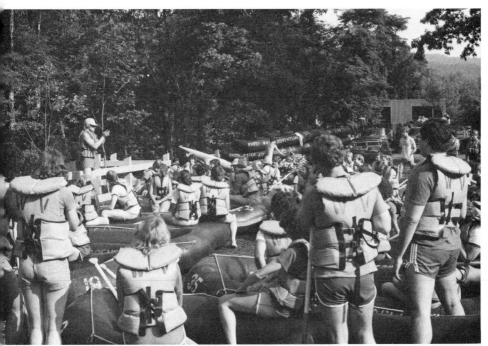

Paul Grabow talks to commercial rafters

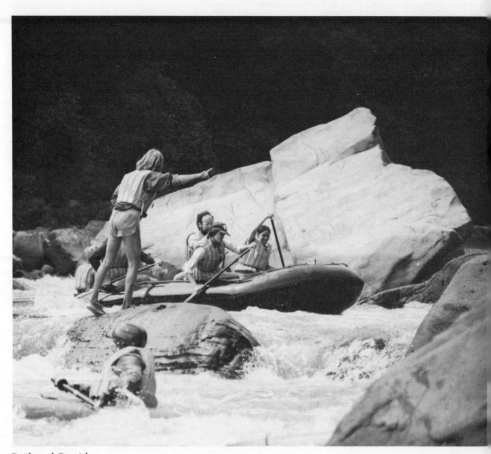

Railroad Rapid

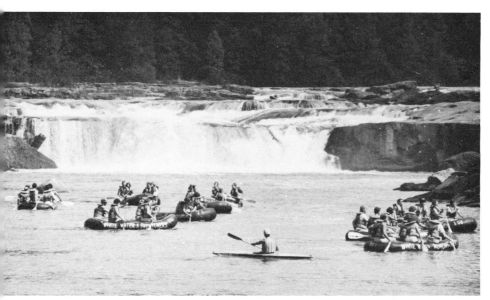

Rafters below the Ohiopyle Falls

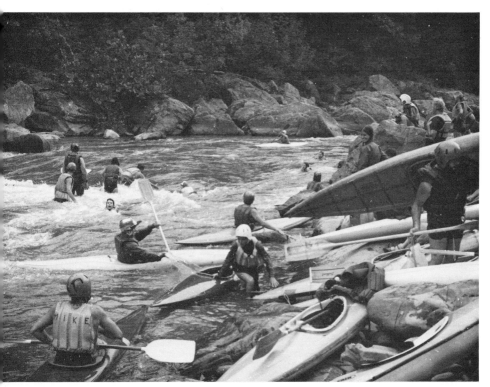

Swimmer's Rapid

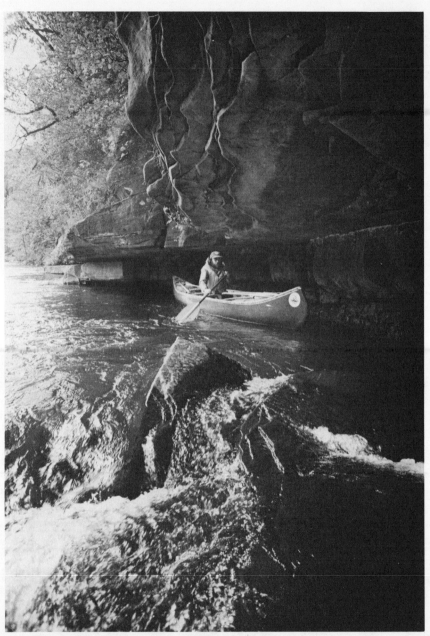

Jim Wilson at the ledges above Indian Creek

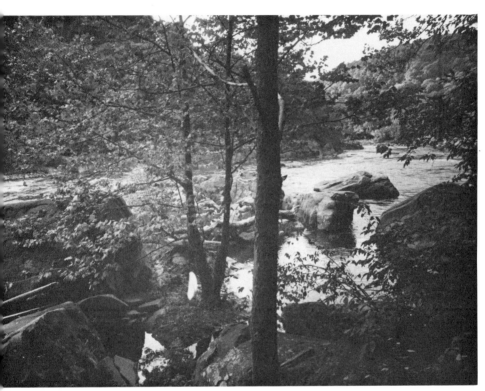

Youghiogheny at Bruner Run

One of the fatalities in recent years was a man with a group that brought one raft of their own and rented others. The man who drowned happened to be in the privately owned raft. In the summer of 1981, I questioned a group of rental rafters who had Youghiogheny Outfitters equipment. They said that they had received no safety talk and no equipment handling instructions. But at the put-in, the state park provides a video tape conveying important information.

White Water Adventurers and Wilderness Voyageurs began renting rafts in 1977. "When they saw that they couldn't beat me, they joined me," Van Nosdeln says. But that is not Marietta's story.

"We didn't want to rent rafts," Bobby Marietta says. "We were hoping to put him [Van Nosdeln] out of business, to kill it. It didn't hurt the guided trips, but we figured it was unsafe." Since Ohiopyle has an ordinance against new permanent signs, the Mariettas propped a Youghiogheny Raft Rental sign on a wagon, parked it next to Van Nosdeln's shop, and waged a rental raft price war. Wilderness Voyageurs also participated.

"We couldn't put him out of business," Bobby admits. "There were so many customers that everybody rented all the equipment they had." Since then, one rental client of White Water Adventurers died on the river, presumably from a heart attack. Apparently Lance Martin, Bob Marietta, and Wendell Holt became convinced that renting rafts is safe, because they continue to do it.

Laurel Highlands does not rent rafts. "I don't like rentals," Mark McCarty says. "There's a market for them, but there's also a safety factor that's completely missing." The economic facts are formidable. Rental rafts are profitable for the outfitters and inexpensive for the customer. But rental rafters must arrange their own shuttle from the take-out parking lot, and if that means driving a second car from Pittsburgh, the added costs are substantial.

Van Nosdeln became known for his antistate views. He feels that he has been stepped on by big government. In addition to river safety, state officials were concerned about the location of Van Nosdeln's shop and Dairy Queen, calling it a traffic hazard. Three side-swipes happened on one weekend. If the topic is a new government attempt to do something, say, to designate the Youghiogheny a national scenic river to prohibit certain kinds of water projects and real estate developments, Van Nosdeln responds with spirited, stalwart views and a rabble-rousing, incendiary, almost evangelical

way of spreading the word. Touching on the ripe topic of government regulation, he says enough of fact, enough of opinion, that discontent rises like a bird and the specter of control grows vivid in the minds of mountain people who are otherwise unfamiliar with these things.

His major current gripe is a narrower issue: "Equity for all at the take-out." At the end of a trip, school buses hired by the guide companies shuttle customers back to their cars near Ohiopyle, but independent boaters must arrange their own shuttle. Van Nosdeln thinks that bus service to Ohiopyle should be provided for the nonguided boaters. Park Superintendent Larry Adams counters that guided boaters pay for their shuttle, that the state can not run trucks for boats and gear the way outfitters do, and that more buses on Kentuck hill would snarl traffic.

Van Nosdeln also criticizes the state for not allowing enough people on the river. If somebody with a permit doesn't show up, their spot may go vacant. From a businessman's view, this is wasted space. Van Nosdeln could fill the vacancies with rental rafters who fail to reserve permits in advance. Larry Adams counters that the state doesn't want to reject people in their telephone-reservations system and then encourage other people to show up for an opening. He says that if people arrive without permits, they will wait long hours for a no-show slot. Their rafts may blow up from overheating in the sun. When they don't get a permit, they'll be disappointed and maybe try to launch anyway. The state already over-books the permits, aiming for half-hourly launchings of sixty people. Out of a daily maximum of 768 nonguided rafters, about 700 spots are filled on most busy days.

Van Nosdeln admits that he is antipark. "But there's a good side. If it weren't for them this river would be polluted. They just over-regulate."

Van Nosdeln was elected mayor of Ohiopyle after Bill Holt retired. "I ran on a platform to keep the Commonwealth from taking any more land," he says. The state park was already acquired. "Our country's floundering because the economy's beginning to slip. Everybody knows and cares except the environmentalists. I see both sides. The state should promote small business. They don't. Environmentalists deter small business.

"Would there be an Ocean City, Maryland, if it was all sandy beach like Assateague Island? Look at James Watt [President

Reagan's secretary of the interior]. Look at the trouble he's in just for saying, 'Let's not buy more. Lets manage what we have.' I agree right here."

Ironically, Van Nosdeln is paid by the Western Pennsylvania Conservancy—has been since about 1970—to buy private property from Ohiopyle area landowners. This is then resold to the state. "He has been able to pick up some properties that we would never have been able to get," says John Oliver, Conservancy president. "We found he was a very effective negotiator."

A former Ohiopyle resident says, "When people found out that Stu was a straw-buyer for the Conservancy, he lost some popularity, let me tell you." Van Nosdeln says that he became involved with the Conservancy because he had seen past abuses regarding acquisition, and that by working with the group, he thought that local people's views would be more respected.

In 1981, Stu Van Nosdeln rented 100 rafts to at least 12,000 people, possibly 15,000, according to his figures. This is about equal to the number of customers served by a guide company. In addition to White Water Adventurers and Wilderness Voyageurs, small rental companies have sprung up in Confluence, Pittsburgh, and suburban Washington.

Managing the River

By the early seventies, the age of river-running had come from the explorers—the Rodmans and Dave Kurtz—to the masses. Tens of thousands of people had come to Ohiopyle, and hundreds of thousands more would come. The staff of Kennywood Amusement Park splashed through Cucumber. Ski clubs with flask-carrying comaraderie scheduled summer flings. Families that treasure security in suburban ranch houses where they mow the lawn and watch TV for the weekend faced close calls at River's End rapid. An organization of gay weight lifters and a group of deaf-mutes were on the same White Water Adventurers trip with good ol' boy guides, and it was a day full of gestures. The percentage of overweight people running the river ballooned. Motorcycle gangs rode in, and so did the big-car-families of governors. Fraternities and sororities came. There were women in floppy hats and kids on drugs. The staffs of embassies in Washington ventured to Ohiopyle to see what America was like. Only a few black people came but their numbers grew slightly

and it was not rare for a pair to accompany seventy-eight other customers. A social profile reveals boaters at Ohiopyle to be white, young, middle class, and highly educated.

Pittsburghers came. In the same way that word spreads about a bar that is suddenly the place to go, word of the Youghiogheny spread through western Pennsylvania. Then beyond: Philadelphians and Washingtonians with indoor tendencies and urban quirks came looking for a river to give them a rubber roller coaster ride they would never forget, and nearly all of them loved it. Midwesterners arrived, starved for gradient.

Gradient—that elixir adding spice and sweat, excitement and change, challenge and speed. It demands youth or at least to be young at heart, and if people can cope with it, it makes them feel young whether they are or not. Gradient—whether shooting skyward like a mountain or dropping unnervingly beneath the horizon like a rapid—draws certain people toward it.

The urbanites from either direction—Pittsburgh or Baltimore/Washington—were not taking resources away from the mountains as in the lumber and coal days. Now the outsiders came to enjoy the land and water for what it is, but the economy of Ohiopyle was still dependent on the economies of the urban areas. If the city people had no time or no money, then there would be no rafting business and no jobs in Ohiopyle. The economies were willing, however, and so the beauty of the Youghiogheny was matched only by its crowds.

Ohiopyle became one of the best-known Pennsylvania parks. Nationwide it became one of the signficant state parks, like the Adirondack Park in New York, Jedediah Smith Redwoods in California, or the ocean parks of the Florida Keys.

People came for fun and thrills in the river-showcase of nature. They came to satisfy an urge, a need that they probably never knew they had. And the river did this in ways that people probably never realized, never fully discovered, in ways that they never counted.

The Youghiogheny became a hot-spot for thrills without skills, and few people thought much more about it. It became an amusement park with nobody making a move to see that the place was respected.

"Gang boating," Sayre Rodman calls it.

"I looked upstream and it was nothing but rafts, bank-to-bank," said one visitor on Memorial Day. "It was a picture that belonged on the last page of *Life* magazine."

"It was kind of sad, and I don't want to go back," says Bob Harrigan, the first canoeist.

It was more than sad. It was chaotic. Traffic congested when rafters walked across Route 381 to reach the put-in, which became a quagmire where mobs from different companies competed for space. It was bumper boats in Cucumber Rapid. There were times when guides from one company caught up to another group and then shouted at the guides ahead of them. Bill Calantoni, who worked for White Water Adventurers, says, "It was none of this, 'Hey man, you think you could speed your trip up a little?' It was, 'Hey, get to hell outta here.'" There were fist fights at the take-out. From 1968 to 1978, fifteen rafters drowned. None of them were with guided groups, most wore no life jackets, and some were drunk.

Friction between guided groups, rental rafters, and independent boaters increased and the heat of it took away the fun. Like uncontrollable floating locomotives, rafts rammed kayakers and canoeists into boulders. A paddler who had been going to the Youghiogheny since 1961 said, "Most of the rafters don't give a good damn about the river. They are there only for the thrills. It's like an amusement park for them. Unguided rafters are in many ways the worst. The guides at least keep their customers together with some hint of environmental insight. You never see them throw trash. But their trips are too large. There's not even a semblance of a wild river."

About the early seventies, Bob Marietta said, "You could cross the river by jumping from boat-to-boat." Free enterprise had reached an extreme that brought anarchy. It was time for the government to manage a problem that individuals held no authority to solve and that commercial outfitters showed no willingness to control. A certain amount of quality had been irrevocably lost before the government moved—before a lid to save a public resource would be put on free enterprise.

Some people criticized the state for waiting so long. Paul Wiegman of the Western Pennsylvania Conservancy says, "Instead of five years earlier when the amount of use was reasonable, the state waited until it was overcrowded. Then they reacted."

The Youghiogheny had become the most-floated whitewater in the country, and the solutions to its problems would eventually make it the most efficiently-run whitewater system. In the management of river recreation, the Youghiogheny would become unique, but not without mistakes, failures, and compromises.

Since boaters used state park land to put in and take out, state officials reasoned that access could be regulated by the Bureau of Parks. In the name of safety and environmental protection, the state would try to limit the numbers of boaters.

How much use is enough? Jean and Sayre Rodman would have preferred the river with maybe half a dozen small parties, spaced an hour apart. Others found forty people per group to be tolerable, but that day was past. Some boaters thought that 1,000 floaters a day would have been reasonable, but on busy days, that number was already dwarfed. When state officials took action to limit growth, their expectations were not high. They would not save an atmosphere of wilderness. They would simply do what they could to prevent the utter chaos that results from overuse.

In 1970, 17,000 people floated the Youghiogheny, and in 1972, 45,000 (floaters in the Grand Canyon of the Colorado averaged on 14,000 a year in the mid seventies). Over half of the Youghiogheny visitors paddled with commercial guides.

Group size had climbed to eighty (eighty customers made a two-bus trip). Each company ran one to four trips a day, and the four companies thrived without competition from new outfitters. While they did not want regulations curbing their activities, they would welcome a government ban on new companies, thus assuring them a captive market.

The Bureau of State Parks struck a deal. They would ban new guide companies if the four outfitters agreed to limit their customers. That was the easy part. The numbers then became the issue: the outfitters each wanted four groups of sixty people or three groups of eighty people a day. This represented about the maximum of 1973. The state ruled that three groups of sixty people would be allowed for each outfitter. The outfitters promptly appealed the regulation to the State Environmental Hearing Board.

Lance Martin says that safety and environmental protection were not the issues. There has never been a drowning on a guided trip. "The state arbitrarily picked some numbers," Martin accuses. "I wanted to freeze everybody, but allow some room to grow. I was running four trips of sixty people then." The state's proposal would have reduced Martin's customers on his busiest days, but would have allowed everybody else to grow. With parks director Bill Forrey and state attorney Arthur Feld, Lance Martin and his attorney negotiated.

The Bureau of State Parks was at a disadvantage. They had no documentation regarding safety or environmental protection, and few precedents had been set regarding river regulation. Floaters on some of the popular western rivers were regulated by the National Park Service, Forest Service, or Bureau of Land Management, but those cases were only remotely similar. Nor did the Bureau of State Parks enjoy a political constituency. The state was without legal or political leverage.

The "negotiations," as Martin calls them, resulted in three trips of eighty people for each outfitter—about the same number Martin was already running on his busiest days. The limit of use was thus established by taking the busiest day of the busiest company, and allowing all four companies to run that many customers every day of the year. State officials didn't think they would need to regulate nonguided boaters, but that was before the boom in rental rafting.

The 1973 agreement did not solve the crowding problems. Far from it. The new rules merely assured that the busiest days would not become even worse. Labor Day weekend crowds could be repeated all summer long. The regulations did not address rental rafts, independent paddlers, scheduling, shuttle systems, or the efficiency of boating on the Youghiogheny. These issues would fall to the new park superintendent, Larry B. Adams.

Adams is neither an office-anchored bureaucrat nor a pipe-puffing old-guard parks and forests man. He fits none of the molds, and perhaps that is a reason for his success. My impression on meeting him is that he is reserved, conscientious, and cautious. He is of medium height, medium weight, and normally mild disposition. His light brown hair is relatively short and curly.

He grew up near Lock Haven in north-central Pennsylvania and learned something about rivers at an early age. "Some other kids and I would take this four-hundred-pound-wooden boat on the West Branch of the Susquehanna," Adams recalls. "We rowed it in floods. Once we took it over the dam; that was really stupid." Run-of-river dams can be dangerous because the flow over the dam is uniform, creating unrelenting reversals at the bottom, unlike the erratic flows at the foot of a natural waterfall where rocks break up the current. As a kid, Adams read Jack London and Zane Gray and wanted to work outside.

He earned an education degree at Lock Haven State College and

completed fifty-six graduate hours at Millersville and Cornell. He was collecting field data for his masters degree in biology. "Some friendly loggers wiped out my research area," he says. The study was never finished. In high schools he taught "environmental biology," "micro medical biology," and "biology and the scientific process," but after six years the challenge was gone. He was going to teach in a college, but the pay cut would have been $4,000, and teaching had not been his dream anyway. Adams's boyhood dream was to be a park ranger and to ride around on a horse and not see anybody. The first part of that has come true. While we talk, the summer of 1981, Larry Adams is thirty-eight years old and signs his name to each of eighteen identical forms required of park rangers.

In 1974 he inquired about work with the Bureau of State Parks, passed a civil service test, and was hired as superintendent at Shikellamy, managing four small parks. He had not landed the glamour job of the bureau, but this was the way a biology teacher broke into a system dominated by green-uniformed career men and later by recreation specialists with college degrees tailored to park managers' needs. "And don't let anybody kid you," Adams says, "a bunch of little parks is a hassle. You have to do everything four times and drive fifty miles to visit one of the parks."

Only two years after Adams accepted the Shikellamy job, Chuck Rea left Ohiopyle for Black Moshannon. From six applicants, Adams was selected as the new superintendent. "He had a good record," says Bill Forrey, "and we figured he could handle the job." With only two years of experience, Adams was taking on Ohiopyle when the outfitters were suing the state, the railroad was closing the take-out, the locals were shooting mad about land acquisition, arson was suspected in hotel and forest fires, the sewage plant wouldn't work, visitation was approaching two million, strip miners were chewing at the boundary, and people were drowning in the river.

Not long after he got there he was climbing on the rocks below the superintendent's house at Entrance rapid. He twisted and broke his leg and fell into the river, luckily splashing into a pothole full of water so he didn't hit his head. It was a hot Saturday afternoon and there were about a hundred people around. Being in full uniform, Adams brought a good laugh from one and all. What does a new superintendent do then? He climbs out of the Youghiogheny, acts normal, limps home, and asks his wife, Nancy, to drive him to the Uniontown hospital.

Adams would gain a reputation for being hard-working, strict, efficient, and fair. One park employee says that he gives you the help you need but doesn't do your job. "He gives you responsibility, but if you start screwing off he finds out about it."

John Lichter, Ohiopyle kayak instructor, says, "He's a pretty good guy. He's learned how to paddle an open boat on the river. On Sunday afternoons he took some C-1 lessons from me because he wanted to be able to patrol the river himself, at any water level."

Stu Van Nosdeln calls Adams rude and uncompromising. To define a waiting area for independent boaters, Adams had a wooden fence constructed, which happened to fall between the Dairy Queen and the ranger check-in station. He also had a cement sidewalk built from Van Nosdeln's shop to the put-in area. In response, Van Nosdeln erected a large sign along Route 381 saying that Larry Adams wastes taxpayers' money.

Adams says, "The hardest thing out here is the lack of support. No citizens' organization, no chamber of commerce. A lot of the park visitors are from out of state, so they're never around to put in a good word. You're on your own."

Bob Marietta says, "He's done a wonderful job. He's solved a lot of problems and he's been fair. A few years ago you couldn't work this river but now you can."

Adams went from small urban parks that were fully developed to a large mountain park that was hardly operational. "There was a lot of facility development to finish," he says, "and more difficult: a lot of operational development was needed. To set up an operational scheme that worked—that was the biggest challenge."

In the mid-seventies, Forrey, Adams, and others at the state level could see more conflicts coming. In 1975 there were 75,000 floaters. The state expected more lawsuits by the four outfitters, they expected lawsuits by other people who might try to offer guided trips as a fifth company, and they expected lawsuits from private boaters. Since rental rafters were considered "private" boaters, the state was getting ready to regulate them, and justification was needed. To prepare themselves for all this, the Bureau of Parks commissioned a study by Charles Strauss, associate professor of Forest Economics, of the Penn State School of Forest Resources.

Working under Strauss, Chuck Myers, an instructor of forestry, surveyed the management of twelve other rivers. Only two were in the East: Georgia's Chattooga and Maine's Allagash. The Chat-

tooga had 66 percent private boaters. No data was available for the Allagash, but most of its boaters were also private. The Snake River had no limit on party size, but among all other rivers, the maximum group was thirty people—only three-eighths the size of the Youghiogheny trips. The Stanislaus of California had a maximum group size of twenty-five. Most river management agencies had a moratorium on new outfitters.

A shoreline study found that "the effects of user impact are readily apparent," but not serious. Strauss warned that eroding banks could result if the number of people increased.

For an economic analysis, Strauss collected information from the four Ohiopyle outfitters, then averaged it into a hypothetical company at 1977 prices. Gross revenue totaled $262,700, about half of it being spent on staff, leaving a net revenue after taxes of 17.5 percent of investments. The study could be criticized for being too conservative, for example, it depreciated rafts to zero value in three years and Ralph McCarty was still using some of his original equipment, but the analysis still indicated that the outfitters could afford to pay the state a fee for use of the park and its facilities. The four companies were not at the edge of poverty, yet the Penn State economists contended that the industry could not support a fifth outfitter. They said that a fifth company would lower average profits to a 4 percent return on capital.

A large part of the Strauss study dealt with acceptable numbers of boaters. The state had already agreed to let each outfitter run three groups of eighty people a day, so Strauss considered no less. "We were working with a situation where the Bureau of Parks had set up agreements," he explains. He considered an increase in nonguided people, since their numbers were unregulated.

The researchers spotted major congestion points, measured the time it takes to paddle from one to the other, and constructed a statistical and computer simulation model of this unusual transportation system. The model would predict the effects of increasing numbers of boaters.

Strauss selected fifteen minutes as the maximum time that people would wait while other boaters went through a rapid ahead of them. Should the system be designed to require maximum waiting time that people will tolerate? Fifteen minutes was a "subjective judgment," but that figure made possible 2,000 floaters a day with one boat going down the river every thirty-six seconds. This was the

figure recommended by the Strauss study: the 960 guided customers already allowed, plus an equal number of nonguided paddlers. To hold nonguided boaters to their quota, the researchers recommended a permit system.

One could argue that 2,000 is too many boaters because fifteen minutes is too long to wait. Five minutes is often the longest I wait in line at a grocery store, and most people do not expect grocery store lines during weekend river escapes. But to allow less than 2,000 would mean less than half nonguided boaters, who would rise a raucous objection, or a roll back in guided customers, leading to a sure lawsuit by the outfitters. Supported by the Strauss study, the state decided on a 50–50 split between guided and nonguided boaters. Was there something inherently fair about 50–50? "It seemed like it," Strauss says. "Whether there is or not remains to be seen."

Larry Adams defends the decision: "At the time the numbers were accepted, commercial [guided] boaters were a majority. The 50–50 split allowed the private sector more growth."

Lance Martin debates the entire differentiation. "The thing that bothers me is that government agencies make a distinction between commercial outfitters and individuals running the river. What's the difference? Our people are individuals too."

The point is hypothetical (so far), but if there were no distinction between guided and nonguided users, the outfitters could conceivably tie up most of the spaces if they were allowed to acquire permits on behalf of customers. On the other hand, if everybody had to get their own permits the way nonguided boaters now do, then the outfitters could suffer. A national lobby of private boaters (the National Organization for River Sports, or NORS) argues the point: they contend that all boaters should be required to secure their own permits from the managing agency, then choose to run the river with an outfitter or by themselves. NORS argues that this is more fair—everyone competes for permits under the same rules. Commercial outfitters argue that customers should not have to do this and that the inconvenience of getting a permit would hurt business. The day may come on the Youghiogheny when this question is raised, but for now, the 50–50 provision is not an issue.

A thornier question dealt with rental rafters. Many boaters regard them as commercial customers because the renters pay money to Van Nosdeln, White Water Adventurers, or Wilderness Voyagers, and rent everything but a guide. In terms of expertise, social make-

up, and attitude, rental rafters are similar to guided rafters, but not at all similar to most independent boaters who have invested in and learned to use their craft. But the state regards rental rafters as "private" boaters. Larry Adams agrees that the rental companies are commercial, but says that inclusion of them in the commercial quotas would be impossible. "There's no practical way to do it. You can't go up to somebody and say 'Where did you get that raft?' or ask them for a bill of sale to prove they own it."

The state, citing more demand by rafters (who were mostly rental customers), accepted a formula for nonguided paddlers allowing 193 hardboaters (kayakers and canoeists) and 768 rafters. The figures are lopsided against hardboaters, even though Larry Adams says, "They are the best safety force on the river. If there are accidents, the hardboaters are the ones who save people."

Through 1981, kayakers and canoeists seldom reached their limit. Ranger Bill Calantoni said, "Without waiting, hardboaters can get on the river at almost anytime they want." But someday the popularity of kayaking and canoeing will probably outstep the permits available, and paddlers will realize that 75 percent of the nonguided boaters and 89 percent of the total boaters allowed by the state are in rafts. If something is inherently fair about 50–50 between guided and nonguided boaters, then how fair is an 89–11 ratio between rafters and hardboaters? Larry Adams says, "The allotment wouldn't change unless the situation changes. If there are lots more hardboats, them maybe we'd consider something else."

Responding to the Strauss conclusion that outfitters could afford to pay a fee to the state, and to an economic logic that says outfitters should help support the facilities that they are using, the state levied a fee on the four guide companies (rental companies pay only sales tax). Each of the guide companies was to offer a lump sum as a competitive bid for a ten-year term. The four highest bidders would get the permits to use the park facilities. The state would also collect 9 percent of the gross annual receipts. With Lance Martin as spokesman, the outfitters objected, saying that they hadn't asked for expensive facilities, and that concessionaires in other parks pay only 5 percent. Larry Adams says, "The state invested millions in the park, and facilities for the rafters were needed. We should get a return. They're using public property to make a profit." Both groups agreed on 7 percent as a compromise. The ten-year lump sum bids of the four companies ranged from $6,700 to $31,000.

Although the state had developed a better rationale for a white-water management system, the execution became ever more troublesome. When private boater permits were required on a first-come, first-served basis, lines formed at the ranger station below the Falls. "Once we had 400 people there," Larry Adams recalls. "Some of them waited four hours. In 1978 we almost had a riot two or three times. Over 200 people were chanting. They were yelling that they'd throw us in the river and that they'd take their rafts down anyway." The rangers called Adams on the radio and he rushed to the put-in. It was late afternoon, and no more trips were allowed except for the Loop. "We just about had to call the state police. We had to crowd around the girl selling tickets and escort her to the truck to get her out of there. The people would have taken the tokens and gone. We're not ready to handle that kind of thing.

"There were people getting permits [which were free] and selling them to a rental company," Adams says. Some people left without tokens, and when they got to Bruner Run, the bus driver wouldn't take them up the hill to the parking lot.

In 1978, 95,000 paddlers came the the Youghiogheny. It was a bizarre era. One night, the White Water Adventurers guides brawled in a barroom with the boys from Dunbar, who hid out the next day above the ill-fated take-out that Stu Van Nosdeln had bulldozed. When the White Water group drifted past, the guys from Dunbar opened fire with high-powered rifles, blasting the water around the guides' kayaks. Nobody was hit. The guides sent word back to park headquarters, and Larry Adams drove to the site. "Part of the group was still there," he recalls, "with fishing rods and a bunch of empty shell casings on the ground. They weren't young. One was in his forties. They'd been drinking. A lot of bottles were broken on the beach. They played it real cool. There was no way to prove they were involved."

It was a ridiculous, difficult time. The state imposed a ban on rafting when the water level reached four feet on the Ohiopyle gauge. One day in February, Jesse Hall and a group of his friends decided to go down the river when it was five feet. Clyde Burnsworth and Dave Whipkey—two rangers—saw the group getting ready. Burnsworth didn't see any life jackets. He told them not to put in, but Hall carried his raft toward the river anyway. Burnsworth grabbed hold of one end, but to stop Jesse was like taking a

banana away from a monkey. He came out swinging. Burnsworth says, "He was pretty boozed up. We got in a tussle, and I had Hall partially subdued. I told him he was under arrest, and as we walked up the path, he turned and slugged me in the mouth, loosened a few teeth. I said, 'give me your nightstick Whipkey,' but Hall took off." Jesse went to court and paid fines.

Larry Adams worked with outfitters, private boaters, and state park planners. Armed with the Strauss study and several years of experience, he proposed solutions. He formed an advisory committee of outfitters, canoe clubs, state officials, and environmental groups in 1978 to review his proposals and suggest changes. Operations were improved while whitewater popularity continued to spiral up.

Boosted by entrepreneurs here in the mountains, escape is a growth industry. In 1979, 105,000 paddlers came to the Youghiogheny below Ohiopyle, and in 1980, 115,000. In 1981, 138,000 people ran the river below Ohiopyle while park visitation totaled about 1.5 million. In 1982, about 150,000 people ran the river below Ohiopyle. Twenty thousand people came to the park on busy days. In comparison, Pittsburgh's Civic Arena holds 17,500 people and Three Rivers Stadium, 54,000. Since the first rafters of 1956, over one million people have paddled the Youghiogheny below Ohiopyle.

The gross conflicts—the fist fights and lines of irate rafters—ceased, and with the new management plan in 1978 and 1979, the Youghiogheny became the most efficiently run whitewhater in the country. Below the Falls at Ohiopyle, a guide company launches every half hour, 8 A.M. to 1:30 P.M. Nonguided boaters, in clusters up to sixty, launch every half-hour between the commercial groups. Except for the off-season, nonguided rafters must secure a free permit in advance. Additionally, these boaters acquire a bus token for $1.25 at the put-in, assuring them and their gear of a ride from the take-out to the Mitchell place parking lot, 1.6 miles up the hill. On weekends, people running only the Loop must wait until 2:00 in the afternoon, but they need no permit. People caught sneaking onto the river are fined $50.

All of this so that 2,000 people can go down the Youghiogheny during one day. "It's your punch-in, punch-out river," Ralph McCarty says. In 1981, 10,000 people paddled kayaks or canoes, 60,000 were on guided raft trips, 35,000 ran in rafts that the people rented or owned, and 33,000 ran only the Loop in rafts or hardboats.

When your time comes to go, you'd best be ready because you may not get the chance again. An early morning commercial trip at Ohiopyle was half an hour late, and by then, another company was due to launch. This would have meant a 160-person bottleneck and no end of congestion. The ranger said they couldn't go, then called Larry Adams because the outfitter intended to put in anyway. Adams stopped them. "I wasn't going to back up a whole days' launch just to accommodate one group," he explains. He required them to wait until 2:00 when all the other commercial trips were gone.

River runners, as a group, are late. When a trip scheduled for 11:00 finally puts in at two, boaters say, "river time." But that doesn't work on the Youghiogheny. You don't go up there and fool around with your gear, put in when you feel like it, and take your time. On busy days, you move to a schedule accommodating a statistical average of one person per 18.5 feet from Ohiopyle to Bruner Run. Running the river takes on a certain stamp of the insect world.

This is on weekends all summer. Weekdays see crowds, but rarely the limit. April, May, and October include idyllic springtime and autumn boating, totally absent the mob. Then during the winter the place hibernates.

This part of the Youghiogheny has been forever changed by the park and by the runners of whitewater, yet reminders of the old days cling to Ohiopyle.

Ohiopyle and the Run

Summer of 1981, Ohiopyle: population 118, plus river guides, plus visitors who will total 20,000 today. More than ever, this is a river town, and in the layout of things, the Youghiogheny comes first. To enter Ohiopyle from the north, you must cross a bridge where you see that the river sets the town's boundaries. From the south, your approach winds down the mountain, offering glimpses of Entrance Rapid. From the east, you roll off Sugarloaf and only brakes save you from the Falls.

Here are forty houses, one general store, a set of gas pumps, five rafting company headquarters, two upstairs boardinghouses, a fire hall, a water treatment plant, railroad tracks, an unused railroad bridge, an empty railroad station, a closed elementary school, 550 parking spaces for visitors' cars, a gift shop, a pickup truck full of hoagies for sale, a youth hostel, a new brick post office, a pair of churches, a historic gristmill housing an outfitter's equipment store, and a Dairy Queen. Twenty-nine houses, many of which were sagging in the 1960s, are gone, and so is the raw sewage that meandered in ditches and in alleys to the river. Now the sewage passes through a treatment plant first.

A three-story brick building still stands with bold, old-fashioned letters at the top saying, "Holt's Department Store," but the place has changed. There formerly were full lines of groceries, hardware, clothing, and appliances. Groceries still populate the shelves, but they are mostly convenience foods for quick meals and picnics. People sit on stools to drink coffee and eat sandwiches at a counter.

From behind it, a TV stares out at the people and urges them to stare back; in the afternoons it broadcasts soap operas. A handwritten sign on the TV warns, "Don't *ever* move this TV. Leo S."

Leo Smith, owner of an aluminum siding business near Washington, D.C., saw an advertisement for Bill and Adalene Holt's store in a Washington paper. "I've been around the world three times in the Air Force," Smith says, puffing on his cigar, "and this is as pretty as anyplace I've seen. The store looked like it had possibilities, so I came." On a busy day, hundreds of people walk through the store (now called Falls Market), and Leo sells them coffee, pop, gas, ice, and ice cream. The store always doubled as a community center. While it is now a less-serious place—nobody does any real shopping there—it is even more a meeting spot, a hangout.

In the mornings, this is a melting pot for the two basic cultures of Ohiopyle: Appalachian locals and river runners. Free news, especially on quieter weekdays, includes local skullduggery, fast-moving rumors, government action exaggerated, clunker cars for sale, free firewood pickings, who is sick, and who is running with whom. Which of these topics is emphasized depends on the group doing the talking. There is a group of kids, one of young bearded local men, one of river runners, one of old-timers, and so forth, all in relatively peaceful coexistence.

If old Winnie ("real name's Bill; don't know how I got Winnie, just did") Glotfelty catches a fish, that will be hashed and rehashed, compared, debated, related to the season and water level, and cooked six ways in the mind's eye. Not by Winnie himself—he is always fishing—but by others to whom his catch is known. "It's something t'do," Winnie explains of his passion. "Beats drinkin' in'a bar." The thing that has really given him notoriety is not the way he pulls fish in, but the way he talks to them. "Here fishey. I'm gonna save ya' from drownin'. I know ya' can't hold yer' breath iny longer."

Out front on the steps, during evenings, high school seniors talk about who is getting married. They talk about enlisting in the service: a rare opportunity for a job, for a ticket out of the mountains, and as for toting guns, that is second nature up here so you may as well collect a paycheck for it. At night some kids sit on the corner and get stoned, or on a weekend they prop a keg in the back of a pickup.

Ohiopyle students ride one hour to Uniontown to high school.

They and others from the country form a distinctive lot: the moun-
tain kids. Not that Uniontown burns any bright lights. It is a de-
pressed and has-been coal town with little to brag about but bygone
wealth and a new Pizza Hut, but culture is nonetheless cleaved by
Chestnut Ridge, Ohiopyle being on the other side. Years ago, the
same difference existed in Connellsville where Dr. George Dull re-
members his schoolmates of the 1920s: Shelby Mitchell, Adalene
Potter, Bill Holt, and others who rode the train to class. "They were
the mountain folk," Dr. Dull says. Some things about Ohiopyle
have changed little, but other things have changed greatly.

River guides act as official hosts of modern Ohiopyle. They form
a culture unto themselves. They are young in a region where the
numbers of elderly reach double and triple the national average.
Guides have sun-tanned legs in a region where men worked for
years in black coal mines or in the shade of trees.

Experienced guides earn about $50 a day, but only from April to
October. Many guides work three months at most. "The pay is
good," says Bill Calantoni who used to guide, "and this is the nicest
place in the whole Northeast according to me, but being a guide—
it's a rat's life. It's day-to-day. Maybe you live out of a van. Maybe
you go south for the winter. That might be exactly what you want
to do, with nothing else mattering, but how long can you go on
doing that? After a while, you want some money for a down pay-
ment. You want to stay put."

River guides burn out. They become saturated with the people
and the pace. "Our guides stay an average of about three years,"
one of the company managers says. "Then they move on to other
things. The Youghiogheny is the worst river to guide on. You have
to take abuse from the rental rafters."

On the Youghiogheny, very few guides are "professional." River
running will not be their career for years to come. They think they
are supposed to do something else; it strains the work ethic to
imagine guiding in the long term. It is a summer job, one for young
people. But a good guide's experience, talent, and expertise amount
to skilled labor, to a profession. In spite of the transience, seasonal
paychecks, Yough lunches, wet shorts, and tourists repeating tire-
some questions, there are many worse ways to live.

Religion and violence are two signs of a cultural gulf between
local people and river runners, and also between two classes of local

people. Many of the older Ohiopyle natives are dressed up and sitting in the Baptist or Methodist church, bells ringing on Sunday morning, while surrounding them are hundreds of paddlers pulling on bathing suits for their whitewater cruise.

Most local people are peaceful, but among a few, the violence is blatant. Fighting is a sport. Jesse Hall and Bobby Marietta disappeared in a fist-filled cloud of dust at the Mountain Freeze one night, only because they hadn't seen each other for a while. A local woman once beat up a woman river guide right in front of Falls Market while ten people, including the town cop, watched. A streak of violence runs deep. Maybe some people just can't stand all the peace that the place normally offers.

Some local people, while not welcoming, envying, imitating, or for that matter meeting the transient boaters, find entertainment in watching. The men sitting on the bench by the Falls Market gas pumps don't miss a thing. Part of this is freak-watching, part is girl-watching, and part is watching anything that moves.

And the urbanites seem satisfied that Ohiopyle remains a mountain town. The locals are part of the set. It is the satisfaction of city people who enjoy bars where the locals stomp to fiddle music. The hillbilly has become a folk hero and the tourists like to see him. It is a unique mixture of cultures, this Ohiopyle.

Overlap with the past is strong. Gwen Holt Waters scarcely knows me but she is comfortable, serene. There dwells an uncommon peace with her that can be credited only to something inside. Because outside, her world has turned over several times. In regard to place, to home, and to belonging, Ohiopyle is everything to Gwen Waters. It is the only place where she has lived, the only place she has really known. And the Ohiopyle of her mind's eye remains an Ohiopyle of the lamplighter and the swimming in long dresses. Since then, the town sputtered in economic decline, its social fabric unraveled, and more than one-third of the buildings themselves were razed for the park. Most of her friends have died. Tourists and boaters flood her surroundings with alien ways. She survives and continues to do the chores, sweep the walk, feed her cats, visit with the Holts next door, smile, and reflect on how good life has been. "The river guides are friendly and nice. We get along fine. Ohiopyle is a real nice place."

It is at once very old and very new. The Potter gristmill houses flour bags and grindstones upstairs, but downstairs it houses Kev-

lar, ABS, and fiberglass canoes and kayaks for sale by Lance Martin. Gwen Waters lives in Ohiopyle and so does Jon Lugbill, world champ C-1 paddler.

Many of the people who enter Falls Market have something to do with paddling. Some boaters—usually Ohiopyle regulars—stop here. A man from Ohio wears a tee shirt that says, "Rolling boaters gather no stones." River guides enter now and then, but most do not hang out. It is not their kind of place, except for the White Water Adventurers crowd which bridges the gap: local to river runner. Wendell Holt or Bob Marietta show up daily. A part-time guide for White Water Adventurers—Bill Heller—orders a prefab egg-on-muffin sandwich, a slice of pie, coffee, and two cookies for breakfast. The organic food revolution has yet to convert many river guides here.

Anita, who began working for Mountain Streams and Trails but now works for White Water Adventurers, is one of the few women guides. She walks in and everybody looks. Her blonde hair falls halfway down to her waist in two braids. Her blue eyes dance. She glows rosy with sunburn, and her figure is one that cannot be ignored. Guys flirt with her and she flirts back. She plops down on an empty stool next to Heller, and he leans over and bumps his shoulder against hers and says, "Hi Anita, looks like you could use some Sea and Ski," and she answers, "What are you eating, an onion sandwich?"

Mark McCarty shows up at the store. He closed the gap between outsiders and locals when he married Linda Marietta. His younger brother, Mike, closed another when he was elected president of the borough council.

Sherry Hall also bridges a gap between local people and the rafting industry. She grew up in Connellsville, coming to Ohiopyle on weekend trips as a kid. Now she attends college at Indiana State and works for Laurel Highlands in the summer. She sees differences between residents and the river crowd: "Local kids and guides both have beer parties, but the local ones are worse. They go on for days." She motions toward the anthill-activity at the put-in. "Most local people don't try to get in on it. Nearly all the employees are from other places, mostly near Pittsburgh. A lot of people here just don't try. You see girls fifteen years old with babies. People here have no idea that they can do whatever they want to do."

The makeup of Ohiopyle is changing. Fifteen years ago, nearly everybody in town had been there for life. Now the river crowd is growing, the local crowd shrinking. John Lichter's kayak instruction business could grow into a whitewater racing center. Who will buy the houses of twenty widows who are in town when they are ready to sell? Will Ohiopyle someday become a town of river runners?

Friday night, while Bill Holt rocks on his porch overlooking the state park lawn and the river, a van stops along the main street and three people unload a bundle of nylon cloth and a four-foot-square basket. A crowd of fifty gathers while the three aliens blow up their hot air balloon with giant fans. Two people then climb in the basket, launch into the sky, and disappear northeastward over Laurel Hill. Bill Holt takes it all in, then says, "I've been sitting on this porch for seventy-three years and this is the first I've seen *that*."

Saturday is square dance night at the fire hall. The firemen and "auxiliary" put on the show with a band and caller—old guys from the outskirts of Uniontown. Local people attend. River guides attend, but not many dance. On the porch of a house across the street, a crowd of guides watches and howls at movies of hot-dog boaters. Near the fire hall, a girl advances under the trees and grabs a young guide named Bill, but the fool runs away. Two women then clog to "Orange Blossom Special." Mike McCarty carries his brother's new baby. Mike's wife, Elaine, and twenty others in Ohiopyle and the adjacent Stewart Township are pregnant this year. The median age of this old place is about to plummet.

Bill Calantoni stands about six-foot-four, weighs about 250, usually wears sun glasses, is bald, and works as a park ranger. You can see him—cannot miss him—patrolling in the state truck, or checking boaters at the put-in, or gulping a cup of coffee at the store. When he is off duty, you can find him swimming at the Ohiopyle beach. He loves to swim as Winnie Glotfelty loves to fish, as Steve Martin loves to paddle, and the Youghiogheny accommodates them all.

Son of a coal miner from Richeyville, west of Uniontown, Calantoni knew Ohiopyle as a kid. "This place goes way back for me," he says. "My old man brought me here. Then in high school, this was the place to go with a date." He worked in a steel mill, gradu-

ated from college, and taught science in the Hill District of Pittsburgh. Kids had little interest in science, and there were days when Calantoni had to hide, had to get away from the nagging world. "Up here was my mental-health retreat," he says of pilgrimages to Ohiopyle in the sixties. "I'd call in mentally ill, and to cure it, I'd go to Ohiopyle."

The retreats overcame the advances, and Calantoni dropped out of teaching. "It was one of those 'leaves without notice,' " he recalls. "I had a car, a motorcycle, a nice pad, but kicked it all in the ass." He caught a plane to Jamaica and loafed for six months, scuba diving and asking, "What am I going to do?" The only thing he really knew was that he loved water. Swimming, scuba diving, sailing, anything with water.

"I came back and had a job lined up with a strip miner. It fell through. Good thing. I'd never do that now. I would have taken a job teaching in a rural area, but there was a glut on the teaching market." No one would hire Calantoni.

"There I was, thirty-four-years-old and all that time I never said 'forget it.' I had never worked just as I pleased." So Calantoni returned once more to Ohiopyle, this time to become a river guide.

Bob Marietta of White Water Adventurers told Calantoni, "Work awhile and we'll see how you do." Back then, that's the way it was done: work for free and maybe get hired. After a couple of days, Marietta said, "Okay, you're on the payroll."

Calantoni loved it and says, "Nothing in the world mattered except that I was doing what I wanted to do."

Guiding at Ohiopyle was different in the mid-seventies. Especially at White Water Adventurers. "The guides were crusty characters," Calantoni says. "Renegades. They drank and fought. They didn't wear fancy shorts like today. They wore cutoffs with half their butt hanging out. Our life jackets were rags that'd fall off when you exhaled. It was rat city. If you could find a roof to live under, that was good. Now they have roofs and plumbing too. But living on the water all summer—what could beat it?" Life was for living, just one day after another. This went on for three years, but something could beat it: security.

"You can do that only so long," Calantoni adds, "but man, I loved Ohiopyle. This is the prettiest place I've ever been. This is where I'm supposed to be. What could be better than this—swimming every day. Go down and sit in those bubblies. Ummm-um!

Kids playing in the street at night. Only an hour-and-a-half to Pitts-burgh if you want the bright lights now and then."

He applied for a summertime ranger job and was hired. After three years as a seasonal ranger, he applied for a year-round posi-tion. "My reason is strictly selfish, I like it here." He was hired full-time in 1981. "Hey Tim," he yelled with a smile from his ranger truck, "I get to live and die in Ohiopyle!"

This Sunday morning in August is typical: foggy. Cars and vans with kayak-covered roofs speed in from Pittsburgh. The town is in a crescendo of activity with river guides, paddlers, and commercial customers congregating and buzzing in a dozen locations. In the whole country, there is no place as much a whitewater town as this.

Outfitters' trucks, stacked high with gear, wheel into the put-in area and guides wearing gym shorts hustle as they blow up black and gray rafts. For the McCarty's, Martin, Marietta, Holt, and Van Nosdeln, days like this will offset the icy dark winter when boaters would rather run the Everglades or the Rio Grande.

Commercial customers drive to the Meadow Run parking lot, one mile beyond town, and at 8:00 the earliest school buses drone from there into Ohiopyle, delivering people to the staging area below the Falls. Independent boaters dress in bathing suits or wet suits and carry their boats to the check-in booth where rangers like Mary Kelly and Alan Schaefer (the first Ohiopyle ranger) labor as gate-keepers to the river. Then the boaters pull on spray skirts, cinch helmets, and stretch while they wait for the half-hourly release of independent boaters.

Ten cars from Pittsburgh are stalled at the tracks while a whistle-blowing train for Baltimore blasts through town. Church bells an-nounce that it is 9:15 and Reverend Art Gotjen, the ex-fresh-water biologist from Confluence, will preach.

At all times, one or two commercial companies prepare their eighty customers for the Youghiogheny descent. A guide talks to them for ten minutes about equipment, technique, and safety. Charlie Granigan—a schoolteacher five days a week—coaches the Mountain Streams and Trails passengers. He stresses the impor-tance of life jackets. He says to pick a commander who has had experience. "If not in a raft, then in a rowboat. If neither, then pick someone who has an aquarium in the living room or a waterbed in the bedroom." More laughter. "Whatever you do, don't pick some-

one who's very bright. Creative types tend to screw this up. The only commands are forward, backward, back left, and back right."

As the morning wears on it grows hot, and everybody limits his clothing to bathing suits or shorts. Traffic doubles. The parking lot at the Falls will fill by 2:00. Almost 2,000 people will run the river today, and among them will be me and two friends, scheduled for a commercial trip with guide Steve Martin.

The Run

Eighteen years have come and gone since the first commercial river trip in Ohiopyle. Today's sixth wave of school buses brakes onto the Route 381 turn-out lane, built for the delivery of rafting customers who will make the run below the Falls. Steve Martin and another Wilderness Voyageurs guide named Dan welcome the people, instructing them to grab a life jacket and paddle, and to find a seat on a raft. My two friends and I do as we're told. Steve wears blue trunks, a wool shirt because the morning is still cool, and a Wilderness Voyageurs cap. He scrunches his face a little and summarizes quietly to me, "Another megatrip."

A rompish foursome sits next to us and one of the women squeals, "Ouch, you hurt me already." A man surveys the rafts lying there on wood chips in the shade of the trees and says, "This doesn't look so scary." One couple can't find partners and they don't want to jump in with just anybody. Maybe they are thinking, "Never trust your life to someone you don't know." They end up with two young women who are also alone.

Steve delivers the "talk-up." When he does this, he is not the zany Steve Martin but the easy-going one. With good humor he stresses safety.

In the formation of pallbearers, but playfully, we carry our rafts to the river and get onto the largest, deepest pool of the entire Youghiogheny—the one at the base of the Falls.

How ridiculous is this? Here are eighty people—mostly adults—squatting over inflated rubber and trying, by the use of plastic sticks, to propel themselves back and forth across a river that for millions of years has been the domain of fish. What an odd flicker this scene forms in the history of this place. We are no doubt a sign of wealth and boredom. Is it frivolous, this emphasis on amusement? Maybe. But is it any more frivolous than a gritty steel-

worker's laboring to produce the steel for the cars that are driven on a lark to Ohiopyle or to jobs from foolishly distant suburbs? Any less than employing garbagemen to haul away trash, 90 percent unnecessary, avoidable, or recyclable? Than highway engineers plotting roads to get us someplace ten minutes faster? What is frivolous and what is not?

Since people are just learning to paddle, they spin like one-legged ducks. We hear the first rapid where this river will fall out from under us. Maybe one-third of these customers have never rafted before, and the tension that has been building for days is about to burst loose. "What will it feel like to run a rapid?" they are wondering. Soon enough they will know, and the miracle of floating—of sitting on top of water—will assume unimagined forms that, in whitewater, are short-changed on stability. For others who have been there, the mystery is less but the eagerness more.

After a few minutes, Steve and Michael Normyle—the third guide—round us up and lead our fleet straight toward Entrance Rapid. Steve instructs like a gas jockey who is asked directions to such-and-such a place: "Stay in the waves in the middle, then go to the right of the rocks, then pull out on the left after you pass all the big waves." It will not be that cut and dried.

The rafts seem to be sucked into the whitewater. They are buoyed high on the waves where the bow paddlers gape down into a four-foot hole in front of them. Then the rubber boats nose-dive and the cold Youghiogheny drenches people and they shriek. Being a part of a rapids brings a new sensation and nothing has ever come close. Most people love it. Rafts collide after one becomes stuck on a midstream rock, but everybody makes it through. When people stop in the pool below Entrance, they are charged up from their first adventure on the river.

What is it about adventure—this activity that makes up so large a part of the Youghiogheny experience? Why would people want to do something risky, let alone pay for it? Danger is not for me. I enjoy life too much, yet it is not sitting around being safe that brings me the enjoyment. Going places and seeing things brings me the enjoyment, and sometimes, danger just happens to lurk in the way.

The motion, the sound, the abrupt changes in temperature (warm air—cold water), the wild scenery, the lack of control as the river pushes you around—all this is part of the excitement. Life normally

beats along at a steady pace, but then this river makes me jump and dance. Years later I have forgotten hundreds of days but I remember the Sunday when I rafted down the Youghiogheny.

Cucumber Rapid is the next dance. Most paddlers follow Dan's animated hand signals, delivered from a rocky perch above the rapid, but some people's eyes are glued to the danger in front of their nose and they pursue their untrained instincts. They will be sorry. They hit one of two holes midstream. Two customers tumble heels-over-head into the drink. One snatches a safety line thrown by Mike (the fourth guide), and swings to shore. In his kayak, Michael Normyle rescues the other by towing her in.

After all the customers pass, Steve Martin paddles his kayak into Cucumber Rapid and invites the holes to devour him. Kayakers and C-1 paddlers who have waited patiently in the eddy on the left plunge back into the rapid and dart like waterbugs.

Small rapids follow, then Dartmouth, where whitewater racers converge each year. During the 1981 event, Steve Martin floated by, guiding a trip. He charged up to a slalom gate and threw his paddle into the air and over the ropes that are strung across the river for suspending the gates. Then he tipped himself over to negotiate the gate upside down. After Eskimo-rolling by using his hands, he propelled himself with them through Dartmouth where he eddy-turned and retrieved his paddle. Then he powered upriver through two or three more gates to the accompaniment of cheers, snickers, catcalls, and shrugs by old Yough regulars who simply commented, "Steve Martin."

We land at a big boulder for lunch. Half an hour is our limit; we must vacate before the next group arrives. It is all action. Nobody really looks at this place closely or gets to know anybody else. This lunch break is one of only two times when people step out of their rafts, unless they fall out or get nudged by their partner.

Commercial rafting is not eat-and-run everywhere, but Steve Martin says, "Here it's the thrill. That's what gives them the escape. It's very shallow, but it could be a lot more. There's something about river trips that we just don't have, that we can't get with this many people, not with trips that are so rushed. Long trips are great. You have time to get into it a little more. Here, you can't point things out to people because you have to worry about keeping your trip on schedule. This bumper-to-bumper bullshit is just for the dollars."

At the bottom of Dimples and Swimmer's rapids the river perco-
lates deep, so boaters stop to swim or to surf in the big hydraulic.
There must be seventy people here when we land. Kayaks and
rental rafts lining the shore could be a used-boat sale. We beach just
below. There is no vacancy among the rocks, so people have the
bows of their rafts overtop other rafts like mating turtles. Many of
us scramble up to the jumping rock where a short line has formed,
and on five-second intervals we begin an intimate union with this
swift rapid by leaping into it.

The first thing when you hit the river, you disappear. The world
turns suddenly blurry, dark, and cold. Then you pop up, unsinkable
in your life jacket. From this perspective where eye-level and water-
level are the same, waves crest like snow-capped mountains. You
hit them and they break over your head. The river engulfs you.
Being in it, instead of on it, is completely different. River power is
inescapable.

At first it feels dangerous. But this is a safe swim, with no sharp
rocks, with still-water below for recovery. The next feeling is ex-
hilaration—being swept away in the chill current that surges up
and down with you in it. And the next feeling, if you get beyond the
excitement, is a feeling of being part of the river. Swept along, you
are like the water. I let the Youghiogheny take over for awhile. It is
a giving-away of power and control that rewards the giver; it is
unexpected pleasure. I think that I am looking at this harder than
the average tourist, but the common denominator, whether Swim-
mer's Rapid is a carnival ride or a metaphysical bonanza, is that it
feels good.

Half of our people swim through the rapid twice, and by then the
next group of eighty has assaulted the beach. Except for neoprene
and fiberglass, the place is wall-to-wall humanity. The line for
swimming could now be a line for one-dollar gasoline. People are
having fun, but it calls to mind an improved-upon Disney World.
When Penn State researchers queried rafters, they learned that most
did not think that the mobs detracted from the fun. But surveys on
other rivers found that as crowds increased, the "user categories"
changed. Simply put, a crowded river attracts people who enjoy a
crowded river. Consider the Chattahoochee: Budweiser promotes a
float on that river near Atlanta, where in one day 37,000 Georgians
paddle eight miles, and most participants say they enjoy it. Those
who are sober enough to answer.

Our guides sweep the area, yelling, "All Wilderness Voyageurs passengers, let's go!" If we linger, we will be a raft-jam in the next rapid, because another company presses behind. We will also congest the take-out and wreak havoc on the schedule of buses, dispatched with stopwatch efficiency to haul us back to Ohiopyle. Steve Martin whoops it up no more.

Steve paddles alongside my raft and says, "I like taking people down rivers. You know, I *love* taking people down rivers. It's just eighty people at once that drives me up the wall."

We pass the mouth of Jonathan Run. It rushes transparently clear, but a few years ago fish were killed by acid from a mine beyond the park boundary. Shelby Mitchell told me about a ford near the mouth of Jonathan where people waded with horses and wagons. For a while, a ferryboat also crossed here. Only a quarter mile up from the Youghiogheny, the run plunges over a rhododendron-framed waterfall—one of the most scenic in the park. Our group cruises past Jonathan without knowing it is there.

The guides consolidate our group and release us one by one to negotiate River's End Rapid. It is potentially dangerous and in some ways challenges boaters more than any other drop, but everyone performs well.

Half the people on the trip squeal and shout. A few water-battle. Most paddle their best, but still bang into rocks here and there. Ten percent check out the scenery. A few nag at their partner for not going left, or not going right, or splashing them, or maybe for just being there. A few are goggle-eyed and scared, but most are not as scared as maybe they should be, and they laugh when they smash into a rock. Some are having the best time of their summer. They say so. We approach Bruner Run.

The take-out lies on the left and the trip ends. Yellow buses wait as they do at three o'clock at the high school. We beach, lug our boat up a short hill and drop them for the guides to heave onto a truck. Without stopping—like disposing garbage and tray in a cafeteria check-out—we pitch our life jackets in one pile, our paddles in another. We board the bus and leave. Trips on other rivers usually mean loafing around, a take-out beer, fooling with gear, and waiting for the shuttle car, but at Bruner, the river-to-land conversion is the ten-minute-ultimate in efficiency. The bus climbs in a low-gear strain out of the gorge. We drip water from soaked shorts and sneakers, the aisle becoming a small river of its own by the time we

reach Ohiopyle. We have finished a trip that has a reputation among river runners nationwide.

"It's a thrill," most rafters say.

"It's crowded, but it's still beautiful, and I want to come back when it's not so busy," some say.

"It's a carnival," says guide Chris Baggot.

Lance Martin belongs to the International Association of Amusement Park Operators. Why? He says, "Not because the Yough is an amusement park. We share a lot of the same suppliers, but mainly, because those guys have a convention like nothing else in the world. Can you imagine drinking New Orleans dry? Well, they ran out of booze. Wasn't a single drop of Scotch in town."

The amusement parks have, in the opinion of many, come to the Youghiogheny, while whitewater has, in fact, gone to amusement parks where waterslides—sliding-board rivers—are popular. Is the Youghiogheny just a seven-mile waterslide? To some, the answer is not obvious because the atmosphere of thrills is so thick along this river.

Serious whitewater runners deride the amusement park mentality, but their own focus on whitewater challenges can be just as lacking in the bigger view: one of West Virginia's best paddlers took a sledge hammer to a rock in the Cheat River to "improve" it for kayak enders (end-to-end flips). At very low water on the Youghiogheny the rapids change with new waves and eddies and rocks that are unseen at other levels. The stream grows greener—a lucid, Rocky Mountain green. But one guide paddled up next to me on a low-water trip, and because the river was not so fast or exciting he said, "Isn't this a poor level?" There is a difference between looking at whitewater and looking at the whole river.

For some, this river is a money-maker, which summarizes the attitude and justifies many things. One of the rafting company owners defends the building of dams: "Without that dam," he says, pointing his thumb toward Confluence, "there's no way people would be doing this." This is true; runnable water would not persist throughout the summer. He says, "You never hear about people supporting dams because they get good runs downstream, but there are a lot of dams that could do that." He does not say that there are already 50,000 large dams in the country, leaving few remaining sites for whitewater boating, and that new dam proposals would obliterate many of these. He says that a good mine-acid spill would

get rid of the fishermen. "I used to canoe that section [Confluence to Ohiopyle] regularly. After it was cleaned up I started to see fishermen, and there's been more damage up there since it was cleaned up than before. One guy was fishing and there was a branch in his way, so he grabbed it and ripped it down. Why clean the river up? If you'd leave it alone, you'd save the cost and you wouldn't have all the use."

Other company owners, however, have been important forces in river conservation. In 1976, Ralph McCarty donated the money from a trip to people who successfully fought Tocks Island Dam on the Delaware. He annually gives the proceeds of a Labor Day trip to the American Rivers Conservation Council—Washington lobbyists for river preservation. McCarty is the largest single source of income for the group. Laurel Highlands and White Water Adventurers donate parts of holiday trips to the Rivers Council. Mark McCarty says, "Just because we don't have big problems here doesn't mean we should sit around. We should help the people on other rivers where they're fighting dams. Who knows when we'll need their help."

What do the first Youghiogheny rafters—Sayre and Jean Rodman—have to say about the Youghiogheny today? "The crowds are inevitable," Sayre says. "Today, I don't see any point in running it. You pass eighty people eating lunch on a rock, and they watch you row. Well, I don't *want* anybody watching me. Me going down the river is none of their goddamn *business*. Rather than get used to a lot of people, we went to other places."

I hear the frontier mentality speaking: as soon as a place is settled, move on. I see the excitement: the adventure of exploration, the thrill of solitude in wild places, the challenge of the unknown; but it sounds like a pioneer wearing out one farm and moving on to another. The Rodmans opened the way for people to follow, but more people drove the Rodmans farther away. So today, wild rivers of Alaska, Chile, and Nepal attract well-heeled tourists. What happens in another hundred years when the places that Sayre Rodman explored have been opened up?

"We're damn lucky to be living now," Sayre answers. "We still have places to go. For mountaineering, I feel there is at least a hundred years of fun left in British Columbia." But those unclimbed peaks and unrun rivers remain because they are difficult to reach. Sayre agrees that it is only an explorer elite which will venture that

far. "Those places can't satisfy the explorer in most of us. Most of us have to use places close to home."

"That's why I like West Virginia," Jean says.

Sayre adds, "It's fun out West. God it's beautiful, but I regard it as one of the really great challenges to get the same pleasure from West Virginia. It's not all wild, but you get up on top of a mountain and look out beyond the farmlands to other wild lands."

Jean says, "We have to find these things close to home. We have the Oakmont 'wilderness.' Starting right here, it's a seven-mile hike without crossing one yard."

For the first time in years, the Rodmans recently returned to the Youghiogheny, just to look around. "Amazing," Jean says. "It's a step up from a roller coaster for thrills, I guess. Seeing the rafts appear on the water was like seeing a hatch of beetles."

Sayre says, "As long as there are other wild rivers, you may as well let the Youghiogheny be a sacrifice area. Get a lot of man-hours out of it. It attracts people who take great joy in going down the rapids, and every one of those people can help you save another river. Because of the Yough, you have a huge number of people who have some feeling for what it means to lose a river to a dam. Keeping the river in the form of rapids would make sense to them, and that is tremendously worthwhile."

Park Superintendent Larry Adams says, "I see the Youghiogheny as an educational opportunity. It's probably all right to have a few rivers in the country used so heavily, so long as there's no environmental damage. It's probably good for rivers generally; the more people who see it, the more who appreciate it. Some other rivers should be kept wild, but this one lends itself to management, and heavy use has become accepted here. After people see the Youghiogheny, they can understand other people wanting to preserve the really wild rivers."

Adams struggles toward divergent ends: to host crowds of people, and to have them gain some perception and understanding from their being here. Yet even in times of shrinking budgets, Adams is expanding the park's interpretive programs to increase awareness of the whole river. "Two million people a year come here. They look at the Falls or run the rapids but don't realize anything about the other parts: where the river comes from and where it goes." Adams would like to encourage more interpretation during guided trips, so that people will gain more insight about the river and its life, but that will be difficult.

"With eighty people, all you do is stay on schedule and keep them

alive," Steve Martin says. The opinion of guides is almost unanimous: trips are too large.

Bobby Marietta says, "Myself, I think it's overused. Eighty is too many. Too many for the wilderness part." His father says, "With the scheduling, it's better now, but there are too many people. Now it's like a carnival. Sixty people on a trip would be enough."

Mark McCarty of Laurel Highlands says, "I think use ought to be dropped back 20 percent. If you break it up so you don't see the other groups in front and behind you, it would be good." I ask why he doesn't cut back himself. He says, "Well, we're thinking about it. But it should be a deal. We'll cut back 20 percent if everybody—including rental rafters—cuts back 20 percent."

Emphatically, raft-renter Stu Van Nosdeln does not favor a cutback. "There's no congestion, It's fluid movement, like water down the sink. It comes in and goes down the drain."

Lance Martin says, "There are two ways of looking at it. The Youghiogheny is within a one-day drive for a big part of the nation's population. It's there to be used. Yes, there's some crowding, but most people don't come for a wilderness experience. Do you severely limit it for a wilderness experience or do you open it up for most people? I happen to think in this case, the more the merrier; use it to the maximum."

Steve Martin says, "They're interested in quantity, not quality. I'd like to see a cutback. Like we used to do—forty people. Then you could talk to people. Then you could look around and see things. With forty people on a trip, the Youghiogheny would be a real special thing."

"I'm one burned-out river guide," Steve Martin says. "I've butchered my hobby bad." I had guessed Steve to be in his late twenties. He is only twenty-four. He says, "Yeah, I feel older too. I feel real worn down." It has been a long summer. Fall is here, winter is coming, and it is time to leave Ohiopyle. Steve says, "Winters are real slow around here."

December through March, Steve works at ski resorts. Skiing lets him release something inside that craves excitement, speed, the outside, sunshine, gradient. But he is changing. "I've been moving every six months, and now I'm getting a little tired of it," he admits. He likes his girl friend, Karen, a lot. "I'm kind of looking for a more settled way of living. Maybe someplace like Idaho—Sun

Valley—where you don't have to go far to get your river fix. Ski in the winter, maybe do carpentry work or guide in the summer. Here, I don't offer much anymore."

Like many other people, Steve had escaped to the Youghiogheny years ago, and like others, he has found that getting away from something does not seem to satisfy, no matter how bad things were, or how good they become. In the long run, escape seems to be an unsustainable goal, because, once free, then what? Except for hard-core fugitives, the search for something more positive sneaks into the consciousness, building tension, breeding discontent. Steve doesn't know what he will do, but he figures he should be doing something else. "I'm weak in all kinds of ways. I've got to try a few things. River guiding here is all I've ever done." He dwells on his weaknesses. What he will do about them is unclear, but he is working on it. One thing he has decided: he will move away.

The escape can blend into the search, and the lucky searchers finally arrive at a place that they can grasp, a land that they can embrace. Bill Calantoni, for example, came here to escape and ended up staying. But the arrival is a rare event, and belonging is a rare feeling. Especially among this generation. It is a feeling which we crave, usually without even knowing what we miss. Steve Martin will leave and I will not know what happens to him.

I am ready to leave Ohiopyle too, but not because I am a burned-out river guide, and not because I want to go to the Gauley or to ski. I am ready because I want to step into my canoe and discover the rest of this river. I want to see the lower reaches of the Youghiogheny by boat, and to do it before the cool winds of autumn.

The gradient of the Youghiogheny has taken us from the top of Backbone Mountain down through the gorges that bisect the western slope of the Appalachians. From Ohiopyle the river will take us through another gorge and beyond. With Jim Wilson and then Mike McCarty, I will paddle the last gap of the mountains and then go along the foothills, skirting the towns and the mines, floating over pools that hide walleye and bass, past the trash and pollution, around the islands, down to the steel mills, seventy-five miles to the inevitable bottom, to the end of our Youghiogheny journey.

It will be a good run. It is the warmest, most colorful day of the fall when Jim Wilson and I carry our canoes on top of our heads to

the put-in at Ohiopyle. Across the Youghiogheny in Ferncliff Park the ash trees shine as yellow as the morning sun. The water is chameleonlike, reflecting the colors of the leaves. The orange-reds of the maples blend and make a river of gold. It runs clear and medium in level. The rocks of Entrance Rapid are outlined with churning water as if by an artist with a white pencil. If you think autumn is the most beautiful season, then today is the most beautiful day of the year. This is the place to be.

Today is Monday and we see nobody. Not even a ranger. Wilson and I step into our canoes and kick from the sandy beach like kids with scooters on the street. We are adrift. The Falls lie behind us, the boiling of Entrance below. Being a river is enough, but the Youghiogheny is a paradise today.

Wilson and I say not a word as we let the river take us slowly to the brink. Then we straighten our boats and dip gently over the first riffles. The river pulls us along. Next come some waves, and our speed increases. I feel small and insignificant, but will feel even smaller in a minute.

The rapid begins and the gold that reflects from the maples gives way to foam. A white-out of bubbles fizzes around me, but I am still entranced by the strange, powerful peace of it all. The canoe sinks lower in the aerated water. The sound increases as I drift closer to places that roar, but I am mesmerized. A ledge is growing larger with a huge hole to the right that would swallow me, and I say to myself, "Okay, here we go." I wake up and dig into the river with my paddle and push the boat with a lurch to the left as I drop over the ledge. Bracing to keep from tipping, I get sucked through a trough, and then a wave wells up underneath me and I rise on it. I draw the canoe into a tongue that misses boulders, left and right, and now there is no stopping.

The Youghiogheny crashes all around me and I do everything I can to stay afloat. This keeps me busy. Wilson is more casual. He has run this many times. He is a good paddling partner. I am comfortable in the absolute knowledge that if I capsize, Wilson will find some way to tow my greatful body and sunken boat ashore. I can count on him.

Wilson strokes only now and then because his paddle is perfectly placed. His leaning causes the hull of his boat to match the surface of the river like a mold. He personally knows all the rocks and holes, and where he wants to be. My descent is more chaotic. Very chaotic

at times. I am making this route up as I go, and the river is doing some making of my route, also. I catch an eddy and let the Youghiogheny stream past me for a minute. Any number of things could still go wrong and cause me to sink, but I feel very strong, very good.

While I'm doing this I forget the rest of the world. The blocking out of everything else makes the intensity. The nine-to-five, the turnpike from Pittsburgh, rain tomorrow, lunch today, even the last minute and the next one—cease to exist. This feels like the ultimate escape and the ultimate arrival. Now it is just me and the river.

Sometimes the Loop below Ohiopyle is too full of people for me to feel it, but there rests a power in this place. Can it be that certain places do special things to people? That places make you feel a certain way? We all come from the earth, and before that we came from the water. Here are the earth and the water both, and it isn't ruined. It is one generation improved from Shelby Mitchell's early days, when the forest was all stumps except for those bulky, lightning-rod hemlocks on Ferncliff that escaped the saw.

There is a sculpture to this place. Things converge here: the mountains encircle us, and the loop of the river almost meets itself. There are at once many attractions in sight. The greens, the golds, and the white are distinct. Everything is accented.

I suspect that I could hunt all over, including every bizarre vision that every saint has ever had of the afterlife, and not come up with anything this good. It occurs to me that this place is perfect, a miracle, and that if we would just take care of it . . . if we weren't banking on something else to be perfect . . . It is time to paddle downriver and catch up to Jim Wilson.

We come to Railroad Rapid and, like a snow squall, the wind showers maple leaves from the woods and onto the river. Winter is on the way.

We are through the largest rapids when we reach Stewarton where Jim Prothero has driven to deliver our camping gear. Wilson and I tie in waterproof bags full of clothes, sleeping bags, and food. We also lash a tent, fire grill, cameras in a waterproof ammunition can, and a box holding cooking pots and a bottle of Wilson's homemade apple wine. We paddle for a half-hour, then make camp and enjoy the first peaceful night in the five-day voyage to the end of the river. We cook and sleep in the gorge that is almost a wilderness.

The next day we run half a dozen Class II or III rapids. This is the first time Wilson or I have paddled here, so every bend brings a new

discovery. One rapid surrounds a rocky island. Wilson paddles to the left and descends a fifty-foot-long flume that ends in a giant's fire-hose nozzle three feet wide. His hat blows off as he glances from the rooster tail at the end, and I call the rapid "Wilson's Hat."

We paddle another mile and then the gorge suddenly changes: it becomes wider at the bottom and higher at the top. The scale is more massive than at any other place on the river. Then, Indian Creek from the east joins the Youghiogheny.

We have left the state park—a fourteen-mile-long sanctuary in the middle of the Youghiogheny. In the park, this river seems to be protected; the most serious issue may be the number of people who should be allowed to enjoy the place at any one time. But at either end it is different. At the upper end is the Casselman basin with its abandoned and active coal mines; at the bottom end of the park is Indian Creek and its coal that is mined with equal intensity.

The park has given us escape and fun and a chance to return to nature, but looking beyond, I see the park to be a small oasis in Appalachia. People who would save the river may have only a tenuous grip on the future, because stip mining and acid mine drainage threaten water quality and the view of the gorge. A solution is to designate the Youghiogheny as a state and national scenic river, but it is more complicated than that. Above and below the park are lands raising issues as basic as the burning of coal to heat Pennsylvania homes, and as basic as water to drink.

The park, the mines, and the water are all tied up together in questions that deserve public attention and debate that has for years been lacking or been piloted by vested interests, misinformation, and fear.

The Mines and the River

N*o place* along the Youghiogheny exposes the conflict between coal mining and water as vividly as Indian Creek. It rises near the Pennsylvania Turnpike, flows south and west to Mill Run Reservoir, then cuts a gorge of boulders and ledges, finally joining the Youghiogheny above Connellsville. This creek may be the most scenic of all Youghiogheny tributaries, but strip mines riddle its headwaters and acid drainage contaminates lower reaches. In the twelve-and-a-half square mile basin the state has issued permits allowing nearly eighty mines.

The technique is simple: miners cut the trees, peel back the soil, and by use of bulldozers, back hoes, drag lines, and dynamite, they dig to depths of sixty feet. This results in a wide trench crossing the mountain for hundreds of yards with a vertical "high wall" on the upper side. Over-burden (the soil and rock removed to expose the coal) is dumped in cone-shaped piles that make town-size tracts of Appalachia look like the South Dakota Badlands. Finally, coal from the bottom of the trench is scraped from an eighteen-to-thirty-inch-thick seam, dumped into trucks, and hauled away on local road systems that often crumble beneath the heavy loads. State and federal laws require control of runoff, replacement of over-burden, and regrading to original contours. Then topsoil—set aside during mining—must be restored and grass or trees must be planted. If all this is done properly, the site may end up looking like a healthy pasture.

Shales overlying Indian Creek coal are extremely acidic. Judging from what they do to streams, I would sooner expect to find these

shales in a toxic waste dump than out here deposited and buried by the ages, but as long as they were buried, there was no problem. It is when they are dug up that the trouble begins. Then, rainfall rinses acid, iron, aluminum, manganese, and mud into Indian Creek and the Youghiogheny. Runoff after strip mining speeds to six times its earlier rate, aggravating floods and flushing silt into streams. The earth cannot be turned upside down without consequences, and so the problems of strip mining cannot be eliminated. If lands are mined properly, however, effects can be minimized.

John Bradley-Steck, a consulting geologist for mining companies, says that he is not for hire in the Indian Creek area. "You can't win," he says. "No matter what you do, it's a losing proposition because the geology is so poor." He concludes this by looking at geologic maps, although various coal-company consultants hold various views on this question.

What does experience show? Jim Ansel, a waterways patrolman for the Pennsylvania Fish Commission, says that he has arrested, or reported violations on, every Indian Creek mining company save one. They fail to maintain siltation ponds, they spill acid into streams, they backfill improperly or not at all, and they expand mines without authorization. Much of this goes uncorrected but little goes unnoticed.

Fern Colborn lives above Indian Creek near the town of Mill Run where she has been president of the Indian Creek Valley Water Authority since 1955. Her job is to guarantee delivery of water to rural people for miles around Mill Run, and so she sees the impacts of mining firsthand. She says, "There have been over fifty strip mines in operation here the last five years, and I've seen three that weren't causing acid." To be explicit, she drives her jeep over pot-holed roads behind Mill Run and Normalville and points to the problems. She delivers a steady, matter-of-fact itemization of people who lost wells to acid-polluted springs, fractured bedrock, and de-pleted groundwater; of farms where topsoil was bulldozed aside and remains unrestored; of house foundations cracked from blast-ing. In two cases, bankrupt miners simply abandoned their sites, leaving a moonscape. Silt killed fish in a private trout hatchery where the owner estimates losses during one business-busting night at $14,000.

To get the other view, I visit several mines. Other than to say they won't talk to me, the operators will scarcely talk to me. One says,

"We're a small operation. We don't want any problems, any pictures, any publicity, any anything." One landowner who lives in Uniontown and leases his mountain property to a strip miner says, "The streams have always been polluted from coal outcrops. Water runs over the coal and washes out the acid. The only way to get rid of it is to mine the coal out of there." He is poorly informed about geology and history both.

What industry spokesmen say, however, is that coal reduces the need for imported oil. Coal can lead to energy independence. Proper operation of strip mines avoids environmental problems. The export of coal helps balance our foreign payments deficit. Mining employs people. Coal comprises 80 percent of our domestic energy reserves but less than 20 percent of energy used. Coal in the ground offers nearly eight times the energy of oil, natural gas, and uranium reserves combined. In the United States, 260 billion tons of coal equal one-quarter of the world's known reserves, and it may well be used.

Along the Youghiogheny, it has been used. Some of the earliest explorers discovered this black, burnable treasure. On October 14, 1770, George Washington wrote from Connellsville: "At Crawford's all day. Went to see a coal mine not far from his house on the banks of the river. The coal seemed to be of the very best kind, burning freely and an abundance of it." Not until the 1800s did settlers dig coal in earnest. Along with logging, mining employed men and justified the existence of many small towns. Crellin, Oakland, Friendsville, Confluence, Ohiopyle, and most of the lower river towns housed at least a few miners.

Early in the 1900s, narrow-gauge railroads penetrated the rocky, cut-over hollows to reach the deep mines that honey-combed the hills. These tunnels were all abandoned, but water continued to saturate the dark chambers and then spew acid. The streams and the river turned sterile, meaning lifeless. In the early 1900s, much of the Youghiogheny sustained not a fish. Back in today's remote woods, thousands of piles of mine tailings abound.

In most areas, mining peaked between 1910 and 1945, and has ebbed since then with sporadic booms such as in the mid-seventies. With the decline of coal after 1945, population dwindled by one-fourth in Fayette County. In 1980, it ranked second statewide in poverty and in welfare recipients. As Shelby Mitchell of Ohiopyle said, "It is not a good place to start a new business."

Most Appalachian coal is high in heat content but also high in sulphur (1 to 6 percent) and ash, aggravating air pollution and causing acid rain after the coal is burned. Youghiogheny coal has been used for electric power, metals manufacturing, and especially for coke in steel production.

Government-funded reclamation programs such as the one along the Casselman have improved the water; the entire Youghiogheny again supports fish. The most recent reclamation was completed along Dunbar Creek which joins the river at Connellsville. Trout Unlimited—a conservation and fishing group—persuaded the Pennsylvania Department of Environmental Resources (DER) and the federal Soil Conservation Service to spend $125,000 to backfill an abandoned mine in 1981. But reclamation, always expensive, is not always successful. State efforts in 1980 to reduce acid from deep mines along Cucumber Run in Ohiopyle State Park cost $900,000 but failed.

In most areas, miners extract less coal today than they used to, but new mines still ruin streams. According to DER records, at least eight Fayette County streams suffered new damage from acid and erosion in 1980 and 1981. Miners hold 527 permits in the county, though only sixty-five are active. About half of the permits involve runoff to the Youghiogheny.

Coal mining is a resource management issue throughout the basin. Along the upper river in Maryland, twenty-six mines lie within five miles of the Youghiogheny, according to a map at the Department of Natural Resources mining office in Frostburg. An additional thirty-five mines eventually drain into the river. Unlike the Pennsylvania coalfields downriver, Garrett County showed an all-time high in coal production in 1967. This coincided with an all-time low in mining employment (203 persons), due to strip mining (69 percent of all coal that was mined) rather than underground mining. Employment swelled in the mid-seventies to 740 persons or 8 percent of the county's workers, and their presence is felt. The laundromat in Oakland has a sign that says, "Mining clothes in front machines only." Miners make more money than most workers; salaries averaged about $18,000 Appalachian-wide in 1980.

Economists expect the post–World War II trend toward strip mining to reverse itself by the year 2000 due to high costs and the depletion of strippable coal. Strip miners can reach only one-tenth of the recoverable reserves in the Youghiogheny basin of Maryland

(161,300,000 tons). In Pennsylvania, most future coal will likewise come from deep mines, though half of it is now stripped.

Pennsylvania's Somerset County, including much of the Cassel-man basin, has 330 strip-mine permits and about 100 producing mines. Mining-related workers comprise 5 percent of the county work force (compared with 6.5 percent in farming and forestry and 22.8 percent in manufacturing). The Pennsylvania Department of Health reports that 31 percent or 2,029 active and retired miners in Somerset County have black lung disease. The County Planning Commission lists acid mine drainage as the "most severe environmental problem."

Farther downriver in Ohiopyle State Park, the state does not own mineral rights to important coal deposits, including Sugarloaf Mountain. Park Superintendent Larry Adams says, "I suspect the day will come when somebody will want to mine that coal." After the Fish Commission stocked Jonathan Run, a mine discharge above the park killed the fish in 1971. Also above the park boundary, miners are opening new sites in the Meadow Run headwaters and near Cucumber Run. With similarities to coal strippings, an abandoned clay mine in the park is the cause of silt in Meadow Run after storms and lies unreclaimed with only 10 of 175 acres being governed by the state Surface Mining Act. Most of the mine was dug up before the law was passed.

A study prepared for the state in 1972 indicated that 160 miles of major streams along Pennsylvania's Youghiogheny—up to 250 during high runoff—are polluted by fifty-nine large mine discharges. The study cites Indian Creek as the highest priority for protection.

"Up here," Fern Colborn says, "the record of the miners is so bad that we can go for miles before we find a landowner—except for absentee ones—willing to sell a mining option." In Colborn's jeep, we pass a ridge-top home where she says, "These people signed an agreement and then took a trip to California. They thought they were going to be millionaires. They came back and got nothing." Another family allowed fifteen acres out their back door to be stripped. "They bought new living room furniture and a logging machine in time to see the miner go broke." Now they have fifteen acres of upside down land—piles of shale that yield mud flows to the steps of the house.

"Enforcement is the problem," says Jim Ansel. "Until lately, DER had two inspectors for about five hundred mine permits." Ansel's

boss, Fish Commission Executive Director Ralph Abele, said that two enforcement officers are "tantamount to no enforcement."

Colborn says, "All we're trying to do is get the law carried out, but of the last four inspectors, only one was any good, and the operators complained so much he was removed."

Peter Duncan, who was named DER secretary in the fall of 1981, says, "The inspectors are improving. We're getting better people now." Two additional inspectors were recently hired for Fayette County, and DER's 1982 budget revealed an expanded coal program—one of only two increases in the department. Whether that means more mine inspections or only more mining remains to be seen.

"The Youghiogheny was pretty bad in the fifties and sixties," Ansel says. "Then it got better, but since '75 I've seen it get worse. We've had a pH of 5 in the river—barely enough to keep fish alive. We've stocked 400,000 trout, but a lot of times we've come close to losing it." Ansel says that further reclamation and sealing of the Shaw mines above the Casselman are the most important job. "Then the old deep mine flume at Melcroft along Indian Creek needs to be cleaned up. It has a pH of 2.5. The bankrupt mines are a mess."

The bankrupt mines fester at the edge of Ohiopyle State Park, within the Youghiogheny gorge between Ohiopyle and Indian Creek. One, a site above Crooked Run, was authorized by the DER's mining bureau even though federal law prohibited the permit since the mine is within the gorge and the Youghiogheny was being considered as a national wild and scenic river. "I don't know whether you'd call it a slip-up or whether we just weren't aware of the wild and scenic study," said J. Anthony Ercole, director of the DER's Bureau of Mining and Reclamation. It is unlikely that the mining bureau was unaware: DER's Bureau of State Parks officially opposed the granting of the permit in 1979.

Operated by the Richter Trucking Company of South Connellsville, the mine sat directly opposite the rafting take-out at Bruner Run and was visible from the hilltop on the Bruner Run side. The mine was not popular with everyone. One day a sniper with a deer hunting rifle shot across the gorge at the stripper's bulldozer. Nor was the mine popular with state officials. Spoil lay too close to the river and could slide onto the Chessie System tracks and into the Youghiogheny. It still could. Acid seeped from the diggings. Ero-

sion-control measures were inadequate, the highwall was too great, and a road culvert was washed out and not replaced. Unable to make payments for equipment, Richter abandoned the mine. It sits in monumental destruction, dirt and shale oozing mud and foul water. It is an immense scar.

To avoid such fiascos, the state requires a bond to fund back-filling and related expenses in the event the miner defaults. DER officials estimate reclamation costs of at least $6,000 per acre, and this is often exceeded. In 1980, DER Secretary Clifford Jones raised bonding rates from a minimum of $1,000 to $4,000 an acre. Then, in a move that confounded landowners, fishermen, and conserva-tionists, he dropped the amount to $3,000 in 1981. For the Crooked Run mine, a bond of $40,000 may be released for recla-mation, but the job requires much more. The only solution may be to allow another miner to dig coal from the same site and regrade the land when he is done.

The ability of the river to sustain fish is Jim Ansel's main concern about strip mining. Fern Colborn's interests are in rural water sup-plies, land values, damage to houses, and protection of the river. Yet another issue is public water export. Is anything so essential yet so taken for granted as water that comes from a tap?

Indian Creek and the Youghiogheny provide about half of the supply of the Westmoreland Municipal Water Authority, which consumes about 15 million gallons a day from the river and 5 million from Indian Creek via a thirty-six-inch pipe built in 1909 and running from Mill Run Reservoir to the filtration plant near Connellsville. Expansion of the plant will allow a doubling of its capacity to 40 million gallons a day. The plant serves Connellsville, Scottdale, Mount Pleasant, New Stanton, Youngwood, Greensburg, South Greensburg, Southwest Greensburg, and all of the townships in between. Included are a glass factory in South Connellsville em-ploying 2,400 workers, the Volkswagen assembly plant near New Stanton, and several Westinghouse Electric Corporation plants. About 32,000 residential customers in the Westmoreland system drink Indian Creek and the Youghiogheny. Used by other water companies including McKeesport, the river serves nearly 200,000 consumers.

Kenneth W. Baker, assistant manager of the Westmoreland Au-thority, says that the Youghiogheny is a "pretty fine raw water source. Water quality has not deteriorated in recent years, but we're

always concerned about it." All mining applications are sent to the Authority for comment, but Baker says, "We haven't recommended that permits not be issued—not yet. I feel DER is going to take care of the problems. If we see a problem, we go to DER and they respond."

But at DER's Bureau of Mining and Reclamation office near Greensburg, a staff member says, "There is definitely potential for problems on Indian Creek. Maybe 1 percent of the applications are denied. To deny a permit, we must have an awful lot of evidence that there's going to be a problem, and that's hard to get. The questions of public water supply should definitely enter into the considerations."

Jim Ansel says, "Acid from Indian Creek could wipe out the Youghiogheny any day, yet they [DER] keep giving out permits."

Jerry Galiardi, legislative committeeman of the Fayette County Sportsmen's League called Indian Creek a "time bomb waiting to explode." In early 1982, six more permits along Indian Creek were pending before the DER.

Acid shale is dug up, coal is hauled away, streams are polluted, wells dry up, and foundations crack—all because the coal can be sold. Ninety percent of Duquesne Light's electricity, serving western Pennsylvania, originates with the burning of coal. When you turn on an air conditioner, or push the button of an automatic dishwasher, or spend the winter in an electrically heated house without storm windows, or take a hot shower without a water-saving flow-restrictor on the shower head, you contribute an extra amount to strip mining, not to mention air pollution and acid rain. It is easy to argue that the strip miners should do a better job and keep the streams clean—the law is even on your side in saying so. But anybody who consumes energy from coal shares some of the credit for the results of its mining. The miners dig coal because we use it.

The less energy we use, the less chance the Youghiogheny and similar places will be affected. No one can change the fact that by being alive, we consume; the point is to avoid wasteful consumption. And it can be avoided without reverting to outhouses, root-digging, or freezing in the dark. In 1979 the Joint Economics Committee of Congress and the Harvard Business School released studies saying that by the year 2000, the nation's population can increase from 225 million to 300 million with a proportionate

growth in the economy, with only our present supply of energy. Referring to many studies, authors John H. Gibbons and William U. Chandler, in *Energy, the Conservation Revolution,* say that up to 50 percent of the energy spent in the home can be saved, that automobile fuel economy can be tripled with less than 10 percent increases in car costs, and that projected energy needs by the year 2000 can be cut by one-third or more.

Whether it uses it or not, the DER staff has the authority to deny any mining application that could threaten a public water supply. Threats to the Youghiogheny gorge are another matter. Strip mining in the state park would probably be opposed by DER's Bureau of State Parks, but permits have been issued over that bureau's objection by DER's Bureau of Mining and Reclamation as recently as 1979. Beyond the park boundary, mining rights are up for grabs, and this includes prime sections of gorge between Ohiopyle and Connellsville. The North American Coal Company proposed a mine within the gorge that could eventually extend for three miles on the northeast side of the Youghiogheny above the mouth of Indian Creek. Other proposals may follow. Thus far, the Youghiogheny's status as a potential national river has prevented strip mines that would be visible from the river (except for the illegally permitted Crooked Run site).

Fern Colborn thinks that the answer is to designate the Youghiogheny a national wild and scenic river. "This is one of the most beautiful rivers in the East, and I'd hate to see it spoiled," she says. "Before long, coal strippers are going to want in there, and it could be the end of fishing, the end of the rafting industry, and the end of other uses of the river. Six million dollars a year are generated by rafting and related businesses. One hundred and fifty jobs are at stake, and I don't know of half a dozen local people who work in mining in the whole Indian Creek area."

An act of Congress started the national wild and scenic rivers system in 1968 with designation of eight rivers and the naming of twenty-seven others, the Youghiogheny included, for study and possible designation (the upper Youghiogheny from the Oakland bridge to Friendsville is in the Maryland Wild and Scenic Rivers System—a similar program at the state level). Federal designation prohibits new dams and halts federal projects that would erode natural river values. In cases where the federal government has

jurisdiction over resource developments, none is allowed on a national river if the project would detract from the stream. For example, strip mines: when a river is in the national rivers system or is being studied for it, Section 522 of the Federal Surface Mining Control and Reclamation Act prohibits mining permits within the river corridor—a narrow strip of land along each shore and rising up to the ridges—but not including other lands in the basin.

Back in the mid-sixties when national status was first proposed, the local congressman, Frank Malinzak, supported it, citing the need for water quality and recreation. The Western Pennsylvania Conservancy backed action in 1966, saying, "All members of the Conservancy will be immediately pleased by this prospect." The Fayette County newspaper and the *Pittsburgh Post Gazette* editorialized for federal protection. But after the Conservancy and the state bought lands for Ohiopyle State Park, residents vehemently opposed anything that could lead to more acquisition of private land. New Conservancy leaders in the late seventies changed their position, dropping support for the designation, saying that it stirred up more trouble than it was worth.

A federal and state team studied the river. Members rafted both the Maryland and Pennsylvania sections in 1975, and government representatives who were on the upper Yough trip still reminisce. It was unique among all field trips taken for national river studies in the Northeast. An older man from the federal mining agency fell out and almost drowned when his hand became wedged between two rocks. The trip required hours more than expected and the team fell behind the Deep Creek Dam release and didn't have enough flow to float. With darkness approaching, they began hiking out on the old railroad grade. No one had a flashlight, and to confound the group, a tornado had swept the valley, leaving the path—obscure to begin with—riddled with timber like a spilled box of matchsticks. Gear was abandoned for Ralph McCarty's guides to retrieve later. Ed Deaton of the Pennsylvania Bureau of State Parks remembers stumbling through the log maze with a federal official in the black of night and hearing the ominous approach of footsteps. They grew louder. The brush in front of the two men cracked under the weight of the mystery creature. "Finally," Deaton says, "this guy I was with screamed, scaring the bejesus out of one of Ralph's guides who was walking up from Friendsville to meet us." They survived and reached their vans at eleven P.M.

When the federal Department of the Interior prepared a draft wild and scenic river study of the Youghiogheny, it found twenty-seven miles in Pennsylvania (Confluence to Connellsville) and twenty-two in Maryland (Miller's Run to Friendsville) eligible for protection. It recommended designation if the governors of the states requested it. Both sections would be administered by the states, not by the federal government. Federal projects that could ruin the river would be banned, yet federal employees would not be involved in management. The draft report recommended acquisition of 2,500 acres of riverfront in Pennsylvania and 800 in Maryland.

Stuart Van Nosdeln, mayor of Ohiopyle in the mid-1970s, organized opposition to the program and delivered speeches against it. Rumors spread and people expected the worst. George Groff of Confluence thought that the federal government would condemn land in Confluence up to the high-water mark, though that was never proposed. In fact, the act disallows condemnation when over half of the river corridor is already publicly owned as it is along Pennsylvania's section of the Youghiogheny. Dr. Edwin Price, a civic leader in Confluence said, "I've heard everything about it, and I'm fighting it from start to finish. What they'd do is take everything you can see from the river. They proposed to take the whole west side of this town. Condemn it. They were going to restrict an area I don't know how many miles out from the river. You wouldn't be allowed to remove trees or anything. Talk to Stu Van Nosdeln. He'll give you the whole thing. I'd be for it—for conservation of the river—but the way they take land is the problem."

The wild and scenic river program was painted as a Communist plot, a government takeover, a city man's swindle, an environmentalist's land-grab; no less than cultural genocide to the mountain people.

Van Nosdeln organized Mountain Area Protection, Inc., a group of municipalities opposed to national river status. In May 1976, a letter was sent from six townships and the borough of Ohiopyle protesting the national river proposal. Led by Van Nosdeln, seventeen elected officials signed the statement: "We believe there is an aggressive move by Dr. [Maurice] Goddard of the Pennsylvania Department of Environmental Resources to establish a monument before his retirement . . . in the form of this Youghiogheny River . . . from Confluence to Connellsville." The letter accused Goddard of a "ploy . . . to regulate white water activity on what we know as the

lower Youghiogheny." Van Nosdeln had started renting rafts on the lower Youghiogheny (at Ohiopyle) three years before. The main thrust of the letter expressed fear of land acquisition: "We pray your indulgence to help us who have already been crushed and dissected by acquisitions for a vast state park which has all but annihilated us. We can stand no more."

In fact, Goddard objected to the national rivers system from the beginning, and an official state position regarding the Youghiogheny said, "the Department is opposed to Federal designation." At that time, DER was concerned about the federal government meddling in state affairs; it was also responding to local pressure.

At a fractious meeting in Confluence on March 28, 1977, with 600 residents and several government officials, Van Nosdeln led the attack on the program. He said, "The economic system which transformed this country from a vast wilderness, into the world's most powerful and wealthiest nation, is now being controlled, restricted, regulated, and criticized to pieces . . . the loss of freedom is sneaky, quiet, and subtle. It may appear in the guise of a new form to be filled out; a new tax to be paid; a new regulation such as this wild and scenic rivers study . . ." and so forth. Van Nosdeln called people to "rally around the flag and to look to God in this our hour of need."

The final report from the Department of the Interior in 1978 called for no acquisition in Pennsylvania but recommended local zoning for 3,500 acres, "to assure that development visible from the river is compatible with the purposes of river designation." For Maryland, the federal study recommended 800 acres of open space acquisition for public access and for a riverfront trail.

The only sections of the Youghiogheny that are now protected from development, dams, and mining are the wild river from Miller's Run to Friendsville, where the state of Maryland regulates new development, and Ohiopyle State Park, together totaling 38 of the river's 132 miles. The Maryland Wild River was established through the efforts of Senator Mason of Cumberland and down-east conservation groups. Ohiopyle State Park was established through Pittsburgh's Western Pennsylvania Conservancy. In both cases, it was nonresidents who brought about the protection. The scenic river proposal for Pennsylvania's section of the Youghiogheny had no support from people outside the local area and was opposed by vocal people within the area, and so it languished. No action has resulted.

In 1981, Stuart Van Nosdeln still opposed the idea. "It's over-regulation. Seventy percent of the corridor is already owned by the state. It would cut back the use of land. I mean seriously cut back. You couldn't touch it." I asked what the designation would prevent. Van Nosdeln answered, "A lot of landowners would be adversely affected. It's that strangle hold. Here comes government grabbing ahold of you," and he grabbed the air with his fists. I asked if he was concerned about strip mines. "You can't get a permit to strip on a hillside anyway; there're state regulations. There's no way it can be done."

Glenn Eugster, chief of planning for the National Park Service in Philadelphia (responsible for the national river proposal in 1981), said, "The zoning would be to avoid crowded development and commercialization. Undeveloped flood plains would remain that way, and other areas would have perhaps five or ten acres required for a lot and a cabin site. Zoning would be enacted by the local municipalities, and the kind of restrictions that we support are usually not much different than what is going to happen in those rural areas anyway. Mainly, it gives you protection against some real estate developer who might come in and build it all up."

Under the national rivers system, if local townships fail to zone, or don't enforce the zoning, the federal agency could recommend that the river be dropped from the system, the reasoning being: if the local government is not doing its share to protect the stream, why should the federal government deny options such as dams, mines, and canals that could be in the national interest? Neither the federal nor the state governments can zone, and neither can force local municipalities to zone. That part of scenic river protection, in Pennsylvania, is voluntary for local governments.

Roger Fickes, administrator of the Pennsylvania state scenic rivers program said, "There are controls on mining—water quality, erosion control, and backfilling—but nothing for the visual threat in the gorge. I'm not saying 'stop strip mining.' I'm only talking about a small area [the gorge from Confluence to Connellsville] where mining could ruin the attractiveness of the area for recreation, which is a very major industry. There are coal operators that want in there, and short of the designation, there may be nothing that we can do to stop them."

The potential mining conflicts in the gorge involve several hundred acres, maybe one thousand at most. The U.S. Bureau of Mines

estimates that the Pennsylvania section of the gorge from Confluence to Connellsville holds 19 million tons of coal. The state's known coal reserves total 22 billion tons—enough to last 250 years at 1981 levels of mining. The Youghiogheny gorge harbors about one-one-thousandth of this. Total reserves in the gorge equal only three months of coal at current production rates in Pennsylvania.

Fickes added, "The other protections under the state Scenic Rivers Act could be important someday. We reviewed a proposal for a hydroelectric dam on Meadow Run in the state park [a state scenic river proposal is intended to offer the same protection as the national system and includes part of Meadow Run along with the Youghiogheny]. The company proposing it backed off, but in the coming years, who knows what will happen unless some of our decisions, now, are firm. If we had the state equivalent of James Watt, we could be in trouble without the designation." In August 1982, under Secretary of the Interior James Watt, the National Park Service recommended revision to federal mining regulations that could open twenty-six national parks to strip mining. Because of political vacillations such as this (the federal regulations had been stronger under the previous interior secretary), environmental groups favor both federal and state scenic river designation.

Recognizing that the final version of the national river proposal calls for no acquisition in Pennsylvania, Fickes reflects, "The public and the private landowners can receive so much protection to keep that place the way it is, it's hard to see why they don't use it. I guess it's a lot easier for a local person to believe what he hears in a bar or from a friend than to believe a government agency. They see it as one small landowner fighting a huge bureaucracy." Fickes says that he would rather see state designation than federal action. "I think that we can be more sensitive to local needs and still accomplish the same river protection goals."

Fern Colborn says that the local hostility to the wild and scenic rivers program is due to "greed and rumor." She says that the proposal does not include—never did include—the kind of land acquisition that local people fear.

Van Nosdeln is not the only rafting businessman opposed to national designation. Lance Martin, owner of the largest rafting company offering guided trips, said in 1981, "They [the federal officials] blew it from the very beginning—they came in here and said there is too much use. No documentation whatsoever. To me, that was it

right there. They can stay out of here." I don't know what the federal officials told Martin, but the draft national river report recommended that "the application for national designation include a recreation management plan which incorporates regulations for eliminating river congestion . . . the recreation plan should accommodate the whitewater interests of both individual users and persons relying on commercial outfitters." That was not such a radical statement back in 1976—one of the years that Bob Marietta referred to when he said, "You couldn't work this river," and before Larry Adams instituted the rafting schedule. The final wild and scenic report recommended that "the Commonwealth of Pennsylvania continue to develop and implement strategies to promote safety and prevent environmental degradation of the whitewater stretch between Ohiopyle and Bruner Run." It called for no cutbacks in river use.

Larry Adams said, "I'd be in favor of the state and national wild and scenic river. The federal study has been the basis for denying mining permits near the river, but that protection will expire in October 1982, unless the river is designated. I think the river should be protected in every way possible. We would continue to manage the river as we're now doing. It would be good to have the protection to Connellsville, but the critical thing is right here in the park."

Viewing the entire state park and its history, Adams reflected, "I think the really important thing is that the Youghiogheny is not being consumed or destroyed, but in fact, is being preserved and many past abuses rehabilitated so that future generations will have the option of continuing or even improving upon what is now being done. That, of course, assumes that we do not allow strip mining or acid runoff from abandoned mines to once again sterilize the water."

Even though the final national river proposal offers long-term protection with little to trouble landowners or outfitters, it would be difficult for anyone to beat the antigovernment rhetoric. As Reverend Arthur Gotjen of Confluence says, "Whether or not people's fears are well-founded is one thing, but the way they feel about it is the reality." With support from the commercial outfitters, a scaled-back national river proposal that would include no acquisition of private property could be possible which would protect the gorge between Confluence and Connellsville from new strip mining. The gorge would be reserved for activities that can be enjoyed nowhere else in Pennsylvania, for a self-perpetuating economy, and for a way of living that is found only along the Youghiogheny.

Beyond the Appalachians

Paddling from Indian Creek toward Connellsville, Jim Wilson and I are leaving the Appalachians. The river has carved a gap in Chestnut Ridge, westernmost of the mountains that begin 150 miles to our east and run like giant north-south corduroy to this spot. The river sprawls across gravel bars. It was about this unseen path to Pittsburgh that Lewis Evans, an English map-maker in the early 1700s wrote, "If we have it, we have the Gate of the Ohio; if the French, they have the Gate to the sea." He was wrong. The Youghiogheny below Ohiopyle brandished too many rapids for the armies of France and England. The gorge was too narrow for them, but not for us. It is our way out of the mountains.

I don't want to leave the mountains but curiosity has got the best of me. By looking only at the map, I have an idea about how the Youghiogheny ends, but I want to see for myself. Ahead are Connellsville, the foothills (which are eroded plateaus), highways, and industry. In a few miles will come the exit of the gorge and the beginnings of what will become the American Midwest.

Elevation and gradient of the mountain do not fade step by step, but stay high and steep. Below the mouth of Indian Creek, we are only three miles from the western edge of the Appalachian Range, yet views are more imposing than any others in all four of the Youghiogheny gorges. Chestnut Ridge climbs 1,380 feet above the river that in some places spans more than 300 feet. The scale that was intimate has become massive. Towering mountain slopes replace cliffs and ferns and details. Continental

winds funnel into the gorge and blow like a gale instead of a lovable woodland breeze.

The mountain is barrier enough to breed weather. Moist air from the Gulf of Mexico, 1,000 miles away, is pushed up on the ridge where temperatures drop two degrees or more for every 1,000 feet of climb. If water vapor is condensing, temperatures drop five-and-a-half degrees for every 1,000 feet. The top of the ridge is five or more degrees colder than Pittsburgh, and less tolerant of moisture. Condensation forms rain and snow; the mountains are said to "rake" or "sweep" moisture from the clouds. This is why the upper basin of the Youghiogheny soaks as one of the wettest regions in Pennsylvania. Jim Wilson and I look downriver—northwest—to blue sky. We look upriver into the mountains and see cottony clouds. Wilson and I team up against the wind: we lash the gunnels of our canoes together. I paddle one side and he paddles the other, the same way that Steve Martin and I rafted on the upper Youghiogheny.

Except for the upper river from the Oakland bridge to Friendsville, the sixteen miles from Ohiopyle to Connellsville are the longest undeveloped section of the Youghiogheny, having even less access by road. Only the Chessie System follows the river. No bridges cross, and except for the old cabins at Camp Carmel opposite Indian Creek, no buildings are seen. Among large streams in Pennsylvania (the Youghiogheny averages 2,540 cubic feet per second here), only the canyon of the upper West Branch Susquehanna competes for wildness, but it runs sterile with mine acid. Lower Laurel Run is the last mountain tributary and the last clean stream to join the Youghiogheny. All of the side streams below will be affected by mine drainage or sewage.

One mile above Connellsville, where the Youghiogheny leaves the mountains, it is 900 feet above sea level. In 87 miles, we have dropped 2,460 feet from the top of Backbone Mountain. To drop the next 900 feet to the Gulf of Mexico we would have to paddle 1,995 miles. The gradient is over; flat-water lies ahead.

Approaching Connellsville, the railroad is uncamouflaged on the right bank. Eighty years ago, coke ovens lined the shore. A quarry has been dug above the tracks. A Class II rapid churns to the left of a small island. In summertime, local kids loaf at the South Connellsville "beach"—a gravel bar on the right, and they swim across to autograph a ten-foot-high rock on the left. Running out of roll-call space, some of the younger breed have buried older cold-chiseled names by spray-painting over them.

At the upstream end of Connellsville, the North Fayette County Municipal Authority, the Western Pennsylvania Water Company, and the Westmoreland Municipal Authority operate filtration plants. Ten million gallons a day are allocated for withdrawal by North Fayette (they actually took only 4.3 million on average in 1981), 1.5 million by West Penn, and 45 million (including Indian Creek) by Westmoreland which withdraws an average of about 20 million now.

When the water arrives at the filtration plant, solids are settled to the bottom by adding alum and allowing the water to flow through a "flocculator" or clarifier. Because of erosion throughout the basin, there are many solids whenever it rains hard upstream. The water is then filtered and chemicals are added: chlorine to disinfect, carbon to remove organisms and chemicals causing taste or odor, and potassium permanganate to remove iron and manganese resulting from mine drainage. Further treatment repeats some of the same procedures with addition of ammonia and with Calgon to prevent deposits in the water lines. Mining problems require extra treatment, but relative to most eastern water supplies, chemists consider the Youghiogheny good water.

At the lower end of the river, the McKeesport Municipal Authority is allocated 12 million gallons a day to serve that city, Liberty, Port Vue, Versailles, and White Oak (their use averaged 10.7 million gallons a day in 1981). Municipal allocations from Connellsville to the Monongahela total 68.5 million gallons daily. In addition, industries withdraw all they want; no permits are required, although state permits are needed for industrial water returned to the river.

Through use of Youghiogheny Dam, the Army Corps of Engineers has for decades averted water shortages, but new limits of supply are being reached as in other places: New York City wants more water from the Delaware River in Pennsylvania, while Philadelphia claims that the river's flow is inadequate for its own needs. On Long Island, salt water intrudes underground because so much fresh water has been pumped out. In Florida, sinkholes swallow homes and streets when the ground caves in due to depleted groundwater. Along the Monongahela River, drought causes water levels to sink close to levels that would require rationing, importing water, or reducing barge traffic.

People in water-short basins such as the Monongahela could look

to the Youghiogheny for extra supplies. This has not yet happened, but if Los Angeles and Phoenix can look to Colorado, Wyoming, and Oregon for water, then the Pittsburgh area could look to its backyard Youghiogheny.

Joe Chunpa of the Department of Environmental Resources (DER) in Pittsburgh says, "In ten or twenty years, when water companies are withdrawing the full amounts allocated, the limit will be reached. If more water than that is taken out, we'll have problems: the discharges by industries and towns are all based on a basic dilution factor—on what the river can handle. If there's not enough water for dilution, the wastes will be too concentrated and it will affect the public safety and the health of the stream."

With new dams being too expensive, state officials point out that 80 to 90 percent of the water withdrawn returns to the stream as waste, and that sewage treatment should be upgraded to maintain or increase usable supplies. But the money is not available.

An economic and faster alternative is to use less water in the first place. The U.S. Department of the Interior reported that through additions of plumbing fixtures costing zero to five dollars, communities have cut water use by 25 percent. Individual homeowners have decreased consumption 40 percent. Energy costs are also reduced by saving hot water, one of the home's largest energy drains. Further, water conservation crops the cost of pumping, which in the Westmoreland system is substantial: thirty-four pumping stations for almost 700 feet of lift.

Beyond the plumbing fixtures, water can be saved by simply being careful. To drink water is one thing but to hose the sidewalk with it is another. Without new hardware, Marin County, California, reduced water consumption by 60 percent during a drought in 1977.

Although the water shortage is near, conservation is not pursued along the Youghiogheny. Even the state permit for withdrawing 20 million more gallons a day by the Westmoreland Authority (allowing it to double consumption) included few conservation requirements or incentives. Like electricity, water is priced so that the more you use, the less you pay per unit. Chunpa says, "We've been blessed with a lot of water, but that's going to end one of these days. People don't think about water conservation in western Pennsylvania, but sooner or later we're going to have a drought."

Jim Wilson and I cruise past the half-mile-long Anchor Hocking Glass plant of South Connellsville and paddle through the deadwater created by Powerhouse Dam, eight feet high, built early in the century for hydroelectricity but no longer used. We lug our gear and boats around the right abutment. The river has chewed away this end of the dam; reinforcing rods stick up where cement has been pulverized. Sandbags retain part of the Youghiogheny.

At Connellsville, the mountains have ended and the hills have begun. An Indian trail forded the Youghiogheny here and a Shawnee village sat along the shore. William Stewart, a scout for George Washington, was the first know white man to live here, in 1753.

On June 28, 1755, General Braddock made his twelfth camp at "Stewart's Crossing" on his way to the Monongahela. Captain Robert Orme wrote in his journal: "We crossed the main body of the Joxhio Geni, which was about 200 yards broad, and about three feet deep." They traveled only two miles that day.

Stewart left, but in 1765 William Crawford arrived and the next year completed a one-room log cabin, now reconstructed at North Seventh Street. George Washington visited at the cabin and on October 13, 1770, wrote, "Crawford's is very fine land, lying on the Youghiogheny River, at a place commonly called Stewart's Crossing." In 1774, Crawford fought in Dunmore's War against the Shawnee Indians of the Ohio Valley, and wrote to Washington that he was building a stockade fort around his own house. Then Crawford fought the Delaware Indians on the Sandusky Expedition where Connellsville's founder was caught and burned at the stake. (The town was named for Zachariah Connell, who had arrived a few years after Crawford.)

Upriver from Connellsville, in the mountains, the place-names are descriptive: Backbone Mountain, Silver Lake, Pleasant Valley, Sunshine (only later changed to Crellin), Oakland, Swallow Falls, Sang Run, Confluence, Laurel Hill, Ohiopyle ("white frothing water"), and Chestnut Ridge. Only Friendsville is named after a person. From Connellsville down, almost all names are of men: Dunbar, Dawson, Vanderbilt, Layton, Whitsett, Banning, Smithton, West Newton, Collinsburgh, Smithdale, Suterville, Blythedale, Scott Haven, Coulter, Greenock, and McKeesport. Only the names of Buena Vista, Eden Park, and Port Vue describe the land, or what the land was.

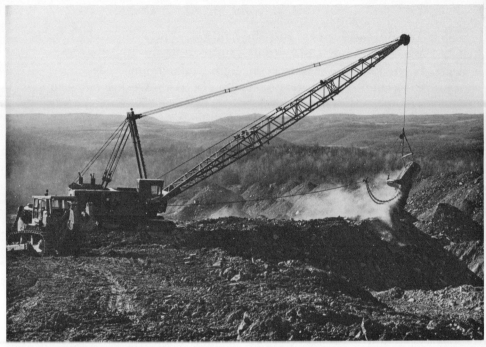
Strip mines above Indian Creek

Fern Colborn

Jim Wilson, Connellsville Dam

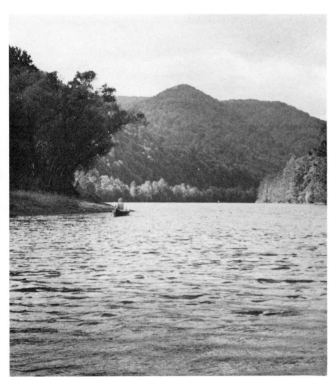

View downstream from Indian Creek

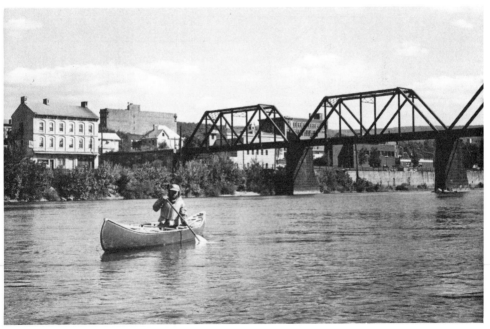

Jim Wilson at Connellsville

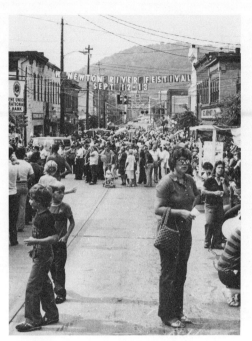

The West Newton River Festival *Mike McCarty*

Mill workers above the Youghiogheny

Boston, pollution discharge

Mouth of the Youghiogheny

Boat building at Connellsville began in 1788 with flat-bottomed barges being constructed near the site of today's municipal building. The iron industry started with a furnace near Jacobs Creek in 1789—probably the first furnace west of the Alleghenies. Pig iron was loaded onto barges and floated to Pittsburgh during high water. Farmers also shipped cattle down the river.

About 1790, Governor Mifflin contracted John Bodollet to survey the Youghiogheny for the shipping of goods. He canoed from Indian Creek down, finding the route blocked by Indians' and pioneers' fish dams, and he urged enforcement of the 1782 law calling the river a public waterway. Rocks, he declared, were the greatest menace to Youghiogheny commerce.

In 1809 Joshua Gilpin wrote, "The Youghiogheny is navigable from about three miles above town (Connellsville) to the Ohio and of course gives an immense outlet for all the produce of this country—the union therefore of wood, coal, iron, and perhaps a variety of other minerals with water carriage to a market down the Mississippi seems to destine it to be a great manufacturing district."

But Franklin Ellis, in his 1882 *History of Fayette County* said that "the Youghiogheny in all that part which passes through Fayette County, and in the greater portion of its course through Westmoreland, is not and never has been a navigable or boatable stream, except for a very small portion of the year, the season of freshets and high water, and even then its navigation is difficult, not to say dangerous, for the passage of coal boats."

The production of coke caused the phenomenal growth of Connellsville during the mid and late 1800s. The "Pittsburgh" coal seam was considered one of richest in the world and ideal for burning in beehive ovens to convert it to the "pearl-gray coke of Connellsville," essential for Pittsburgh's steel industry. A ton of coal makes less than a ton of coke, the difference going up in smoke and being dumped as ash, so for efficiency in shipping, producers did the burning here, near the mines. Beginning in the 1830s, the coke was floated by barge down the Youghiogheny and Monongahela to Pittsburgh. Some boats continued to Cincinnati. In this way, the Youghiogheny, barely out of the mountains, became an industrial river. Connellsville was transformed from a quiet agricultural, lumber, and mining town to an important cog in the huge wheel of the industrial revolution.

In 1871, at age twenty-one, Henry Clay Frick, born near Scott-

dale along Jacobs Creek, acquired a loan from Pittsburgh's Thomas Mellon to form a company to buy coal and build coke ovens. Nineteen years later Frick owned 60 percent of the region's coal and produced 80 percent of the coke. In 1906, ninety-nine plants with 23,713 ovens in the Connellsville area belched acrid smoke without end. Shelby Mitchell remembers that in the early 1900s the sky to the west of Kentuck Mountain glowed red at night. Twenty-one million tons of coke were produced per year, making Frick one of the industrial magnates of Pittsburgh.

The population of Connellsville doubled in the 1860s, again in the seventies and again in the eighties. By 1910, 32,752 people lived here. Among a dozen hotels, the Youghiogheny House was the most popular, and the Hotel Marietta was owned by relatives of Ohiopyle's Bob Marietta. Seven banks handled the money going in and out. An opera house provided some of the entertainment. Toll-keepers collected money from people who crossed a suspension bridge strung over the river in 1899.

Gwen Waters of Ohiopyle rode the train to Connellsville early in this century to shop, to see movies, and to attend school. "It was nice," she recalls. "It was a booming little town with shops and people working in the coal mines and at the coke ovens."

The coke industry died in the late 1920s as the Pittsburgh seam was depleted and the ten-foot-diameter beehive ovens were rendered obsolete by large processing plants at Clairton that captured valuable by-products for plastics. Connellsville has been in decline ever since, the population dwindling to 10,307 by 1980. In Fayette County, the 32,000 people working in mining in 1930 fell to 5,000 in 1980.

Connellsville declined thirty years before the rest of the county, and it shows. Seventy-nine percent of the houses were built before 1939. You can find well-kept, quiet residential areas that are attractive, with people who would live nowhere else, but much of Connellsville is the typical worn-out mining town with the heavy look of old—now lost—industrial wealth. It represents boom and bust. Maybe the justification of mining towns makes this ending inevitable; towns that were built through the hauling-away of lifeless minerals look different than ones built around a sustainable economy.

Dr. George Dull has practiced podiatry in downtown Connellsville for over forty years and has seen his city decline from the vibrant, industrial community of his youth to its sagging condition

today. I ask him what it was like watching the town go downhill. He answers, "Terrible."

Today, Anchor Hocking Glass employs 2,400 people in South Connellsville. West Penn Power, the railroad, the Connellsville Independent Mining Supply, a sportswear maker, and some metals industries remain. The Volkswagen plant at nearby New Stanton employs people, though lay-offs there have been heavy in the early 1980s. "Young people move out, closer to Pittsburgh and to other places for work," Dr. Dull says. Census data indicates that 13.9 percent of the people are over sixty-five years old. This is only slightly more than the state average, although the percentage seems much higher as I walk around town. About one-third of the high school graduates leave.

Eighty years of dirt darkens the frame, stone, but mostly brick buildings of downtown. Paint peels. A rusty sign says, Quality Department Store. A turn-of-century tailor shop occupies one of the most prominent sites in the business district. There are shoemaker shops and a Bible and religious supply store. A fortresslike brick building houses the Pittsburgh National Bank branch.

In MaMa Marias Italian restaurant, three men who are perhaps in their sixties are drinking morning coffee. Two canes lean against one of their chairs. "If this man can last a couple of years, he'll straighten this country out," one of the coffee drinkers says. He is talking about President Reagan.

"I'm not against helping people, but the damn Three A's [American Automobile Association] do more to help people than the government does." The president had just furloughed federal employees for one day. "How many employees does the government have, anyway?"

"Seventy percent of the people in America work for the government." This statement reflects a point of view rather than fact.

Some local leaders are struggling to improve Connellsville. In 1980 a city council and chamber of commerce committee met to develop a revitalization plan. A design consultant encouraged restoration of buildings with architectural interest. Storefront renovation, a downtown mall, and trees are being considered, but this type of project in a depressed town has almost always depended on federal funding and the money is not there. In 1971 a regional plan had recommended recreational development and parks along the river, where a new access area was built in 1981.

The big improvement in Connellsville is the Youghiogheny's water quality. "Used to be there were no fish," Dr. Dull recalls, "but they cleaned up enough of the acid that it's now pretty good through town." Ron's Barbershop sponsors a fishing contest. The recent winner caught a forty-inch musky, and a nineteen-inch brown trout was also caught. Since the water is too warm to "carry-over" or keep trout alive from one season to the next, the Fish Commission stocks bass and other warm-water species from Connellsville down. The Youghiogheny Fishermen's Association stocks trout.

When I visit City Hall, which overlooks the Youghiogheny, I have to look through closed blinds in order to catch the view of the river. Yet, Dr. Dull says, "People are very conscious of the river. It's considered quite an asset. For years, kids have been taking inner tubes up above—sometimes clear to Ohiopyle—and floating down." With safety regulations at the state park, tubing from the Falls is no longer legal, but kids can still go to Bruner Run, Indian Creek, or Camp Carmel, and float back home. "In July there's a river festival and a race," Dr. Dull says. "Anything that floats."

Paddling in our two canoes rigged as one, which looks like a cross between a Hawaiian outrigger and the feet of a seaplane, Jim Wilson and I drift under the bridge at Crawford Avenue while school kids walk across it. The Youghiogheny is about two hundred and fifty feet wide. From here to the river's end is forty-five miles, dropping gently at three feet per mile.

Most of the water that is withdrawn above Connellsville for urban use is eventually returned, but it includes a few things that the water up above does not. "From Connellsville down the river deteriorates," Jim Ansel of the Fish Commission says.

The Connellsville sewage plant accomplishes primary treatment only: solids settle for two hours and chlorine kills bacteria. Some of them. Then the waste water is dumped back into the river. Storm sewers collecting runoff from the streets are piped into the treatment plant and overload it during rainfall. In Dunbar, a mining town three miles to the south, pipes collect waste but lead only to Dunbar Creek, so the town's sewage hits the river raw. Dunbar is the largest town (1,370 people) without sewage treatment along Pennsylvania's Youghiogheny, outdone only by Oakland in Maryland.

The state ordered Connellsville and adjoining municipalities to

install and upgrade treatment. With $121,500 from the federal government, engineers were hired in 1972 to prepare a plan for the Connellsville Municipal Authority which ranks ninety-ninth on a national priority list, but funding reductions to the federal Environmental Protection Agency have eliminated the chance for an improved sewage plant. Don Bialosky, DER field inspector says, "There's not a public health hazard, but I wouldn't swim below there." For the first time since Oakland, the waters of the Youghiogheny are uninviting.

Below Connellsville, the river riffles slowly but steadily, and in two-and-a-half miles we pass Broadford, where Indians and settlers waded the Youghiogheny and where the abandoned Overholt Distillery still stands.

Another three miles bring us to Dawson, a country town of 662 people on the right bank. It has the old frame houses, the backyard sheds, and the woodpiles of a mountain village, but also the brick, stone, and railroad tracks of a coal town—of a western Pennsylvania town. This mongrelization of makeup and architecture—mountain and industrial—continues to McKeesport where the weight of industry will gain total dominance.

Dawson is the only place on the lower Youghiogheny where people can rent canoes. Liberty and Vanderbilt lie as small towns to the left, mostly out of sight. A railroad roundhouse operated on the left shore and a coal tipple on the right, below Dawson.

At an access area on the upriver edge of town, Mike McCarty waits. Jim Wilson must quit the trip to resume teaching school, so he lifts his canoe onto the Mountain Streams and Trails van and returns to his own car at Ohiopyle. Mike, who could not join us for the first three days, will paddle with me to Pittsburgh. Like Jim Prothero who worked on the Youghiogheny but had never seen the headwaters, Mike McCarty has never seen the end. "Someplace I've never been," he says of his motive in coming.

Mike and I leave Dawson in the warm light of early evening, pass a string of skinny islands, and enter the most scenic reach of the foothills Youghiogheny. Through five miles and five bends to Layton, the river cuts beneath 400-foot bluffs. Riffles alternate with pools. Muskrats track the wet shoreline. We see a red-necked grebe migrating south, a red-tailed hawk, a kingfisher, a great blue heron, and a deer. But plastic trash and cans have also been with us since Connellsville.

On October 14, 1770, George Washington traveled through this area and wrote, "The lands which I passed over today were generally hilly and the growth chiefly white oak, but very good notwithstanding; and which is extraordinary and contrary to the property of all other lands I ever saw before, the hills are the richest land, the soil upon the sides and summits of them being black as coal and the growth walnut and cherry. The flats are not so rich, and a good deal more mixed with stone."

Except for the railroad, the flats along the river between Dawson and Layton remain as undeveloped as they were when Washington saw them. Mike and I camp on a rocky bar across the river from Linden Hall. This is a thirty-seven-room mansion built in 1913 by the daughter-in-law of James Cochran, who amassed a fortune in coal mining and coke production. The United Steelworkers of America operate the property as a conference center with lodging, swimming, golf, tennis, and mansion tours.

The village of Layton lies on the right. Men worked in a brickyard here in the 1800s. Below the village, an old railroad bridge that was used for hauling coal and coke has been converted to a highway bridge. One mile up the road is Perryopolis. It is a historic town: among other things, it housed the first bank west of the Allegheny Mountains. After a few years it went bankrupt.

During his trips to the frontier, George Washington was attracted to this area. On September 21, 1767, he wrote to his friend William Crawford of Connellsville: "Could such a piece of land be found you would do me a singular favor in falling upon some method of securing it immediately from the attempts of others, as nothing is more certain than that the lands cannot remain long ungranted when once it is known that rights are to be had." In 1769 Crawford bought 1,643 acres for Washington near today's Perryopolis. Visiting the site in 1770, Washington wrote that it was "as fine land as ever I saw." A mill for grinding grain was opened in 1776 on Washington Run and operated until 1900. Only foundation ruins remain.

Below Layton, the two largest islands of the Youghiogheny stretch for half a mile each, shaded by mature beech, ash, and oak. Aside from the stand in Victoria Flats above Ohiopyle, this may be the largest bottomland timber along the river. When Bob Hutchinson and friends rowed a john boat on overnight expeditions to West Newton in the 1920s, they floated to the right of the islands, but the channel has changed; in 1981 we veer left.

Another two miles brings us to Whitsett and then Banning: coal towns with company-style houses and a coal-town look that will be carbon-copied many times betwen here and McKeesport. The Republic Steel Corporation operated the last deep mine along the Youghiogheny on the left shore at Banning until January 1982. Ten million gallons of polluted water a day continue to pour from the mine and are processed in three treatment plants. Republic Steel and the DER are trying to settle an agreement about continued operation of the plants. One mile below Banning, Jacobs Creek, gross with mine drainage, enters from the right.

Smithton, population 563, is two miles farther. The Jones Brewing Company, maker of Stoney's Beer, dominates the town, with buildings rising straight from the river's edge. Water for the beer is drawn from wells across the river.

Founded by "Stoney" Jones, the brewery is now run by William B. Jones III. Stoney's granddaughter, Shirley, grew up here, then acted in movies, winning an oscar for best supporting actress in *Elmer Gantry,* and starring in *The Music Man.* The brewery remains dedicated to "a pure, all-grain beer devoid of any artificial materials and/or additives, a traditional brew much like that of the 'old world.' " The fact that old Stoney was a diabetic but liked to drink a lot of beer, may have had something to do with his natural recipe that derives easily assimilated sugar from barley, malt, and corn. Being unpasturized, Stoney's is sold fresh. Ninety percent has been marketed within seventy-five miles, but the radius is expanding into West Virginia, Maryland, and Ohio. One hundred people work here, including about a quarter of Smithton's labor force. The brewery is the largest taxpayer in town.

Neither the brewery, which has primary treatment, nor the town, which treats sewage not the slightest, meets state pollution-control requirements. In two places, milky gray effluent oozes from the Smithton shore. It may be the foulest-smelling of all discharges to the Youghiogheny. DER and brewery representatives are trying to reach an agreement and a schedule for improving treatment.

Ed Hogan, vice-president in charge of sales and marketing, maintains that the brewery takes out as much of the solvents from their waste as possible, and that their discharge consists of natural food and organic matter that can help the river. "We're not a chemical or coal company. We don't deal with anything that is harmful to the stream. Our concern is that DER not require us to build something

that is beyond our means. Our proposal is to spend one million dollars over the next ten years. If that is our commitment, what is the town's commitment? We're willing to do what we can to keep the river clean, but if something is beyond our financial means, we'd have to leave the business." DER has supported a proposal that they say will cost less than $1 million.

For six miles Mike and I drift slowly. We see an osprey soar overhead and dive for a fish. By suppertime we reach West Newton.

So far this is the second-largest Youghiogheny town, with 3,377 people. Each September the West Newton River Festival draws thousands to the downtown and riverfront. Local groups and businesses line barricaded streets with merchandise and food stands. Craftsmen and women display goods and demonstrate skills. Kids play games and a band plays country and bluegrass music. Down at the river, a fishing contest lasts all day, and catches include smallmouth bass, muskellunge, northern pike, crappies, bluegills, perch, and rock bass. Races are held for canoes, inner tubes, and—highlight of the day—anything that floats. The Youghiogheny has been a common sea for many navies: Floyd Cowger's rowboats at Silver Lake, outboards powered by Evinrude motors on the reservoir, canoes below Confluence, rubber rafts and fiberglass kayaks below Ohiopyle, and down here at West Newton in September—a floatable freakshow with kids and adults racing in crooked paths down the river at the shout of "go."

Here the Youghiogheny is not a wilderness river, and that is okay with Mike and me. There is a time for wild rivers and a time for pizza and beer, and we are smart enough to know the difference. Mike guards our gear and from a black bag he retrieves two cans of beer to cool in the river while I walk one block into town, secure advice from three twelve-year-olds, and buy a pizza. Mike and I then eat on an old bridge abutment at the public access area. Fifty yards away a man is sitting in a ten-year-old car, guzzling beer and heaving the bottles into the river where they bob right side up as they pass us. He is about six-foot-four. I think that he is plastered, but with only a flip of the wrist those bottles go sailing five canoe lengths. We consider throwing our empties toward his car whenever he throws one at our river, but decide that he will have more empties to throw and that we would sooner drown in a rapid than here in the West Newton flat-water. He steps out of the car and relieves himself. He hits the horn in rhythm with the radio. Mike

visits town to buy groceries, and when he returns, the man wings his last bottle, pitches the cardboard carton on the grass, and drives away. We are left in trashy peace.

Although barges went downriver from Connellsville and even from Indian Creek in the 1800s, the limit of "improved navigation" was West Newton. In 1816 the Youghiogheny Navigation Company was incorporated, but investors apparently had no intention of digging a channel. The charter included a section granting authority to open a Connellsville bank. The Connellsville and West Newton Navigation Company was incorporated in 1814 to build locks, but it wasn't until 1850 that another Youghiogheny Navigation Company constructed two dams and opened a four-foot barge channel for eighteen-and-a-half miles from the Monongahela to West Newton. Two steamboats were built here between 1851 and 1854. Floods and ice destroyed the dams within fourteen years, but the Pittsburgh and Connellsville Railroad, completed in 1861, had replaced barges anyway.

An 1875 study to extend the Chesapeake and Ohio Canal from Cumberland to Pittsburgh by way of West Newton called for fifteen dams in a forty-four mile section, and as recently as the 1930s the local congressman advocated a Youghiogheny canal. Nothing is now proposed.

Just as there were changes in the river's character at the Little Youghiogheny confluence, at Sang Run, Friendsville, Confluence, Ohiopyle, and Connellsville, West Newton marks another turning point. From here the river flows slowly. Shorelines grow grass; there are no more big rocks. Hills no longer climb rugged or high. It seems that the Youghiogheny should have a mature, gentle, serene ending, but not so.

West Newton's sewage plant dumps its load into a long flat-water pool, and two miles below is the mouth of Sewickley Creek, bubbling mine acid and sewage. The cumulative effect of the towns, the mines, Jacobs Creek, and Sewickley Creek makes a difference. The river will not meet safe water quality standards by the 1983 deadline mandated in the Federal Clean Water Act, and DER officials blame lack of funds for sewage treatment as the chief reason.

Good campsites cannot be found because railroads crowd the shorelines left and right. Both sides accommodate roads, homes, and cabins. Trains pass now and then, including Amtrak carrying passengers from Pittsburgh to Washington in eight hours. The route

follows the Youghiogheny to Confluence, the Casselman toward the high divide above Cumberland, and then the Potomac.

Mike and I paddle until dark when we stop at the mouth of Pollock Run, next to the railroad. I put on shoes because of broken bottles. Foot-thick mud borders the river. Mike steps out of the canoe and slides back downhill. The next morning it rains and is worse.

Two miles below Sewickley Creek is Sutersville, with the most picturesque of all urban riverfronts along the Youghiogheny. An old man mows the lawn and rests while watching us. A mother pushes a child in a stroller. One homeowner stacks firewood for the icy winter; another rakes leaves. From our distance, this all seems to be a hometown movie without sound.

Since leaving Backbone Mountain, I have been finding my way down the Youghiogheny with the help of topographic maps: sixteen sheets at a scale of two-and-five-eighths inches per mile, showing the river, roads, houses, barns, forests, and contour lines which describe gradient and terrain. Urban areas, where there are too many buildings and streets to be shown individually, are red. Now, as Mike McCarty and I leave Sutersville, population 853 and not colored red, we cruise one mile downriver to where map number fifteen ends and the final topo sheet begins. The map is called McKeesport and at its top is a huge, solid, overwhelming mass of red. We will be in it tonight.

We pass Buena Vista. Undeveloped reaches of steep slope alternate with flats that are worn-out farmland dotted with coal-town homes. One of the bends loops around the Youghiogheny Country Club and we see a second osprey fleeing south. His winter plans, unlike mine, are worked out well in advance. Mike and I pull our boat north and west. An older couple paddle upriver in a homemade canoe.

It is late in the day when we round the final rural bend of the Youghiogheny and drift toward the Boston Bridge connecting the town of Boston, on the left, with Versailles—population 2,153—on the right. Pronounced Ver-SAILS, it marks the beginning of the agglomeration of red that splays almost nonstop to the Point in Pittsburgh. The only interruption is a brief gap of white where the map says, "Mine Dump."

About one-quarter mile long, hundreds of feet high, and supported by stone piers that are the work of artisans, the Boston

Bridge is the first massive bridge to span the Youghiogheny. Above it, a milky discharge of pollution seeps in from the left shore and paints a ten-foot-wide stripe down the river.

The current changes. It has been slow, but now it almost disappears. Only the water in the middle moves steadily, and then I notice that the water along the shore creeps upstream: an eddy where the lay-of-the-river says one should not be. It is a sure sign of dam-induced slack-water. Eight miles away, the dam blocks the Monongahela River. The Youghiogheny current, running free for all but eighteen of its miles so far, ends right here. The last four of 132 miles lie impounded as part of the navigation system that brings barges from New Orleans to Morgantown, West Virginia. Two motorboats hum past.

Mike and I beach on a grassy, knotweed-covered flat. Evening fishermen launch small motorboats from a public access area. One man fishes in shiny shoes, knit pants, and a navy windbreaker. Two younger guys rev up a speed boat. I walk into town where rush-hour traffic is dense and fast. For the first time anywhere along the Youghiogheny, I wait for the light to cross the street. My tour of Boston takes me past a gas station, hair dresser shop, laundromat, needlecraft store, Dari Delight, and closed deli with a sign: "Pizza and subs coming soon." A dog barks behind a house and a man yells, "Cut it out." People walk past and nobody looks at me, nobody smiles, and nobody speaks.

Mike and I wait until dark before pitching the tent so that we don't attract attention—so that we don't get chased out. The Boston Bridge is like an ink-line drawing against gray-blue skies. There is no escape from the sounds of traffic, jet airplanes, and Pittsburgh industry which begins half a mile downriver.

Rain falls in the night, pounds the flimsy skin of our tent, and continues until morning when it soaks the ground and runs in fingers to the river. We staked our tent on sand which absorbs the water, but in other places the rain piles up in puddles. Drops hit the river in thousands of bull's-eyes that form and vanish each second. Rain greases the banks. It glues sand to our shoes and is impossible to keep out of the tent. Dampness permeates everything. The rain leads us to dig into our waterproof black bag in search of books.

As soon as the rain quits I walk into Boston and across the bridge to Versailles. It is an old industrial community, one among scores of Pittsburgh satellites with dark brick buildings and two-story houses,

old, without the smallest fragment of fancy trim, without shutters, without trellises for vines, without porch swings, and many without porches. Some are shingle-covered, some are peeling their paint, some survive within aluminum siding. Most cling to hillsides. Gas stations crowd intersections, traffic is heavy, and the whole scene is grim. The Youghiogheny has come to the mill towns of western Pennsylvania.

The outside environment does not seem to count for much here. The hills were cut and dug and notched for houses, the riverfront is monopolized by the railroad and by trash, and the neighborhoods reflect mill-town gray. One theory is that the people in these Monongahela and Ohio Valley towns live inside: within their home, family, church, job, and ethnic group. These are the important things. Outside appearances are superfluous. To many, clean air does not seem important. The air has been smoky or hazy for generations. The land does not seem important. It hasn't been much to look at for a hundred years, and many people learn to skip it in their view of the world.

This lower end of the Youghiogheny once ran clear, much better than today's chemical tap water. The river was jumping with fish, edged by tan sandbars and fat-trunked trees. Down here, the original river has been traded for industry, steel, jobs, and money, and the trade has helped to pay for the livelihoods of several generations.

Mike and I load the canoe for the last day of paddling. Styrofoam cups drift past; men painting the bridge have finished their coffee break. The river is not much a part of anybody's life here, and if it is not, who can be expected to treat it with respect?

The first large industrial plant stands around the bend at the lower end of Versailles. Next, a plant at Eden Park, then McKeesport and Port Vue. They are old industries, and in 1981 most operate at less than capacity. Much less. The recession is deep in the mill towns of the Ohio Valley, and some of these plants may barely be operating at all. Those that close may never reopen. The wave of heavy industry that stormed this region since Carnegie and Frick is waning, maybe dying. New demands and increased mechanization might revive industry, or cause it to evolve into modern viability, but maybe not. Maybe people will have to leave, the way that two-thirds of them left Connellsville after the coke ovens closed. The old prosperity was based on cheap resources, cheap energy, and cheap labor, and none of those exists any more. Those things are as

much in the past as Gwen Water's Ohiopyle or Elsie Spurgeon's Somerfield. Except that here, we don't know what will replace the towns and jobs of today. And here, more people stand to lose.

Catching a river-break from the noise of the mill, six hard-hatted workers eat lunch and wave to us from the top of a fifty-foot wall rising from the river. The water has grown worse with every mile, yet we see a kingfisher and great blue heron. The shores remain mostly green with willow, sumac, and weeds.

The Youghiogheny has been a mountain creek, a pastoral stream, a wilderness gorge, a reservoir, a canoeing and fishing river, a playground, and a mature waterway. Now it takes a different image. Now it becomes the outcast, a place for railroad tracks and hobos. It is the broken-bottle, empty-oil-drum backside of Ohio Valley industry. This is the Youghiogheny as it nears its end.

Up in the mountains, one could write chapters of history about use and abuse of resources for the urban good. Logging, coal mining, damming—the effects were sometimes devastating. But those effects do not compare to what the urban area did to itself. People died from poison air in Donora. The coke ovens in Clairton, across the Monongahela, were one of the worst air pollution sources in the state. The rivers were cordoned off by railroads, power lines, industries, and highways, but the water carried such waste that few people would have gone there anyway. The rural fringe was gobbled by suburban sprawl. People faced some of those conditions and made improvements, but now the system that brought those conditions is, itself, failing. The production, the jobs, and the money are drying up.

What kind of future is there? Will it be one of only surviving, of trying to keep jobs, and homes, and groceries on the table? To just stay alive may be the main thing. The best future possible may be to perpetuate this—to maintain what we see here at the end of the Youghiogheny. To do only that seems a difficult struggle in 1981. Years ago when immigrant laborers came to this valley for jobs, I suppose this place met some of their dreams. Whose dreams does it meet now? What kind of dreams do people have for themselves or for their land?

It is easy, down here near the Monongahela and Ohio, to see why escape to the river up above is so important. Here where the most people live, the river and the land are worst. If the urban riverfronts had open space, clean water, and festive afternoons of swimming

and playing, would Ohiopyle be so popular? Would Youghiogheny Reservoir be so popular? Our use of the land and the rivers where we live has driven people away. The urban rivers are cleaner than they used to be, and with parks here and there, the waterfronts are used more than they were ten, twenty, or fifty years ago, but getting away remains a weekend goal supporting a growth industry. The economic recession may solve the problems of crowded rafting at Ohiopyle, but not yet; 1982 brought a record year of business for those trafficking in escape to the mountains and to the whitewater. Temporary escape is a way of life to many people, but to growing numbers of others, it is too great an expense.

The sense of rediscovery and recycled frontiers that Jim Prothero and the Rodmans talked about has been applied to the mountainous sections of this river, but it has not been applied at the lower end. The challenge is greater, because the place is not so exotic or exciting, but the needs are greater because there are more people. If it were cleaner, and accessible, the river could be used more than it is.

McKeesport, on the right, is the last city. It was named for David McKee, an Irish settler in 1755 who piloted a ferry boat across the Monongahela to the West Mifflin area. McKee was a leader in the Whiskey Rebellion of 1794. Here near the mouth of the Youghiogheny, George Washington met with the Seneca Indian queen, Alliquippa, in 1753. General Braddock camped near here, below the mouth of the Youghiogheny on his way to defeat at Turtle Creek in 1755. In 1776 colonial Colonel George Morgan built thirty bateaux (large rowboats) here for the Revolutionary War.

Today McKeesport houses 31,017 people. Together with the other Pittsburgh area cities along the bottom three miles of the river, this is larger than all other Youghiogheny riverfront towns and cities combined. Kids fish at a McKeesport park, and black people sit along the riverbank. We can see steeples of seven old churches at once.

Ahead, the bridges overlap in a tangle of steel. We pass under the high arches of Fifth Avenue, then under the railroad where the river is three hundred or more feet wide. Finally we reach the bottom of the Youghiogheny. From the river's beginning up in that clear-cut at the source, we have arrived at the river's end. Now, in the slackwater of a Monongahela dam, the final shoreline on the left houses a sewage treatment plant and the final land on the right supports a

U.S. Steel tube mill—a complex of three-story metal buildings, smoke-stacks, warehouses, furnaces, fork lifts, railroad cars, stock piles, trash piles, banging machinery, bells and alarms, all sprawled toward Pittsburgh for a mile and all tended by hard-hatted, steel-toed workers.

Six barges of coal are being pushed up the Monongahela by a riverboat named the *Steel Pioneer,* pitching Mike and me up and down as its wake travels under us and then washes against a beach at the confluence. In the shadow of the bank that supports the steel mill, half an acre of sand is mixed with small chunks of coal and large chunks of plastic trash. The Youghiogheny disappears into the muddy Monongahela.

This is the first time that the Youghiogheny joins the larger flow. It will meet the Ohio, then the Mississippi, the Gulf of Mexico, the Atlantic Ocean, and finally our river will return to the sky as water vapor in a rising wind that will scatter it across the globe.

Winter

*T*he ducks* have gone south and here I am back in Confluence. The leaves have fallen and snow squalls begun. I needed a place to build a fire and keep warm, and Jim Prothero said he would be pleased to have his River Path headquarters occupied, so home has become the second story of his old house below the dam and next to the Youghiogheny. In ten minutes I can walk into the heart of Confluence, which is Viola's restaurant where I eat breakfast now and then.

Having been vacant for ten years, the house was in poor condition when Prothero bought it in 1977. He launched a plan of total renovation with the bold first step of stripping out the insides: plaster, linoleum, interior walls, almost everything but the shell. Busy renting canoes and giving paddling lessons, he has not yet started step two, whatever it might be, so for makeshift protection, I nail cardboard over the holes and create some walls out of a twenty-by-thirty sheet of plastic. From the rafters, black wires hang down like spaghetti gripping switch and junction boxes. You would not believe that the owner of this place is an electrician. The house will remain this way, of course, only temporarily. Only for the winter when I am here.

I need no weatherman or windows to describe outside conditions. The inside approximates them closely enough. Clothing forms my first line of defense. I wear four shirts and sometimes my ten-year-old down parka. Then the trick is to create a heat source and position myself so that the heat hits me on its rapid exit from the

house. I set the kitchen table behind the Fisher stove and burn oak logs. When it's icy cold, I light my Kero-Sun heater, bought on sale from Leo Smith in Ohiopyle, and I slide it under the table where it warms my entire working surface. Then I sit with my back two inches from the stovepipe and my knees almost against the Kero-Sun. Ahhhh, winter. There are ways to survive, and I have found them. There are ways to enjoy it, and I am working on that.

In accepting Prothero's offer, I have joined a not-wild yet not-caged managerie, all of us seeking shelter from the elements, though only I have been invited. It is tempting to buy a flash attachment and launch a career in indoor wildlife photography. Every night, half an hour after I go to bed, an opposum cruises through the house, upstairs included. Its yellow eyes are close together, closer than a cat's. The first night I try chasing it away, but it plays dead beneath the electric range. The animal's instincts deliver an effective and disarming defense. I smack around with a broom, then feel stupid, trying to beat up on this foot-long opposum to make it leave. I decide to keep my food locked up and to coexist. Invited or not, the opposum will cause no harm that I know of.

The red squirrels have cached pine cones up above. A sparrow who wants out even more than I want him out darts between the rafters. The bats with their fluttering wingbeats seem to have retired for the season, but I still find solace in an article that says there have been only ten cases of bat-transmitted human rabies in the United States since 1946. The article also says that 100 brown bats eat forty-two pounds of insects in four months. If only they ate flies this time of year.

I do not understand the life cycle of the fly, but on warm days in late autumn they arise from the dead and set this place to buzzing. For two weeks they crowd the windows in the afternoon and the lightbulbs at night. They land on my table and buzz, belly-up. They land on my book and fall in the binding between pages. They land on the rolled-up magazine that I'm swatting them with. They are pesky.

At least I have shelter from the snow. Except for the flurries that come in around the stovepipe. Except for the ones that come in around the windows. There will be snows so big-flaked, steady, and silent that I will use my mind's picture of them to help me fall asleep at night. Snows to split wood by. Snows for digging out the longjohns. Snows to remind me of sled riding. Snows for the joy of

children. Snows to make me wonder what in the world summer was like and to wonder how it could have happened right here. The snows will remind me of the miracle that is the seasons. This cold phase of the miracle attracts less wonderment than other phases but is perhaps even more awesome.

I have cold running water, although it is saturated with iron. The longer it sits on the Fisher stove to make bathwater, the rustier it gets, just like the drainage from the mines up the Casselman. I wonder if my water continues to oxidize and get red after I drink it.

Well, I have lived in worse places. Look at this as deluxe camping with everything including the kitchen sink and the flies. I have a telephone and will probably think of somebody to call. Maybe. Through the evening a great horned owl hoots, on the lookout for a skunk in the black winter night.

Spending early winter in Confluence, provincial as it may in some ways be, is like living all over the continent at once. The temperature will reach 50 degrees with sunshine, then the sky will turn cloudy and deliver rain and wet snow, all on the same day. The weather keeps changing but the lows drop steadily lower and I pile blankets steadily higher.

Winter weather is stormy—anything but boring—yet it leads to boredom. Steve Martin had warned me, "Ugh. The winter is real slow here." Darkness is domineering. Plenty of darkness. The darkness begins to push me around a little; it begins to affect the way I feel. It will be obsidian black at five o'clock, and that makes a long evening when alone. When those days come, I will leave Confluence on some extended trips. While not comparing to mine, Steve's winter will be slow, too. He will find a job as a ski instructor in Jackson Hole, Wyoming, but in the old-time Steve Martin way, he will break his arm fooling around between lessons during his first day at work. He will spend his winter sitting and walking, with one of America's greatest mountains for skiing in his view.

A slow winter is what I need. I have been meeting people and exploring the Youghiogheny for months. Now it is time to hide and write. Winter rises up around me and I feel myself deeper in it each day. If my intent was to escape from everything else in life, I have done it well. Maybe it is time that I call it quits to the escape and get on with the next phase: the search. Maybe I will even end up arriving someplace, as have a lucky few who first sought escape along the Youghiogheny.

The winter up on Backbone Mountain makes Confluence look like a South Carolina retirement community. Up there at the top of the basin, it is frigid now with winds howling, unbroken since leaving Canada or the Rockies. Pleasant Valley farmers have boarded up for the duration, maybe tearing down a tractor engine or two while a wood stove and trouble-light burn in the garage end of the barn. In Oakland, people have fortified their homes with fuel oil and firewood and are ready for the isolation that winter brings. Some people must leave that place from time to time, and following the worst storms, the state police will lead convoys of Garrett Countians down Interstate 48 in white-out conditions to Cumberland. Farther down the river, Rusty Thomas sees no kayakers.

The Army Corps has drained the reservoir so that the historic but flooded Somerfield bridge nearly appears. Before the snow falls, a few summertime residents return to comb the reservoir shores that are now mud but were directly beneath the boat docks all summer. The hunters find worthless treasures: a rusty pocket knife, somebody else's keys. One winter, Red Jordan returned looking, to no avail, for his teeth. He had been swimming the prior July, and his lovable Labrador retriever had jumped from the dock and onto Red's back, knocking his dentures out. This happened twice in the same summer.

In Confluence, old guys in dark winter coats and red hunting shirts show up at Viola's each morning. In Ohiopyle, it is quiet. Wendell Holt or Bob Marietta drink coffee at the store, and life is slow, the way it always used to be. Skeleton crews fix rafts at the five companies, and the office staffs—reduced to one or two women each—mail brochures to thousands of prospective river runners.

Shelby Mitchell puts out extra feed for the birds and sits bored in retirement. January through February, Bill and Adalene Holt abandon town for their daughter's home in South Carolina. The miners keep stripping all winter long; frozen earth is nothing but pie crust to the temporarily superior drag line. In Connellsville, the old city looks even more bleak with slush-streets and gray skies. In the mill towns at the bottom of the river, the recession and the winter are a grim team.

From Backbone Mountain to McKeesport, people hide indoors. Not everybody—there are some who flock to Garrett and Somerset Counties to cross-country ski if the snow is deep enough. A few men hunt or run trap lines through the winter. In January a trio of

wet-suited kayakers run the Loop in Ohiopyle, but they are the hard core, and not from around here. Mostly people remain inside. The apparent security of the indoors is sought too much, and becomes a powerful source of restlessness and discontent. A mountain heritage of woodworking, fiddle playing, and quilting has, over the years, served purposes, not the least of which has been to keep people sane. Now, most people watch TV a lot. Some drink a lot, and homes—including mine, open-air as it is—can become prisons. Eventually, the winter gets on almost everybody's nerves.

Ice overcomes the river, glassing shut every pool. At the rapids, piles of ice form, one crystal at a time. On sub-zero days, ice builds up on rocks underneath the flowing current, painting the river-bottom blue-gray. As temperatures bottom-out in January, most of the basin's water is locked in ice and the river level drops. The Youghiogheny is as clear as tap water. Not my tap water, but other people's. At the river's edges, ice grows too large to support itself and renegade chunks break away. They land on another shore and fashion a jumbled surface like a glacier which then freezes fast. The silence is as striking as the current's singing was in the summer. The fish and other life in the river shift into a winter pace, barely alive, saving fat and energy for the long cold haul.

From my window, I see the Youghiogheny, not frozen here because of the warmer water that comes from the bottom of the dam. Mist lies thick because the water is warmer than the frigid air. Along the bank, an old man hunches forward with a long stride. He looks around constantly: ahead, sideways, backward, and a duck-billed cap accentuates this. He exhales short, steamy breaths like stunted smoke signals in the low morning sun. He is a silhouette in a scene all-gray.

So what has all this meant? Why write a book about a river in the Appalachian Mountains? There are more important things to do in 1982. Here we sit with unemployment in the mountains and the Ohio Valley reaching 20 percent, with acid rain sterilizing water supplies and cutting productivity of the very soil, with dam builders tackling half the wild rivers of the West for air-conditioner power, with a federal government hellbent to serve private profit by giving away public resources, and with international leaders playing poker with nuclear weapons. Who cares about the Youghiogheny? All I can say is that this is a tiny piece of the earth—a good piece—and of everything that we have in this world, a good piece of earth

might be the most important. So for this place, I've written down what I've seen. My version of the way it is. Or was. Maybe we can decide what to do with this place—and decisions are being made all the time—if we know more about it.

I'm up here because I wanted to explore the river, to know it. Why? To be a part of it maybe. Is there anything better to be a part of? But after all these months—after hiking to the headwaters, swimming through a rapid, canoeing to the end of the river—I realize that I am still a long way from being a part of this place. This is all unsettled and impossible, having something to do with dreams.

Springtime, when all that life is bursting out, is the time of dreams, of wild imaginings of what could be. But in the dead of winter we need dreams to see us through, to pick up the pace, to thaw some of the chill from our hearts. Right now the dream supply seems to be short.

Along the river, I have found some people with roots and some who can't wait to leave. Some who have come for a day; others for a lifetime. Some who live for their future and some who live for the moment. Some live for the past. There are people with families, with jobs, and others who are firmly entrenched in the welfare state. There are people with madness and craziness that erupts in rare forms. There are many kinds of people, but few of them would I call dreamers. This land and these times seem not to have bred people who use extra imagination when building their futures. Many people are emphatically practical types and they don't talk about what is to come, or what ought to be, or what they are trying to be, or what they wish were true. But maybe I just have to look more closely. Rusty Thomas wants his children to have what he had, growing up along the river at Sang Run, and I guess that is a dream.

I know what Jim Prothero's dream is. His dream and mine is to have a good half-foot of fiberglass insulation in the ceiling of this house. Past that, his dream is to build, here along the Youghiogheny at Confluence, a river center where people will come to learn about the Youghiogheny and about paddling. If he turns a profit someday, so much the better.

Gwen Water's dream is so much different. Her heart is still young, and she dreams of old Ohiopyle and happiness there: of swimming long-skirted in the Youghiogheny, of train-loads of city

people coming for fun in her town, of fiddle and piano duets filling the summer evening's air, sweet and warm.

Steve Martin may dream of arriving someplace that is right, of a way of life and a home that suits him. He and Karen will be married this year.

Lance Martin, I suspect, once had a dream of building a good business on the Youghiogheny, and that has come true. Bill and Adalene Holt dreamed of having more time to relax, to do the things they wanted to do. Now they have the time but they have run out of youth, and face the day when they may have to leave their home.

Shelby Mitchell, old Shelby, dreamed of stability, of life equalizing itself between the ups and downs, of a life that he could simply call good. Now in retirement at seventy-three, he is stable, but dreams of youth. And although he is secure in the mountains above Ohiopyle, he has been away enough that he still dreams of the return, of what he sees whenever he comes back: the ridges one behind another fading in summer haze; the green tangle of blackberries, elderberries, raspberries, grapevines, and greenbrier; the green-and-white river and its rush over the Falls where he swam countless times, the Falls and its background music that entertains Ohiopyle. Shelby is a lucky man. He knows that he is home. What does this place have that other places do not?

The winter crawls on at its slow, earth-turning pace, and the darkness that came at five o'clock now comes at six. In another few weeks, the thaw will start. A sunny day will begin to melt the cold shell of the winter Appalachians, and water will run. The water, once again. The ice will go to McKeesport, and in late February the geese will sail over, heading north, maybe landing here at Confluence to join the local flock for a day or two. The streams will swell and burst with runoff in March, and then the yellow-greens of April, so full of life, will begin a new year along the Youghiogheny.

Acknowledgments

Sources

Index

Acknowledgments

From river guides and park rangers to mountain farmers and retired coal miners, the people who have shared the stories of their lives along the Youghiogheny are the people who have made this book possible.

Special appreciation for true tales and hospitality goes to Shelby and Lois Mitchell and to Bill and Adalene Holt of Ohiopyle. Steve Martin, John Lichter, Jim Wilson, and Mike McCarty were excellent river guides, helping to keep me alive while I saw the Youghiogheny close up. They were also excellent storytellers.

Boyd Murray spent many hours, including his summer vacation, reading the entire manuscript and noting hundreds of helpful suggestions, adding greatly to the readability of the final draft. Likewise, Ralph Haurwitz read much of the book and offered more comments and changes than I wish had been necessary. It is a fortunate writer who has two reviewers such as these. Jerry Meral and Melinda Wright also read the manuscript and contributed their own special insight.

Ronnie James typed the book four times and filled the nearly impossible role of my most critical yet most supportive reader.

Thoughtful reactions to ideas for the initial draft were provided by Bonnie Piper. Draft chapters were reviewed for accuracy and general content by many people: Tim Dugan, Garrett County Planning Director; David Wineland, Maryland Department of Natural Resources; Larry Adams, Ohiopyle State Park Superintendent; Bill and Adalene Holt, Ohiopyle residents; John Oliver, President of the

Western Pennsylvania Conservancy; Paul Wiegman, director of natural areas programs for the Western Pennsylvania Conservancy; Roger Fickes, director of wild and scenic river programs for the Pennsylvania Department of Environmental Resources; Richard Roos-Collins, publicist for Friends of the River in California; and Nina Norton who grew up in Connellsville. Sections of one chapter were reviewed by Dr. Maurice Goddard, former Secretary of the Department of Environmental Resources, and by David Fahringer, a landscape architect who worked under contract to the Western Pennsylvania Conservancy and the Department of Environmental Resources. Part of another chapter was reviewed by Charles Strauss, forest economist at The Pennsylvania State University.

Information and reflections were especially important from those people as well as the following: Pete Zurflieh, Rusty Thomas, Bernice Thomas, Senator Edward Mason, Imre Szilagyi, George Groff, Elsie Spurgeon, Bob and Evelyn Hutchinson, Red Jordan, Jim Prothero, Ed Jackson, Dr. Maurice Goddard, Jean and Sayre Rodman, Dave Kurtz, Lance Martin, Ralph McCarty, Wendell Holt, Mark McCarty, Stu Van Nosdeln, Bill Calantoni, Jim Ansel, Fern Colborn, and Dr. George Dull.

Additional information was provided by Dorothy Towhig of The Papers of George Washington project at the University of Virginia; Anna McNallie, Garrett County Planner; Kevin Steinhilber, coal mining consultant; Edgar Harmon, Garrett County Environmental Health Department; Tom Thayer, a realtor in Oakland; John Harrington, the Pennsylvania Electric Company in Johnstown; Gene Amocida, Army Corps of Engineers in Pittsburgh; John Reed, Army Corps of Engineers; Herb Wise, Army Corps of Engineers; Julia Roberts, librarian for the Army Corps of Engineers; Brent Blackwelder, Environmental Policy Center in Washington, D.C.; Chuck Hoffman, the American Rivers Conservation Council in Washington, D.C.; Dr. Edwin Price, Confluence; Reverend Arthur Gotjen, Confluence; Donna Landis and Karen Saxman, Somerset County Planning Commission staff; M. Graham Netting, Western Pennsylvania conservancy board member; Paulette Johnson, Western Pennsylvania Conservancy naturalist; Richard Pratt, Sierra Club, Pittsburgh; Bob Harrigan, Washington, D.C.; John Berry, Riparius, New York; John Sweet, State College, Pennsylvania; Carrilee Hemington, Fayette County Planning Director; Glenn Eugster, National Park Service in Philadelphia; Kenneth Baker, Westmoreland

Municipal Water Authority; and Ed Hogan of the Jones Brewing Company in Smithton. From Ohiopyle were Sherry Hall, Al Davis, Tom Love, Bob Marietta, Bob Marietta, Jr., Becky Holt, Leo Smith, and Elaine McCarty. River guides were Kevin Grady, Michael Normyle, Blake Martin, Chris Baggot, Ginny Stillman, Cass Chestnut, Phil Coleman, Tom Clark, Bobby Daniels, and Tom Finn. Bureau of State Parks employees were Bill Forrey, Ed Deaton, Mary Kelly, and Clyde Burnsworth. From other bureaus of the Department of Environmental Resources were Bud Friedrich, Terry Fabian, John McSparran, Joe Chunpa, Mark McClellan, and Peter Duncan— Secretary of the Department. From the Pennsylvania Fish Commission were Jim Ansel and Blake Weirich.

From files of the *Pittsburgh Press,* I gleaned important historical information covering a fifty-year period beginning in 1930. This included an excellent series about strip mining published in 1981. *Youghiogheny State and National Wild and Scenic River,* prepared by the National Park Service, included useful information about the basin. Stephen Schlosnagle's *Garrett County, A History of Maryland's Tableland,* was helpful, as was William Curry's *Laurel Hill Study,* and Sarah Hopkins's unpublished paper on Ohiopyle history, prepared for the Pennsylvania Bureau of State Parks. Scores of other sources are listed at the end of the book.

Jim and Lois Palmer, Jim Prothero, and Cindy and Stan Swaintek provided homes and shelter near the river where I was able to stay for days or months at a time. Pat Munoz, Howard Brown, and others at the American Rivers Conservation Council provided information about other rivers and offered their Washington, D.C., office as a place for me to work and live for several weeks.

Mark Anderman of Williamsport, Pennsylvania, printed the black and white photos with an undying curiosity for my adventures revealed to him only in a dark room, and with a dedication to quality in his work.

The book would never have been written without the special interest and support of Frederick Hetzel, Director of the University of Pittsburgh Press. Editor Catherine Marshall provided essential help in refining the manuscript and in guiding it toward publication. I also thank Sam Hays for his brief but important role in launching the project. A grant from the Pittsburgh Foundation made it possible for me to survive while working full-time on the book.

I owe special thanks for the encouragement of my good friends Kathy Garrett and Dennis Piper who read the entire manuscript, and to Neen and Art Davis who provided insight of many kinds, a contagious enthusiasm, and a home while I worked for several weeks in Pittsburgh. Perhaps most importantly, I owe thanks for the interest and love of my family.

Sources

Chapter 1. The High Ridge

Brooks, Maurice. *The Appalachians*. Grantsville, W.Va.: Seneca Books, 1965.
Pennsylvania. Department of Environmental Resources. Bureau of Topographic and Geologic Survey. *Pennsylvania Geology Summarized*. By Bradford Willard. Harrisburg, 1962.

Interviews

Jim Prothero, Confluence, Pa.
Floyd and Edith Cowger, Silver Lake, W.Va.

Chapter 2. A Gathering of Waters

"Boy Survives Tumble Over Yough Falls." *Pittsburgh Press*, May 27, 1975.
Browning, Meshach. *Forty-four Years of the Life of a Hunter*. Philadelphia: J. B. Lippincott, 1859.
Butterfield, C. W. *The Washington–Crawford Letters Concerning Western Lands*. Cincinnati: Robert Clarke and Co., 1877.
Darlington, William M. *Christopher Gist's Journals*. Pittsburgh: J. R. Weldin and Co., 1893.
Deep Creek Lake–Garrett County Promotion Council. *Garrett County and Deep Creek Lake, Maryland*. Oakland, Md., 1981. (Brochure obtainable from the Council, Courthouse, Oakland, Md.)
"Dempsey Believes Engineers Will Favor Youghiogheny-Potomac Project." *Pittsburgh Press*, Jan. 28, 1930.
Garrett County Planning Commission. *Garrett County Comprehensive Plan*. Oakland, Md.
Hattery, Thomas H., ed. *Western Maryland: A Profile*.
Hindman, William Blake. "The Great Meadows Campaign." *Tableland Trails* (Oakland, Md.) 2, no. 1 (1955).

Kline, Benjamin. *Tall Pines and Winding Rivers.* 920 Wheaton Drive, Lancaster, Pa. (Booklet.)

Maryland, Department of Natural Resources. *Deep Creek Lake State Park.* (Brochure obtainable from the Department, Tawes State Office Building, Annapolis, Md.)

―――. *Herrington Manor State Park.* (Brochure obtainable from the Department, Tawes State Office Building, Annapolis, Md.)

―――. *Swallow Falls State Park.* (Brochure obtainable from the Department, Tawes State Office Building, Annapolis, Md.)

Maryland. Department of Transportation and the Department of Economic and Community Development. *Economic Development and Transportation Improvements, Garrett County, Maryland.* Final report by Hammer, Siler, George Associates, and Barton-Aschman Associates, Inc. Washington, D.C., 1980.

McClenathan, John Carter. *Centennial History of the Borough of Connellsville, Pa., 1806–1906.* Columbus, Ohio: The Champlin Press, 1906.

McCombs, Phil. "Battle Rages Over Yough in Maryland." *Pittsburgh Press,* Nov. 6, 1976.

Pennsylvania. Department of Forests and Waters. *Pennsylvania Gazetteer of Streams, Part 1.* Water Resources Bulletin 6, by L. C. Shaw and W. F. Busch. Prepared in cooperation with the U.S. Department of the Interior, Geological Survey. Harrisburg, 1970.

Russell, Francis. *The French and Indian Wars.* New York: American Heritage, 1962.

Schlosnagle, Stephen, and the Garrett County Bicentennial Committee. *Garrett County: A History of Maryland's Tableland.* Oakland, Md.: Garrett County Historical Society, Inc., 1978.

Shaffer, Robert. *History of Crellin, Maryland.* Oakland, Md.: Sincell Publishing Co., 1976.

U.S. Army Corps of Engineers. *Potential Plan of Development, Water Resources in Appalachia.* Pittsburgh.

U.S. Department of Commerce. Bureau of the Census. *Statistical Abstract of the United States.* Washington, D.C., 1980. (Obtainable through the Superintendent of Documents, U.S. Government Printing Office, Washington, D.C.)

U.S. Department of the Interior. National Park Service. *Fort Necessity.* (Brochure obtainable from Fort Necessity, Farmington, Pa.)

Wallace, Paul A. *Indians in Pennsylvania.* Harrisburg: Pennsylvania Historical and Museum Commission, 1961.

Interviews

Tim Dugan, Garrett County Planning Director
Anna McNallie, Planner, Garrett County Planning Commission
John Nelson, Garrett County Zoning Officer
Gloria Salazar, Oakland
Edgar Harmon, Garrett County Environmental Health Department
Drew Ferrier, biology instructor, Garrett County Community College
Pete Skinner, kayaker, Albany, N.Y.
Charles Rosenbery, Penelec, Deep Creek Dam

Dennis Piper, National Park Service, Washington, D.C.
Gerry Sword, Park Manager, Swallow Falls State Park

Chapter 3. Wild River

Appalachian Wildwaters. *Current Events* (Albright, W.Va.), Winter 1982. (Rafting company newsletter.)
"Battle Rages over Yough in Maryland." *Pittsburgh Press*, Nov. 6, 1976.
Fitzpatrick, John C., ed. *The Writings of George Washington.* 39 vols. Washington, D.C.: Government Printing Office, 1931–1944.
Garrett County Planning Commission. *Planning Commission's Critical Areas Recommendations.* Memorandum 77-12. Oakland, Md., June 29, 1977.
Gertler, Edward. *Maryland and Delaware Canoe Trails.* Springfield, Va.: Seneca Press, 1979.
Hylton, William H., ed. *The Rodale Herb Book.* Emmaus, Pa.: Rodale Press, 1974.
Maryland. Department of Natural Resources. Capital Programs Administration, Land Planning Services. *Regulations for Wild Segment, Youghiogheny River, Garrett County, Maryland (Amended Feb. 26, 1976).* Annapolis, 1976.
———. Regional Forester, Savage River State Forest. *Fact Sheet.* Cumberland, Md.
———. General Assembly. *Wild and Scenic Rivers Act As Amended in the 1976 Session of the General Assembly.* Article—Natural Resources, Section 8-401 through 8-410, Annotated Code of Maryland. Annapolis, 1976.
Meyer, Eugene L. "River Rumble." *Washington Post*, May 3, 1982.

Interviews

Steve Martin, Ohiopyle
Al Davis, Ohiopyle
Dave Kurtz, State College, Pa.
Sayre and Jean Rodman, Oakmont, Pa.
Phil Coleman, Ohiopyle
Pete Zurflieh, Harrisburg
Jim Prothero, Confluence
Jean Stuben, Sang Run
Bryson (Rusty) Thomas, Sang Run
Bernice Thomas, Sang Run
Residents, Sang Run area
Senator Edward Mason, Cumberland, Md.
State Delegate Decorsey Bolden, Oakland
David Wineland, Maryland Department of Natural Resources
Tom Horton, *Baltimore Sun*
John H. Harrington, Adminstrator, Public Information, Penelec, Johnstown, Pa.
Tom Thayer, Oakland
Keith Bachlin, Albright, W.Va.
Al Fauber, Friendsville
Karen Fauber, Friendsville
Ed Sliger, Friendsville

Carl Helmick, Friendsville
Bud Fisher, Friendsville
Emery Friend, Friendsville

Chapter 4. The Dam

American Rivers Conservation Council. *A Citizens Action Guide to the Federal Flood Insurance Program.* Washington, D.C., 1974.

American Rivers Conservation Council and Environmental Policy Center. *95 Theses.* Washington, D.C., 1974.

"Dam to Erase Noted Village Dating to 1818." *Pittsburgh Press,* Sept. 29, 1940.

Environmental Policy Center. "EPC Urges Realistic Policy." *Washington Resource Report,* April 1981, p. 3.

Flood Commission of Pittsburgh, Pa. *Transmittal to Chamber of Commerce of Pittsburgh.* April 16, 1912.

"The Great Flood." *Pittsburgh Press,* April 18, 1936. (Supplement to newspaper.)

Hause, Mary. "Gigantic Youghiogheny Dam at Confluence Completed." *Pittsburgh Press,* Dec. 19, 1943.

"Lock, Dam Conditions Cited as River Threat." *Beaver County Times,* July 16, 1981.

Lorant, Stefan. *Pittsburgh: The Story of an American City.* Lenox, Mass.: Authors Edition, Inc., 1975.

Louisville Today. Louisville, Ky., Sept. 1978. (Entire issue.)

Mount Vernon Ladies Association of the Union. *The Diaries of George Washington, 1748–1799.* Cambridge, Mass., 1925. Vol. 1, p. 83.

Potter, John. *An Inquiry.* Uniontown, Pa.: J. & T. Patton, Printers, 1820.

Schlosnagle, Stephen, and the Garrett County Bicentennial Committee. *Garrett County: A History of Maryland's Tableland.* Oakland, Md.: Garrett County Historical Society, Inc., 1978.

Sierra Club. *Engineering a Victory for Our Environment: A Citizen's Guide to the U.S. Army Corps of Engineers.* Ed. Thomas M. Clement, Jr., Glen Lopez, Pamela T. Mountain, Charles M. Clusen. Originally prepared by the Institute for the Study of Health and Society, Washington, D.C., 1972. (Obtainable from the American Rivers Conservation Council, Washington, D.C.)

U.S. Army Corps of Engineers. Institute for Water Resources. *National Hydroelectric Power Resources Study: Preliminary Inventory of Hydropower Resources.* Vol. 6; *Northeast Region.* Ft. Belvoir, Va., 1979.

———. *National Waterways Study, Review Draft.* Ft. Belvoir, Va., 1981.

———. North Atlantic Division. *Water Resources Development in Pennsylvania, 1981.* New York, 1981.

———. Office of Appalachian Studies. *Water Resources in Appalachia. Main Report, Part 1, Summary Report.* Cincinnati, Oh., 1969.

———. Pittsburgh District. *A History of the Pittsburgh District, U.S. Army Corps of Engineers.* By Dr. Leland R. Johnson. Pittsburgh.

———. *Definite Project Report. Report Upon Proposed Youghiogheny River Reservoir, Upper Ohio River Basin for the Protection of Pittsburgh, Flood Control Act June 28, 1938.* Pittsburgh, Dec. 15, 1939.

————. *Master Land Use Plan, Youghiogheny River Reservoir, Pennsylvania and Maryland.* Pittsburgh, 1949.

————. *Design Memorandum No. 1, Master Plan Update for Youghiogheny River Lake.* By Stanley Consultants, Inc. Pittsburgh, 1979.

————. *Ohio River at Pittsburgh, Pa.—Point Gage, Flood Peaks and Reservoir Reductions.* Pittsburgh [1981?]. (On file in the Army Corps office.)

————. *Public Information Fact Sheet, Youghiogheny River Lake.* Pittsburgh, 1981.

————. *Tabulation of Visitation and Activity Participation for the Calendar Year 1980.* Pittsburgh. (On file in the Army Corps office.)

————. *Youghiogheny Lake.* Pittsburgh. (Brochure.)

U.S. Congressional Research Service. *Federal Aid to Domestic Transportation.* By Thompson, Maflei, and Lipford. Washington, D.C., April 1977.

U.S. Federal Energy Regulatory Commission. *Order Issuing Preliminary Permit and Denying Competing Applications.* Washington, D.C., May 29, 1981.

U.S. House of Representatives. *Report No. 2353.* 75th Cong., 3d sess., April 13, 1938.

U.S. House of Representatives. *House Document 644.* 78th Cong., 2nd sess., 1944.

U.S. House of Representatives. Committee on Flood Control. *Committee Document #1.* 75th Cong., 1st sess., 1937.

U.S. Office of the President. *Executive Message and Executive Orders on Flood Plain Management.* 1977.

U.S. Congress. *Flood Control Act of June 22, 1936.* Public Law No. 738.

U.S. Congress. *Flood Control Act, June 28, 1938.* Public Law No. 75-761.

U.S. Water Resources Council. *A Unified National Program for Floodplain Management.* Washington, D.C., 1979.

Interviews

Gene Amocida, Hydrology Branch, Army Corps of Engineers, Pittsburgh
Herb Wise, Army Corps, Pittsburgh
Bo Damario, Army Corps, Pittsburgh
John Reed, Army Corps, Pittsburgh
Howard Brown, American Rivers Conservation Council, Washington, D.C.
Chuck Hoffman, River Conservation Fund, Washington, D.C.
Brent Blackwelder, Environmental Policy Center, Washington, D.C.
Jim Palmer, Youghiogheny Lake
Red Jordan, Youghiogheny Lake
Bob and Evelyn Hutchinson, Youghiogheny Lake

Chapter 5. The Confluence

Curry, William, et al. *The Laurel Hill Study.* Prepared through the Department of Landscape Architecture and Regional Planning, University of Pennsylvania, Philadelphia, 1975.

Somerset County Planning Commission. *Somerset County Housing Element.* Somerset, Pa., 1977.

———. *Somerset County Preliminary Coal Impact Assessment Report.* Somerset, Pa., 1980.
Somerset County Planning and Zoning Commission. *Somerset County Economy Study.* Somerset, Pa., 1973.
———. *Somerset County Initial Water Resources Study.* Somerset, Pa., 1974.
———. *Somerset County Recreation Study.* Somerset, Pa., 1975.

Interviews

Jim Prothero, Confluence
Jim Wilson, Confluence
Elsie Spurgeon, Confluence
George Groff, Confluence
Donna Landis, Somerset County Planning Commission staff
Karen Saxman, Somerset County Planning Commission staff
Reverend Arthur Gotjen, Confluence
Dr. Edwin Price, Confluence

Chapter 6. The Singing River

"Conservancy Transfers Deed for 17 Miles of River Gorge Trail Near Ohiopyle." *Conserve* (Pittsburgh) 21, no. 1 (Jan. 1979).
Craig, Neville B., ed. *The Older Time.* Pittsburgh: J. W. Cook, 1846.
Curry, William, et al. *The Laurel Hill Study.* Prepared through the Department of Landscape Architecture and Regional Planning, University of Pennsylvania, Philadelphia, 1975.
Martin, Alexander C.; Zim, Herbert S.; and Nelson, Arnold L. *American Wildlife and Plants: A Guide to Wildlife Food Habits.* New York: Dover, 1951.
McCoy, C. J. *Poisonous Snakes of Pennsylvania.* Pittsburgh: Carnegie Museum of Natural History, 1974. (Brochure.)
Pennsylvania. Department of Commerce. *Pennsylvania Forest Industries Statistics.*
Pennsylvania. Department of Environmental Resources. *Mine Drainage Survey, Casselman River Basin, Somerset County.* (Paper available from the department, Harrisburg.)
———. Bureau of Topographic and Geologic Survey. *Pennsylvania Geology Summarized.* By Bradford Willard. Harrisburg, 1962.
———. Office of Resources Management, Bureau of State Parks. *Pennsylvania Trail Guide.* Harrisburg, 1979.
River Path Outfitters. *Whitewater Canoeing, Kayaking, Rafting.* Confluence, Pa., 1982. (Brochure.)
Twohig, Dorothy, Associate Editor, The Papers of George Washington. Alderman Library, The University of Virginia. Letter to Tim Palmer, April 19, 1982.
U.S. Forest Service. Northeastern Forest Experiment Station. *The Timber Resources of Pennsylvania.* By Roland H. Ferguson. Upper Darby, Pa.
"Youghiogheny River Battle Vowed." *Pittsburgh Press,* Nov. 21, 1965.
"Yough River Making Comeback as Play Stream." *Pittsburgh Press,* Mar. 18, 1951.

Interviews

Jim Prothero, Confluence
Andrew Friedrich, Chief, Division of Abandoned Mine Reclamation, Department
of Environmental Resources, Harrisburg
Ralph McCarty, Ohiopyle
Larry Adams, Ohiopyle State Park Superintendent
Adalene Holt, Ohiopyle
Bill Holt, Ohiopyle

Chapter 7. Ohiopyle: The Old Days

Ellis, Franklin, ed. *History of Fayette County, Pennsylvania, with Biographical
Sketches of Many of Its Pioneers and Prominent Men.* 2 vols. Philadelphia: L. H.
Everts and Co., 1882.
Pennsylvania. Department of Environmental Resources. Bureau of State Parks. "A
History of the Ohiopyle Area." By Sarah E. Hopkins. 1977. (Unpublished
paper.)
"Shoals' Idea Proposed Here." *Pittsburgh Press,* June 6, 1933.
U.S. Army Corps of Engineers. Pittsburgh District. *Reconnaisance Report on
Youghiogheny River Survey Report.* Pittsburgh, Sept. 29, 1938.

Interviews

Shelby Mitchell, Chalk Hill
Lois Mitchell, Chalk Hill
Adalene Potter Holt, Ohiopyle
Bill Holt, Ohiopyle
Gladys Jackson, Ohiopyle
Gwen Waters, Ohiopyle
Dr. George Dull, Connellsville
George Groff, Confluence
Edward Jackson, Chalk Hill

Chapter 8. The Park

Jennings, O. E. *Trees and Shrubs of Ferncliff Park.* Pittsburgh: Western Pennsylva-
nia Conservancy, 1965.
Pennsylvania. Department of Environmental Resources. Bureau of Resources Pro-
gramming. *A Comprehensive Master Plan for Ohiopyle State Park.* Report by
Environmental Planning and Design, Pittsburgh. Harrisburg, 1976.
———. *A Transportation Study for Ohiopyle State Park.* Prepared by Environ-
mental Planning and Design, Pittsburgh, and General Analytics, Inc., Monroe-
ville, Pa. Harrisburg, 1974.
———. Bureau of State Parks. *Ohiopyle State Park Attendance Summary.* Ohio-
pyle: Ohiopyle State Park, 1981.
———. "Recreation Areas of Pennsylvania Under the Jurisdiction of the Bureau of
State Parks." Harrisburg, Oct. 21, 1981. (Paper on file.)

———. Bureau of Topographic and Geologic Survey. *Geologic Features of Interest, Ohiopyle State Park.* Harrisburg. (Brochure.)

Pennsylvania. Department of Forests and Waters. *Outdoor Recreation Horizons.* By David Fahringer et al. Harrisburg, 1970.

Pennsylvania. Governor's Office of State Planning and Development. *Pennsylvania's Recreation Plan. Summary.* Harrisburg, 1976.

Western Pennsylvania Conservancy. "The Laurel Highlands Trail from State Game Land 111 to Ohiopyle." Pittsburgh, 1982. (Paper on file.)

———. *Summary of Conservancy's History.* Pittsburgh. (Paper on file.)

Interviews

John Oliver, Western Pennsylvania Conservancy, Pittsburgh
Paul Wiegman, Western Pennsylvania Conservancy
David Fahringer, Monroeville, Pa
Dr. Maurice Goddard, Carlisle, Pa.
Ed Jackson, Chalk Hill, Pa.
Gwen Waters, Ohiopyle
Bill Holt, Ohiopyle
Adalene Potter Holt, Ohiopyle
Shelby Mitchell, Chalk Hill, Pa.
William Forrey, Director, Bureau of State Parks, Department of Environmental Resources, Harrisburg
Ed Deaton, Bureau of Resources Programing, Department of Environmental Resources, Harrisburg
Roger Fickes, Bureau of Resources Programing, Department of Environmental Resources, Harrisburg
Richard Pratt, Sierra Club, Pittsburgh
Paulette Johnson, Western Pennsylvania Conservancy
Larry Adams, Ohiopyle State Park Superintendent
Clyde Burnsworth, Ohiopyle

Newsletters and Magazines

Conserve: Water, Land, and Life. Western Pennsylvania Conservancy. 1969–1982.

Chapter 9. Whitewater

Bradley-Steck, Tara. "Success Hasn't Spoiled Ohiopyle." *Beaver County Times,* July 26, 1981.

Burmeister, Walter F. *Appalachian Waters.* Vol. 5: *The Upper Ohio and Its Tributaries.* Oakton, Va.: Appalachian Books, 1978.

Burrell, Bob, and Davidson, Paul. *Wild Water West Virginia.* Morgantown, W.Va.: Burrell and Davidson, 1975.

Instruction in Kayak, Canoe, C-1. Ohiopyle: Riversport, 1982. (Brochure.)

Louisiana State University. *1977 Scenic Rivers Symposium Papers.* Baton Rouge, La.: Department of Landscape Architecture, Louisiana State University, 1977.

Pennsylvania. Department of Environmental Resources. Bureau of State Parks. *An*

Operational Analysis of the Ohiopyle State Park Float-Trip System. By Charles H. Strauss, Charles L. Myers, Jr., Jeffrey B. Schmitt, and Donald N. Thompson. Harrisburg, 1978.

————. *Whitewater Boating Operational Guidelines.* Ohiopyle: Ohiopyle State Park, 1979. (Four-page paper.)

River Conservation Fund. *Flowing Free: A Citizen's Guide for Protecting Wild and Scenic Rivers.* Washington, D.C., 1977.

Spindt, Katherine M., and Shaw, Mary, eds. *Canoeing Guide to Western Pennsylvania and Northern West Virginia.* 6th ed. Pittsburgh: American Youth Hostels, 1975.

Sweet, John R. "Going for Gold! The Evolution of C-1 Slalom in the United States." *Whitewater* (U.S. International Slalom Canoe Association, Rochester, N.Y.), 1979.

U.S. Comptroller General. *Hydropower—An Energy Source Whose Time Has Come Again.* Report to the Congress. Washington, D.C., Jan. 11, 1980.

U.S. Department of the Interior. Bureau of Outdoor Recreation, and the Pennsylvania Department of Environmental Resources. *Northeast Regional States Scenic Rivers Planning Workshop, May, 1976, Summary of Proceedings.* Philadelphia, 1976.

U.S. Forest Service. *Allocating River Use.* By Bo Shelby and Mark Danley. Oregon State University, 1979.

————. North Central Forest Experiment Station. *Proceedings: River Recreation Management and Research Symposium, 1977.* St. Paul, Minn., 1977.

"U.S. Forest Service Chief Calls Equal Permits a 'Feasible Alternative.'" *Currents* (National Organization for River Sports), March 1982.

"U.S. National Slalom and Wildwater Champions." *Whitewater* (U.S. International Slalom Canoe Association, Rochester, N.Y.), 1981.

Walsh, Lawrence. "Chaplain on 'Frightwater' Trip." *Pittsburgh Press,* Aug. 13, 1978.

Interviews

Steve Martin, Ohiopyle
Jef Huey, Washington, D.C.
John Sweet, State College, Pa.
Sayre and Jean Rodman, Oakmont, Pa.
Bob Harrigan, Washington, D.C.
John Berry, Riparius, N.Y. (letters)
Dave Kurtz, State College, Pa.
Tom Smyth, State College, Pa.
Lance Martin, Ohiopyle
Walter Burmeister, El Paso, Tex. (letters)
Glen Kovak, Ohiopyle
Paul Grabo, Ohiopyle
Leslie Adams, Ohiopyle
Ralph McCarty, Monroeville, Pa.
Mike McCarty, Ohiopyle
Elaine McCarty, Ohiopyle

John Lichter, Ohiopyle
Chris Baggot, Ohiopyle
Tom Love, Ohiopyle
Jim Prothero, Confluence
Mark McCarty, Ohiopyle
Kevin Grady, Ohiopyle
Mark Singleton, Ohiopyle
Sherry Hall, Ohiopyle
Bob Marietta, Ohiopyle
Shirley Marietta, Ohiopyle
Bob Marietta, Jr., Ohiopyle
Wendell Holt, Ohiopyle
Becky Holt, Ohiopyle
Bobby Daniels, Ohiopyle
Bill Calantoni, Ohiopyle
Kelly McGuiness, Ohiopyle
Phil Coleman, Ohiopyle
Ginny Stillman, Morgantown, W.Va.
Cindy Swaintek, Ohiopyle
Larry Adams, Ohiopyle State Park Superintendent
Clyde Burnsworth, Ohiopyle
Mary Kelly, Greensburg, Pa.
Charles Strauss, State College, Pa.

Chapter 10. Ohiopyle and the Run

Interviews (all in Ohiopyle)

Leo Smith
Winnie Glotfelty
Johnny Moore
Cindy Swaintek
Shelby Mitchell
Bill Holt
Adalene Potter Holt
Gwen Holt Waters
Lance Martin
Mark McCarty
Mike McCarty

Chapter 11. The Mines and the River

Davis, Arthur A. *Coal and Its Consequences.* A report of the Pennsylvania Land Policy Project, an activity of the Western Pennsylvania Conservancy. Pittsburgh: the Conservancy. 1980.
Haurwitz, Ralph. "Local Fears Bar Yough River from U.S. Program." *Pittsburgh Press,* Nov. 23, 1981.

——. "Scenic River Rapid Shuffle Perils Yough." *Pittsburgh Press*, Nov. 22, 1981.
——. "State Secretly Alters Strip-Mine Rules." *Pittsburgh Press*, July 5, 1981.
——. "Wastelands Return to Our 'Model' State." "Lax Enforcement Key to Mine Woes." "Dig-and-Run Strip Miners Still on Loose." "State's Strip-Mining Records a Shambles." "Residents Scarred by Strip-Mine Abuse." "Keeping an Eye on the Strippers." "Strip Mine Issues Mired in Politics." "Strip-Mine Cave-In." *Pittsburgh Press*, Mar. 8–12, 1981.
Meeting of Federal Bureau of Outdoor Recreation, Pennsylvania Department of Environmental Resources, Concerning Youghiogheny/Wild and Scenic River Project. Transcript by Dr. Edwin Price. Mar. 28, 1977.
Pennsylvania. Department of Environmental Resources. *Policy Statement on the Youghiogheny River.* Harrisburg, Mar. 28, 1977. (Three-page paper.)
——. *Youghiogheny River Basin Mine Drainage Pollution Abatement Project, Operation Scarlift.* By Gibbs and Hill, a subsidiary of Dravo. Harrisburg, 1972.
U.S. Department of the Interior. Heritage Conservation and Recreation Service. Northeast Regional Office. *Proposed Youghiogheny State and National Wild and Scenic River, Maryland-Pennsylvania.* Philadelphia, Oct. 3, 1978.
"Youghiogheny Aid is Urged." *Pittsburgh Press*, Nov. 29, 1965.
"Youghiogheny 'Wild River' Study Blasted." *Morning Herald–Evening Standard* (Uniontown), May 12, 1976.

Interviews

James Ansel, Pennsylvania Fish Commission, Dunbar
Fern Colborn, Mill Run, Pa.
Kevin Steinhilber, Oakland, Md.
Nancy Dimeolo, Bureau of Mining and Reclamation, Department of Environmental Resources, Greensburg, Pa.
Stephen Beam, Penns Woods West Chapter, Trout Unlimited, Pittsburgh
Andrew Friedrich, Chief, Division of Abandoned Mine Reclamation, Department of Environmental Resources, Harrisburg
Kenneth Baker, Westmoreland Municipal Water Authority, Greensburg, Pa.
Ralph Haurwitz, *Pittsburgh Press*
Ed Deaton, Bureau of Resources Programing, Department of Environmental Resources, Harrisburg
Roger Fickes, Bureau of Resources Programing, Department of Environmental Resources, Harrisburg
Dr. Edwin Price, Confluence
Stuart Van Nosdeln, Ohiopyle
Lance Martin, Ohiopyle
Glenn Eugster, Chief, Planning Division, National Park Service, Philadelphia

Chapter 12. Beyond the Appalachians

Burmeister, Walter F. *Appalachian Waters.* Vol. 5: *The Upper Ohio and Its Tributaries.* Oakton, Va.: Appalachian Books, 1978.
Colelli, Camillo. "Perryopolis." *Tableland Trails* (Oakland, Md.) 2, no. 1 (Spring 1955).

Ellis, Franklin, ed. *History of Fayette County, Pennsylvania, with Biographical Sketches of Many of Its Pioneers and Prominent Men.* 2 vols. Philadelphia: L. H. Everts and Co., 1882.

Galley, Henrietta. *History of the Galley Family with Local and Old-Time Sketches in the Yough Region.* Philadelphia: Philadelphia Printing and Publishing Co., 1908.

Jones Brewing Company. *All About Jones Brewing Co.* Smithton, Pa. (Brochure.)

McGhee, Ronnie; Mary Reardon; and Arleen Shulman, eds. *Readings in Water Conservation.* Washington, D.C.: National Association of Counties Research, Inc.

Pennsylvania. Department of Environmental Resources. Bureau of Water Quality Management. *Water Quality Inventory.* Pittsburgh, April 1980.

Pennsylvania. Governor's Office of State Planning and Development. *A Land Use Strategy for Pennsylvania: A Fair Chance for the Faire Land of William Penn.* By Arthur A. Davis. Harrisburg, 1974.

Pennsylvania. State Planning Board. *An Economic Atlas of Pennsylvania.* By E. Willard Miller, Department of Geography, The Pennsylvania State University. Harrisburg, 1964.

Regional Plan for the Connellsville Area. By Beckman, Yoder and Seay, Inc. Connellsville, 1971.

Swetnam, George, and Smith, Helene. *A Guidebook to Historic Western Pennsylvania.* Pittsburgh: University of Pittsburgh Press, 1976.

Uhl, Shirley. "Amtrack Ride to D.C. a Scenic Delight." *Pittsburgh Press,* Jan. 17, 1982.

United Steelworkers of America. *Linden Hall.* Dawson, Pa., (Brochure.)

"Yough Survey: Variety of Fish." *Morning Herald-Evening Standard* (Uniontown), Oct. 1, 1976.

U.S. Water Resources Council. *The Nation's Water Resources 1975–2000.* Vol. 1: *Summary, Second National Water Assessment by the U.S. Water Resources Council.* Washington, D.C., 1978. (Obtainable from the Superintendent of Documents.)

Interviews

Kenneth Baker, Westmoreland Municipal Water Authority, Greensburg, Pa.

Joseph Lawrence, Westmoreland Municipal Water Authority, Connellsville

James Ansel, Pennsylvania Fish Commission, Dunbar, Pa.

Terry Fabian, Regional Engineer, Bureau of Water Quality Management, Department of Environmental Resources, Pittsburgh

Don Bialosky, Bureau of Water Quality Management, Department of Environmental Resources, Pittsburgh

Alvin Brown, Bureau of Water Quality Management, Department of Environmental Resources, Pittsburgh

Walter O'Shinski, Bureau of Water Quality Management, Department of Environmental Resources, Pittsburgh

Carilee Hemington, County Planning Director, Fayette County Planning Commission

Dr. George Dull, Connellsville

Bob Hutchinson, Youghiogheny Lake

Ed Hogan, Vice-President in charge of sales and marketing, Jones Brewing Co., Smithton, Pa.

Index

Abbey, Edward, 198
Adams, Larry, 128, 135, 225, 238–40, 243–46, 262, 272, 282
Agriculture, 20–21, 90–91, 146
Allagash River, 240–41
Allegheny County, 15
Allegheny River, 17, 79
Al's Riverside Lounge, 67–71
American River, South Fork, 196
American Rivers Conservation Council, 261
Amish residents, 21
Ansel, Jim, 121, 269, 272–75, 295
Appalachian Mountains, 5–6, 11, 86, 113, 137, 157, 267, 284
Appalachian Regional Commission, 22, 51
Armstrong, John, 145
Army Corps of Engineers, 22, 26–27, 74–77, 80–87, 91–93, 97–98
Augustine, Eleanor, 103, 117

Backbone Mountain, 4–9, 20, 310
Banning, 298
Berry, John, 201
Bickham, Bill, 33, 202
Bicycle trail, 129
Big Sandy River, 10, 31, 196
Blackwater River, 10, 31, 196
Bolden, Decorsey, 57
Boston, Pa., 291, 301–02
Braddock, General Edward, 12, 18, 88, 138, 287, 305
Brownsville, 19, 77, 78, 96
Bruner Run, 138, 183, 231

Buena Vista, 301
Burmeister, Walter, 201

Calantoni, Bill, 226, 236, 249, 252–54, 264
Camping, 127–28, 184
Canoeing, 124–27, 129, 135, 200–01, 223, 264–67, 283–84, 295
Carter, President Jimmy, 85
Casselman River, 14, 17–19, 27–28, 80, 118, 120–22, 157, 267
Chattahoochee River, 258
Chattooga River, 196, 240–41
Cheat River, 10, 52, 60, 78–79, 139, 196, 260
Chesapeake and Ohio Canal, 19, 300
Chestnut Ridge, 16, 113, 283–84
Chief Seattle, 117
Clarion River, 129, 181
Climate, 15, 284, 310
Coal Run, 28, 120
Coke production, 292–93
Colborn, Fern, 180, 269, 272–74, 276, 281, 288
Coleman, Ed, 213–14
Conemaugh River, 123
Confluence, 19, 74, 82, 85, 87, 90, 103, 108, 110, 112–18, 140, 307, 309–10
Connellsville, 77, 80, 92, 155, 270, 284–85, 287, 289, 292–96, 310
Crawford, William, 297
Crellin, 21–22, 46, 51
Crooked Creek, 198

Cucumber Run and Falls, 144, 168
Cumberland, 17–19

Damaree, Dave, 34
Dams, 4, 7, 21, 26, 50–51, 72, 77–85, 150, 157, 260, 279, 281, 286–87, 302
Davis, Al, 32, 61, 67, 211
Davis, Mount, 28
Dawson, 296
Deaton, Ed, 179, 181–82, 277
Deep Creek, 15, 27
Deep Creek Dam, 11, 32, 75
Delaware Indians, 12–13
Delaware River, 14, 129, 174, 285
Dugan, Tim, 20, 60
Dull, Dr. George, 141, 155, 249, 293–95
Dunbar Creek, 271, 295
Duncan, Peter, 273

Eagle Rocks, 9–12
Economy and industry, 22–23, 27, 115, 143, 150, 157, 270–71, 276, 294, 303–05
Eichbaum, Bill, 175
Energy and coal, 270–71, 275; conservation of, 275
Eugster, Glen, 280

Fahringer, David, 172–73, 182
Fallingwater, 149
Faucett, Tom, 138
Fayette County, 15, 270
Ferncliff Park, 140, 153, 162–65, 216
Fickes, Roger, 280–81
Fish, 90, 92–93, 96, 103, 105, 120–23, 144, 273, 295
Floods and flood control, 74, 76, 78–85, 91, 300
Forbes, John, 18
Forrey, Bill, 179, 181, 187
Fort Necessity, 18, 87
French and Indian War, 17–18, 88, 138
Frick, Henry Clay, 292, 293
Friedrich, Andrew, 121–22
Friend, Charles, 19
Friend, Emery, 71–72
Friend, John, 114
Friendsville, 71–72, 80, 87

Garrett County, 10, 15, 20, 22–24, 27
Garrettland Realty, 53
Gauley River, 60, 68, 189, 196

Geology, 98, 122–23, 162, 269
Gertler, Edward, 31
Gist, Christopher, 7, 14, 113
Goddard, Maurice, 173–77, 180–81, 278
Gotjen, Reverend Arthur, 117, 282
Grand Canyon, 237
Grantsburg, 17, 19
Great Crossings, 17, 87–88, 99
Green, Greg, 211
Gristmills, 145, 150
Groff, George, 90–91, 102

Hall, Jesse, 39–40, 244
Harmon, Edgar, 24
Harrigan, Bob, 201, 236
Harvard Business School, 275
Heinz, H. J., 79
Holt, Adalene and Bill, 146–49, 167, 185, 187, 196, 310
Holt, Wendell, 215–16, 220
Holt family, 147
Holt's store, 144, 147–48, 155, 225, 247–48
Hoyes Crest, 9
Hudson River, 196
Hughes, Governor Harry, 56
Hutchinson, Bob and Evelyn, 95, 297
Hydroelectric power, 22, 26–27, 51, 77, 83, 139, 164
Hydrology, 6, 14–15

Indian Creek, 15, 268–69, 273–76, 283
Indians, 13–17, 117, 137, 287
Ions, negative, 191
Islands, 130, 297

Jackson family, 139, 144, 158, 178–79
Jacobs Creek, 15, 292, 298
Jennings, Dr. O. E., 162
Jockey Hollow, 86, 88–89, 145
Jonathan Run, 259, 272
Jordan, Red, 93, 310

Kaufmann, Edgar, 147, 163
Kendall, 66, 70, 72
Kendall Lumber Company, 21, 139, 150
Kentuck Mountain, 138, 178
Kiskiminetas River, 14
Kurtz, Dave, 33–34, 201–02, 224

Land use, 15–16, 20–21, 27, 60, 75, 280, 301, 303–04

Laurel Highlands River Tours, 213–14
Laurel Hill, 122, 128
Laurel Hill Creek, 15, 82, 121–22
Laurel Ridge Trail, 20, 128
Layton, 297
Lehigh River, 195
Lichter, John, 104, 194, 211, 240, 252
Linden Hall, 297
Little Conemaugh River, 85
Little Youghiogheny River, 15, 23, 47
Loch Lynn, 9, 24
Logging, 7–8, 21–22, 90, 140, 151, 166
Loop, the, 167, 192–94, 201, 266
Love, Tom, 211–12
Lugbill, Jon, 207, 251
Luke, Md., 11

McCarthy, Ed, 205
McCarty, Mark, 180, 212, 214, 251, 263
McCarty, Mike, 209, 212, 296
McCarty, Ralph, 129, 207–13, 245, 261
McEwen, Tom, 38–39
McKeesport, 4, 303, 305
McKinley, President William, 89
Mahoning River, 14
Manning, Joe, 63–66
Marietta, Bob, 180, 215–17, 220, 224,
 236, 240
Marietta family, 153, 216–17, 293
Martin, Lance, 189, 203–07, 237–38, 243,
 260, 263, 281, 312
Martin, Steve, 29–33, 66–67, 188–92, 222,
 255–59, 262–64, 309, 312
Maryland Department of Natural Re-
 sources, 24, 55, 64
Mason, Senator Edward M., 49, 55–57,
 65–66
Meadow Run, 18, 145, 150, 170, 272
Meyersdale, 21
Miller's Run, 64–65
Mine drainage, 22, 28, 83–84, 120–21,
 144, 158, 173, 268–77, 284, 298
Mining, 28, 56, 67, 78, 83, 96, 143–44,
 151, 156, 267–77, 280–82, 288, 292–93
Mississippi River, 17
Mitchell, Shelby, 139–43, 152, 159–60,
 166, 185, 197, 204, 259, 270, 293, 310,
 312
Mitchell family, 138–39, 141–42, 144, 185
Mountains, 5, 9, 25, 28, 122–23, 133, 137,
 142, 283

Mountain Streams and Trails, 207–13
Monongahela River, 14, 19, 77–81, 285–
 86, 302, 306
Moshannon Creek, 201
Motorboating, 92, 102, 302
Mountain Lake Park, 24
Mount Storm Power Plant, 11
Muddy Creek, 26

National Road, 19, 77
Navigation, rivers and canals, 19, 77–78,
 83–84, 292, 300, 302, 306
Nemacolin, 17
Netting, M. Graham, 161, 163
New River, 60, 196

Oakland, 9, 22–24, 47, 88, 140
Ocoee River, 196
Ohio Company, 17, 113
Ohiopyle, 247–55, 310; history of, 77, 107,
 136–61
Ohiopyle Falls, 137, 139–40, 150, 164, 169
Ohiopyle House, 133, 152, 163, 180
Ohiopyle State Park, 16, 128–29, 134,
 172–87, 235, 239, 267, 272–73
Ohio River, 14, 16, 77, 79–84
Ohio Valley, 303–04
Oliver, John, 129, 163, 181–82, 187
Olmstead, Frederick Law, Jr., 176
Orme, Captain Robert, 13, 88, 287

Palmer, James, 146
Pennsylvania Department of Environmental
 Resources, 121, 174, 237, 273, 276, 296,
 298, 300
Pennsylvania Electric Company, 11, 26–27,
 50–51
Pennsylvania Fish Commission, 120–21
Penobscot River, West Branch, 196
Pine Creek, 128, 203
Pittsburgh, 11, 18–19, 78–85, 92, 151, 292
Pittsburgh Post Gazette, 277
Pittsburgh Press, 92, 221
Plant life, 117, 130–31, 162
Pleasant Valley, 20–21
Pollution, 23–24, 84, 140, 154, 158, 284,
 291, 295–96, 298, 300, 304
Population, 15, 20, 22–23, 115, 305
Potomac National Heritage Trail, 19
Potomac River, North Branch, 10, 196, 198
Potter, John, 88–89, 145

Potter family, 143, 145–46
Pratt, Richard, 183
Preston County, 5, 15
Preston Lumber Company, 21
Price, Dr. Edwin, 114, 278
Project 70, 177
Prothero, Jim, 3, 5, 7–8, 46, 106–12, 116, 124, 194, 210–11, 307, 312

Rafting, 198–200, 222–23; commercial, 60–63, 107, 112, 169, 203–21, 227, 229, 232–34, 241–44, 255–64; rental, 219–21, 232–34
Railroads, 19, 66, 88, 90, 112, 118, 128, 134, 150–51, 155, 156, 165, 270, 300
Republic Steel, 298
River guides, 209, 249, 253
River Path, 108–12
Rodman, Jean and Sayre, 34, 197–200, 203, 235, 261
Route 40, 16–19, 87, 89, 100

Salisbury, 21
Sang Run, 28–31, 35–38, 41, 51, 61, 77, 80
Savage River, 10
Schuylkill River, 14
Selbysport, 88, 91
Seven Springs, 83
Sewickley Creek, 15, 300
Shapp, Governor Milton, 175
Shipley, Harry, 133
Sierra Club, 183–84
Siltation, 4, 97, 122
Silver Lake, 4, 22
Skinner, Pete, 61
Sliger, Ed, 70–71
Smith, Leo, 148, 248
Smithton, 298
Smyth, Tom, 33, 201–02
Snowy Creek, 22
Snyder, J. Buell, 82, 90, 157
Somerfield, 87, 89, 90–92, 100
Somerset County, 15, 272
Spurgeon, Elsie, 86–91
Stanislaus River, 128, 196
Stewart, Andrew, 150, 153
Stewarton, 182
Stoney's Beer, 298
Stony Creek, 85
Strauss, Charles, 240–42, 245

Sugarloaf Mountain, 133, 272
Susquehanna River, 14; West Branch, 201, 238, 284
Sutersville, 301
Swallow Falls, 18, 25, 26
Sweet, John, 194
Szilagyi, Imre, 50, 60–63

Tennessee River, 157
Thayer, Tom, 57, 59, 63–66
Thomas family, 35–46, 49–55, 312
Thornburgh, Governor Richard, 175
Tourism, 27, 153, 156, 186, 245
Trails, 26, 128
Tributaries, 14–15
Tub Run, 89
Turkeyfoot, 113
Tygart River and Dam, 78, 81

Uniontown, 13, 92, 249
U. S. Steel, 306

Van Nosdeln, Stuart, 183–84, 219, 221, 224, 232–34, 240, 244, 263, 278–81
Versailles, 301–03
Victoria, 26, 88, 133–34, 297
Viola's Restaurant, 116–17, 310

Washington, George, 7, 13, 17–19, 32, 72, 87, 113, 119, 137, 270, 287, 296, 305
Water supply, 76, 83, 267, 269, 274–75, 285–86; conservation of, 286
Waters, Gwen, 152–56, 250, 293, 312
Western Pennsylvania Conservancy, 128, 148, 153, 161, 163, 172–73, 175, 177–83
Westernport, 9
West Fork River and Dam, 10, 81–82, 91
Westmoreland County, 15
Westmoreland Municipal Water Authority, 274–75, 285–86
West Newton, 77–78, 83, 290, 299–300
White, Gilbert, 85
Whitewater, 26, 28, 31–34, 68, 108, 122, 125–27, 134–35, 162, 171, 188–203, 256–60; boating, management of, 186, 234–38, 240–46
White Water Adventurers, 155, 215–19, 244, 253
Whitsett, 298
Wiegman, Paul, 162, 183, 236

Wild and scenic river designation: in Maryland, 43–44, 50–51, 55–66; in national system, 117, 273, 276–82; in Pennsylvania, 280–81

Wilderness Voyageurs, 203–07, 221

Wildlife, 117, 120, 131–33, 296, 304

Wilson, Jim, 110–12, 124, 134, 194, 230, 264, 265–66, 283

Wineland, David, 38, 58–60, 63

Youghiogheny Dam and Reservoir, 14, 72–102, 285

Youghiogheny River: statistics, 4, 11–12, 14; naming of, 13–14; exploration of, 16, 87, 113, 137; gradient of, 16, 20, 31, 162, 235, 283–84, 295; access to, 37–38, 182–84, 237

Zurflieh, Pete, 35–37, 41, 54

Books by Tim Palmer

Rivers of Pennsylvania
Stanislaus: The Struggle for a River